African American Faces
of the Civil War

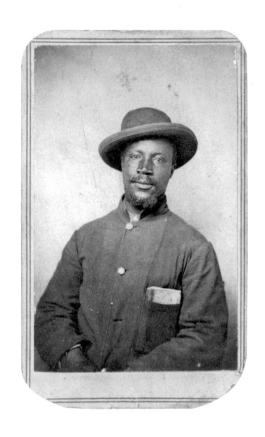

This *carte de visite* is printed at actual size.
The photographs in this collection have
been enlarged.

African American Faces *of the* Civil War

AN ALBUM

Ronald S. Coddington

WITH A FOREWORD
BY J. MATTHEW GALLMAN

THE JOHNS HOPKINS UNIVERSITY PRESS
BALTIMORE

© 2012 The Johns Hopkins University Press
All rights reserved. Published 2012
Printed in the United States of America on acid-free paper
2 4 6 8 9 7 5 3

The Johns Hopkins University Press
2715 North Charles Street
Baltimore, Maryland 21218-4363
www.press.jhu.edu

LIBRARY OF CONGRESS CATALOGING-IN-PUBLICATION DATA
Coddington, Ronald S., 1963–
African American faces of the Civil War : an album / Ronald S. Coddington;
with a foreword by J. Matthew Gallman
pages cm
Includes bibliographical references and index.
ISBN 978-1-4214-0625-1 (hdbk. : alk. paper) — ISBN 978-1-4214-0723-4
(electronic) — ISBN 1-4214-0625-X (hdbk. : alk. paper) —
ISBN 1-4214-0723-X (electronic)
1. United States—History—Civil War, 1861–1865—Participation, African
American—Pictorial works. 2. United States—History—Civil War, 1861–1865—
Biography. 3. United States—History—Civil War, 1861–1865—Portraits.
4. United States. Army—African American troops—Biography. 5. United
States. Army—African American troops—Portraits. 6. United States. Colored
Troops—Biography. 7. United States. Colored Troops—Portraits. 8. African
American soldiers—Biography. 9. African American soldiers—Portraits.
I. Title.
E540.N3C64 2012
973.7'415—dc23
2012002231

A catalog record for this book is available from the British Library.

*The frontispiece photograph, by an unidentified photographer, is from the
collection of Sam Small. It depicts Tom Henderson, who acted as a servant to
Lt. Col. Charles B. Lamborn of the Fifteenth Pennsylvania Cavalry.*

*Special discounts are available for bulk purchases of this book. For more information, please
contact Special Sales at 410-516-6936 or specialsales@press.jhu.edu.*

The Johns Hopkins University Press uses environmentally friendly book materials, includ-
ing recycled text paper that is composed of at least 30 percent post-consumer waste, when-
ever possible.

For Anne, always and forever yours

For Mom, with love and gratitude

In memory of my grandmother, Louise Bodnar,
who continues to inspire

Contents

Foreword

J. MATTHEW GALLMAN

HISTORIANS ARE FOND OF USING THE NOTION OF A "SNAP-shot" to describe and explain certain historic phenomena. It is a useful expression. A snapshot captures a particular place and time, while revealing little about what is to come or what has gone before. Sometimes the evidence of a moment cannot capture change over time, and we are wise to look at it through this static interpretive lens. Other snapshots might capture a diversity of facts coexisting at that moment, and by focusing on that historic moment, while ignoring what happened after the shutter clicked, we can gain important insights or remind ourselves of things that we should not have forgotten. Historic actors might have had feelings about how events would unfold, but they did not know what would appear on the next page. Even where historians might recognize the preconditions of future events in one moment's data, the participants did not necessarily see what was to come. Thus, we now speak of the "antebellum" decades although nobody in the 1850s used the term, few anticipated war, and none correctly predicted the carnage that would follow. As Gary Gallagher has recently demonstrated in *The Union War*, even though the Civil War became a war for emancipation and irrevocably changed the racial landscape of the United States, on the eve of the War Between the States the vast majority of white Northerners thought much more about preserving the federal Union than they did about slavery or racial inequalities. As Gallagher reminds us, it is a crucial error to read the emancipation narrative into the war years and antebellum years. A snapshot of 1860 contains many Northern abolitionists but many more people who thought little about the issue. Of course, not everyone was in the same snapshot.

By an interesting coincidence, the Civil War years saw two important turning points in American life. Both transitions are illustrated in the seventy-seven photographs assembled by Ronald S. Coddington in his fascinating volume, *African American Faces of the Civil War: An Album.* The two narrative threads are quite distinct, but they come together to point to some larger conclusions about the meaning of race and citizenship in mid-nineteenth-century America. It is perhaps not pushing the metaphor too far to suggest that two very distinct historic snapshots come together in these photographs.

The first narrative concerns the roles of African Americans, and particularly black men, in American public life. Prior to the outbreak of the Civil War, the national debate over slavery had certainly placed racial issues at center stage in political discourse; but in truth, those debates had concerned a fairly narrow array of issues. Some Northerners differed with most white Southerners over the future of slavery in the territories, as well as over the fundamental morality of slavery as a system of labor and of unfree labor as the basis for a political culture. As Lincoln would famously write to Alexander H. Stephens on December 22, 1860, shortly after his election, "You think slavery is right and ought to be extended; while we think it is wrong and ought to be restricted." But the heat of some of these quarrels—and the fact that they would soon lead to bloodshed—should not mask the fundamentally narrow swath of terrain over which these rhetorical battles were being fought. Although radical abolitionists called for the ending of slavery all over the United States, antislavery politicians made no such proposals, and there is no reason to believe that many observers seriously predicted an end to the South's peculiar institution in the near future.

Meanwhile, free blacks in the Northern and Southern states navigated a world of restricted opportunities and unequal rights. Some African Americans accumulated substantial wealth, and in the South more than a handful became slave owners. Most cities had some semblance of a black elite, populated by editors, ministers, and successful businessmen. The vast majority of free

blacks were poor members of the working class. Both law and public practice regarding civil rights varied from state to state and from community to community. But at midcentury there was no doubting that communities across the United States treated African Americans as unequal members. In most places they could not vote, serve on juries, or hold elective office. They could not join local militias or serve in the federal military. Access to transportation and public institutions was commonly restricted, following some combination of law and local practice. Still, the precise dimensions of black civil rights and the nature of black citizenship remained somewhat unclear. An African American traveling from state to state was liable to encounter very different cultural and legal practices.[1]

And it was not as if the march of history was clearly moving race relations in a positive direction. In 1850 Congress passed the notorious Fugitive Slave Act, which added teeth to existing federal laws requiring the return of fugitive slaves. As a consequence, free blacks living in the North—regardless of whether they were in fact escaped slaves—had to be ever vigilant for the arrival of money-hungry slave catchers.[2] Then, in 1857, the Supreme Court issued its stunning decision in *Dred Scott v. Sanford*, ruling that African Americans had no citizenship rights. In his infamous opinion, Chief Justice Roger Brooke Taney surveyed the status of blacks in America since the Constitution and concluded that African Americans "had for more than a century before been regarded as beings of an inferior order, and altogether unfit to associate with the white race, either in social or political relations, and so far unfit that they had no rights which the white man was bound to respect."[3]

Dred Scott was a startling ruling, and the fact that it disturbed so many contemporary observers is worth contemplating. By denying that African Americans had any rights as citizens, the Taney Court rolled back the clock, undermining progress that had been made in some corners of the North. Nonetheless, free African Americans living in the Northern states in 1860 might reasonably have believed that their status as members of a com-

munity—if not their legal status as citizens—remained largely contingent on where they were. They also recognized that under no circumstances could they expect to be perceived as political, legal, or social equals by most whites.

And then, as Lincoln so famously put it, "the war came."[4]

If the outbreak of war against the slave-owning states was bound to raise the hopes of both free and enslaved African Americans, they had no real reason to believe that the Civil War would suddenly usher in a movement towards black equality, much less emancipation. And for more than a year after the firing on Fort Sumter, events provided little cause for optimism. For nearly two years after his election Abraham Lincoln took every opportunity to underscore the point that this was a war to preserve the Union and not to end slavery, and in the meantime the Union military made it clear that the federal government had no plans to arm black men. True, individual Union generals had taken it upon themselves to free enslaved people in their midst, eventually making use of general and lawyer Benjamin Butler's deft characterization of runaway slaves as "contraband of war," but the Lincoln administration had taken measures to limit those advances. When free black men in the North offered their services to the Union army, the government turned them away.[5] In short, in the fall of 1862 free black observers had every reason to hope that the federal forces would defeat the Confederacy, and even to hope that the war would eventually destabilize the institution of slavery; but there was little cause to anticipate that, as events unfolded, there would be important gains in the public status of free black men.

It is here that we reach the crucial turning point, where events might have left the black observer—living within his own snapshot—thinking that important change was on the way. The Second Confiscation Act of 1862 and the Militia Act of that year opened the door for the use of black labor in the struggle against the Confederacy. Lincoln's Preliminary Emancipation Proclamation that September made things more explicit. In November, Attorney General Edwin Bates ruled that free-born African

Americans were indeed citizens, a pronouncement that ran directly counter to the *Dred Scott* ruling. By the time the Emancipation Proclamation took effect on January 1, 1863, plans for raising regiments of black soldiers were well under way.[6] From a distant perspective, the flow of events followed an internal logic that seems to make some sense. We can see the seeds of Lincoln's grand proclamation in his earlier words. The political and military events that gradually turned the Union army into an army of liberation, aided by the actions of both white military leaders and runaway slaves, do seem to lead to the Emancipation Proclamation as the predictable next step. How could the war have continued much longer without turning it into a war for emancipation and not merely to preserve the Union? And how could the Union cause have survived and triumphed without the arming of black men? But in truth, Lincoln's decision was a huge break with the past. Shortly before the proclamation was to take effect, Frederick Douglass, who had pushed hard for emancipation, celebrated with these words: "This is scarcely a day for prose. It is a day for poetry and song, a new song."[7]

Douglass rightly celebrated the day as a major step towards emancipation, and that is how we recall this crucial turning point; but he also recognized that it was a milestone in the relationship between the federal government and black men, both free and soon to be freed. When the Lincoln administration finally agreed to let black men take up arms against the Confederacy, an important door opened that would be very difficult to close. By arming black men, the Union was acknowledging something about black humanity and specifically about the manhood of these new soldiers. The administration was also implicitly acknowledging that they needed these new recruits to help win the war and restore the Union. Although celebrated as an immense moral step, the Emancipation Proclamation and the subsequent recruitment of soldiers into the regiments of the United States Colored Troops represented decisions born out of explicit military necessity, and they were presented to Northern voters on those terms. Some observers, both white and black,

were particularly pleased to see this door opened; far more were simply happy to have the military assistance.

Much has been written about the impact of black military heroism—or even just black military competence—on white perceptions of racial difference. Before black men had the opportunity to fight, various white prejudices persisted unchallenged. How would the black man stand up to the horrors of armed combat? Would he demonstrate the intellect necessary to learn the art of war? Would he prove properly suited to the harsh discipline of soldiering? What did it suggest about war as a gentleman's pursuit if the army invited African Americans to take part? The objective evidence from the battlefield challenged the more racist assumptions about black men, even if it could not erase white prejudice. Black soldiers commonly received inferior supplies, and black regiments routinely found themselves assigned unappealing tasks, doing manual labor or tedious guard duty; yet, when given the opportunity to fight, the men of the USCT generally rose to the occasion. Observers who approached the question with an open mind had good reason to recognize the fighting qualities and overall manhood of these black men in blue. Certainly nothing the black troops could do on the battlefield would erase centuries of white racism in the North or the South, but at least some observers, and particularly those soldiers who fought with or against black regiments, came away with a grudging respect for those men who "had no rights which the white man was bound to respect."[8]

In the grander scheme of things, the arming of black men had huge implications for black citizenship and for the public participation of African Americans. In the Northern states, it became more difficult to defend policies of segregation on public transit or in public places when the people being denied access were men in uniform or their family members. After the war, the contributions of black veterans to the Union cause became woven into the public discourse about the expanded citizenship rights of African Americans and the calls for black manhood

suffrage.[9] As Americans constructed their collective memories of the Civil War, the image of the black veteran who sacrificed a limb for the cause became a ubiquitous symbol of black sacrifice and valor.[10] Surely, the decades to come would be thick with disappointment, but in those final years of war and in its immediate aftermath, African Americans had reason to believe that the performance of black men in uniform constituted an important step in how white Americans viewed black men.

The significance of the black military experience does not end with the important military role that the USCT soldiers played in ensuring victory or in the symbolic impact of armed black men fighting alongside—and against—white men. During the Civil War, the members of the USCT marched under the federal flag. One might even argue that their ties to the federal government were more explicit than those of their white comrades, who fought almost exclusively in state-numbered regiments. All but four of the 175 regiments of the USCT fought under USCT numerals rather than state designations, and even the famed Fifty-fourth Massachusetts Volunteer Infantry was composed of men from all over the North.[11] By serving in the Union military, African American men and their families established themselves in a new and distinctive relationship with the federal government. The point was made plain during the celebrated pay controversy, when the men of the Fifty-fourth Massachusetts refused to accept the wages of a military laborer ($10 a month, with deductions for their uniforms) rather than those of a regular Union soldier ($13 per month). That controversy, famously dramatized in the movie *Glory*, is widely known.[12] Less well known is the fact that Massachusetts governor John A. Andrew offered to make up the pay difference out of state coffers, but the men of the Fifty-fourth and Fifty-fifth Massachusetts insisted that they should receive their pay from the federal government, like other Union soldiers. In July 1864, men from the Fifty-fifth Massachusetts petitioned Abraham Lincoln for federal redress, noting that although the state of Massachusetts had offered to

"make up all Deficienys which the general Government Refused to Pay," such treatment would set them apart from "Troops in the general service" and was thus unacceptable.[13]

As Coddington's extensive research eloquently demonstrates, black veterans and their widows routinely turned to the federal government for pensions or medical assistance. That assistance, however limited, set the veteran—both black and white—apart from other postwar citizens. Moreover, the conviction that the federal government would, and should, be a source of such assistance constituted a major shift in the position of these men in public life.[14]

In sum, although we should not sugarcoat the story, the decision to arm black men had a substantial impact on the broader political terrain and the ongoing discussion of black citizenship. As soon as those first blue-coated black men marched off to war, it became more possible to envision a world of expanded political roles and even black manhood suffrage. This, then, was an historic snapshot worthy of careful contemplation and celebration.

As fate would have it, technological developments in the years before the Civil War left the soldier with unprecedented opportunities to record these dramatic personal transitions, and therein lies the second narrative. On the eve of the Civil War, commercial photography had been available in the United States for about a generation. The daguerreotype process dates to the late 1830s and became perfected for the production of multiple copies from one glass negative in the early 1840s. Before long, professional photographers had opened studios across the United States, and the nation's elites had begun having their portraits taken. The changes in the science and technology of photography moved at a dizzying pace in these years. As photographic historian William C. Darrah explained, "in the mid 1850s, five types of photographic images were being produced: daguerreotypes, calotypes, ambrotypes, tintypes, and albumen paper prints from glass negatives." These different sorts of images varied in their chemical processes, development techniques,

and surfaces. For a brief period of time they all competed for dominance in a rapidly changing market.[15]

The collodion-glass method, in which the negative is produced on a glass plate, proved particularly significant, because the photographer could make multiple prints of a single image from one glass negative. The possibilities expanded immensely after 1854, when French inventor A.-A.-E. Disdéri introduced a method allowing multiple different images to be printed from a single glass plate. Before long, this process for producing small *cartes de visite* had become standardized, creating an international sensation. Specially designed cameras produced eight images on a single glass plate. From the resulting paper print, the photographer could then cut out each image, measuring $2\frac{1}{8}$ by $3\frac{1}{2}$ inches, and glue it to card stock, measuring about $2\frac{1}{2}$ by 4 inches. The results were modestly priced photographs the size of a calling card that the subject could afford to give to loved ones. The combined impact of the novelty of these new photographic images and their low cost unleashed what became known as "cartomania." Between 1861 and 1867 more than three hundred million of these *cartes de visite* were sold in England alone. In the United States the new fad took hold immediately. In early 1860, professional photographers in New York, Philadelphia, and Boston were already offering the new *cartes de visite* to their customers. By the outbreak of the Civil War, the new pictures were available across the country. In July 1863, Oliver Wendell Holmes, who had long been an admirer of the stereoview, acknowledged that the popular new "card-portraits" had become "the social currency, the sentimental green-backs of civilization."[16]

How did the dramatic transitions in the science of photography affect the lives of everyday Americans? In the most obvious sense, these developments meant that almost anyone could record his or her own image for posterity, whereas in previous decades such an option was restricted to those who could afford to hire a portrait painter or sketch artist. Small photographic portraits sat atop bureaus, lined shelves in sitting rooms, and

decorated kitchens or perhaps the top of a piano. By allowing for the inexpensive production of multiple copies of the same image, the *carte de visite* shifted how people could think about portraits, and this presumably had an impact on the culture of picture giving. Whereas a unique tintype in a framed case might be the prized possession of a family member or lover, the man or woman who had a *carte de visite* portrait taken could share copies more broadly, with friends, more distant relatives, classmates, and the like.

This marked expansion in commercial photographs of private consumers was accompanied by the emergence of an enormous market for mass-produced *cartes de visite* featuring the images of famous people.[17] In some cases, these were photographs distributed by commercial houses; in other cases, competing companies produced cheap reprints of the originals. Sometimes these celebrity *cartes de visite* were reproductions of earlier images. By 1860, Mathew Brady and Edward Anthony had begun copying their large collections of daguerreotype portraits into inexpensive *cartes de visite*. In 1862 Anthony and his brother issued a catalogue of two thousand portraits in the new format.[18] The mass production of these images had a fascinating impact on the nature of fame. Now consumers could affirm their admiration of a favorite orator, author, actor, or politician by purchasing a small likeness of that celebrity. Particularly enthusiastic supporters would write to their favorites, asking for autographed photographs. Some of these emerging celebrities, in turn, recognized that their professional fame was now connected to the number and character of *cartes de visite* in circulation.[19]

Because antebellum Americans had gained the capacity to assemble stacks of pictures of friends, loved ones, and public figures, it is no surprise that these years saw an expansion in the market for handsome albums in which to store all these photographs. Even the most sumptuous home had only a limited amount of space to display framed pictures, so the album became the place where collectors of photographs could store

all those images. And a larger truth emerged: set side by side in an album, the latest picture of famed minister Henry Ward Beecher or celebrated actress Charlotte Cushman was fundamentally similar in size and composition to the pictures of the album owner's aunt or uncle. In practice, people placed images of family members and celebrities in the same album, rather than drawing a sharp distinction between the famous and the familiar.[20]

This dramatic transition in the commercial possibilities of portrait photography coincided with the outbreak of the American Civil War. The changes in the nature of photography had an enormous impact on how the war was recorded and understood. The development of portable studios enabled professional photographers to take their equipment right to the battlefield, recording harrowing images of the dead and other evidence of the war's destructive impact. Mathew Brady and his small army of assistants took thousands of battlefield pictures. In the fall of 1862, New Yorkers flocked to Brady's studio to see his exhibition "The Dead at Antietam," which provided civilians with stark evidence of the war's horrors.[21]

The *carte de visite* became the ideal vehicle for recording likenesses of both the anonymous soldier and the military hero. Across the nation, young men who were soon to leave for war visited the photographer's studio to have portraits taken to present to friends and loved ones. The recruits arrived proudly dressed in their new uniforms, often carrying a weapon or some other military item. The photographers sometimes offered an illustrated backdrop or ornate chairs, tables, and small pillars as props. Meanwhile, entrepreneurial photographers quickly identified an enthusiastic market for photographs of the war's heroes and martyrs. Not long after the fall of Fort Sumter, Northern consumers could purchase *cartes de visite* of Major Robert Anderson. When Col. Elmer Ellsworth became one of the North's first casualties in Alexandria, Virginia, images of the fallen hero became a staple in photograph albums. The leading publishers of photographs soon hawked entire series of portraits featuring

both military and political leaders. Shop windows displayed the latest images, and before long the lines between patriot and fan blurred, as collectors filled albums with their favorite heroes.[22] Civil War era photograph albums kept by Northern citizens commonly included scores of pictures of men, women, and children in civilian clothing, interspersed with *cartes de visite* of young soldiers in uniform and pictures of admired people like Abraham Lincoln, Charles Sumner, Ulysses S. Grant, Robert Anderson, and Anna Dickinson. Some collectors clustered their *cartes de visite* of famous figures together in part of their album, but it seems that in many instances the individual just added new images into their albums as they were acquired. Whatever their intentions, this commingling of fundamentally similar images of the familiar and the famous created a collective impression that seems to illustrate the fundamentally democratic nature of the people's contest.

These two entirely unrelated transitions unfolded in the United States at almost precisely the same moment in history. Suddenly African American men, who had been denied equal rights of citizens before the war, and the opportunity to take up arms against the Confederacy after the firing on Fort Sumter, saw a door open. They were offered the chance to put on a federal uniform and take up arms against the slaveholding South. It would have been foolish for them to see a clear road ahead to social and political equality, but they did have every reason to believe that this might well be an important step in the history of African Americans in the United States. The transition to commercial portrait photography and the development of inexpensive *cartes de visite* meant something quite significant to ordinary Americans, white and black. By the 1850s, portrait photography had become widely accessible, but the advent of the *carte de visite* expanded that access immensely, changing how individuals thought about having their picture taken and with whom to share those images.

Does the coincidental timing of these two transitions offer any additional insights into the larger history? Perhaps. If the

transitions in commercial photography constituted both a democratization of the access to portraiture and a subconscious social leveling, African Americans of even limited means could take part in those developments. The seventy-seven images in this fine volume portray African American men who chose to have their pictures taken at this exciting moment in United States history. A handful of the pictures show men who are not in uniform, and in some cases they were never true Union soldiers. One or two appear to be "subjects" posed by the photographer, rather than soldiers who had chosen to have their portrait taken; and one man, Silas Chandler, was a Southern slave who traveled with the Confederate army. But at least seventy of these images are portraits of men who served in the Union army and who (we can safely presume) individually decided to take the opportunity to have a photograph made. Some pictures were taken before the young men went off to war; others show men on furlough or soldiers whose enlistments had expired.

The reader's eye first goes to the faces in these photographs. What can they tell us about the significance of the moment? The recruiting posters and rhetoric aimed at prospective recruits stressed that the war offered a chance for black men to demonstrate their manhood to white observers.[23] Nearly all Civil War recruits understood going to war as a test of manhood, but it seems evident that African Americans recognized military service as providing a collective opportunity, not so much to test themselves as to demonstrate to others larger truths about race and masculinity. These faces suggest a seriousness of purpose, but beyond that the expressions reveal little.[24]

Perhaps there is more to discover by considering how these soldiers responded to the photographer's studio. The act of having a portrait made involves a transaction between the photographer and the subject, framed by traditional conventions as well as the constraints imposed by the technology itself. A successful portrait required that the subject remain still for several seconds. That affected how individuals chose to pose and the expressions they adopted. More importantly, the photographer—

as artist and as self-appointed recorder of truths—can have a crucial impact on how the subject is presented. Nineteenth-century photographers who sought to record the images of racial, ethnic, and economic "others" commonly constructed images—framed by clothing, settings, and poses—that revealed as much about the artist and his or her cultural assumptions as about the subject. What hidden narratives framed their approach to the photographs? How was the photographer arranging the photograph with a future audience in mind? Were photographers intent on portraying the exotic? The noble? Did they see their subjects as in need of support? Or control? The examination of historic photographs requires consideration of the tale the photographer was trying to tell, either consciously or subconsciously.[25]

These Civil War photographs are certainly shaped by the conventions of portrait photography at the time, as well as by the added expectations associated with soldiers' portraits, but it seems that the photographer's artistic hand might not have been very heavy. Consider the poses the men adopt. Many stand, but quite a few are seated; perhaps that depended on the photographer and his studio. Of those who stand, some pose at attention, with their backs ramrod straight; others adopt much more casual stances, sometimes even leaning against a chair or another prop. As one flips through the volume, considering all seventy-seven portraits, it is striking that they are so varied even while nearly all share the essential traits of the wartime soldier portrait.

At least eight soldiers in this volume, all men of the 108th USCT, had standing portraits taken in the Rock Island, Illinois, studios of Gayford & Speidel in March 1865. The setting is identical, with a pillar to the soldier's left. When standing before the camera, each man adopted his own stance and style. Regimental drummer John Sample stands with arms crossed, one leg casually turned at an angle to the camera. Jesse Hopson poses at attention, with his weapon at his side. Wilson Wier's pose is almost indistinguishable from Hopson's, except that he chose to

wear his kepi at a jaunty angle. George Brown, who stood under five feet tall, posed in the same spot as his comrades but chose to rest his left arm casually on the pillar, with his left leg crossed over his right and his other hand on his hip; the impression is one of casual seriousness. Pvt. Lewis Chapman wears no hat and adopts a three-quarter pose, with his hand resting on the pillar, much like Brown, and also like Brown is not looking at the camera. Chapman, unlike nearly all of his comrades, seems almost to be smiling for the camera. Sgt. Abram Garvin proudly displays his stripes, while standing with one hand on the pillar. Although not quite at attention, his bearing is a bit more rigid than several of the others. Charley English also displays his sergeant's stripes while adopting a military demeanor; he poses with a sword held in both hands, the point resting on the floor in front of him. Finally, Dave Long stands with one hand on the pillar and the other casually placed inside his unbuttoned uniform coat.

Together these men of the 108th offer an interesting small sample of soldier behavior. All enlisted in Kentucky. According to Coddington's biographies, at least seven had been slaves. Some escaped from slavery, whereas others enlisted with their master's support. The regiment had mustered in the previous June, so most of these men had served together for several months. It seems a reasonable guess that all or most of them had never before had their picture taken or even been inside a photographer's studio. It is striking, then, how diverse these eight images are. A few carry a weapon, but most do not. Two stand at attention and some adopt very formal poses, but others rest a hand on the pillar, cross their legs or arms, or in other ways communicate a more casual demeanor. Some wear kepis; others are bare-headed. Even the variation in how they wear their hats suggests strong individualism rather than the imposition of some sort of military discipline.

Coddington selected these portraits of men from the 108th from a wonderful collection of images housed at the Beinecke Library at Yale University. The thirty-one photographs in the

collection were sent by Lt. Theodore F. Wright, of Company F, to his mother, Sarah A. Wright, who placed the images in a photograph album. Twenty-six of these *cartes de visite* bear the stamp of Gayford & Speidel on the reverse of the image, demonstrating that the portraits were taken at the same location.[26] If we expand our analysis to all twenty-six pictures the point is even clearer. Half of the images feature uniformed men; most wear the infantryman's kepi, but two do not. In two, no pillar is present. Half posed seated rather than standing. Here, again, they seem to have gone out of their way to pose in different ways. Four sit with legs crossed; the rest have both feet on the ground. Some sit up straight and others nearly recline on the chair. In four cases the soldier sits sideways on the chair, with one arm thrown casually over the chair back. Seven rest an arm on a small side-table; the table does not appear in the other pictures. None of the seated soldiers carries a weapon or any other military item. Given the constraints of uniform and location, these comrades seem to have gone to great lengths to adopt different postures and expressions.

The viewer who looks at the thirty-one *cartes de visite* of men from the 108th cannot help but perceive a wide range of personalities captured by the photographer's lens, even where the facial expressions reveal little. Lt. Wright jotted down notes on the backs of most of the pictures, offering a few words about each of his comrades, but even without these clues the images seem remarkably expressive. Some men appear extremely sober. Others manage to communicate a whimsical air, even while taking the moment very seriously. Some adopt a rigid bearing, while others lean or slouch or seem to go to lengths to reject the pose of a soldier at attention. Perhaps these impressions are wildly inaccurate, but there is no denying that in the moment when the photographic exposure was made these men looked very different even while they shared so many fundamental similarities.

If we apply the same sort of analysis to all of the images assembled by Coddington in this album, the impression is even more striking. Men who presumably had little or no experience

with photographers chose all sorts of ways to present themselves. They stood, they sat, they leaned. They carried weapons and musical instruments or they appeared empty-handed. They wore full uniforms or parts of uniforms. No doubt, the professional photographers made their suggestions, but surely those commercial artists did not dictate such a range of poses.

This is Ron Coddington's third volume in this format. His first book, *Faces of the Civil War: An Album of Union Soldiers and Their Stories*, featured *cartes de visite* of seventy-seven white Union soldiers. That album and this provide images of two different samples of soldier photographs,[27] and *African American Faces of the Civil War* really includes two groups of black men: those who were born in freedom or who had been free for quite some time when the war began, and those men who were enslaved as of 1861.[28] In myriad ways these three groups of men came from very different circumstances and might reasonably have had very different attitudes about the Civil War and about their roles as soldiers. Yet, in the photographer's studio those differences seemed to dissolve. The white soldiers—like their black comrades—adopted a wide range of physical postures, wore varied uniforms or portions of uniforms, and displayed a diversity of weapons and other props. In these small photographic images there is really little to distinguish among these men in blue, either in their expressions or in how they posed.

Within the range of broad similarities, there are a few minor but perhaps interesting points of difference. The white and black soldiers seem to have been similarly inclined to pose with a weapon, although the white soldiers (a group that includes quite a few officers) were somewhat more likely to display a sword, whereas the black soldiers—nearly all infantrymen—were more likely to pose with a rifle or musket. A few men pose with some other item: five white soldiers carry books or letters or some similar item; several black soldiers pose with their musical instruments (a drum or bugle, reflecting their military position) and four, including Medal of Honor recipient Sgt. William Carney of the Fifty-fourth Massachusetts, pose with flags.

The pictures also reveal a slight difference in how the subjects approached their headgear. The white soldiers divided equally between those who wore their kepi or hat, those who posed with their hat in their hand or on their lap, and those who posed bare-headed with no headgear in sight. Relatively more of the African American soldiers wore their headgear. The flags might be understood as a particular affirmation of citizenship and patriotism, although at least in the case of Carney it might also reflect the photographer's inspiration. Perhaps the fact that a much greater proportion of the men from the USCT chose to wear their hats reflected a particular pride in wearing the uniform.

The photographs of these black soldiers record a single moment as lived by a diverse assortment of black soldiers. The visual evidence suggests that these men approached that unfamiliar moment in a photographer's studio very much as their white comrades did. The photographs themselves were treasured—saved and shared and displayed with pride. Visitors to a home would see and admire the photographs of the family's young men at war. And in the pages of family albums the infantryman, the general, the politician, and the orator all appeared on similar 2½ by 4 inch cards.

Historians commonly describe the Civil War as a conflict that evolved from a war for union to a war for emancipation. We see the end of slavery as one of the war's great legacies, but the war also brought about a crucial transition in the status of individual black men and in their relationship to the federal military and the federal government. The photographs of the time captured men in the midst of that transition. Both the blue uniforms they wore and the *cartes de visite* they brought or sent home spoke of these changes. The men, whether they were born in slavery or into one of the elite African American families in New York or Boston, lived in a moment when racial prejudices and cultural barriers had not been erased, but hopes for the future seemed great, and a simple photograph of a man in uniform could suggest wondrous possibilities.

Notes to Foreword

Full source information may be found in the book and article sections of the References at the back of the book.

1. On discrimination in the North, see Litwack, *North of Slavery*. For a recent discussion of African Americans and citizenship during the Civil War era, see Joseph P. Reidy, "The African American Struggle for Citizenship Rights in the Northern United States during the Civil War," in Ural, *Civil War Citizens*, pp. 213–236.

2. Campbell, *The Slave Catchers*.

3. Fehrenbacher, *The Dred Scott Case*.

4. Abraham Lincoln, Second Inaugural Address, March 4, 1865.

5. A small number of black men did manage to join state regiments earlier in the war, before the advent of the United States Colored Troops. See Reidy, "African American Struggle for Citizenship Rights," p. 220, 233–234, n 25; Ira Berlin et al., "The Black Military Experience, 1861–1867," in Berlin et al., *Slaves No More*, pp. 190–191.

6. For excellent summaries of this chain of events, see Berlin et al., "The Black Military Experience"; and Reidy, "African American Struggle for Citizenship Rights."

7. Stauffer, *The Black Hearts of Men*, p. 151.

8. The scholarship on the USCT is vast. For a useful recent overview see John David Smith, "Let Us All Be Grateful That We Have Colored Troops That Will Fight," in Smith, *Black Soldiers in Blue*, pp. 1–77. On the responses of white soldiers to black troops, see Mitchell, *The Vacant Chair*, pp. 55–70; and McPherson, *For Cause and Comrades*, pp. 126–128. For the response of white soldiers to black men on one battlefield, see J. Matthew Gallman, "'In Your Hands That Musket Means Liberty'": African American Soldiers and the Battle of Olustee," in Gallagher and Waugh, *Wars Within a War*.

9. Reidy, "African American Struggle for Citizenship Rights," pp. 226–227. See also McPherson, *The Negro's Civil War*, pp. 252–254; and Foner, "The Battle to End Discrimination Against Negroes in Philadelphia Streetcars, (part one) pp. 261–291 and (part two) pp. 355–379.

10. See Fahs, *The Imagined Civil War*, pp. 164–181; and Dickinson, *What Answer?* pp. 147–153.

11. A few other regiments originally mustered in under state numerals and were later redesignated as USCT. See Smith, "Let Us All Be Grateful That We Have Colored Troops That Will Fight," p. 28.

12. On the pay crisis, see Donald Yacovone, "The Fifty-fourth Massachusetts Regiment, the Pay Crisis, and the 'Lincoln Despotism,'" in Blatt, Brown, and Yacovone, *Hope and Glory*, pp. 35–51.

13. Berlin et al., "The Black Military Experience, 1861–1867," p. 215; and Reidy, "African American Struggle for Citizenship Rights," p. 223, citing

Sgt. John F. Shorter et al., to President of the United States, July 16, 1864, in Ira Berlin et al., *The Black Military Experience*, pp. 401–402.

14. See Berlin et al., "The Black Military Experience, 1861–1867," pp. 222–233. For a case study that suggests the limited gains for USCT veterans in the postwar years, see Richard Reid, "USCT Veterans in Post-Civil War North Carolina," in Smith, *Black Soldiers in Blue*, pp. 391–421.

15. Darrah, *Cartes de Visite in Nineteenth Century Photography*, pp. 1–2. Other useful general histories of nineteenth-century photography include Trachtenberg, *Reading American Photographs;* and Sandweiss, *Photography in Nineteenth-Century America.*

16. Oliver Wendell Holmes, "Doings of the Sunbeam," p. 8.

17. Collectors and patriots could also purchase a wide array of larger engravings and lithographs depicting military scenes or celebrated heroes. See Neely and Holzer, *The Union Image.*

18. Darrah, *Cartes de Visite*, pp. 43–59. On portrait photography as an emerging enterprise, see Barbara McCandless, "The Portrait Studio and the Celebrity," in Sandweiss, *Photography in Nineteenth-Century America*, pp. 49–75.

19. For discussions of how nineteenth-century celebrities made use of the *carte de visite*, see Painter, *Sojourner Truth;* and Gallman, *America's Joan of Arc.*

20. This observation is based on my personal inspection of dozens of nineteenth-century albums at ephemera fairs, in antique stores, and in other settings. I know of no systematic scholarly analysis of this point. For a fascinating and somewhat related discussion of the collection and sharing of photographs as anthropological objects by late-nineteenth- and early-twentieth-century scholars, see Elizabeth Edwards, "Exchanging Photographs, Making Archives," in Edwards, *Raw Histories*, pp. 27–50.

21. On war photography and the American Civil War, see Keith F. Davis, "'A Terrible Distinctiveness': Photography of the Civil War Era," in Sandweiss, *Photography in Nineteenth-Century America*, pp. 131–179; and Trachtenberg, *Reading American Photographs*, pp. 71–118.

22. Wartime journalism and the widely circulated color lithographic images of favorite generals certainly contributed to this cult of celebrity among military officers. When Philadelphians visited their Great Central Fair in June of 1864, they could pay a small fee to vote for their favorite general or their favorite general's wife. The winner of each election received a handsome prize, with the remaining profits going to the Sanitary Commission.

23. See Gallman, "'In Your Hands That Musket Means Liberty.'"

24. In his celebrated 1863 essay on wartime photography, Oliver Wendell Holmes offered extended observations about what could be learned by looking at a photographic portrait. Holmes, "Doings of the Sunbeam," p. 9.

25. Historians of photography, and anthropological historians in par-

ticular, have written extensively on these topics. For recent examples, see Peck, "Performing Aboriginality," pp. 214–233; and Stevenson, "The Empire Looks Back," pp. 142–156. See also the many case studies assembled in Edwards, *Anthropology and Photography, 1860–1920.*

26. The remaining images in the Wright collection are also pictures of men from Company F of the 108th, including one joint portrait of two white officers. It is not clear if the other pictures were taken in the same studio.

27. Technically, neither volume includes a random sampling of soldiers' photographs, in that Coddington selected his subjects from a larger universe of images. Coddington's chief goal was to find pictures of men who could be identified, and whose histories could be uncovered in some detail.

28. It is worth noting that most of the freedmen pictured in this volume, like the men of the 108th USCT, had been enslaved in border states and not in the deep South.

Preface

THE PERIOD THAT BEGAN WITH AN ANNOUNCEMENT BY President Abraham Lincoln of the Emancipation Proclamation and ended with his assassination and the surrender of the rebellious armies marked a dramatic transformation for Americans of African descent. It lasted no more than a heartbeat along the national lifeline, from September 1862 through May 1865—an age without a name, wedged between war and peace, between the enslavement of a race and the hope of universal freedom. Thirty-two months during which the linkage of war and the abolition of slavery called ordinary citizens to examine their conscience and faith and to act on great ethical questions and moral themes that had rippled across societies for generations.

It was the dawn of a new age of equality. Here, along the ragged edges of the tears in the social, economic, and political fabric of the nation, those who embraced liberty and justice for all began the slow and arduous process of building a new culture that bound the country together more strongly than before.

The possibilities seemed endless. Witness the Northern officer who proclaimed in a speech before African American soldiers at an Emancipation Day jubilee that he had set his former prejudicial views aside, the white commander of an African American infantry regiment who admonished his fellow white officers not to punish their black troops by beating them because it suggested the relationship of master to slave, and the slave who was offered freedom by the Southern officer he served.[1]

Among those in the vanguard of reformation were men of color who enlisted in the Union army and navy. Roughly 200,000 strong, they joined the fight for their independence in this second American Revolution from all parts of the continent. Some

escaped, with no more than tattered rags on their backs, from masters determined to keep them in perpetual servitude. Others were released by benevolent owners who glimpsed a future where freedom reigned or by practical-minded individuals who saw the end of slavery coming. More slaves, displaced by invading federal armies, crossed into occupied territories and enrolled in the military. Some were sons of men and women who had fled bondage by traveling the Underground Railroad and had settled in the Northern states or Canada during the decades before the war. The majority were illiterate. A small number had received elementary reading, writing, and math instruction from abolitionists and Christian charities. A very few were well-educated, having attended colleges or other institutions of learning.

They spent their enlistment in a variety of settings. They served garrison duty in locations across the South and as guards in prisoner of war camps in the North. They sailed on vessels that patrolled key rivers and blockaded vital Confederate harbors. They fought veteran Confederate troops in South Carolina at the battery known as Fort Wagner, in Florida along the lowlands and pinewoods near Olustee Station, in Virginia along the front lines of Petersburg at the Crater and near Richmond at New Market Heights, and in North Carolina during the capture of Fort Fisher. They fired the final shots of the war in Texas at Palmito Ranch. On these battlefields they proved their combat worthiness. The moral victories gained here are comparable to strategic successes at Gettysburg, Vicksburg, and Atlanta.

And while battling Confederate troops, these men also fought with their own politicians and generals to be given the same pay, opportunities for advancement, and treatment as their white comrades in arms.

Another group of African Americans who participated in the war were the thousands of men who acted as servants to officers in the Union and Confederate armies. Variously referred to as personal attendants, manservants, aides, valets, and body servants, these individuals never formally enlisted in the army, although some joined the military after the federal government

allowed them to become soldiers and sailors. They saw much of the war firsthand, and their stories are part of the larger African American experience during this time.

This volume includes narratives of a representative sample of all of these types of participants in the war, each illustrated with an original photograph. It follows the same format as my previous books, *Faces of the Civil War: An Album of Union Soldiers and Their Stories* and *Faces of the Confederacy: An Album of Southern Soldiers and Their Stories*. The sequence of publication of these three books reflects the number of photographs available. The most abundant are photographs of Union soldiers. Photos of Confederate soldiers are in much shorter supply. For a while, I was unsure I would be able to find enough photographs of African American participants in the war. I describe my search for them below.

The personal accounts of all of these men are the transformative stories of the Civil War. Those pictured on the pages of this volume played an important though little remembered role during a critical period in which the fate of the disunited states was far from certain, and the future of freedom and democracy hung in the balance.

The African American men ultimately experienced a fraction of the freedoms they fought to establish. The spirit of unity kindled during this period began to erode as soon as the Confederate armies disarmed. Almost immediately, white Southerners bent on reestablishing their antebellum authority methodically regained control in their states. Men and women of color were deprived of their rights despite constitutional amendments to the contrary. Northerners were complicit in these actions. Flames of hatred and prejudice not extinguished after four years of bloody war burned bright throughout the country.

The children and then grandchildren of these men, with others in the African American community, have waged a long campaign to stop these incursions into their personal freedoms and to redirect the country onto the course charted by Lincoln. One Civil War veteran labeled this campaign the Moral War.[2] Its

high-water mark occurred a century later with the civil rights movement.

About This Volume

The origin of this volume dates to September 2004 at Baltimore's annual book festival. I made the drive from my home in Arlington, Virginia, to attend my first event as the author of *Faces of the Civil War*. Among the visitors to the Johns Hopkins University Press tent was a woman who stopped at the table and quietly thumbed through a copy of that first book. Then she looked up at me and said in earnest, "You know, there were men of color who also fought." She turned and walked away without waiting for my reply.

Her words stayed with me. Four years later, after the publication of *Faces of the Confederacy,* my next project was a foregone conclusion.

The challenge of a new book excited me. The thought of finding enough images caused me deep concern. My worry was well founded. I have seen only a handful of African American soldier and sailor photographs in thirty years of collecting wartime images. Rare is the occasion when one is for sale or on display at a Civil War relic show. An informal survey of books in print revealed the same few images repeated again and again. Despite the evidence, I believed that these images existed and determined to find them.

I set a goal to locate ninety-five original, identified wartime examples. From this group I planned to select seventy-seven images for inclusion in the book, a number consistent with my first two volumes. The number has no significance other than being the total of images and profiles featured in the first book.

I began the search for images in October 2008 on the Internet. Thanks to universities and historical societies with finding aids, or guides to their collections, a small number of promising leads turned up. In some cases, the images turned out to be copies of photographs since lost or of unknown origin. In other cases, the trail led to an original photograph and I made

arrangements to get digital scans and permissions. About two-thirds of the total images were secured in this manner.

A significant number of the pictures came from a single photograph album owned by the Beinecke Rare Book and Manuscript Library at Yale University (in the Randolph Linsly Simpson African-American Collection of the James Weldon Johnson Collection). The album had been presented by 1st Lt. Theodore Wright, a white officer of the 108th U.S. Colored Infantry, to his mother, Sarah Augusta Wright. It is full of *cartes de visite* of members of Company F. On the back of almost every photograph, Lt. Wright wrote a brief note describing the character of the subject.

That Wright took the time to put together the album suggests that he saw beyond color and viewed these soldiers as men, placing him in a small but growing segment of white society in the vanguard of support for universal freedom.

Ten *cartes de visite* from the album are included here. Only one regiment is represented by more photos, the Fifty-fourth Massachusetts Infantry. Eleven of its members are profiled on these pages.

The contrast between these two regiments is extreme.

The 108th, composed mostly of illiterate Kentucky slaves, participated in one minor skirmish during its term of enlistment and served a stint guarding Confederate prisoners at Rock Island, Illinois. In early 1865, the regiment became implicated in controversy after newspaper articles charged its rank and file with the harsh treatment of prisoners. The stories appear to be exaggerated. The timing suggests a counterreaction to reports of atrocities at the Union prisoner of war camp in Georgia known as Andersonville. Like many regiments that performed garrison and guard duties away from the front lines, the 108th is little remembered for its contribution to the war effort.

The Fifty-fourth Massachusetts Infantry was composed in part of educated free African Americans and other black residents of various Northern and Southern states and Canada; it fought in several battles and participated in numerous raids and

other operations from 1863 to 1865. Although it was not the first organized black unit to fire shots in hostility, the conduct of its men during the assault on the battery known as Fort Wagner made national headlines and proved to skeptical officers and to the public at large that men of color could and would fight. The regiment ranks among the best known, black or white, formed during the war.

Representative stories of volunteers from these regiments illustrate the diversity of war experiences, from the relative safety of garrison duty in obscure theaters of the war to combat on the battlefields of Virginia and elsewhere.

The balance of the images, roughly one-third of the total, came from collectors.

I began the search by networking with friends and acquaintances who share my passion for historic photography and by visiting Civil War shows up and down the East Coast and as far west as Ohio. At each event I asked dealers if they had images that met my criteria (original photograph and subject identified). The majority of the time I received negative responses.

There were successes. I met Tim Kernan at the 2009 Civil War show in Gettysburg. He shared his outstanding tintypes of the Owens brothers and provided me with names and contact information for a number of individuals in possession of African American soldier images. Several are included here.

Chance meetings at other venues paid off. At the 2009 Daguerreian Symposium in Philadelphia, my wife, Anne, struck up a conversation with Jerome "Pepper" Broad, a collector of occupational tintypes. He suggested I contact Ron Rittenhouse of Westover, West Virginia. Ron shared images from his collection, including one featured here. He also directed me to John Cuthbert of the West Virginia University in Morgantown. John provided five images pasted onto the pages of an illustrated diary kept by Maj. John W. M. Appleton of the Fifty-fourth Massachusetts Infantry.

The events that began at the Philadelphia symposium and ended with the Appleton images unfolded over nine months.

This is one example of a lead that produced results. For every success, I followed dozens of paths that led to a dead end. I kept a written log of my investigations to track progress. Those that concluded with an addition shared the same last entry: "Image secured. Case closed!"

Three images came from families of the pictured men. I found Dave Brown and Dr. Donald Cunnigen online. Both men possessed much knowledge of their ancestors, Samuel Truehart and Emanuel Cunnigen, and generously supplied their research. I met Chandler Battaile for lunch at a restaurant in Washington, D.C. We chatted about his family for more than two hours, during which he described an unusual tintype of his great-grandfather, Andrew Chandler, posed with Silas, a family slave, who had accompanied him to war. At the end of our meeting, Chandler Battaile produced the original image, which had recently appeared on an episode of PBS's *Antiques Roadshow*, and charged me with its safekeeping until I could make a high-resolution digital scan and return it to him. He also introduced me to Bobbie Chandler, the great-grandson of Silas. Chandler Battaile's trust in me, and his desire to tell a fair and balanced story of his family, black and white, is truly memorable. This is the only wartime image that I was able to find that pictured an identified African American participant on the Southern side.

Two images came from my own collection; they were acquired from dealers after this project began.

I spent two years securing photographs. The ninety-fifth and final image, a wonderful tintype of James Cummings, came after a trip to New Jersey to meet Paul Loane, a great guy with an impressive collection of Civil War militaria.

This book contains three photographic formats: ambrotypes, *cartes de visite*, and tintypes. This is a departure from the previous two volumes, which featured only *cartes de visite*. I expanded into other formats after early searches confirmed the scarcity of photos. Three ambrotypes and twenty-two tintypes are included, about a third of the images.

The choice to use only *cartes de visite* in the Union and Con-

federate albums was based upon my fascination with the format and its unprecedented popularity coincident with the war years. Although "cartomania" raged across America during this period, ambrotypes and tintypes, which came into vogue during the mid-1850s as less-expensive alternatives to the daguerreotype, continued to be offered by photographers.

I researched and wrote profiles of the men concurrent with the search for further images. Early on, I came to several realizations that make the content of this volume different from my other two books.

The stories of these men are intertwined with and inseparable from those of the individuals who owned them or their forefathers. I therefore added to the men's profiles basic information, when available, about their masters, including their occupations, the number of slaves they owned, details about their character, and decisions they made that profoundly affected the lives of their slaves. The knowledge that one man toiled on a country plantation with a hundred others in bondage while another was one of a few slaves in the household of a physician or lawyer who resided in a city adds to the appreciation of the life story of the subject and contributes to a better understanding of the pervasiveness of slavery.

Many African American men would likely have joined the army at the outset of the war had they been allowed to enlist. Some served instead as personal servants to officers, as teamsters, and in other support roles until the federal government cleared the way for them to become military men. In recognition of these individuals who were not permitted to serve, I expanded the scope of this book to include African Americans who participated in the military activity of the war in other ways, rather than limiting it to those who served in uniform. Five of the men in this book never officially enlisted. This inclusion provides a better understanding of the role of African Americans through the entire war period, from 1861 to 1865, than would focusing on their role as soldiers and sailors, which for all prac-

tical purposes did not begin until mid-1863, the halfway point of the conflict.

Some freedmen changed their surnames after the war. Slaves often were identified by the surname of their most recent master at the time of their enlistment in the army. After the war, they adopted the surname of their father. For example, in 1864, Allen Walkup enrolled in the 122nd U.S. Colored Infantry using the surname of Pete Walkup, a farmer who had owned him for the previous seven years. At some point after Pvt. Walkup mustered out of the army in 1865, he changed his name to Allen King to honor his biological father, Beverly King, who had also been a slave. That the surname he adopted was that of another slave owner was apparently of little concern compared to the satisfaction of being united in name to a father. The white population generally dismissed this practice as a quaint local custom. However, its widespread occurrence indicates a social movement to reconnect with long-lost relatives and to establish a genealogy to pass down to their children and grandchildren. In these cases, I have used their adopted names in captions and elsewhere in the accompanying profiles, out of respect for their decision, though they were not known by this name during the war.

I followed the same research method used in previous volumes. My effort began online by submitting queries to genealogical sites and Civil War forums; searching digital books and finding aids of collections owned by institutions of higher education, historical societies, archives, and libraries; and searching subscription databases that house military service files, genealogical records, newspapers, and other source material.

I gathered additional information in frequent trips to the National Archives and Library of Congress in Washington, D.C., by visits to other archives, libraries, and museums, and through my local interlibrary loan program. I communicated with descendants by e-mail, telephone, and personal visits. I purchased books and magazines.

Of particular interest are African American pension applica-

tions and supporting documents. Those enslaved prior to their enlistment often had a difficult time proving many of the basic facts of their existence, as birth records for them were often unavailable and slave marriages were not considered legal and so were seldom recorded. Pension Bureau examiners scrutinized the applications and conducted intensive interviews to get as close to the facts as possible. Their investigations generated a large amount of paperwork that resulted in case files sometimes twice as thick as those of white applicants.

Anecdotes recorded in pension files and other source documents reveal much about the relationship between slaves and their owners. On these pages are found examples of masters capable of benevolence or brutality. Thirteen of the profiles—seventeen percent of the total—contain references to mixed-race children.

County histories, a reliable source of information for previous volumes, contained almost no mention of African American communities. However, they were helpful in providing biographical information about slave owners.

Much to my delight, I discovered vibrant African American–owned newspapers. These provided a wealth of detail on military, political, and cultural issues, including writings by black soldiers and correspondents. Searchable online databases have made these publications readily available.

Access to these databases enabled me to find interviews of prominent African American soldiers, such as William Carney, who received the Medal of Honor for his actions during the assault on Fort Wagner. Carney shared his experiences many times during the postwar decades. Over the years, he honed his story, adding new details and dropping others. I examined a number of versions and tell a revised version of his Fort Wagner experience that incorporates details previously edited out.

The typical research cycle averaged two months per individual, although some required up to a year. I spent nineteen months researching and writing these stories.

The profiles are informal biographies, not genealogical his-

tories. Dates, names of superior officers and family members, and other particulars may have been omitted to focus on salient points of each story. Regimental history details and explanations of government acts, military orders, and social customs appear in the text and the endnotes when relevant. Descriptions of campaigns, battles, skirmishes, and other troop movements are included when they are necessary to understand the circumstances encountered by the individual.

The profiles are arranged in chronological order by the date in the introductory section of each story. Two stories are set before the war, three in 1861, two in 1862, eighteen in 1863, twenty-seven in 1864, twenty in 1865, and five after the war.

The caption below each photograph notes the subject's final assignment and rank. Consequently, the rank in the caption does not always correspond with that displayed by the individual in his portrait. The photographers' names, places of business, and life dates are in the captions, when available.

News, narratives, and notes documenting my experience are posted in a blog linked from facesofwar.com and my author page on Facebook, providing first impressions and fresh perspectives about the war from the soldiers and sailors who participated in it.

Considered from the African American viewpoint, there can be no doubt that the Civil War heralded a second American Revolution. It began on January 1, 1863, when President Abraham Lincoln issued the Emancipation Proclamation.

The day after Lincoln's action, a Union colonel from Kansas stood before his new regiment of colored troops and declared, "For nearly two years we have been fighting this unholy rebellion, or pretending to do so, without any attempt to injure or destroy our enemies. The war so far has been unsuccessful, simply because it *was not* war. Now, we seem to have awakened to our situation, and to-day our noble President issues his first edict of war, aimed directly at the very foundation of the support for our enemies."[3]

These rookie soldiers of color in Kansas seized this opportu-

nity to serve their country in the War to End Slavery. In Louisiana, South Carolina, Massachusetts, and elsewhere, African Americans rose up to fight for their freedom, called to arms by Frederick Douglass and other leaders who had long spoken out for social reform and justice.

The men profiled on these pages had deep connections to the states in rebellion. The Kansas colonel referred to his men as members "of the class that comprises the loyal people of the South."[4]

Southern loyalists they were, men who loved their homeland and despised slavery. One soldier explained, "I had no ill feeling for the Southern white people, some of them had been my best friends; but this was not a personal matter, but a question of national issue, involving the welfare of millions, and my soul was on fire for the question, Slavery or No Slavery, to be forever settled and that too as soon as possible."[5]

The colored regiments were officered by white men, who joined the army for a variety of reasons: advancement, money, patriotism, union, and to abolish slavery. Some of these white officers began their military service as enlisted men or noncommissioned officers in 1861 and mustered out with the survivors of their African American regiments as late as 1867—a span of six years in uniform.

Roughly one hundred African Americans received commissions as officers during the war. While the North came to accept black men as soldiers, it struggled with the idea that they should be in positions of authority.

Some of the enlisted men who served in colored regiments joined the postwar army, becoming what were known as Buffalo Soldiers.

The accounts of the men on these pages chronicle a unique part of our nation's history. Their portrait photographs stand as a unique visual record, documenting faces of war at a moment in time when the sun was setting on slavery, the storm clouds of war were rocking the republic to its very foundation, and free-

dom was dawning across an America reborn in the spirit of a new age of equality.

These men went on to participate in the Moral War that followed, a monumental struggle waged to enforce new rights guaranteed by the Constitution and to defeat the underlying racial prejudice that sought to undo them. These warriors fought to the end of their days, unaware that the fight would continue for more than a century.

On a November night in 2008, I followed the results of the nation's presidential election on television and online. Forever etched in my mind are scenes of men and women, black and white, who cried tears of joy after the announcement that Barack Obama had been voted the forty-fourth president of the United States of America.

I cried, too, in part for these men, long gone and little remembered, who fought for liberty and freedom.

African American Faces
of the Civil War

THE PROFILES

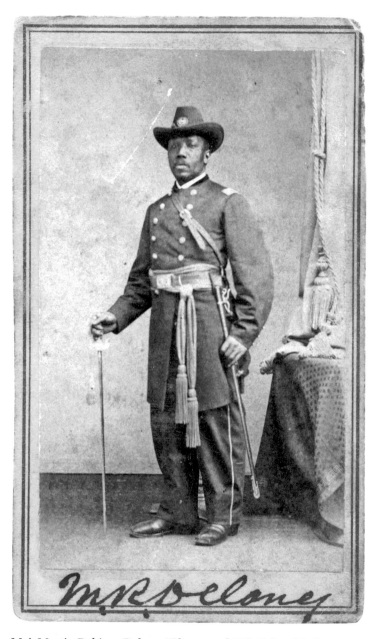

Maj. Martin Robison Delany, Fifty-second U.S. Colored Infantry

Carte de visite by unidentified photographer, about 1865. Collection of the Gettysburg National Military Park Museum.

"Most Defiant Blackness"

"I am for war—war upon the whites."[6]

These are the words of Henry Blake, the protagonist of *Blake; or, The Huts of America*, a novel by ardent black nationalist Martin Delany. Evidence suggests that he wrote the work as an antithesis to Harriet Beecher Stowe's bestseller *Uncle Tom's Cabin*. Her docile mulatto slave Uncle Tom could hardly be more different from Delany's Henry Blake, a strong-willed, full-blooded West Indian slave who championed the freedom of his people.[7]

One scholar described *Blake* as "a montage of personal observations and experience, contemporary political debate and incidents drawn from slave narratives."[8]

Among the narratives that influenced Delany were those of his African forefathers. His paternal grandfather, a Gola chief captured in war then sold to slave traders and brought to colonial Virginia, died at the hands of a slaveholder. His maternal grandfather, a Mandingo prince named Shango, was also a prisoner of war who came to America in bondage. He later gained his freedom and returned home.[9]

Delany's life began in 1812 with his free birth in Charlestown, Virginia.[10] At nineteen he worked as a barber in Pittsburgh and attended school in an African American church at night to supplement his scanty education. Interested in medicine, he briefly attended Harvard and might have become a career physician or dentist. However, abolitionism and moral reform fueled his deepest passions, and he lent his voice to the mainstream antislavery movement in the 1840s, as founder and editor of a weekly newspaper, *The Mystery*, and as coeditor, with Frederick Douglass, of *The North Star*.[11]

Uncle Tom's Cabin debuted in 1852, the same year Delany

published *The Condition, Elevation, Emigration, and Destiny of the Colored People of the United States, Politically Considered.* In it, he broke with the antislavery establishment when he attacked white abolitionists for social and economic discrimination. Moreover, he advocated black emigration to ancestral homelands—a dream of his own.[12] He pushed a radical agenda in speeches, papers, and an 1859–1860 trip to West Africa to explore the formation of a colony to be populated by blacks from the United States and Canada.[13]

During the 1850s he also wrote *Blake.* Unlike the immediate success of *Uncle Tom's Cabin,* Delany's novel was not published in full until 1861, in serial form in *The Weekly Anglo-African.* It went largely unnoticed by a public preoccupied by civil war.

The war preoccupied Delany, too. "He stated that it had become inseparable with his daily existence, almost absorbing everything else, and nothing would content him but entering the service," explained a biographer, who added, "He cared not how, provided his admission recognized the rights of his race to do so."[14]

Delany initially failed to get into the army.[15] His eldest son, Toussaint L'Ouverture Delany, fared better. He became a private in the Fifty-fourth Massachusetts Infantry and survived a wound received during the July 1863 assault on Fort Wagner.[16]

Martin Delany worked behind the scenes as a recruiter until February 1865, when President Abraham Lincoln received him at the White House. He informed Lincoln, "I propose, sir, an army of blacks, commanded entirely by black officers." At the conclusion of the meeting, the president scribbled a note on a card addressed to Secretary of War Edwin M. Stanton: "Do not fail to have an interview with this most extraordinary and intelligent black man." A few days later, Delany met the secretary and soon received a commission as major of infantry—the first African American appointed an army field officer.[17]

By this time the war was almost over. In April 1865 he joined the 104th U.S. Colored Infantry at Charleston, South Carolina.

He remained with the regiment until it disbanded the following February, then transferred to the Fifty-second U.S. Colored Infantry. He spent little time with either regiment, serving on detached duty with the Freedmen's Bureau. He mustered out of the army in 1868 and stayed in the Palmetto State.

A biography published the same year he left the army described Delany thus: "In personal appearance he is remarkable; seen once, he is to be remembered. He is of medium height, compactly and strongly built, with broad shoulders, upon which rests a head seemingly inviting, by its bareness, attention to the well-developed organs, with eyes sharp and piercing, seeming to take in everything at a glance at the same time, while will, energy, and fire are alive in every feature; the whole surmounted on a groundwork of most defiant blackness."[18]

Delany played an active role in South Carolina politics through the Reconstruction era. In 1874 he ran for lieutenant governor as an independent and narrowly lost to another black candidate. After Democrat and former Confederate general Wade Hampton won the gubernatorial election of 1876, Delany received an appointment as a judge. Two years later, the Democratic base crumbled and Delany lost his position.

Out of power and money, he again attempted to realize his dream of a colony in Africa. It failed. In December 1884 he joined his family in Xenia, Ohio, where he died one month later of tuberculosis at age seventy-two. His wife, Catharine, whom he had married in 1843, and seven of their eleven children survived him.[19]

After his funeral on January 27, 1885, twenty members of the Grand Army of the Republic, a veterans association, accompanied his body to its final resting place. "Conspicuous among his effects was his suit as a Major of the United States Army and a sword,"[20] likely the same uniform and saber pictured in his *carte de visite* portrait.

"A rigorous debater, fluent speaker, with an uninterrupted flow of language, he was a power in shaping events," noted one

newspaper tribute, which also declared, "His ever ready and trenchant pen did much to mould popular sentiment in favor of freedom of the slave."[21]

"I thank God for making me a man simply," Frederick Douglass reportedly stated, "but Delany always thanks Him for making him a *black man*."[22]

Fighting for the Cause of Human Freedom

As a boy, Jeremiah Asher listened with rapt attention to his grandfather, Gad, as the old man told his only grandson the stories that had shaped his life: his abduction by "men-stealers" along the Guinea coast when he was Jeremiah's age, the voyage to British Connecticut, decades in bondage, military service as a substitute for his master in the Revolutionary War, the Battle of Bunker Hill, permanent blindness attributed to a cold he caught by exposure to harsh conditions on campaign and in camp, and how he bought himself out of slavery after the Revolution.[23]

Jeremiah never forgot the stories of his grandfather's journey to freedom.

Forty years later, on the morning of December 2, 1859, Jeremiah, by then a prominent Philadelphia minister, stood before a crowd of four hundred packed into his tiny Shiloh Baptist Church. All had come together to pray for John Brown during the very hour of his execution two hundred miles away in Virginia. The fiery abolitionist was dead by the time Asher addressed the audience. A newspaperman reported that Asher "believed that God was working out means for the abolition of slavery in His own way, and said, emphatically, 'If the cause of human freedom will be served by Brown's death, then I want him to die.'"[24]

Asher's strong words were characteristic of the man. He had long stood fast against oppression and prejudice and had displayed an independent streak from his youngest days. At age twelve, his father decided that Asher had had enough education; he expected the boy to follow in his footsteps as a shoemaker.

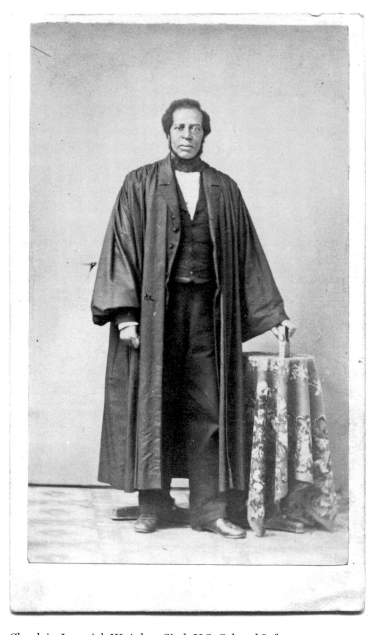

Chaplain Jeremiah W. Asher, Sixth U.S. Colored Infantry

Carte de visite by Thomas W. Searby (b. ca. 1831) of Philadelphia, Pennsylvania, about 1861–1863. Collection of Joyce Werkman.

Asher refused. He became a farmhand, and later a servant and coachman.[25]

In 1839, at twenty-six, he peacefully protested a policy that confined black members of his church to an uncomfortable "Negro pew." Called before the pastor and deacons to explain his actions, Asher persuaded them to allow him and others to sit where they pleased in the church galleries. "If ever I felt the presence of God, it was that day," he later observed. This event launched his career as a preacher and led to his first congregation, in Providence, Rhode Island.[26]

He left Providence a decade later to take the pulpit of Shiloh Baptist in Philadelphia. The church badly needed money, and Asher toured Great Britain to raise capital. His story, and the plight of African Americans, caught the attention of many. This interest inspired him to write his memoir, which was published in London in 1850.

After the Civil War started and the federal government subsequently allowed blacks to enlist in the military, Asher lent his voice to a chorus of interested persons advocating for army chaplains of color.[27] They prevailed, and about a dozen ministers received commissions, including Asher. A few days before Christmas 1863, he joined the Sixth U.S. Colored Infantry in Virginia.[28] His flock at Shiloh resolved, "that our brother carries with him the prayers and sympathies of this church, that his life and health may be preserved, and labors abundantly blessed of the Lord while absent from us."[29]

He did not make it back alive. Asher contracted typhoid fever while tending sick soldiers at the regimental hospital in Wilmington, North Carolina. His condition worsened over a period of weeks. Removed to a private home during his last days, he succumbed to the infection on July 27, 1865, at age fifty-two. His wife of twenty-five years, Abigail, and two sons, Thomas, eighteen, and John, ten, survived him.[30]

As a token of their esteem, the men of the Sixth purchased a metallic case and handsome coffin for the clergyman's remains. A friend accompanied the body to Philadelphia. On the afternoon

of August 8, more than thirty ministers, black and white, assembled for Asher's funeral at Shiloh. "A procession was formed and walked to the church, which was soon crowded in every part, including the galleries. The pulpit was draped in mourning, and the United States flag covered the coffin," observed a writer.[31]

Among those present were members of the church's Young Men's Christian Association. The group adopted a series of resolutions to honor Asher, including, "That the members of this Association deplore with inexpressible sorrow and anguish this, our Church's greatest calamity,—and that while we bow in submission to the decree of an all-wise Providence, we pray that peace and unity may reign throughout the land; then will the object be attained for which our illustrious pastor has died."[32]

Asher might have viewed his own death as he did that of John Brown—a necessary sacrifice for the cause of freedom.

First Defender, First Blood

ON THE AFTERNOON OF APRIL 18, 1861, FOUR DAYS AF-
ter the Union garrison at Fort Sumter marched out of the bat-
tered bastion, five companies of hastily organized Pennsylvania
volunteers, about 475 men, escorted by a few dozen regulars
marched rapidly through the streets of Baltimore, Maryland,
pursued by a formidable mob of yelling and screaming pro-se-
cessionists.[33] The soldiers, many lacking uniforms and muskets
and most armed only with revolvers, hurried to board a Wash-
ington-bound train in response to President Abraham Lincoln's
urgent call for troops to suppress the rebellion.

A long thin line of policemen stretched ten paces apart pre-
vented the surging protestors from assaulting the soldiers.
However, "they could not stop the mouths of the people," noted
a news report. Between cheers for "Jeff Davis" and the "South-
ern Confederacy" the belligerent citizens hurled insults and ob-
scenities at the Pennsylvanians, who included several colored
servants employed by company officers.[34]

One servant, Nick Biddle, wore the regulation outfit and fa-
tigue cap of the Washington Artillery, a Pennsylvania militia
company commanded by Capt. James Wren.[35] Biddle's attire
infuriated the mob. "The crowd raised the cry, 'Nigger in uni-
form!' and poor old Nick had to take it," recalled Capt. Wren.
The verbal abuse continued to the Camden Street depot. As the
soldiers boarded the cars, one protestor threw a jagged chunk
of broken brick. It struck Biddle in the head and left a deep cut
that bled profusely.[36]

Some consider Biddle's blood the first shed in hostility during
the Civil War.

Little is known about Biddle's early life, not even his real

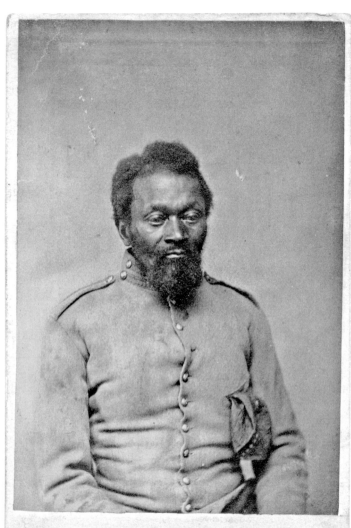

"NICK BIDDLE,"

Of Pottsville, Pa., the first man wounded in the Great American Rebellion, "Baltimore, April, 18, 1861."

Published by W. R. Mortimer, Pottsville, Schuylkill County, Pa.

Nicholas Biddle

Carte de visite by William R. Mortimer (b. ca. 1823) of Pottsville, Pennsylvania, about 1861. Collection of Thomas Harris.

name. Evidence suggests that he hailed from Delaware and moved to Pennsylvania in his youth. He worked as a servant in the Philadelphia home of prominent banker Nicholas Biddle and took the name as his own. At some point, possibly after the financier's death in 1844, Nick Biddle settled in Pottsville, located in coal mining country about forty miles northwest of Philadelphia. There he became associated with the Washington Artillery.[37]

State officials had mustered the artillerists into service at Harrisburg on April 17, 1861, and they had left the next morning for Washington. The soldiers marched quickly through Baltimore. "It was difficult to keep the men from using their pistols," noted Capt. Wren.[38] Most had boarded the train already when Biddle suffered his injury. As he got aboard, the frenzied mob climbed atop the cars and began jumping up and down on the roofs. Biddle wrapped his head with a handkerchief, pulled his fatigue cap close over the wound, and rode to Washington.[39]

He and the others arrived that evening and encountered enthusiastic crowds who welcomed them as saviors. They occupied temporary barracks in the north wing of the Capitol. One officer remembered when Biddle entered the rotunda of the building: "He looked up and around as if he felt that he had reached a place of safety, and then took his cap and the bloody handkerchief from his head and carried them in his hand. The blood dropped as he passed through the rotunda on the stone pavement."[40]

A grateful President Lincoln greeted the Pennsylvanians. He reportedly shook hands with Biddle and encouraged him to seek medical attention. Biddle refused. He preferred to remain with the company.[41]

The next day, more federal troops marched through Baltimore and met the same mobs. This time the soldiers, who belonged to the Sixth Massachusetts Infantry, opened fire. About a dozen citizens and four soldiers were killed. Scores suffered injuries. When the New Englanders arrived in Washington that

night, exhausted and hungry, the Pennsylvanians shared their rations with them.

News of the deadly Baltimore riot overshadowed the timely arrival of the Pennsylvanians, who came to be known as the "First Defenders," in honor of their being the earliest responders to Lincoln's call to arms.

Biddle and the Washington Artillery remained in the District of Columbia until their ninety-day enlistment expired, then returned to Pottsville. Biddle was at the front of the company as it marched through town. Many reenlisted and formed Company B of the Forty-eighth Pennsylvania Infantry, a regiment remembered for its role in digging for and detonating the mine placed on the front lines of Petersburg, Virginia, that prompted the July 30, 1864, Battle of the Crater.

Biddle stayed behind in Pottsville, where he sat for his *carte de visite* portrait. "Nick himself sold thousands of these photographs," remembered one veteran, who added, "A photographic album is not considered complete in Pottsville without the picture of the man whose blood was first spilled in the beginning of the war."[42]

The money he made from sales of his likeness and earnings from odd jobs provided him with a modest sum he intended to use to pay his funeral expenses. According to one writer, he "had a sort of morbid horror of being buried through charity." But his health began to decline, and he used up the savings. At his death in 1876 he was destitute.[43]

The First Defenders paid his final expenses and attended his funeral en masse, along with a large crowd that gathered at his home. Biddle's body lay inside an open casket in the front yard. "A pretty floral cross rested upon the old man's breast. Except that the marks of death were visible in the attenuated look, there was but little change in the face," noted a local newspaper. Not reported, but observed by many during his last years, was the deep scar on his head, left by the Baltimore mob.[44] Biddle had considered it "his military badge and brand of patriotism," explained a biographer.[45]

A long procession led by a drum corps escorted Biddle's remains to his final resting place, located in the "colored burying ground" behind a local church.[46]

Briefs in newspapers across the country noted his death. A Pennsylvania minister penned the poem "The Grave of Nick Biddle" to honor his memory.[47] Others linked his name to that of another man of color, Crispus Attucks, who lost his life at the Boston Massacre in 1770.

In 1951, ninety years after the Baltimore incident, Pottsville residents dedicated a bronze commemorative plaque in memory of the First Defenders and Biddle.[48]

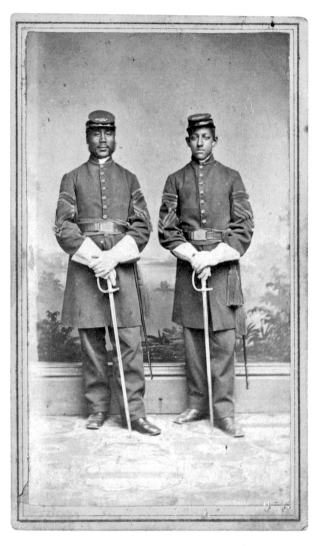

Q.M. Sgt. Alexander Herritage Newton (*left*) and Q.M. Sgt. Daniel
Stanley Lathrop, both Twenty-ninth Connecticut Infantry

Carte de visite by James Horace Wells (b. ca. 1828) & David C. Collins (b. ca.
1805) of New Haven, Connecticut, about 1865. Collection of the Beinecke Rare
Book and Manuscript Library, Yale University.

Out of the Briars

"I WAS BORN UNDER THE REGIME OF SLAVERY, A FREE child, my mother being a free woman," explained North Carolina–born Alexander Newton, "My father was a slave, so that in my family, I learned what slavery was. I felt its curse in my bones and I longed for an opportunity and the power to play the part of a Moses in behalf of my people. I suppose this was the wild dream of every child born during slavery."[49]

Flash forward to April 12, 1861. The bombardment of Fort Sumter signaled the start of war—and for Newton an opportunity to realize his boyhood dream. "My bosom burst with the fire of patriotism for the salvation of my country and my people," he declared.[50] At the time he lived in Brooklyn, New York, headquarters of the Thirteenth New York National Guard Infantry. It mobilized for duty within days after the attack. Newton could not enlist because of the color of his skin. "The United States was not taking Negro troops," he noted, without further comment, in his autobiography.[51]

The policy did not stop him. On April 23, 1861, when the Thirteenth left for Washington, D.C., to protect the capital, Newton went with them.[52] He may have served as an officer's valet or in another supporting role.

The regiment made it as far as Annapolis, Maryland, when federal authorities ordered it to Baltimore to maintain law and order among the city's pro-South populace. The New Yorkers left Baltimore in August 1861, after the expiration of their three-month term of enlistment.

The Thirteenth was activated again for brief stints in 1862 and 1863. Evidence suggests that Newton accompanied the regiment both times. The latter mobilization, organized to resist the

Confederate invasion of the North that ended with the Battle of Gettysburg, ended prematurely after New York State officials recalled the regiment to quell draft riots in New York City. The Thirteenth arrived a day after the angry mobs were broken up.[53] Violent protestors intent on harassing blacks still roamed the streets, however. Fearing for his life, Newton fled the city.

He wound up in New Haven, Connecticut. By this time the Emancipation Proclamation and a series of congressional acts enabled black men to join the army. Newton enlisted in the Twenty-ninth Connecticut Infantry in December 1863. He received an appointment as second sergeant in Company E.[54]

The regiment left for South Carolina in early 1864. It passed through Annapolis, where Newton had been three years before as a civilian attached to the Thirteenth New York. This time he wore a blue uniform. "I was in the full realization of what it meant to be again in the South, not a cringing black man, but a proud American soldier with the Union and Old Glory behind, before, over and under me."[55]

His return to the South opened old wounds as he was reminded of injustices committed against him and others. "I confess that I had a burning desire to eke out some vengeance which for years had been pent up in my nature," he admitted. His better angels prevailed. "But, of course, from the Christian standpoint, this was all wrong. I was all wrong. I was then on a higher mission than trying to get personal vengeance on those who had mistreated me and mine. I was fighting for the liberty of my people and the righting of many wrongs that belonged to their social and religious welfare."[56]

In the summer of 1864, the Twenty-ninth moved to Virginia and found itself on the front lines near Petersburg. Within days the regiment went into action at Deep Bottom, where Newton came close to death. "I remember a twenty-pound cannon ball coming towards me, I could see it distinctly through the smoke. It looked like it had been sent especially for me." He said a quick prayer. "When the ball was within about three feet of me it struck the ground and bounded over my head."[57]

This was the first of many narrow escapes from death for Newton. Perhaps his closest call occurred on August 29. On that day he stood in the trenches, talking with his comrades, when an artillery shell struck the ground and exploded. It killed the private next to him. The force of the blast threw sand and dirt into Newton's face and temporarily blinded him. He never fully recovered his eyesight and later wore glasses.[58]

About this time, he became a quartermaster sergeant and joined the regimental staff. He was serving in this capacity on April 3, 1865, when the Twenty-ninth numbered among the first Union forces to enter Richmond after Confederate troops withdrew. The next day, Abraham Lincoln visited the fallen Confederate capital. Newton noted, "We were present in Richmond when President Lincoln made his triumphal entry into the city. It was a sight never to be forgotten."[59]

The Twenty-ninth left the Richmond area about two weeks later and, after a brief stint guarding prisoners at Point Lookout, Maryland, sailed for Texas. In October 1865, the regiment mustered out of service and returned to New Haven.

Newton rejoined his wife, Olivia, the daughter of *Weekly Anglo-African* newspaper editor Robert Hamilton,[60] and his young daughter and son. He abandoned his profession as a mason and became a minister in the African Methodist Episcopal Church. After Olivia died, in 1868, he tended to the faithful at various places across the country. In Little Rock, Arkansas, he met a Sunday school secretary named Lulu Campbell. They married in 1876. Newton fathered another boy and girl with Lulu.

Newton rose to become an influential and respected church elder based in Camden, New Jersey. At the pinnacle of his career, personal tragedy devastated him. Over a six-year period beginning in 1899, he suffered the deaths of both of his daughters, his younger son, and his mother. He paid tribute to his family in a 1910 book, *Out of the Briars*. The title, he explained in the preface, is a metaphor that represents his emergence, torn and bleeding, from the thorns and briars of prejudice, hatred, and persecution of slavery.[61]

Newton lived until age eighty-three, dying of heart problems in 1921.

In 2008, eighty-seven years after his death, families of the veterans in the Twenty-ninth dedicated a monument to the regiment in New Haven. It is composed of eight stone tablets marked with the names of those who served. The tablets surround an obelisk. Engraved on one face of it is a portrait of Newton and fellow quartermaster sergeant Daniel Lathrop[62] taken from this *carte de visite* image.

Captured at the Battle of Bull Run

EARLY IN THE MORNING OF JULY 22, 1861, COL. AM-
brose Burnside[63] and his battered brigade entered the city of
Washington, foot-sore and exhausted after an all-night retreat
that followed the debacle at Manassas.[64] In his official report
written two days later, Burnside described the actions of his
command in the thick of the fight and noted the loss of sev-
eral key officers.[65] One man not mentioned, and whose loss he
perhaps felt most keenly, was that of his longtime valet, Robert
Holloway, who was captured by the Confederates.

Holloway had worked for the colonel eleven years. The two
had met in 1850 in New Mexico, about the time that region be-
came a territory of the United States. The army sent twenty-five-
year-old Lt. Burnside to protect mail routes.[66] How Virginia-
born Holloway, about thirty-five at the time, came to be there is
not known.

Over the next decade, Holloway acted as servant and body-
guard to Burnside as he embarked on hazardous military mis-
sions on the western frontier, worked in Rhode Island as a ci-
vilian manufacturer of a popular breech-loading firearm, the
Burnside carbine, and, after his company folded, served as trea-
surer of the Illinois Central Railroad.

Burnside organized the First Rhode Island Infantry imme-
diately after the bombardment of Fort Sumter in April 1861.
Among the first regiments to arrive in Washington, it entered
the capital on April 26 with Col. Burnside in command and
Holloway in attendance.

Less than three months later Burnside led his Rhode Island-
ers and the rest of their brigade at the First Battle of Bull Run.
He received a brigadier's star for his conduct in the Union de-

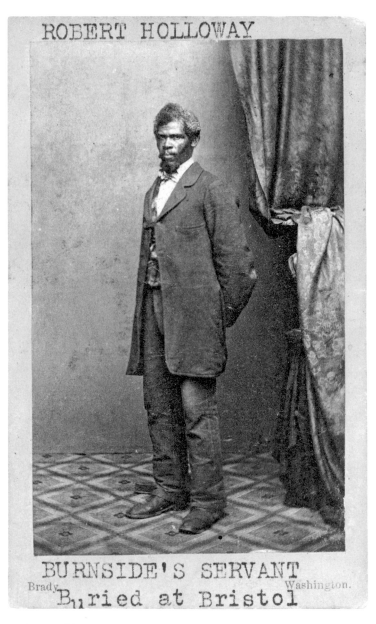

Robert Holloway

Carte de visite by Mathew B. Brady (b. ca. 1823, d. 1896) of New York City and Washington, D.C., about 1862. Collection of the Rhode Island Historical Society.

feat. Victorious Confederates carried Holloway to Richmond and put him to work as a cook in a military prison.[67]

Burnside's initial efforts to get him back failed. A new opportunity presented itself on February 8, 1862: Burnside, then in command of an amphibious expedition that put much of North Carolina's coast under Union control, captured the Confederate garrison on Roanoke Island. Among those surrendered were four senior Southern officers. Each had become separated from his servant. Burnside made sure they got them back. In return, the officers petitioned their government to free Holloway.[68] The Confederate authorities agreed and released him. Not knowing where Burnside was, Holloway made his way to Washington. Anxious to return to Burnside, he skipped a visit to his wife and child in Rhode Island and set out by ship for North Carolina.[69]

On March 9, 1862, the two men reunited on the *Alice Price*, a steamer being used as expedition headquarters. Holloway had spent about seven months in captivity. Burnside's private secretary noted in a letter to Mrs. Burnside that Holloway seemed "very much pleased to be with the General again and refused many offers in Washington, 'preferring to be with his old master.' He wishes to be remembered to you and says that he means to come home with the rest 'through Richmond.'"[70]

Holloway made good on his word. He followed Burnside's rising star after his promotion to major general and commander of the Army of the Potomac, and his fall after failures at Fredericksburg and the Petersburg mine assault.

After the war, Burnside entered politics and won elections as Rhode Island governor and U.S. senator. Holloway remained at his side.

The men were not separated until 1877, when Holloway died at about age sixty-two. He was buried in Jupiter Cemetery in Bristol, Rhode Island, and his stone marker is engraved "30 years a faithful servant to Gen. Burnside, at Home and in the Field."

Burnside died four years later. Holloway's son, Robbie, tended

to the general during his final illness.[71] Burnside's remains reside at Swan Point Cemetery in Providence.

On Decoration Day in 1886, veterans of the Bristol post of the Grand Army of the Republic[72] commemorated the occasion with a procession to town hall, followed by music and a speech. The final tribute, a recital of the Roll of Honor, included the names of 125 deceased comrades who served Rhode Island and the Union.[73] Among the names read aloud were Burnside and Holloway.[74]

The Pilot

ONE DAY IN LATE APRIL 1862 IN CHARLESTON HARbor, a member of the slave crew on a Confederate cotton boat–turned–military transport joked with his fellow crew members that they should seize the vessel and surrender it to the Yankee navy, which had blockaded the South Carolina seacoast.[75]

One slave, a genial and persevering young man called the "Major" by his crewmates, took the idea seriously. Robert Smalls served as the pilot of the boat, a steam-powered side-wheeler named *Planter*, and he could navigate her through harbor security. Like some independently employed enslaved people, Smalls lived apart from his master. He called the crew to his home and together they devised a plan.[76]

Smalls cancelled the first attempt at seizure because he felt that one of the slaves could not be trusted.[77] He tried again in the early morning hours of May 13, 1862. The three white officers in command[78] had gone ashore to get a good night's rest, as they expected to be away from Charleston for several days. They left the *Planter* docked near Confederate headquarters, loaded with munitions destined for a newly constructed harbor fort.

Smalls and five crewmates pulled away from the dock at about 2 a.m. and traveled to a nearby wharf. There they picked up ten friends and relatives, including Smalls's wife Hannah, fourteen years his senior, and their two young children.

"The whole party had solemnly agreed in advance, that if pursued, and without hope of escape, the ship would be scuttled and sunk; and that, if she should not go down fast enough to prevent capture, they would all take hands, husband and wife, brother and sister, and jump overboard and perish together!" noted a reporter who interviewed Hannah soon after the event.[79]

They steamed away from the wharf about 3:25 a.m. The first obstacle in the harbor was Fort Johnson. Smalls followed protocol and exchanged signals with the guard without rousing suspicion.

Then the ship approached Fort Sumter. Smalls donned the distinctive, large straw hat left behind by the *Planter*'s captain. At some point, possibly about this time, he exchanged his worn

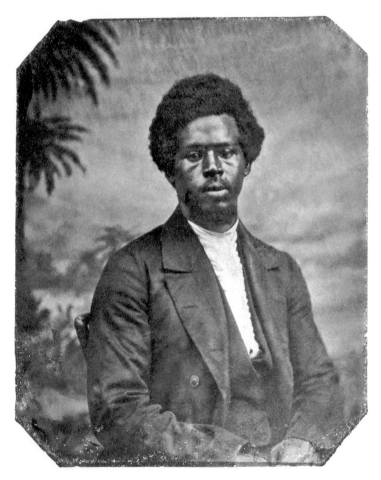

Robert Smalls

Tintype by unidentified photographer, about May 1862. Collection of the Bettmann Archive / Corbis.

red flannel shirt and jeans overalls for a suit that an officer had stowed on board.[80]

Smalls impersonated the captain. "I leaned out of the window of the pilot house and gave the signal, receiving 'All right' in return," recalled Smalls, and the ship "passed beyond Sumter's guns before anything wrong was suspected. When they saw that the *Planter* was making for the Federal lines they tried to stop us." It was too late.[81]

The *Planter* passed out of the harbor mouth and into the Atlantic.

Meanwhile, jittery Union sailors expected an attack from rebel rams after rumors circulated that the ironclad monsters were prowling the waters. At sunrise, as the early morning mist rolled across the waves, men aboard at least two warships feared the worst when they spotted the *Planter* headed towards them, black smoke belching from its stack.[82]

The *Planter* steamed rapidly towards the clipper *Onward*, whose sailors readied for combat. *Onward*'s commander, J. Frederick Nickels,[83] was about to order his men to fire when an officer spotted an improvised truce flag, made from a towel, handkerchief, or bed sheet.[84]

By this time the *Planter* was within audible range. Nickels "asked what boat that was, and what she wanted. The reply was given and the *Planter*'s errand explained," according to one account. Another report explained how "one of the Colored men stepped forward, and taking off his hat, shouted, 'Good morning, sir!' I've brought you some of the old United States guns, sir!'"[85]

Nickels told the *Planter* crew to bring the vessel alongside the *Onward*. They did not hear the order. The boat moved in the wrong direction. Nickels barked in a thundering voice, "Stop, or I will blow you out of the water." This time they heard and obeyed.[86]

Nickels sent an officer and four men to board the *Planter*. After expressing their initial joy and relief, Smalls and the crew requested an American flag. Nickels ordered that the *Onward*'s

ensign be lowered, carried to the *Planter*, and raised on her halyards.[87]

Navy personnel escorted Smalls to the fleet commander, Flag Officer Samuel Du Pont.[88] According to his official report, Smalls pointed out four disassembled cannon on the *Planter*'s deck; they would now never be delivered to the Confederate fort for which they were intended. Smalls claimed that one of these guns had been inside Fort Sumter and had been struck on the muzzle during the bombardment in April 1861.[89]

The seizure and surrender of the *Planter* made newspaper headlines North and South. An admiring Philadelphia newspaper called Smalls the "Black Lion."[90] A *New York Tribune* editorial pronounced, "If each one of the Generals in our army had displayed as much coolness as he did when he saluted the Rebel flag and steamed past the Rebel fort, by this time the Rebellion would have been among the things that were."[91]

Smalls received full credit as the mastermind of the operation. He also earned a share of the prize money, a common navy practice, and later used part of it to buy the very plot of ground in Beaufort, South Carolina, on which he was born and raised by his mother Lydia. She toiled as a slave in the household of her master, John McKee, who, according to her descendants, was the biological father of Smalls.

In the summer and fall of 1862, as President Abraham Lincoln waited for an opportunity to announce the Emancipation Proclamation, Smalls made two trips to the North organized by political and military men who had identified him as a potential leader and recruiter of African American military volunteers. The visits advanced the cause of freedom and equality.[92]

In October 1862, Smalls returned to South Carolina and, eager to participate in the war, reported to Du Pont to offer his services to the Union navy. The officer tapped his knowledge of the area's waterways and the locations of underwater mines that Smalls had helped place in defensive positions while he was under Confederate control.

Smalls resumed working as a pilot, this time as a civilian con-

tractor for the U.S. government. Over the next three years he served on several vessels, including the twin-turreted monitor *Keokuk*. He was aboard the ironclad during an April 7, 1863, attack on Fort Sumter. Struck ninety-six times by enemy shot, the *Keokuk* sunk the next day. Smalls survived the attack but suffered powder burns that affected his eyesight.[93]

Later that year, Smalls piloted the *Planter* on a mission to deliver rations to soldiers on Morris Island. The ship got caught in a heavy crossfire between Confederate and Union gunboats and land-based batteries. The captain of the *Planter*, a man named Nickerson, panicked and took shelter in an onboard coalbunker. Smalls assumed control and navigated the *Planter* to safety. The captain was cashiered. Smalls was given his position and title, and he served in this capacity until 1866.[94]

The *Planter* eventually became a packet ship, running goods and passengers up and down the coast of the Palmetto State. In 1876, she sunk off Cape Romain, about forty miles north and east of Charleston.[95]

By this time Smalls had entered politics, first as a state legislator and then, from 1875 to 1887, as a U.S. congressman. His political career was tainted by scandal in 1877 after a court found him guilty of taking a bribe in a case motivated by an anti-black backlash during the waning days of Reconstruction. The governor pardoned Smalls two years later.

Smalls went on to serve as a U.S. Collector of Customs in his hometown of Beaufort.

He died in 1915 at age seventy-five of malaria and diabetes. He outlived Hannah, who died in 1883, and second wife, Annie, whom he wed in 1890. Two daughters and a son survived him.

The "Hero of the *Planter*" charted a course to equality for African Americans. "My race needs no special defense, for the past history of them in this country proves them to be the equal of any people anywhere," Smalls once stated. "All they need is an equal chance in the battle of life."[96]

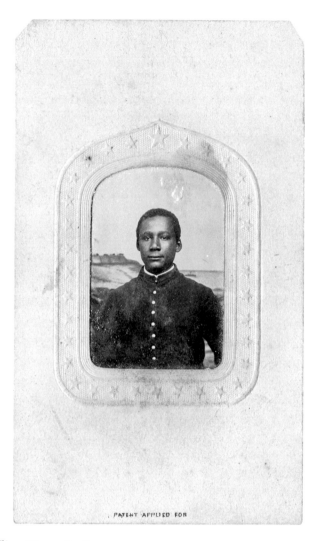

PATENT APPLIED FOR

William Henry Scott

Tintype by unidentified photographer, about 1862–1865. Collection of Manuscript, Archives, and Rare Book Library, Robert W. Woodruff Library, Emory University.

A Confederate Sword

AT SOME POINT DURING THE FIGHTING AT FREDERICKS-
burg in December 1862, young Henry Scott approached a pon-
toon bridge being used by Union troops to attack Confederate
forces on the heights on the far side of the Rappahannock River.
He intended to cross into the battle zone. The fourteen-year-old
encountered a guard, who ordered him to halt and asked to see
his pass. Henry did not have one. He explained that he served
a Union officer wounded in combat and wanted to bring him
something to eat. The sympathetic guard allowed him to cross.

Henry soon found himself in an area strewn with carnage
and debris. He "had not been on the battlefield very long before
he realized it was a very unhealthy place for a boy, and retreated
in good order to the other side of the Rappahannock," noted one
writer, who added, "He did not return empty handed, however,
for he carried with him a trophy, picked up on the field, a sword."
The Spanish-made saber had belonged to a Confederate.

Henry had told a partial lie to the guard at the bridge. He did
serve an officer, Loring Muzzey,[97] the regimental quartermas-
ter of the Twelfth Massachusetts Infantry, but Muzzey had not
been wounded. Henry had stolen away from him, curious to see
a battle. He returned to Muzzey and gave him the sword.[98]

The two had known each other about seven months before
Fredericksburg. Henry, a half-white slave child fathered by his
master, had vowed at age eight that he would escape bondage.
He made his break for freedom in April 1862 after the Massa-
chusetts men encamped near the plantation in Fauquier County,
Virginia, where he lived. Muzzey, a genial and big-hearted mer-
chant during peacetime, took Henry on as his servant.[99]

Muzzey, discovering that the boy could not read or write, cast

himself in the role of teacher. He began with a spelling book. Henry did not know which end of the book was up, a problem corrected by drawing a horse on the cover, "which device soon told when the horse was upside-down and could not stand upon his legs," according to one writer. At times, Muzzey "would observe a light late at night in the small tent outside appointed to Henry for his sleeping quarters. He had a curiosity to know what kept the boy up at such unseasonable hours, and peeping through the canvas of the little tent he beheld Henry earnestly bending over his spelling-book, with his finger upon the letter, lest he should lose his place. He had improvised a salt-box for his study table, a potato for a candlestick, wherein burned his candle."[100]

Other officers helped Henry, and even Muzzey's mother got into the act. She had learned of the boy's progress through her son's letters home and sent Henry a Bible, its red morocco covers imprinted with his name in gilt letters.[101]

Henry mastered his books and became a favorite around camp. According to one corporal, Henry "had the respect and confidence of all the men of the regiment, and they were proud of him."[102]

Henry attended Muzzey for the duration of the war. He witnessed more action than many soldiers, including the Battle of Gettysburg and the Appomattox Campaign, where Muzzey, by then a U.S. Commissary Department captain, provided much-needed supplies to surrendered soldiers in the defeated Army of Northern Virginia.[103]

When Muzzey left the army in October 1865 and returned to his home in Lexington, Massachusetts, he brought Henry along. He and his mother encouraged then seventeen-year-old Henry to further his learning and religious development in the Baptist church.

Henry Scott left the Muzzey family after a short time and spent the next two decades working in Maryland, Virginia, and the District of Columbia as a teacher, minister, and bookstore

owner. He became politically active and emerged as a powerful voice in the struggle for equal rights. "His speeches were very forcible, his expressions sharp and to the point," declared a biographer.[104] Words he spoke in 1905 at a celebration of the one hundredth anniversary of the birth of social reformer William Lloyd Garrison support this statement: "In these days...northern minions and southern rapers of the constitution, are telling the Negroes to wait and learn how to vote and when they shall have become rich and millionaires, then, and not until then, shall they have the right to vote."[105]

During this year Scott became one of the twenty-nine original members of the Niagara Movement, the predecessor of the National Association for the Advancement of Colored People. Another of its founders, William Monroe Trotter,[106] teamed up with Scott and "fought everything and everybody who denied identical rights or who by compromise accepted or aided such denials," including Booker T. Washington and other dominant voices in the greater African American community who sought common ground with powerful whites as Jim Crow segregation eroded the legal freedoms established after the Civil War. "No colored man has ever organized and agitated for freedom in the land so persistently for so long a period," noted Trotter of Henry Scott's efforts.[107]

By this time Scott had returned to Massachusetts, as pastor to several Baptist church congregations in the greater Boston area. He also rekindled his friendship with Loring Muzzey, a lifelong bachelor who still lived in Lexington. The aging Muzzey still possessed the Confederate sword Henry had picked up at Fredericksburg and now returned it to him. The trophy became one of Scott's most cherished mementoes.[108]

Muzzey died in November 1909. Scott succumbed to tuberculosis seven months later at age sixty-two.[109]

Before his death, he reportedly told a friend that a "great race clash" would happen in the future. He may have anticipated the civil rights struggle of the 1960s.[110]

His wife of fifteen years, Marion, survived him. Four sons were alive at the time of his death, one boy from a rocky first marriage and three more by Marion.[111]

Friends and admirers remembered him as "an upright minister of God and a defender of the rights of his race. No oppression or unjust legislation detrimental to his race ever escaped his notice; and he fought them with a singleness of purpose which awakened the admiration, respect and praise of all true men."[112]

Said his friend William Monroe Trotter at Henry's memorial service, "He was a lover of liberty, liberty for its own sweet sake."[113]

The First Man of Color in Kansas

THE LIGHT OF DAWN ON JANUARY 1, 1863, REVEALED cloudy skies over Fort Scott, Kansas. The absence of sunshine did not dampen the spirits of the officers and men of the First Kansas Colored Infantry, who sat down that afternoon to an elaborate lunch to celebrate the Emancipation Proclamation, which had gone into effect that day. The soldiers feasted on barbecue ox, hogs, and chicken, and listened to speeches, including one by Capt. William Matthews of Company D.[114]

"I am a Southern man with Northern principles," the thirty-five-year-old Marylander told the troops. "To-day is a day for great rejoicing with us. The President has proclaimed freedom." He reflected, "I am not surprised while I rejoice. As a thinking man I never doubted this day would come."[115]

His wait for emancipation began along the Eastern Shore of the Old Line State. Born free to a full-blooded African father who hailed from Delaware and a half-white mother once owned by her French father, Matthews's early life was marred by prejudice.[116]

"The first time I knew of any difference on account of color was when, a little chap, I thrashed a white boy for breaking my waggon." He remembered, "His father came to mine and wanted to cowhide me." Matthews's father told young William never to strike a white child again, for if he did the law would punish him.[117]

Further incidents over the years prompted Matthews to leave home. He went to Baltimore at age twenty-one and from there went to sea. In 1854 he purchased his own vessel and cruised the Chesapeake Bay and Potomac River as a commercial fisherman.

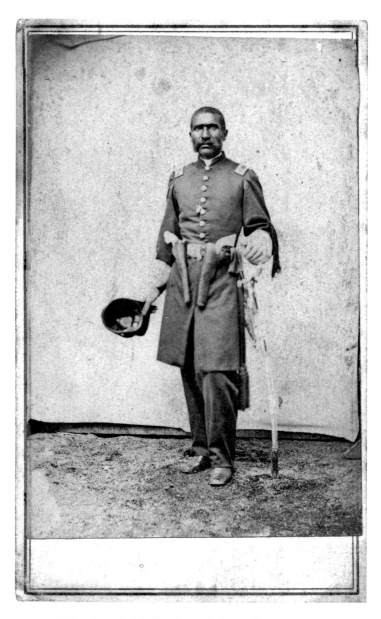

1st Lt. William Dominick Matthews, Independent Battery, U.S.
Colored Light Artillery

Carte de visite by unidentified photographer, about 1865. Collection of the
Kansas State Historical Society.

He ran up against discriminatory laws that prohibited him from earning a living.[118]

He sold his boat and left Maryland. "I always believed in freedom and determined to find a place freer than that State," he declared.[119]

He moved to the Kansas Territory in 1856. "I found a great fight for freedom in progress," he noted of the struggle to determine if the territory should enter the Union as a free or slave state.[120]

Matthews jumped into the fray. "In Leavenworth I opened a large eating house where I was patronized by most of the wealthy whites of the town and while I entertained them in the front of the house my back door was always ajar for the fleeing traveler on the Underground Railroad which had one of its terminals at my house and in connection with John Brown and other antislavery men I succeeded in baffling the pursuers."[121]

Matthews collaborated with other abolitionists, including suffragist Susan B. Anthony's brother Daniel.[122] In 1861, as Kansas joined the Union as a free state, he converted his house into a home for runaway slaves. "At this time I organized a company of 100 men and stood guard night and day protecting the slaves as they came to Kansas from their masters." He added, "I also offered my services with my company of 100 men to the government to aid in the war but was told that it was a white man's war and we were not wanted."[123]

By early 1862, the federal government's attitude towards black men as soldiers began to shift towards acceptance. Matthews was perfectly positioned as a recruiter.

That summer, Kansas senator Jim Lane[124] interpreted an order to recruit new regiments to include black troops. According to one report, "The first 'man of color' taken into the scheme was Matthews. He not only raised his own company, but he brought in 200 ex-slaves to swell the ranks."[125] The new regiment regarded him as more than a recruiter. "Matthews was the ruling spirit with the men. He more than any one person, black or white, held the organization together."[126]

On October 29, as the regiment awaited formal authorization to join the Union army, a detachment participated in a skirmish in Missouri at Island Mound and became the first black troops in blue to engage in combat during the war.[127]

On January 1, 1863, when Matthews spoke at the emancipation barbecue, he concluded with a call to action: "Let me speak a word to my people. Now is our time to strike. Our own exertions and our own muscle must make us men. If we fight we shall be respected. I see that a well-licked man respects the one who thrashes him."[128]

About two weeks later, the First mustered into the army— without Matthews. The officer assigned to muster him refused to do so because, he explained, he lacked the authority to enroll a person of African descent as a company officer.[129] Outraged supporters of Matthews worked unsuccessfully to overturn the decision. A distraught Matthews worried about the impact on his recruits and fired off a letter of protest to Senator Lane.[130] It failed to achieve the desired effect. The captaincy went to a white man.[131]

The First went on to fight in numerous battles and earn a distinguished reputation.[132]

Matthews returned to Leavenworth. After brief stints as a policeman and an army recruiter, he raised men for the Independent Battery, U.S. Colored Light Artillery, in late 1864. By the time he mustered into the battery in February 1865, attitudes towards black men as officers had begun to change for the better. Matthews entered the service as a first lieutenant, perhaps of solace to him after the loss of his captaincy two years earlier. Matthews distinguished himself as a leader.[133] One of his superiors praised him: "You have been a model of proper discipline and subordination, strictly attentive to duty, promptly obedient to orders, and acting with a wise discretion in all matters requiring the exercise of your individual judgment."[134]

Matthews mustered out with his comrades in October 1865 and returned to his home and wife, Fanny, whom he had mar-

ried shortly before he enlisted. They raised four children who lived to maturity.[135]

Matthews became an influential figure in politics as a member of the state's Republican Central Committee, but elected office eluded him. In 1877, members of the colored Masons voted him as one of six officers of the National Grand Lodge, formed to extend the mission of the organization across the country.[136] He died in 1906 at age seventy-eight.

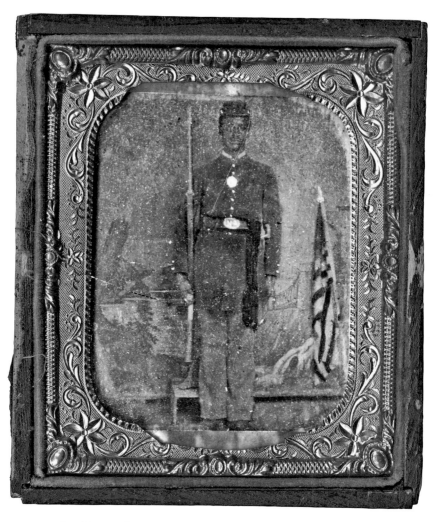

1st Sgt. Emanuel Monroe Cunnigen, Company I, Sixty-sixth U.S. Colored Infantry

Tintype by unidentified photographer, about 1865–1866. Collection of Donald Cunnigen.

"A Man Who Covered the Ground
He Walked On"

THE CAMPAIGN TO CAPTURE VICKSBURG AND SECURE
control of the Mississippi River for the Union entered its fourth
month in February 1863. Federal forces established and occu-
pied enclaves on the west side of the great river and sent am-
phibious forces into the Mississippi Delta in an effort to gain the
bluffs up and down river from Vicksburg. During the operation,
troopers in the Third Illinois Cavalry came upon a plantation
outside Yazoo City, Mississippi. How long they stayed and the
purpose of their visit is not exactly known. One fact is certain:
they left with Emanuel Cunnigen, a laborer who toiled in the
nearby fields.[137]

A young man of great stamina, the six-foot-tall eighteen-year-
old had lived in the area all his life. "I was a slave & belonged to
Joseph Regan," Cunnigen stated; "Never was owned by anyone
else."[138] Regan, a planter, state legislator, and Confederate cap-
tain, held sixty-five slaves and about two thousand acres of land
before the war.[139] It is likely he also owned one or both of Cun-
nigen's parents and a sister of his who died young.[140]

Cunnigen's life changed forever when he departed with the
cavalrymen. He left behind a wife, Lucinda, or "Cinda," whom
he had wed in a slave marriage. The troopers put him to work as
a teamster. He traveled with the regiment through the remain-
ing six months of the Vicksburg Campaign, including the battles
of Port Gibson and Champion Hill. He was also present during
the subsequent siege that ended, on July 4, 1863, with the sur-
render of the city of Vicksburg and its garrison—an irreparable
loss to the Confederacy.

During this summer of Union success, Cunnigen suffered a
personal loss when Lucinda died. The couple had no children.

Before the end of the year he enlisted in the Fourth Mississippi Infantry, African Descent, and joined Company I as a private.[141] In March 1864, the Fourth became the Sixty-sixth U.S. Colored Infantry.

The regiment served on post and garrison duty in Mississippi, Louisiana, and Arkansas over the next two years. Cunnigen remained with his company during this time, with the exception of two brief stints as a hospital guard. In June 1865, he received a promotion to sergeant, and he mustered out with his comrades in March 1866 as a first sergeant at Natchez, Mississippi.[142]

Cunnigen spent the next year in Vicksburg. In 1867 he moved to Magnolia, a village in the southwestern part of the state, where he wed Martha Blount, a former house servant and cook. According to family history, he had met Martha during his military service, fallen in love, and promised to marry her after the war. They started a family that grew to include eleven children, seven sons and four daughters.[143]

Cunnigen used army pay that he had saved to buy forty acres of land, and the family settled into a rough wood cabin on the property. Over the years he added to the modest dwelling as his family grew. It eventually became a sprawling two-story home with leaded-glass windows and a wraparound porch.[144]

Cunnigen received a license to preach the year he married. Ordained in 1868, he became the first African American Baptist minister in the area. He founded several community churches and tended the flocks of local congregations over a career that spanned more than four decades. Firmly believing in the separation of church and state, he voted Republican but avoided political office. A staunch advocate of education, he founded a school for black children and taught its students.[145]

He was also active in fraternal orders, including the Masons and the Odd Fellows.[146]

In 1913, he suffered a debilitating stroke that left him paralyzed on the right side. He lived another eight years, dying at age seventy-six in 1921.[147]

Family and friends mourned his passing. A genealogist noted that Rev. Cunnigen's children remembered him "as a man who covered the ground he walked on," a suggestion that wherever he went, he did so with determination, and left behind a positive impression for future generations.[148]

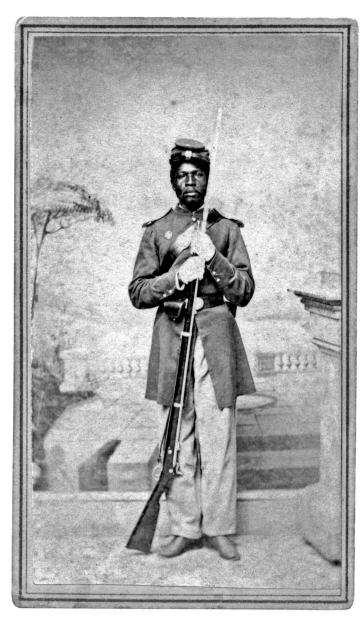

Pvt. Albert E. Jackson, Company A, Seventy-eighth U.S. Colored
Infantry

Carte de visite by unidentified photographer, about 1863–1864. Collection of
the Gettysburg National Military Park Museum.

They Never Saw Him Again

IN THE SPRING OF 1863, IN THE SOUTHERN ALABAMA county of Baldwin, along the Tensaw River at a plantation about four miles from Hurricane Bayou, a slave and skilled shoemaker named Albert Jackson bid farewell to his wife Sarah and their three children and ran away to join the Union army. They never saw him again.[149]

Sarah had been married to Jackson eleven years when he left. They met back in 1851 after Sarah's widowed mistress married Jackson's widowed master.[150] Jackson and Sarah wed the following year in an unofficial and informal slave union. Her mistress remembered the event with perhaps a hint of annoyance: "The girl Sarah was not satisfied to go together as most slaves did and my husband read the ceremony." Over the next decade, Sarah bore Jackson four daughters, one of which died tragically in a house fire.[151]

Jackson might have been motivated to join the army by the Emancipation Proclamation, issued a few months before he left home. Legally free to do as he pleased, he made his way about sixty miles south and east to Union-occupied Fort Barrancas, Florida. On May 18, 1863, he enlisted in the federal army, which actively recruited men of color in the region. He traveled with other volunteers to Port Hudson, Louisiana.[152] There he mustered into Company A of the Sixth Corps d'Afrique, one of five regiments raised for an all-black brigade commanded by Brig. Gen. Daniel Ullmann.[153] The designation of Jackson's new regiment was later changed to the Seventy-eighth U.S. Colored Infantry.

Health problems plagued Jackson from the start of his military service. He bounced in and out of the post hospital

on twenty-three separate occasions over a period of fourteen months. He suffered from diarrhea, fever, scurvy, and other ailments. On October 24, 1864, he landed in the hospital again. A doctor diagnosed him with chronic bronchitis. Treatments failed and his symptoms worsened. He died exactly one month later.[154]

Medical personnel listed Jackson's official cause of death as dropsy, which may have been the result of kidney or heart disease. He was buried the same day.[155]

His widow Sarah married Isaac Armstrong in 1869 and started a new family that included two boys. They named their eldest son Albert, possibly in honor of her first husband, whose journey to freedom ended in Port Hudson.[156]

"To Waver Once Was to Fall Forever"

BOSTON BUZZED WITH EXCITEMENT. THRONGS OF CITI-
zens and dignitaries lined the streets as the Fifty-fourth Mas-
sachusetts Infantry, African American soldiers led by white offi-
cers, marched to the wharf to ship out for the South on May 28,
1863. As the regiment entered State Street, in the area where
Crispus Attucks had become a martyr during events leading up
to the Revolutionary War, David Moore of Company H and his
fellow bandsmen marched to the tune of "John Brown's Body"
and the crowds cheered.[157]

Moore might not have expected such a sendoff when he en-
listed a month earlier. The fifteen-year-old drummer, one of
about seven children born to Pennsylvanian David Moore and
his wife Elizabeth, had lived in Ithaca, New York. The family
then moved to Elmira, where young Moore went to work as a
horse driver. In April 1863 he left his job and family to enroll
in the Fifty-fourth. He used his middle name, Miles, perhaps to
distinguish himself from his father.

The *New York Tribune* put the march made by Moore and
the rest of the Fifty-fourth through Boston in perspective in an
editorial attributed to Horace Greeley. "Though it was greeted
with cheers and borne on by the hopes of the loyal city which
had trusted the fame and lives of its noblest white sons to lead
their black comrades, yet that procession was the scoff of ev-
ery Democratic journal in America, and even friends feared half
as much as they hoped. Many a white regiment had shown the
white feather in its first battle; but for this black band to waver
once was to fall forever, and to carry down with it, perhaps, the
fortunes of the Republic."[158]

The Fifty-fourth did not waver. The actions of its officers and

men against Fort Wagner in the summer of 1863 dealt a death blow to those who argued that race would be a factor in battle and secured their reputation as a brave regiment.

Records indicate that Moore was present for duty at Wagner and other major engagements in which the Fifty-fourth participated, including the Battles of Olustee and Honey Hill. He mustered out with his surviving comrades in August 1865—a veteran at age seventeen.

Moore became a Buffalo Soldier, serving in the American West, after he returned to the army in the fall of 1867. He joined the Thirty-ninth U.S. Infantry, one of four African American regiments organized during the postwar period. He again served in the band. During his three-year enlistment, the Thirty-ninth

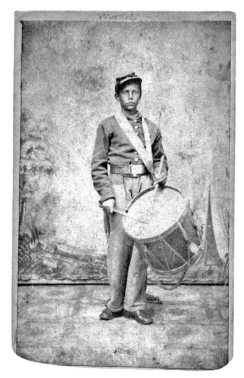

Pvt. David Miles Moore, Twenty-fifth U.S. Infantry

Carte de visite by unidentified photographer, about 1863–1865. West Virginia and Regional History Collection, West Virginia University Libraries.

was consolidated with another regiment to form the Twenty-fifth Infantry.[159]

Moore mustered out at Fort Clark, Texas, in 1870. He moved to Louisiana and resided in New Orleans, where he married and started a family. They moved to New York in 1888, settled in Saratoga Springs, and Moore went to work as a liveryman. He lived until 1904, dying of heart disease at age fifty-six. His wife, Ardele, and five children, four boys and a girl, survived him.[160]

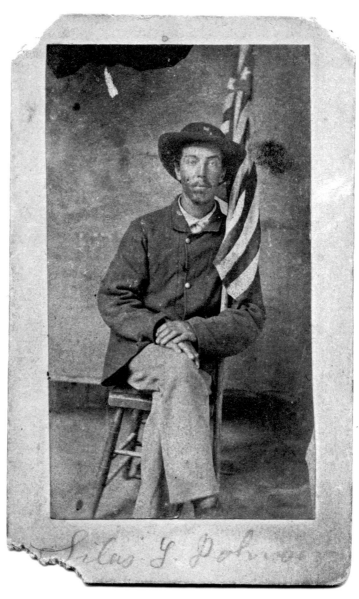

Sgt. Silas L. Johnson, Company I, Ninety-sixth U.S. Colored
Infantry

Carte de visite by unidentified photographer, about 1864. Collection of Ronn
Palm.

Vicksburg Refugee

THE FALL OF VICKSBURG SENT SHOCK WAVES RIPPLING across the Mississippi Delta in July 1863. Panic and fear gripped the region in the wake of the surrender of the gray army garrison. The news spread quickly from plantation to plantation. A significant part of the civilian population fled the area to avoid the Yankee juggernaut.

Among the many who left was Silas Brown. Born a slave in Warren County, Mississippi, he labored at Alterra, a prosperous plantation that belonged to the Brown family. Louisiana ("Lou" or "Lulu") Brown[161] was managing the home, land, and about forty-three slaves, including Silas,[162] in the absence of her New York–born physician husband, Cyrus, an officer in the Eighteenth Mississippi Infantry.[163] As she faced the threat of invasion, he was in Pennsylvania tending Confederate wounded after the Battle of Gettysburg.

Capt. Brown, having remained with those too badly injured to be moved, fell into Union hands.[164] Evidence suggests that Lou Brown hastily packed up and left Alterra accompanied by Silas and other slaves. Like many displaced persons in the Delta, they headed east and became refugees in Alabama. They remained there for the better part of a year.[165]

In the summer of 1864, during the return trip to Alterra, Silas had gotten as far as Canton, Mississippi, when he decided it was time to join the Union army. In August, he mustered into Company I of the Ninety-sixth U.S. Colored Infantry. About this time he sat for his *carte de visite* portrait wearing a hat adorned with a pin in the shape of the army engineers—emblematic of the regiment's organization a year earlier at New Orleans as the

Second Corps d'Afrique Engineers. Its designation had been changed to the Ninety-sixth a few months before he enlisted.

Silas soon advanced to sergeant.[166] He served with his regiment at various points in the Gulf region, including the successful campaign that ended with the capture of Mobile in April 1865. He mustered out of the army with his comrades in January 1866.

Silas returned to Mississippi and went to work for his former owners, Lou and Cyrus Brown, at Alterra. He earned a portion of the corn and cotton harvest and other considerations for his labors.[167] He changed his last name from Brown to Johnson. The change suggests that Silas or his father was once the property of a master named Johnson. Like many freedmen, he adopted the earlier surname. In 1872 he married Tibby Mack. She, like Silas, had once been a slave at Alterra.[168]

In the late 1880s, an illness left Silas partially paralyzed on his right side. He relied on Tibby for almost total support until he died in 1894 at about age fifty-eight.[169]

The Descent on James Island

ON JULY 10, 1863, ALONG THE SOUTH CAROLINA COAST in the vicinity of Confederate-controlled Charleston, a Union brigade supported by ironclad gunboats and heavy artillery batteries landed on James Island. The federal force captured a portion of the strategically important island after a fierce fight.

The next day, more Union troops arrived to exploit the newly gained ground. The reinforcements included the Fifty-fourth Massachusetts Infantry. One of its officers recalled the event: "The regiment landed, marched about a mile, and camped in open ground on the furrows of an old field. The woods near by furnished material for brush shelters as a protection against the July sun."[170]

Among the soldiers who busied themselves about the camp was Abraham Brown, a sailor born in Toronto, Canada.[171] Details of his early life are not known. It is probable that his parents were escaped slaves, who, like other African American men, women, and children, fled to freedom in the North along the Underground Railroad and settled in the British-owned colonies.

At some point after the war started, he crossed over to American soil. He enlisted in the Fifty-fourth in April 1863 and joined the ranks of Company E as a private. He and the rest of the regiment left for duty in the South the following month.

As Brown and his comrades settled into their James Island camp that day, word arrived that Brig. Gen. George Strong[172] and his brigade had crossed over to neighboring Morris Island and assaulted Fort Wagner that morning. This was the same brigade that had successfully captured part of James Island the previous day. But this time, Strong and his men failed. They were unable

to take the formidable fort, despite a gallant effort by four companies of the Seventh Connecticut Infantry, who had made it to the parapet before being driven back by stubborn Confederates.[173]

The Fifty-fourth would lead a second assault on Fort Wagner the following week. Pvt. Brown would not be there. At some point during that first day in camp, while cleaning a pistol, he accidentally discharged the weapon and mortally wounded himself. He died the next day. He was about twenty years old.[174]

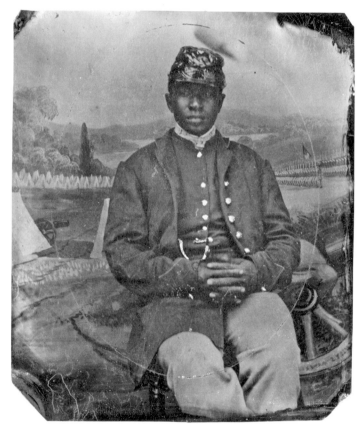

Pvt. Abraham F. Brown, Company E, Fifty-fourth Massachusetts Infantry

Tintype by unidentified photographer, about 1863. Collection of the Massachusetts Historical Society.

"The Original Drummer Boy"

Col. Robert Gould Shaw of the Fifty-fourth Massachusetts Infantry reportedly called Alex Johnson "the original drummer boy."[175] Many others recognized the sixteen-year-old from Company C as the first black musician to enlist in the army during the war. Technically, Johnson was not the first; at least three others joined the regiment before he did.[176] However, no one challenged his place as "the original."

Alex's passion for percussion was rooted in his youth in New Bedford, Massachusetts. According to a newspaper report, he "beat a drum every day he has been able since childhood." Born Alexander Howard, his ancestry may have included African, Hawaiian, and Narragansett Indian blood. At some point before his fifth birthday, some unknown event or events resulted in separation from his parents and his adoption by a local man of color, William Henry Johnson. Mr. Johnson, who had escaped bondage in Virginia and fled to New Bedford, became an antislavery lecturer and one of the earliest—possibly the first—African American attorney in the nation.[177]

Alex left Johnson's home and enlisted in the Fifty-fourth on March 2, 1863. Years after the war, he recalled the regiment's first action, on July 16, 1863, a skirmish on James Island, along the South Carolina coast near Charleston. He noted: "We succeeded in driving the enemy back. After the battle we got a paper saying that if Fort Wagner was charged within a week it would be taken."[178]

Two days later the Fifty-fourth marched on the fort: "Most of the way we were singing, Col. Shaw and I marching at the head of the regiment. It was getting dark when we crossed the bridge to Morris Island" (on which Wagner stood). "Col. Shaw ordered

me to take a message back to the quartermaster at the wharf, who had charge of the commissary. I took the letter by the first boat, as ordered, and when I returned I found the regiment lying down, waiting for orders to charge."[179]

Johnson recounted, "Before he gave that order, Col. Shaw asked the boys if they would stand by him. 'We will, father!' they

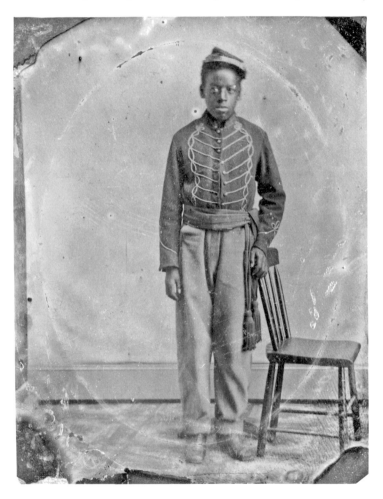

Musician Alexander Howard Johnson, Company C, Fifty-fourth Massachusetts Infantry

Tintype by unidentified photographer, about 1863. Collection of the Massachusetts Historical Society.

yelled. They always called him father. He then gave the order to rise and charge bayonets, at a double quick." The assault failed. "We lost our good colonel."[180]

Johnson mustered out of the army with his comrades in August 1865 and returned to New Bedford. He spent two years as a drummer on a revenue cutter and two more employed by a steamship company. In 1869 he settled in Worcester and married. His wife, Mary Ann, gave birth to seventeen children, of which seven were stillborn.[181]

Johnson always maintained his love of drumming. "He is probably one of the best drummers in Massachusetts, and boasts that there is hardly a drummer who marches the streets of Worcester who has not received instruction from him," according to a newspaper interview. He organized "Johnson's Drum Corps" and led the band as drum major. He called himself "The Major."[182]

The bronze relief memorial to the Fifty-fourth located across from the Massachusetts State House, unveiled in 1897, depicts Col. Shaw and his men leaving Boston for the South with a young drummer in the lead—a scene reminiscent of the July day in 1863 when Shaw and Johnson marched at the head of the Fifty-fourth to its destiny at Fort Wagner. Johnson pointed out the figure to friends during a Grand Army of the Republic event in 1904. All agreed the resemblance to him was very noticeable. This is only a coincidence, as sculptor Augustus Saint-Gaudens based the figures of the enlisted men on hired models.

The drum carried by Johnson at Wagner remained in his possession as late as 1907,[183] and there is no reason to doubt he still owned it upon his death in 1930 at eighty-three.

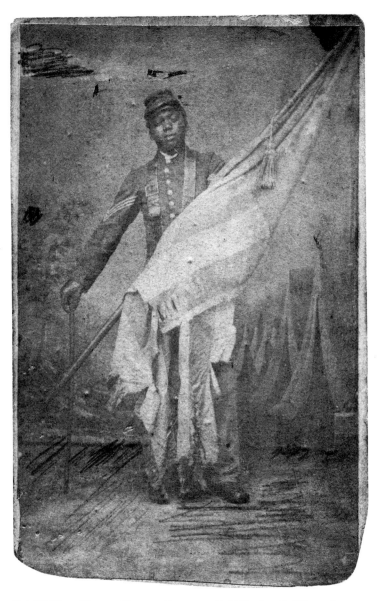

Sgt. William Harvey Carney, Company C, Fifty-fourth Massachu-
setts Infantry

Carte de visite by unidentified photographer, about 1863–1865. West Virginia
and Regional History Collection, West Virginia University Libraries.

The Messenger

As DARKNESS DESCENDED ACROSS COASTAL SOUTH CARolina on the evening of July 18, 1863, infantrymen from the Fifty-fourth Massachusetts advanced across a beach towards the battery known as Fort Wagner. At a place where a marsh jutted into the dunes near the ocean, soldiers pushed through a narrow strip of sand and marched towards waiting Confederates. About this time, the Fifty-fourth's color sergeant dropped the regiment's national flag.

Sgt. William Carney of Company C found it.[184] "As quick as a thought I threw away my gun, seized the colors and made my way to the head of the column," joining Col. Robert Shaw in the vanguard of the assault.[185] Night had by now fallen, and Wagner erupted in a "mound of fire," noted the regimental historian, who described the scene. "A sheet of flame, followed by a running fire, like electric sparks, swept along the parapet" from Confederate cannon and muskets. Shaw with sword in hand, Carney with the flag in his, and others struggled up the ramparts towards the parapet.[186]

Then Shaw fell dead with multiple wounds.

Carney continued to climb the ramparts. "All around me were the dead and wounded, lying one upon top the other," he later recalled. He made it to the parapet. "It seemed a miracle that I should have been spared in that awful slaughter. When I recovered from my semi stupor, on account of the scenes of blood about me, I found myself standing on the top of the embankment, all alone. It were folly for me to try to advance, so I dropped on my knees among my dead comrades, and I laid as low and quiet as possible."[187]

He gripped the Stars and Stripes in his right hand and planted the hilt of the staff in the ground as musket bullets and canister shot plowed into the earth and sprayed sand into the air. "I was almost blinded by the dirt flying around me and nearly distracted by the shrieks and groans of the wounded and dying men about me. As soon as I could distinguish anything in the darkness, I could see dimly on one side a line of men mounting the ramparts and going down into the fort. I thought they must be our own men, but in the light of a cannon flash I saw they were the enemy."[188]

He realized at this point that the assault had failed. "I looked about for a chance to retreat under cover. I wrapped the precious colors about the staff and cautiously picked my way among the dead and dying." Near the outer perimeter of the fort he jumped into a rifle pit and landed hard against a wooden support. The fall injured his breastbone and left a bruise as big as his outstretched hand.[189] About this time a bullet ripped into his left hip and fractured the thighbone. He fell to the ground. "I still had the power to crawl and did so."[190]

He soon encountered a white soldier from the 100th New York Infantry, another regiment involved in the assault. That man gave Carney a drink of water and offered to carry the banner. "No, sir," Carney replied. "No man gets these colors unless he is a Fifty-fourth Massachusetts man." The New Yorker helped him up. Moments later Carney crumpled to the ground after a canister shot struck him along the top of the head. The soldier again helped Carney to his feet and they continued a short distance. Then the New Yorker fell. Others came to their aid. Carney never saw the man again, and did not get his name.[191]

Other soldiers led Carney to a group of twenty-five to thirty survivors from the Fifty-fourth. "When I reached these men they cheered me and the flag, and my reply was 'Boys, the old flag never touched the ground.'" He delivered the colors to the lone officer present.[192]

Medical personnel transported Carney to a military hospital in nearby Beaufort. He returned to the Fifty-fourth about five

months later, but the injuries ended his combat service and he left the army with a disability discharge in June 1864.[193]

Carney returned to New Bedford, Massachusetts, where he had settled before the war after his escape from slavery in Norfolk, Virginia. He married in late 1865. In New Bedford, he worked for a merchant and as superintendent of streetlights, then he and his wife moved to California and he took a job with a real estate company. They returned to New Bedford in 1869 and he became a letter carrier. He was a familiar figure about town, clad in his postman's uniform, noticeably lame from the bullet that remained embedded in his hip.[194]

The eight words he spoke on that summer night in 1863 after he safely brought back the Fifty-fourth's flag made him a living icon. He would tell the story of how he came to say them at army reunions and other memorial events, and to his comrades in the Grand Army of the Republic, a society of Union veterans. Carney was a founding member of the Robert G. Shaw Post in New Bedford.[195]

One newspaper described him in these eight words: "The bravest colored soldier of the Civil War."[196] Another newspaper placed him in context in American history when it listed him alongside Crispus Attucks, martyred at the Boston Massacre in 1770.[197] Carney's story inspired song, sculpture, prints, and paintings. His quote turned up in at least one schoolbook.[198]

His actions also led to his receiving the nation's highest military honor. In preparation for the Paris Exhibition of 1900, organizers planned a display of photographs of African American Medal of Honor recipients. A researcher, discovering to his surprise that Carney had never received one, filed the necessary documents. On May 23, 1900, the government awarded Carney the medal.[199]

The following year he retired from the Post Office and accepted a position as messenger at the State House in Boston. He delivered documents to government officials.

In a sense, Carney's career as a messenger began at Wagner. His actions there sent a powerful message to all Americans—

that black men could fight on par with and possessed moral courage equal to the bravest white soldier. He shattered myths and racial stereotypes deeply rooted in more than two centuries of slave culture.

Carney lived until age sixty-eight, dying in 1908 after an elevator accident mangled the leg injured at Wagner. His wife, Susanna, and daughter Clara survived him. Millions mourned his passing.

On the Front Lines in the Fight
for Equality

DURING THE JULY 18, 1863, EVENING ASSAULT ON FORT Wagner, Confederate artillery fire took a frightful toll on the ranks of the Fifty-fourth Massachusetts Infantry, massed at the base of the parapet, while the sounds of exploding shells and hissing lead fragments mingled with the screams and shouts of men. Above the din, the powerful voice of the regiment's sergeant major, Lewis Douglass, urged the men forward.[200]

"Come on boys," Douglass bellowed, "we are on review today before Governor Andrew."[201] His reference to the state executive who authorized the regiment drew cheers from the men as they rallied and stormed the fortification. Douglass might have summoned another name to inspire the troops—his father, Frederick Douglass.

The elder Douglass played an important role in the formation of the Fifty-fourth, with the publication of "Men of Color, to Arms!" a few months before the battle at Fort Wagner. "Massachusetts now welcomes you to arms as her soldiers," Frederick Douglass announced. "She has but a small colored population from which to recruit. She has full leave of the General Government to send one regiment to the war, and she has undertaken to do it. Go quickly and help fill up this first colored regiment from the north."[202]

African Americans across the country responded to Douglass's call, including his oldest son, Lewis.[203] Many considered him the ablest of the orator's five children. Born two years after his father escaped bondage in Maryland, Lewis, even as a boy, helped runaway slaves who stopped at the Douglass home en route to freedom on the Underground Railroad. During his teen

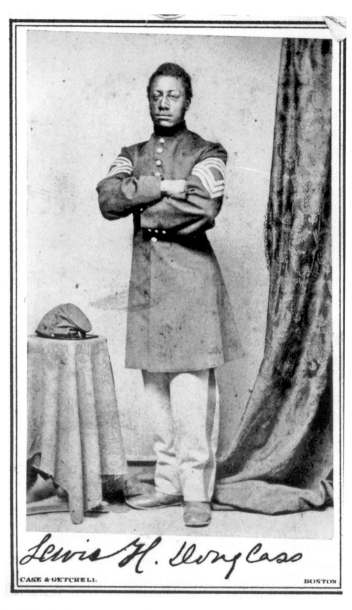

Sgt. Maj. Lewis Henry Douglass, Fifty-fourth Massachusetts Infantry

Carte de visite by John G. T. Case (b. ca. 1818) & William H. Getchell (1829–1910) of Boston, Massachusetts, about 1863–1864. Collection of Moorland-Spingarn Research Center, Howard University.

years, he worked his way to foreman in his father's print shop in Rochester, New York.[204]

In late 1862, he signed on to an expedition destined for Central America to establish a colony of colored people from the United States. His plans changed, however, after President Lincoln announced the Emancipation Proclamation on January 1, 1863, and Gov. John Andrew that same month announced the formation of a black regiment.[205]

As the Fifty-fourth's sergeant major, Douglass held the highest rank at which a black man could serve at the time. He earned respect as a calm, courageous leader.[206] These traits served him well as he and his troops scaled Wagner's walls under heavy fire.

"I had my sword sheath blown away while on the parapet of the Fort," he wrote in a letter to his parents. "The grape and canister, shell and minnies[207] swept us down like chaff, still our men went on and on, and if we had been properly supported we would have held the Fort, but the White troops could not be made to come up. The consequence was we had to fall back, dodging shells and other missiles." In another letter he confessed, "How I got out of the fight alive I cannot tell, but I am here."[208]

Frederick Douglass put the actions of the Fifty-fourth into context: "After that assault we heard no more of sending negroes to garrison forts and arsenals, to fight miasma, yellow fever, and small-pox. Talk of his ability to meet the foe in the open field, and of his equal fitness with the white man to stop a bullet, then began to prevail."[209]

Less than two months after Wagner, Sgt. Maj. Douglass's military service all but ended after doctors diagnosed him with cachexia, or a weakened condition of the body, complicated by diarrhea and a spontaneous gangrenous infection on his scrotum, apparently nonsexual in character. He remained on the regiment's rolls until he received a medical discharge in May 1864.[210]

Douglass returned home to recuperate. He joined the Freedman's Bureau as a teacher and moved to Maryland in the sum-

mer of 1865. "By a singular coincidence, he is teaching in the same neighborhood where his father was brought up," noted a newspaper report. His students included slaves whom his father had secretly taught to read some thirty years earlier. He refreshed and improved their reading skills. He also educated their children and grandchildren.[211]

In early 1866 he and his father were part of a delegation that confronted President Andrew Johnson at the White House about the Black Codes, a series of laws passed by the governments of Southern states that limited the rights of freed African Americans.

Douglass moved to the Colorado Territory that same year. He worked as a typesetter for a Denver newspaper and as secretary of the Red, White and Blue Mining and Reducing Company, formed by freedmen to process silver ore found in the Rocky Mountains.[212]

He returned east in 1867, settled in Washington, D.C., and became a typesetter at the Government Printing Office. Two years later he applied to join the local chapter of the National Typographical Union. A small, determined group of the union's white membership mired the nomination in bureaucracy, amidst charges of racism. His case, a microcosm of socioeconomic discrimination, made headlines in newspapers across the nation.

"There is no disguising the fact—his crime was his color," stated his father.[213]

According to a report in the *Washington Bee*, President Ulysses S. Grant reportedly visited Douglass at the GPO. Grant "urged him to 'stick,' and he did stick; the 'union' for its own safety being obliged to open its doors to colored membership, though Douglass was made the target for the bitterest and most cowardly kind of intimidation. Threats of death, cross bones and skulls, and every other means to force him out were employed, but he would not surrender. Thus he opened the way for many others of his race who have since found employment there."[214]

Lewis Douglass continued the struggle for equality in the nation's capital in a variety of jobs. As editor of the short-lived

newspaper *New National Era,* he railed against racism. As a District of Columbia assemblyman, he introduced a bill that ordered restaurants, ice cream parlors, and soda fountains to post "in a conspicuous place the price list of the articles they have for sale" to prevent overcharging persons of color, a tactic used by white establishments to keep blacks away.[215]

Lewis Douglass also served as an aide to and representative for his father, who died in 1895.

A stroke in 1904 marked the beginning of Lewis's decline. He died four years later at age sixty-seven. His wife of thirty-eight years, Amelia, survived him. Although a lover of children, he had none of his own.[216]

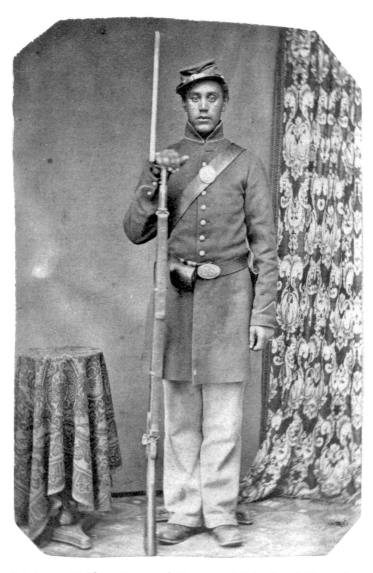

Pvt. James Matthew Townsend, Company I, Fifty-fourth Massachusetts Infantry

Carte de visite by unidentified photographer, about 1864–1865. Collection of Greg French.

"Look for Me Well Up in the Line
of Battle"

CORP. JAMES "JIMMY" TOWNSEND[217] STRUGGLED TO THE top of the parapet of Fort Wagner with his comrades from the Fifty-fourth Massachusetts Infantry and battled Confederate foes for possession of the defensive work. "Numbers, however, soon told against the Fifty-fourth, for it was tens against hundreds," related an officer in the regiment.[218] At some point during the evening assault, Townsend stumbled in the darkness and fell hard into a rifle pit near the parapet. He got up and continued fighting until forced back.[219]

Townsend's courage under fire did not surprise tentmate Albanus Fisher,[220] who respected him for his "valor gentility and manley deportment, an obedient soldier, ready and willing for duty when ordered." Credit for Townsend's character is due in part to his mother and father, who provided him with "the most careful, religious and moral training," noted one writer.[221]

His parents, William and Mary, had fled their home state of Virginia[222] and settled in Gallipolis, Ohio. James, their only son, was born free there about 1842. He moved with his folks to Oxford, Ohio, where, at twelve years old, he professed religion and joined the African Methodist Episcopal Church. In 1859, at about age eighteen, he became a preacher.[223]

"At the beginning of the rebellion he had a strong conviction that the war would result in the emancipation of his race," explained a biographer, and he "therefore sought the earliest opportunity to take up arms in defense of the Union and Freedom."[224] He took that earliest chance, traveling to Massachusetts to enlist in the Fifty-fourth in April 1863. He joined Company I as a private and soon advanced to corporal. He served at that

rank in the assault on Fort Wagner on the South Carolina coast on July 18, 1863.

Townsend made it safely back after the failed charge, but the fall strained his abdominal muscles and left him with a serious hernia. He remained confined to his tent laid flat on his back for some days, until a doctor fitted him with a truss. The injury ended his combat role. He reverted to private and served the rest of his enlistment on duty at the regimental hospital. He mustered out of the army with his comrades in August 1865.

Townsend returned to Ohio and decided to go to school. "I was a poor untaught uneducated wood-sawer, a poor boy with patches on the knee and a brown straw hat," he later recalled. "In that condition, I was preparing to go to college with $22.50 in my pocket with which to pay current expenses of a college student for one year."[225] He attended Oberlin and stayed two years, then moved to Indiana to serve a yearlong stint as principal of the colored schools in Evansville.[226]

In 1871 he married Cornelia Ann Settle. That same year he was ordained a deacon and went on to hold pastorates in several Indiana cities.

Townsend also served at the national level of the church. He traveled across the United States and abroad and became well known as a champion of African American rights. "Above all else," he explained, "I have endeavored to look to that which was for the best interest of my people; best for their religion, best for their development, best for their enlightenment."[227]

Indiana voters sent him to the General Assembly in 1885—the second African American in the state to be so elected.[228] During his first week as a representative, he introduced a bill to abolish racial distinctions in state laws. It failed, but his strong voice for equality resulted in a bill that banned discrimination in public places. It passed.[229]

Townsend helped mobilize black Republican voters in the 1888 presidential election that sent former Civil War general Benjamin Harrison to the White House.[230] Harrison named Townsend to be recorder of the General Land Office in Wash-

ington, D.C., in recognition of his efforts. After Harrison's secretary of the treasury died in early 1891, an editorial in *The Boston Courant* urged the president to appoint a man of color to the post and suggested several qualified candidates, including Townsend and Frederick Douglass. The position went to a white man.[231]

Later that year, Townsend left politics and Washington. In his farewell speech, he said, "Wherever I shall be, look for me well up in the line of battle, where the fight is up and where the smoke is ascending and the hurry and clash of arms are heard. Look for me there." His words illustrated his commitment to being a leader in the ongoing fight for equal rights. They also described his actions on the July day in 1863 at Fort Wagner when he and his comrades proved beyond a doubt that black men would fight for freedom.[232]

Townsend returned to Indiana and church service. He lived until age seventy-one, dying in 1913 of prostate problems and kidney failure. His wife and a daughter survived him.

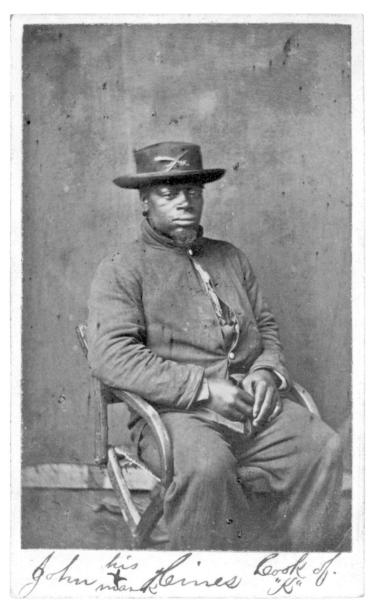

Under Cook John Hines, Company K, Fifteenth Pennsylvania
Infantry

Carte de visite by unidentified photographer, about 1863–1865. Collection of
Sam Small.

Injured at Chickamauga

JACK HINES HAD LITTLE REASON TO BE CONCERNED FOR his personal safety. Detailed as one of the under cooks responsible for feeding three companies of Union cavalrymen assigned to the headquarters of Maj. Gen. William S. Rosecrans,[233] Hines's duties kept him off the front lines. All that changed in September 1863 at the Battle of Chickamauga, where federal forces suffered a major loss. During the chaos of the two-day engagement, probably towards the end of the fighting, when Rosecrans's Army of the Cumberland was retreating in great confusion, Hines lost control of his horse. The frightened animal ran away with its rider. Hines held on as best he could but finally fell heavily to the ground, injuring his left hip.[234] He managed to get on his feet and limp away with the defeated companies and the rest of the army to Chattanooga, Tennessee. He had been a soldier for a few months before his injury.

Born in Bowling Green, Kentucky, Hines was one of about seven slaves owned by farmer Rix Hines.[235] His given name was John, but most folks knew him as Jack. He stood less than five feet in height. "We always called him Stumpy," recalled the daughter of the man who owned Hines. She explained: "He was very black, and had kinky hair. He had quite a long body. His legs in proportion to his height seemed to be shorter than his body."[236] Another of the master's relatives described him as "a very low chunky fellow."[237]

When Union troops arrived in the vicinity of the Hines farm in early 1863, Jack left his wife, Adeline, and three young sons and fled to the federals. His master caught Hines and brought him home. Soon afterward, he escaped again. This time he made it to the camp of the Fifteenth Pennsylvania Cavalry.[238]

Predictably, the soldiers commented on his small size. However, they also noted his big personality. "Jack was a good-natured, hard-working, faithful fellow," wrote an officer.[239] On April 16, 1863, the regiment's colonel, William Palmer,[240] enlisted Hines as one of two under cooks for Company K. Palmer cited a recent general order from the War Department in Washington, D.C., that authorized the enlistment of two under cooks of African descent to assist each white company cook.[241]

Regimental staff did not officially muster Hines into the Fifteenth until October 1863, about a month after he hurt his hip at Chickamauga. He eventually recovered from his injury, although it pained him in damp weather for the rest of his life.[242]

Hines became a familiar figure in Company K. He walked around camp dressed in uniform with a Navy Colt revolver tucked into his waist belt. His equipment consisted of eight or nine big kettles. "I used to cook beans and rice and potatoes and pork for the men. We served it in tin pans. We ground a bushel of coffee for one hundred men. That made a big spoonful to each man," recalled Hines. "When the meals were ready I called 'Grub pile! Grub pile!' And the men came up and got their grub and carried it off." Hines prepared food for Company K until July 1865, when the Fifteenth mustered out of the army.

He returned to Bowling Green to reunite with Adeline and his boys. He arrived home to find that she had given birth to a half-white child. A distraught Hines left his family and fled about 150 miles to McKenzie, Tennessee. Anyone who asked him about his past was led to believe that he had a wife who died or from whom he had become separated due to the war. One person who knew the truth was his second spouse, Jane. They married in 1869 and became the parents of two daughters. They later settled in nearby Martin.[243]

Hines labored on a farm, in a hotel, as a poultry dresser, and at other jobs to make ends meet. For a time he became a migrant railroad worker. In the late 1880s, while working on the Wabash Railroad in Illinois, a crosstie or rail crushed his left big toe and it had to be amputated. Several years later he filed for an

army pension. The government approved his claim. He received payments until his death from pneumonia in 1902 at about age seventy-seven.[244]

Hines "always had the reputation of being honest and reliable," remembered one of Martin's leading citizens.[245]

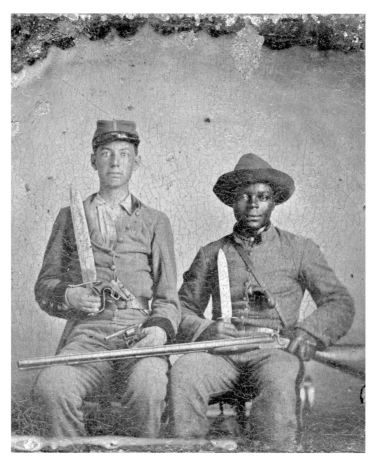

Silas Chandler (*right*) and Sgt. Andrew Martin Chandler, Company F, Forty-fourth Mississippi Infantry

Tintype by unidentified photographer, about 1861. Collection of Andrew Chandler Battaile.

He Aided His Wounded Master

On September 20, 1863, during the thick of the fight at the Battle of Chickamauga, a Union musket ball tore into the right ankle and leg of Confederate Sgt. Andrew Chandler.[246] A surgeon examined the nineteen-year-old Mississippian as he lay on the battlefield, determined the wound serious, and sent him to a nearby hospital.[247]

Soon afterward, the injured sergeant was joined by Silas, a family slave seven years his senior. Silas attended his young master as a body servant—one of thousands of slaves who served in this capacity during the war.

According to family history, surgeons decided to amputate the leg. Silas stepped in. A descendant explained: "Silas distrusted Army surgeons. Somehow he managed to hoist his master into a convenient boxcar." They rode by rail to Atlanta, where Silas sent a request for help to Andrew's relatives. An uncle came and brought both men home to Mississippi, where they had started out two summers earlier.[248]

Back in July 1861, Andrew had enlisted in a local military company, the Palo Alto Confederates. It later became part of the Forty-fourth Mississippi Infantry. He left home with Silas, one of about thirty-six slaves owned by his widowed mother Louisa.[249]

Born in bondage on the Chandler plantation in Virginia, Silas moved with the family to Mississippi at about age two. He grew up to become a talented carpenter. The pennies he earned doing woodworking for people outside the family were saved in a jar hidden in a barn, according to his descendants. About 1860, he wed Lucy Garvin in a slave marriage not recognized by law at the time.[250] A light-skinned woman classified as an oc-

toroon, or one-eighth black, Lucy was the illegitimate daughter of a mulatto house slave named Polly and an unnamed plantation owner. Some said Cherokee Indian blood coursed through Lucy's veins.[251]

The following year, Silas bid his wife farewell and went to war with Andrew. Silas shuttled back and forth from home to encampment with much-needed supplies, delivering them to Andrew wherever he was as the Forty-fourth moved through Mississippi, Kentucky, and Tennessee.[252] It is probable that it was Silas who brought word home to the Chandlers when Andrew fell into Union hands at the Battle of Shiloh in April 1862 and wound up in the prisoner of war camp at Camp Chase, Ohio. Andrew received a parole five months later and, after being exchanged, returned to his regiment.[253]

In 1863 at Chickamauga, three of every ten men of the Forty-fourth who went into battle became casualties, including Andrew.[254] Thanks to Silas, he avoided an amputation. According to one of Andrew's grandsons, "A home town doctor prescribed less drastic measures and Mr. Chandler's leg was saved."[255]

Andrew "was able to do Silas a service as well," according to the family. During one military campaign, Silas "constructed a shelter for himself from a pile of lumber, the story goes. A number of calloused Confederate soldiers attempted to take Silas' shelter away from him, and when he resisted threatened to take his life. At this point Mr. Chandler and his comrade Cal Weaver, came to Silas' defense and threatened the marauders with the same kind of treatment they had offered Silas. This closed the argument."[256]

Silas left Andrew to serve another member of the Chandler family—Andrew's younger brother Benjamin, a private in the Ninth Mississippi Cavalry. The switch may have happened at Benjamin's enlistment in January 1864. At the time, Andrew was absent from his regiment, likely at home recuperating from his Chickamauga wound.

Benjamin and his fellow horse soldiers went up against

Union Maj. Gen. William T. Sherman's army group in Georgia and the Carolinas. A portion of the Ninth, including Benjamin, as their final assignment, formed part of a large escort for Jefferson Davis when the Confederate president fled Virginia after Richmond fell. On May 4, 1865, near Washington, Georgia, Davis separated from his escort and rode off with a much smaller force in an effort to move faster and attract less notice as federal patrols infiltrated the area. Benjamin was among those who were left behind. Benjamin surrendered on May 10. Silas was also there. Union troops captured President Davis at nearby Irwinsville, Georgia, the same day.[257]

Silas returned to Mississippi, rejoined Lucy, and met his son William, who had been conceived while Silas was home after Andrew's capture at Shiloh and was born in early 1863. Silas and Lucy had a total of twelve children, five of whom lived to maturity.[258]

Silas established himself as a talented carpenter in the town of West Point, Mississippi. He taught the trade to his sons—there were at least four—and all of them worked together. "They built some of the finest houses in West Point," noted a family member, who added that Silas and his boys constructed "houses, churches, banks and other buildings throughout the state."[259]

In 1868, Silas and other former slaves erected a simple altar at which to celebrate their Baptist faith, near a cluster of bushes on land adjacent to property owned by Andrew and his family. They later replaced it with a wood-frame church. In 1896, Silas's son William helped to build a new structure on the same site.[260]

Silas remained active as a Baptist and also as a Mason. He lived within a few miles of Andrew and Benjamin, who raised families and prospered as farmers.

Benjamin died in 1909. Silas died ten years later at age eighty-two in September 1919. Andrew survived Silas by only eight months; he died in May 1920.

In 1994, the Sons of Confederate Veterans and the United Daughters of the Confederacy conducted a ceremony at the

gravesite of Silas in recognition of his Civil War service. An iron cross and flag were placed next to his monument. This event prompted mixed reactions from Chandlers, black and white.

Myra Chandler Sampson wrote of her great-grandfather Silas: "He was taken into a war for a cause he didn't believe in. He was dressed up like a Confederate soldier for reasons that may never be known." She denounced the ceremony as "an attempt to rewrite and sugar-coat the shameful truth about parts of our American history."[261]

Andrew Chandler Battaile, great-grandson of Andrew, met Myra's brother Bobbie Chandler at the ceremony. He said of the experience, "It was truly as if we had been reunited with a missing part of our family."[262]

Bobbie Chandler accepts the role of his great-grandfather. When asked about Silas and his connection to the Confederate army, he observed, "History is history. You can't get by it."[263]

Loss of a Faithful Soldier

ALONG THE COAST OF SOUTH CAROLINA AT THE MOR-ris Island camp of the Fifty-fourth Massachusetts Infantry, the sick list grew at an alarming rate in the late summer of 1863. The regimental hospital filled with ailing men, including one of Company E's most faithful soldiers, Sgt. Henry Steward. He suffered chronic diarrhea.[264]

Steward hailed from the Michigan county of Lenawee, a stop along the Underground Railroad located near the border of Michigan and Ohio.[265] Born free in the state about 1840, his parents may have been escaped slaves.

He grew up to be a six-foot-four-inch farmer who lived and worked in the town of Adrian, the county seat.[266] In early 1863, after news spread that Massachusetts needed black volunteers for a new Union regiment, Steward left home to join the army. According to an historian of the Fifty-fourth, he "actively engaged in recruiting the regiment."[267] About sixty-four Michigan residents signed up, including Steward and seven others from Adrian.[268]

His work as a recruiter may have contributed to a promotion to sergeant soon after his enlistment in April 1863. About that time he posed for this portrait photograph, wearing chevrons on his sleeves to indicate his rank.

Three months later, Steward suffered a wound in action during the assault on Fort Wagner. Regimental records do not disclose the nature of his injury. The following month, reports show him absent from duty and sick in his quarters. He may have suffered at this time from the chronic diarrhea that landed him in the hospital.[269]

On September 27, 1863, he succumbed to the disease at about

age twenty-three. His comrades buried him with full honors on Morris Island the next day.

The loss of Steward prompted the staff of the Fifty-fourth to take steps to improve living conditions for the men. According to the regimental historian: "His and other deaths, with an in-

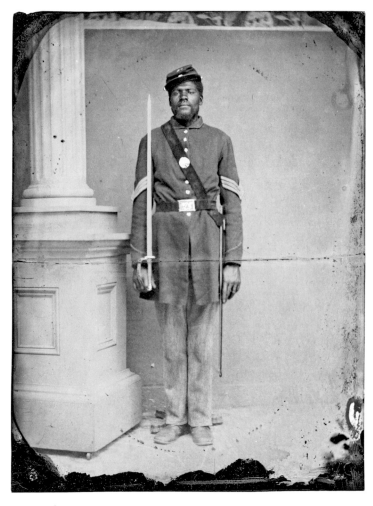

Sgt. Henry F. Steward, Company E, Fifty-fourth Massachusetts Infantry

Ambrotype by unidentified photographer, about 1863. Collection of the Massachusetts Historical Society.

creased sick list, called for sanitary measures about this time. No radical change of camp was possible, as the ground available for such purposes was limited; but tents were struck so that the air and sun could reach the ground beneath, and a daily inspection of company streets, sinks, and the cooked food instituted."[270]

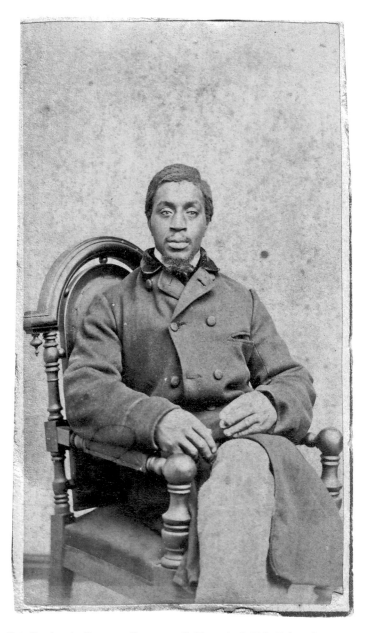

Pvt. Benjamin Benson, Company C, Twentieth U.S. Colored
Infantry

Carte de visite by William G. Grotecloss (d. 1909) of New York, New York,
about 1863. Collection of Donald M. Wisnoski.

In the Ranks of New York City's
First Colored Regiment

A SOLID BLUE WAVE OF A THOUSAND SOLDIERS POURED down Manhattan's Fifth Avenue in perfect military order on the sunny Saturday morning of March 5, 1864. The infantrymen, including Pvt. Ben Benson, marched to the sound of their shoes striking the street and to music provided by a local band as cheering throngs clapped hands and waved handkerchiefs from sidewalks, windows, and piazzas.[271]

The sight of soldiers marching through New York was commonplace by the third year of the war. However, citizens took note of this group, the Twentieth U.S. Colored Infantry, for it had the distinction of being the first black regiment raised in the city.

In a speech delivered during a flag presentation ceremony in Times Square, Columbia College president Dr. Charles King[272] acknowledged the regiment's historic role: "In addition to the appeals suitable to every soldier, lies in a higher and holier sense an appeal as emancipators of your own race, while acting as the defenders and champions of another. You are in arms not for the freedom and laws of the white man alone, but for universal law and universal freedom."[273]

The Twentieth's African American chaplain, George Washington LeVere,[274] wrote, "It seemed that New York, for once, was anxious to acknowledge the manhood of her black sons and to give them such an ovation as their loyalty and bravery entitled them to."[275]

For Benson, the Manhattan march marked the official beginning of army life. Born free in New Jersey, he became orphaned as a child and grew up with white farm families in Hackensack, a few miles west of the Hudson River.[276] He left his job as a la-

borer in December 1863 to join the Twentieth. Organizers assigned him to Company C, and he reported to Riker's Island with other recruits for basic training. The regiment shipped out for Louisiana soon after the Times Square event. It spent the majority of its enlistment on garrison and guard duty in rebellious states along the Gulf Coast and mustered out of the army at Nashville, Tennessee, in October 1865.

Benson returned to New Jersey, married Euphemia Jackson in 1868, and started a family that grew to include eight children. He worked odd jobs to support them. A modest army pension awarded to him by the government in 1891 helped make ends meet.

He lived until 1917, dying of heart disease at eighty-two. His wife and three children, two daughters and a son, survived him. Benson's last pension check paid for his burial.[277]

Townspeople remembered him favorably. One local man wrote of Benson, "He is without education, but has always borne a good reputation."[278]

New Fifer

LOSSES FROM THE ASSAULT ON FORT WAGNER AND OTHER causes depleted the ranks of the Fifty-fourth Massachusetts Infantry, making it difficult to perform basic regimental functions. In late November and early December 1863, help arrived in the form of ninety-five recruits and conscripts fresh from Boston, including John Goosberry.[279]

One of more than twenty Canadian residents who served in the regiment, Goosberry had worked as a sailor in St. Catharines, about fifteen miles west of the New York border and Niagara Falls. Goosberry was born in New Orleans, Louisiana, and details about how he came to be in Canada are not known. He likely escaped slavery via the Underground Railroad.

He enlisted in the Union army at Boston on July 16, 1863, two days before the Fifty-fourth spearheaded the attack on Fort Wagner on Morris Island, South Carolina. Recruiters ordered him and other new men to Long Island, in Boston Harbor, for basic training. There they remained until called up for active duty.

On November 28, 1863, he reported to the regiment in camp on Morris Island. By this time, Fort Wagner had finally fallen into Union hands, after a two-month siege.

Goosberry served as a musician in Company E. He participated in operations in South Carolina, Georgia, and Florida over the next twenty-one months.

He mustered out with his comrades in August 1865 and instead of returning to Canada went back to his birthplace. He became a foreman at the Rost Home Colony, one of four experimental, self-sustained agricultural collectives in Louisiana established by the federal Bureau of Refugees, Freedmen and

Abandoned Lands.[280] Located outside New Orleans, it occupied plantation lands owned by Pierre Rost,[281] who had served as a Confederate representative in Europe and had remained there.

Goosberry lived with his wife and two children at the colony.

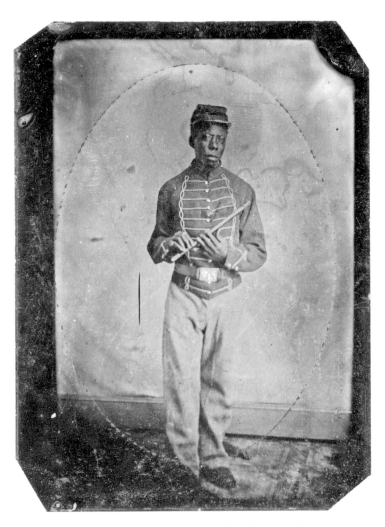

Pvt. John Goosberry, Company E, Fifty-fourth Massachusetts Infantry

Tintype by unidentified photographer, about 1863. Collection of the Massachusetts Historical Society.

The collective disbanded in December 1866 after Rost returned from self-imposed exile in Europe and reclaimed his property. By this time, sickness had decimated the inhabitants of the colony. Evidence suggests that both of Goosberry's children died of disease.

Goosberry relocated to New York State with his wife and planned his next move.[282] In the summer of 1875 he petitioned President Ulysses S. Grant for land in Louisiana. Ten individuals endorsed the document, which described Goosberry's situation: "He is poor & needy is willing to work & lend his assistance in building up the desert places in the South & is anxious to commence operations at once. We therefore pray your Excellency to give him & his beloved spouse a pass from this place to the Government lands in Louisiana where he proposes to devote the remaining years of his life to making the desert bloom like the rose."[283]

He never got the chance. Soon after the petition was sent, he entered a National Home for Disabled Volunteer Soldiers with chronic rheumatism. He died six months later at about age thirty-eight.[284]

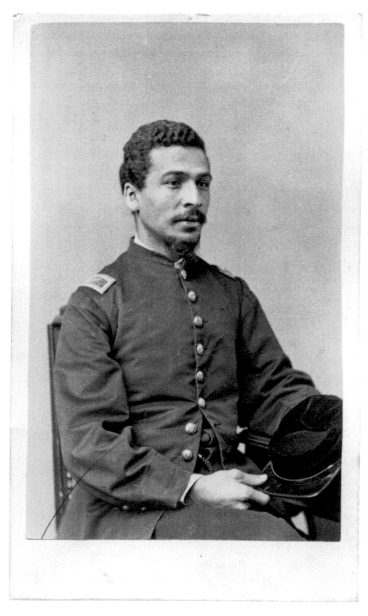

2nd Lt. James Monroe Trotter, Company G, Fifty-fifth Massachu-
setts Infantry

Carte de visite by John Adams Whipple (1822–1891) of Boston, Massachusetts,
about 1865. Collection of Greg French.

"We Will Not Degrade the Name
of an American Soldier"

ON DECEMBER 14, 1863, SGT. MAJ. JAMES TROTTER AND
the rest of the colored Fifty-fifth Massachusetts Infantry as-
sembled for an announcement regarding their pay. The federal
government would not be giving them the promised soldier's
salary of thirteen dollars per month but ten dollars a month,
the amount paid to black freedmen who worked for the army
as laborers and cooks.[285] The state of Massachusetts planned to
make up the balance.

The regimental historian recorded, "Several non-commis-
sioned officers and privates expressed their views and those of
their comrades, in a quiet and proper manner, the remarks of
Sergt.-Major Trotter being especially good." They declared that,
on principle, they would accept no pay unless they were given
the usual soldier's pay.[286] A fellow enlisted man recalled that
Trotter "was the first soldier to step forth and say to the paymas-
ter 'No, sir; we'll never take it. We are soldiers, we will accept
nothing less than the soldier's pay. We are perfectly willing to
take the soldier's fare, but we will not degrade the name of an
American soldier.'"[287]

That Trotter would speak out is no surprise. Throughout his
life, he moved in the vanguard of leaders who struggled to se-
cure liberty for African Americans, unafraid to face off against
the majority and its opinions.[288]

Trotter had known slavery firsthand as a child in Grand Gulf,
Mississippi, where he was born to Richard Trotter,[289] a white
planter, and Letitia, a slave. In 1854, at about age twelve, the
boy left the state. One account claims that he escaped with his
mother and siblings; another declares that Richard Trotter freed

them. Whatever the explanation, they relocated to Cincinnati, Ohio. Trotter attended a school for free blacks[290] and worked in a hotel and on a riverboat. He studied music and art, and became a schoolteacher.[291]

In early 1863, when officials in Massachusetts began to recruit men for the Fifty-fourth Massachusetts Infantry, men of color from across the Union traveled to Boston to sign up. Trotter arrived too late to join the Fifty-fourth and enlisted instead in its brother regiment, the Fifty-fifth.

The rank and file of both regiments deplored the proposition that they would receive inferior pay compared to white soldiers of the same rank. The position taken by Trotter and others, that they would take no money until the government reviewed its policy, had consequences. Their families suffered without their income. Morale in the regiment, which had been high, dropped.

The governor of Massachusetts had also created problems by nominating a select group of black men in both regiments, including Trotter, for officers' commissions. This had opened another debate, as no provision for black officers existed. Approval to muster them bogged down in bureaucracy, and the possibility of black officers stirred racial bias among some of the white officers. Trotter called it "Colorphobia."[292]

The government settled the pay issue in favor of the black troops in the summer of 1864.[293] Trotter was one of the first in the Fifty-fifth to receive his due.[294] He and his comrades had gone ten months without compensation. Trotter later declared "that in their struggle for equal pay and recognition the Massachusetts colored troops finally won for themselves, for all other colored troops, and relatively for their race and its friends, a complete, a glorious victory."[295]

The regiment fought its first battle after settlement of the pay question on November 30, 1864, at Honey Hill, South Carolina. This battle proved that the Fifty-fifth could fight, just as Fort Wagner did for the Fifty-fourth. Like Wagner, Honey Hill was a Union defeat despite the good conduct of the men. Casualties in

the regiment totaled 144, and they included Trotter. He suffered a "slight graze of neck" and another, undisclosed, injury.[296]

The Fifty-fifth remained on duty in South Carolina and Georgia for the rest of the war. Trotter's appointment as an officer became legal in June 1865, two months before the regiment ended its army service.[297]

Trotter settled in Boston and became a post office clerk. In 1868 he married Virginia Isaacs, whom he had met in Ohio before the war. They began a family that included five children, three of whom lived to maturity.

His lifelong interest in the arts culminated in his 1878 book, *Music and Some Highly Musical People*, "a sincere tribute to the winning power, the noble beauty, of music, a contemplation of whose own divine harmony should ever serve to promote harmony between man and man."[298]

Trotter took an active interest in politics. A staunch Republican, he soured on the party after President Rutherford Hayes withdrew the last federal troops from the former Confederate states in 1877. A few years later, he was denied a promotion by a Post Office administration that was dominated by Republicans. He switched to the Democratic Party. "Characteristically independent," noted a biographer, "he was a black Democrat in an age when most Negroes were fervently loyal to the party of Lincoln."[299]

In 1887 he landed a lucrative political appointment as recorder of deeds in Washington, D.C. He replaced Frederick Douglass, the first African American to hold the position. According to one historian, "Trotter's activism among black Democrats won him the Washington appointment despite the objections from Republicans—who hated his politics—and from fellow Democrats—who hated his color."[300]

In 1889, Republican Benjamin Harrison moved into the White House. Democrat Trotter returned to Boston. He died of tuberculosis three years later at age fifty. His wife and children survived him. His son, William Monroe Trotter,[301] became a prominent publisher and political activist.

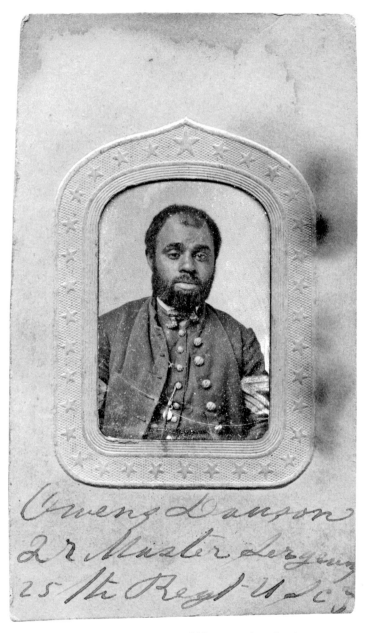

Q.M. Sgt. Owens Dawson, Twenty-fifth U.S. Colored Infantry

Tintype by D. Lothrop (life dates unknown) of Philadelphia, Pennsylvania,
about 1863–1865. Collection of Joyce Werkman.

Trained at Camp William Penn

COLONEL FREDERICK HITCHCOCK[302] OF THE TWENTY-fifth U.S. Colored Infantry brimmed with *esprit de corps* when he described the transformation of his regiment from a collection of raw recruits to a disciplined fighting machine after basic training at Philadelphia's Camp William Penn: "After a proper time had been devoted to its drill, I never for a moment doubted what would be its conduct under fire." He also noted "the soldierly bearing, fidelity to duty, and patriotism of its men."[303]

One of the new soldiers who earned Hitchcock's confidence was Owens Dawson, a free man born in Philadelphia to parents who hailed from Maryland.[304] In December 1863 he left his job as a waiter, said goodbye to his wife Cecilia, and enlisted in Company B of the Twenty-fifth. He started as a sergeant and soon advanced to quartermaster sergeant on the regimental staff.[305]

Dawson became one of more than ten thousand men of African descent in eleven regiments who walked through the main gate of Camp William Penn as civilians and marched out as soldiers. The camp was the first and largest federal facility organized to train black recruits. Strategically located near Philadelphia and the North Pennsylvania Railroad Depot, it included barracks, officers' quarters, stables, and other outbuildings. The property was leased to the government by Edward Davis, the son-in-law of noted women's rights advocate and antislavery activist Lucretia Mott. She lived nearby.[306]

Dawson and his comrades left Camp William Penn for Louisiana in the spring of 1864. They spent the rest of the war first in the defenses of New Orleans and later in Florida as part of the garrison of forts Barrancas and Pickens. The regiment never

faced hostile fire, which Col. Hitchcock regretted: "It would have done its full duty beyond question. An opportunity to prove this the Government never afforded, and the men always felt this a grievance."[307] The regiment mustered out in December 1865.

Dawson returned to Philadelphia then, but he left the city in 1869 after Cecilia died of congestion of the lungs. They had been married for about sixteen years. He moved to Washington, D.C., and landed a job near the White House at the Winder Building, in which were located offices of the U.S. War Department. About this time he began to court Margaret "Maggie" Johnson, a seventeen-year-old born in Fauquier County, Virginia. She was twenty-seven years his junior and had been about six years old at the start of the Civil War. The couple married in 1872 and started a family that grew to include five daughters and a son. All lived in the nation's capital with the exception of a brief time around 1880, when the family relocated to Campbell County, Virginia, where Dawson served as a minister of the gospel. His decision to preach may have been rooted in personal tragedy: of the nineteen children he fathered with his two wives, thirteen died young.[308]

In the spring of 1904, Dawson came down with influenza and succumbed to the disease after two weeks of suffering. He had lived until age seventy-six.[309] His wife and six children survived him, and his comrades in the local Grand Army of the Republic post remembered him devotedly.[310] Family and friends arranged for his body to be buried at Arlington National Cemetery.

A Captain's Valet

A STEADY MIX OF RAIN AND SLEET FELL THROUGHOUT the evening of the last day of 1863 as Capt. Elijah Hogue of the Ninth Ohio Cavalry inspected a picket post that protected Union-occupied Knoxville in East Tennessee. Strong winds and frigid temperatures hampered his efforts. The chilled captain checked the men every hour until relieved. Then, freezing, wet, and exhausted, he collapsed in his tent as others rang in a new year.[311]

He came down with a cold and dragged himself to the quarters of the regiment's doctor. The physician treated him, and he returned to his tent to recuperate. Hogue's valet at the time, John Sample, helped him get back on his feet.

Sample and Hogue had been together only a few months. Both men hailed from Virginia. The captain, born in Loudoun County, had moved to Ohio during his youth. Sample, originally from Fredericksburg, had settled in Henry County, Kentucky, and gone to work as a bartender. The men may have first crossed paths as the captain and his cavalrymen patrolled the Kentucky countryside during the summer of 1863. The captain hired Sample as his personal servant in the fall.

The arrangement ended later that winter, after the captain recovered from his cold.[312] The two men parted ways amicably. Hogue advanced to major of the Ninth and survived the war. Sample went on to become a top-ranked Buffalo Soldier.

Sample joined the army as a substitute for a Henry County farmer who had been drafted.[313] He mustered into the 108th U.S. Colored Infantry as a drummer, advanced to principal musician, and served until the regiment mustered out and disbanded in 1866.

He then moved to Washington, D.C., and became a laborer. In early 1867 he returned to the military with the Fortieth U.S. Infantry, one of four new regular army regiments composed of African American troops and white officers. He spent the next

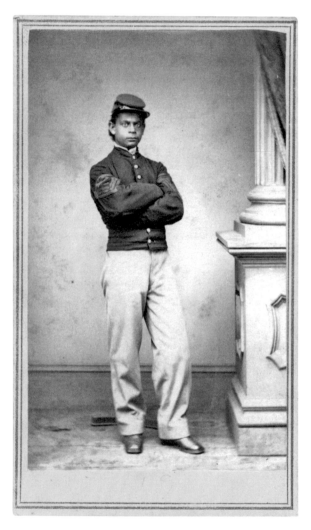

Sgt. Maj. John Sample, Twenty-fourth U.S. Infantry

Carte de visite by Alfred B. Gayford (b. ca. 1828) & Conrad S. Speidel (b. ca. 1827) of Rock Island, Illinois, about March 1865. Collection of the Beinecke Rare Book and Manuscript Library, Yale University.

eighteen years as a Buffalo Soldier, most of the time as a sergeant in Texas and the Dakota Territory. A comrade remembered that Sample usually wore dark glasses due to sensitive eyes.[314]

In 1880, he transferred to the Twenty-fourth U.S. Infantry and ended his career five years later as the regiment's sergeant major—the highest rank that was available to an enlisted man.

Sample returned to the nation's capital and became a waiter at a hotel a few blocks from the White House. His health began to deteriorate in the late 1890s. In 1899 he gained admission to the Soldier's Home, where he died six years later at age sixty-nine. He never married.[315]

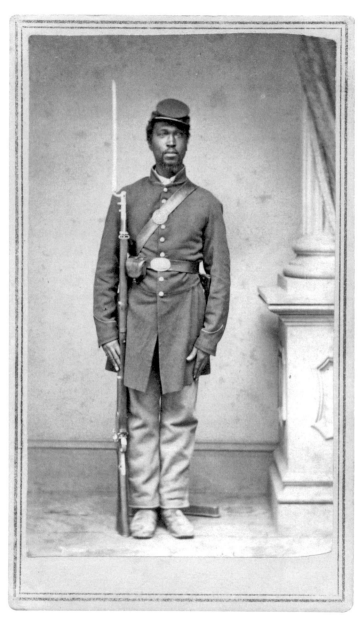

Pvt. Jesse Hopson, Company F, 108th U.S. Colored Infantry

Carte de visite by Alfred B. Gayford (b. ca. 1828) & Conrad S. Speidel (b. ca. 1827) of Rock Island, Illinois, about 1864–1865. Collection of Gettysburg National Military Park Museum.

Escape through the Swamps

ONE DAY DURING THE WAR, AT A PLACE IN WESTERN KEN-tucky where the Cumberland and Tennessee rivers are separated by a narrow strip of land a half-dozen miles wide, a slave named Jesse made his break for freedom. He disappeared into swamplands and likely followed the waterways north and west.[316]

His master soon learned of the escape. Joshua Hopson, a vigorous man in his early fifties who lived with his family on the land between the rivers, in an area known as Golden Pond, owned a 2,500-acre farm on which about thirty men, women, and children in bondage toiled. He took immediate action to retrieve his slave.[317]

Hopson hunted Jesse through the swamps. After a week he gave up the chase and turned back. Meanwhile, Jesse had found a boat and continued his journey. At some point, he made it to Union-occupied Paducah, after a journey of about fifty miles.[318]

On June 21, 1864, he enlisted in the army and reported for duty to Louisville as a private in Company F of the 108th U.S. Colored Infantry, a new regiment composed mostly of escaped and freed slaves. Jesse made a solid soldier, according to one lieutenant. The officer noted that Jesse "performed his duty well" although he was "not very smart."

Over the next twenty-one months, Jesse served a variety of guard and garrison duties, including a stint on patrol at the prisoner of war camp in Rock Island, Illinois, and in Louisiana, where he helped build a telegraph system.[319]

Jesse mustered out with his comrades when the regiment disbanded in March 1866 in Mississippi. He returned to Kentucky, to the area from which he had come, and worked as a day

laborer near Golden Pond, where he might have crossed paths with his former master, who lived until 1877.[320]

Jesse survived his old owner by more than a quarter-century. Upon his death at about age sixty-eight in 1903, he had been suffering from heart disease and rheumatism. A son, Willie, survived him. His wife, Jane, whom he had married in 1870, predeceased him.[321]

The Men Dropped "Like Leaves in Autumn"

In July 1863, the Fifty-fourth Massachusetts Infantry proved that men of color could fight on par with white troops, after an assault on Fort Wagner, South Carolina, that cost the lives of many soldiers and its young colonel, Robert Gould Shaw. Seven months later, in an eerily similar event, another African American regiment provided further proof that they were equal to any troops in battle.

On February 20, 1864, Col. Charles Wesley Fribley[322] led the Eighth U.S. Colored Infantry into action at Florida's bloodiest battle, in Olustee. It suffered one of the highest casualty rates of any regiment in any battle during the war. More than half of the men and officers, 303 of 565 engaged, were listed as killed, wounded, or captured, including Corp. John Peck.[323]

The slaughter started soon after the rookie regiment arrived on the scene of its first fight, in pinewoods dotted with shallow swamps sixty miles west of Jacksonville, Florida. "We were double-quicked for half a mile, came under fire by the flank, formed line with empty pieces under fire, and, before the men had loaded, many of them were shot down," remembered a lieutenant.[324] The regiment's surgeon wrote, "The men commenced dropping like leaves in autumn."[325] Stunned and shocked soldiers fell to the ground to protect themselves. They eventually rallied and returned fire. Casualties mounted as the color guard planted the U.S. flag alongside an artillery battery about two hundred yards from the Confederate line. Col. Fribley, having determined that the position could not be held, passed down the line and ordered each company to fall back. Before he reached the end of the line a bullet ripped into his chest and through his heart. He died minutes later. More officers fell, wounded. Com-

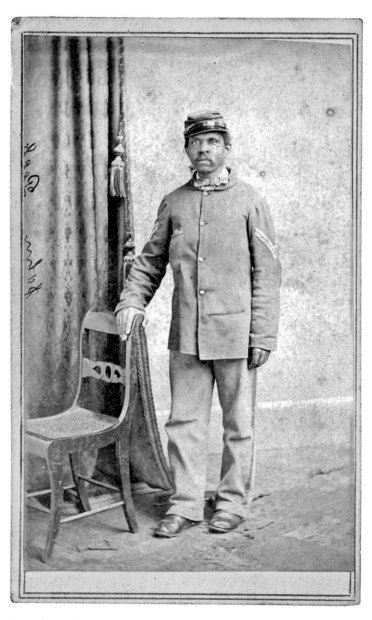

Sgt. John Peck, Company E, Eighth U.S. Colored Infantry

Carte de visite by unidentified photographer, about 1863–1864. Collection of
Ron Rittenhouse.

mand devolved upon a captain, who led the survivors out. In the confusion, the flag was left behind.[326]

Peck made it out alive. During the action he suffered a cut on his head that extended from his right eyebrow to his hairline. He claimed it was the result of a saber blow.[327]

Peck's experience with cuts before he joined the army had involved scissors. He was a barber by trade, but details about his early life are sketchy. Evidence indicates that he was born in western Kentucky to slaves who hailed from Virginia, escaped bondage in his youth, and fled to Indiana. He numbered among a small group of Hoosiers recruited for the Eighth, which was made up mostly of free men from Pennsylvania and assembled in the summer of 1863.[328] He reported to Camp William Penn outside Philadelphia to learn the art of war.

A lieutenant pointed to improper training as the cause of the high number of casualties at Olustee: "Our regiment has been drilled too much for dress parade and too little for the field. They can march well, but they cannot shoot rapidly or with effect."[329] The Eighth's white surgeon, a staunch advocate of black troops, took a different view: "Here, on the field of Olustee, was decided whether the colored man had the courage to stand without shelter, and risk the dangers of the battle-field, and when I tell you that they stood with a fire in front, on their flank, and in their rear, for 2½ hours, without flinching, and when I tell you the number of dead and wounded, I have no doubt as to the verdict of every man who has gratitude for the defenders of his country, white or black."[330]

The Eighth went on to perform with distinction in several Virginia battles, including the September 29, 1864, attack on Fort Harrison, where Peck sustained his second wound of the war, a gunshot to the left side of the head that fractured his skull and kept him out of action for six weeks.[331] He returned to his regiment as a sergeant and served in this capacity until he mustered out with his fellow soldiers at Brownsville, Texas, in November 1865.[332]

Peck returned to Kentucky. In 1880 he was working as a barber in Paducah, where he lived with his cousin Sarah and an elderly boarder.[333] In 1891 he filed for a pension for his war wounds and rheumatism. Officials rejected his claim on grounds that the injuries did not interfere with his ability to earn a living. This is the last time his name appears on a government record. He was about fifty years old then.[334]

Injured While Attending
a Fallen Comrade

Casualties mounted quickly in the ranks of the Fifty-fourth Massachusetts Infantry as battle raged across the lowlands near Olustee, Florida, on February 20, 1864. Members of the regimental band and others scrambled to attend fallen friends. In one incident, drummer Bill Netson and another man carried off a wounded soldier on a stretcher along a road. Suddenly, from the direction of the front lines, a runaway artillery caisson drawn by horses bore down on them, its wheels spinning out of control.[335]

Netson did not see the caisson coming. Fellow drummer Alex Johnson looked on helplessly and described what happened next: "They struck him, knocking him down violently...I went to him at once. I saw him lying on his back and some of the comrades that were retreating stop and help him up. I remember the remark he made to me 'O, Alex, I believe that my back is broke.'"[336] Netson also suffered an injury to his left eye, which according to Johnson was "bleeding bad."[337]

The accident did not break his back but did cause serious damage. He returned to the Fifty-fourth two weeks later. According to Johnson, Netson "stood bent and crooked and it seem to me that it was his left side affected, he could not wear a knapsack after that or bear to have his coat button around his waist" due to the pain.

In November 1864 Netson became drum major. "All he ever did was to give the orderly sergeant his directions and to superintend the drilling; he took no active part himself, as he had done before in handling the staff and drum stick," stated Johnson.

Netson remained in the position seven months. In 1865, his hands unexpectedly and inexplicably began to swell. "His hands

were so bad that on dress parade he could not wear the ordinary white gloves," reported Johnson, who added, "I got for him a very large pair and he had to cut the fingers off to get them on." Regimental staff returned Netson to the ranks and assigned him to Company K.

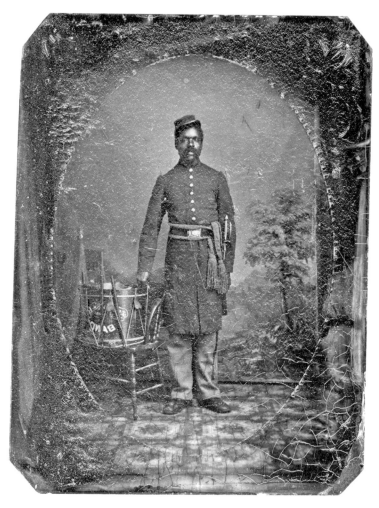

Pvt. William James Netson, Company K, Fifty-fourth Massachusetts Infantry

Tintype by unidentified photographer, about 1863. Collection of the Massachusetts Historical Society.

Netson mustered out with his comrades in August 1865. Over the next sixteen years, he resided in Canada, Washington, D.C., and New Haven, Connecticut. He worked a variety of jobs, including captain of a fire company and a janitor at Yale College.[338] He married twice, and deserted both wives after relatively brief relationships.[339]

In 1881 he moved to Norwich, Connecticut, and became a bank janitor. In 1882 he married a widow, Emily Carty. They stayed together for about thirty years. In an interview for a military pension, she told the story of his origins: "He claimed his father was Arab and his mother an Indian squaw. He did not claim to be a negro." She also said that he had told her he was born in Demerara, part of British Guyana on the northern coast of South America, and had made his way to Canada to live with his aunt and uncle, former American slaves who had escaped bondage. Netson later moved to Niagara, New York, from where he left to enlist in the Fifty-fourth.

The injuries suffered at Olustee affected him for the rest of his days. His left eye remained permanently weak, inflamed, and ran with tears. He wore a flannel belt above his hips to stabilize his back, and used various liniments and plasters to relieve the pain. An acquaintance observed in 1891, "He has a habit of putting his hand to his side in a way that is noticeable and that indicates there is some trouble there."

Netson lived until age sixty-eight, dying of liver cancer in 1912. His wife survived him.[340]

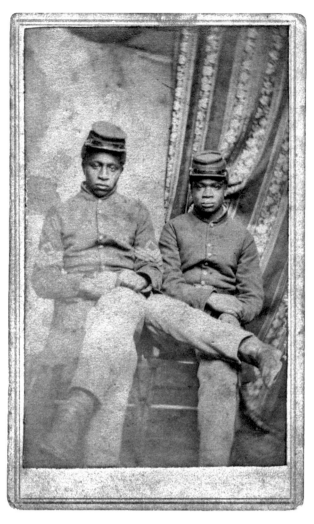

1st Sgt. Thomas Stafford, Company E, and Principal Musician
Gentry Emerson, Sixty-fifth U.S. Colored Infantry

Carte de visite by Frey (life dates unknown) & Olsen (life dates unknown) of
Morganza, Louisiana, about 1865–1866. Collection of the Beinecke Rare Book
and Manuscript Library, Yale University.

Attack on Mount Pleasant Landing

BEFORE DAWN ON MAY 15, 1864, CONFEDERATE HORSE soldiers surrounded the Union stockade at Mount Pleasant Landing, located along the Mississippi River near Port Hudson, Louisiana. At daylight the cavalrymen attacked the guard of twenty enlisted men and a lieutenant from Company E of the Sixty-seventh U.S. Colored Infantry. The troopers overpowered them and captured many of the guard and its commanding officer. Then they set fire to a sawmill and other buildings on site and plundered valuable supplies.[341]

The first sergeant of Company E, Tom Stafford, of Missouri, had been promoted to the rank two weeks earlier. Born a slave about one hundred miles west of St. Louis in Callaway County, he was the property of a farmer also named Tom Stafford.[342] Master Stafford owned two other slaves, recorded only by their gender and ages: a woman in her thirties and a teen-aged girl. They may have been Tom's mother and sister.[343]

In the 1850s, Master Stafford moved with his wife and slaves, including Tom, about 115 miles south to Lebanon. The town happened to be located along the Wire Road, named for miles of telegraph lines that ran alongside the former Indian trail from St. Louis to Fort Smith, Arkansas. This made Lebanon of some military value. Union troops occupied it almost continually after February 1862 to protect the wire.[344] It was probably here that Tom Stafford met his first federal soldiers.

In December 1863, Tom enlisted as a private in the Third Missouri Colored Infantry. Its name was later officially changed to the Sixty-seventh U.S. Colored Infantry. Stafford reported to Benton Barracks on the outskirts of St. Louis for training. In March 1864, he and his regiment traveled to Louisiana for duty.

The Confederate attack at Mount Pleasant Landing two months later turned out to be the lone action in which the regiment participated. The commander of the Union forces in the region, Brig. Gen. Daniel Ullmann,[345] hastily organized a counterattack and sent cavalry from his garrison to engage the raiders. "After a rapid pursuit of 3 miles the cavalry came up with the enemy and had several sharp skirmishes with them. They succeeded in rescuing most of the prisoners taken at Mount Pleasant, but were not able to recover the stock and merchandise plundered by the rebels," noted Ullmann in his after-action report.[346] They also failed to free the lieutenant of Company E. His captors executed him about twelve hours later for his role as a white officer in command of black soldiers.[347]

Stafford survived the attack. He spent the rest of the war in Louisiana on garrison duty. In July 1865, the Sixty-seventh ceased to exist, after military authorities consolidated it with another Missouri regiment, the Sixty-fifth U.S. Colored Infantry. Such consolidation was a common practice throughout the army; it served to maintain unit integrity as regiments lost men due to deaths, disease, and discharges for various causes. About this time Stafford sat for this *carte de visite* photograph with Pvt. Gentry Emerson, a fifer who later became the regiment's principal musician.[348]

Emerson died in April 1866, nine months before Stafford and his comrades mustered out of the army. Stafford stayed in Louisiana, settled in Baton Rouge, and married Selina Jones. They named their first child, a son, for the late fifer. The couple went on to have six more children, three boys and three girls. Stafford labored at St. Delphine Plantation, known as "The Big House," a sugar plantation. In later years, as rheumatism and other ailments slowed him down, he became a gardener.

In 1919, his wife passed away. Stafford lived until age eighty-two, dying in 1927 due to heart problems. At least one daughter survived him.[349] The Knights of Canaan, a fraternal organization and benevolent society organized to help men and women of color, paid his funeral expenses.[350]

Original Member of the Kearsarge Crew

ON THE AFTERNOON OF JUNE 19, 1864, HOURS AFTER the sinking of the Confederate raider *Alabama* by the *Kearsarge* off the coast of Cherbourg, France, victorious Union Capt. John Winslow[351] wrote a dispatch to Secretary of the Navy Gideon Welles with news of the success. It ended with a tribute to his crew: "It affords me great gratification to announce to the Department that every officer and man did his duty, exhibiting a degree of coolness and fortitude which gave promise at the outset of certain victory."[352]

One of the 163 men aboard the *Kearsarge* that historic day, Charles Redding of Massachusetts, was a member of the original crew.[353]

Born in Boston, he became separated from his parents for reasons unknown. In 1850, at about age ten, he lived in the House of Industry, a South Boston poorhouse.[354] Later in the decade, in the nearby town of Newton, local resident Henry Lemon[355] encountered the teenaged boy under a railroad bridge and brought him into his household.[356] Lemon, an opponent of slavery, numbered among his friends Sen. Charles Sumner and future Union major general Benjamin Butler.[357] Redding may have met these men, who were entertained at the Lemon home.

Redding parted ways with Lemon before the war began and became a bank watchman. He left this job to join the navy in January 1862. He trained on an old receiving ship, the *Ohio*, then joined the crew of the newly commissioned steam sloop *Kearsarge*. He acted as steward and cook in the steerage section, providing food and comfort to his comrades during the hunt for Confederate vessels in European waters.

Redding served in this capacity during the fight with the

Alabama and survived without injury. News of the action arrived in America shortly after the Fourth of July holiday. "Our national anniversary has again brought victory with it, and a victory most delightful to the national heart,"[358] proclaimed the *New York Herald*, referring to the Battle of Gettysburg and Siege of Vicksburg a year earlier. The loss was hard on the South. One eyewitness declared, "For the Secessionists and their European

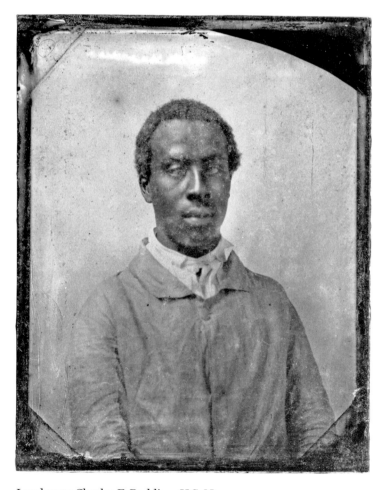

Landsman Charles F. Redding, U.S. Navy

Ambrotype by unidentified photographer, late 1850s. Collection of the Jackson Homestead and Museum, Newton, Massachusetts.

sympathizers, the blow was terrible, and provoked louder and more prolonged swearing probably than any event of this eventful war."[359]

Redding remained a member of the *Kearsarge* crew until his three-year term of enlistment expired in 1865. He reenlisted and served for two-and-a-half more years. He spent the majority of this time as a cook on the *National Guard*,[360] a supply ship for the fleet in Europe.[361]

Redding returned to the Boston area after leaving the navy in 1867 and became a janitor. For many years he remained a bachelor. In 1886, in his mid-forties, he married Isabella "Bella" Sherman, born the year after he left the navy. They lived together until his death in 1902 at about age sixty-two.[362]

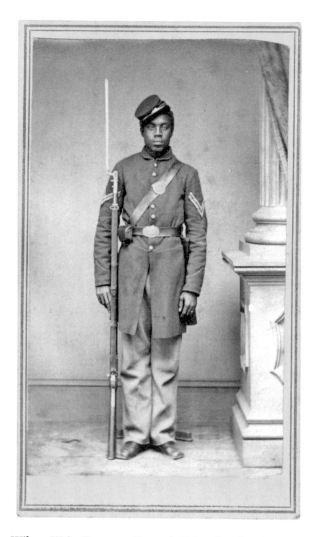

Corp. Wilson Weir, Company F, 108th U.S. Colored Infantry

Carte de visite by Alfred B. Gayford (b. ca. 1828) & Conrad S. Speidel (b. ca. 1827) of Rock Island, Illinois, about March 1865. Collection of the Beinecke Rare Book and Manuscript Library, Yale University.

"A Thorough Soldier"

WILSON WEIR LEFT HIS HOME IN GREENVILLE, KENtucky, with a friend, and joined the Union army in the summer of 1864.[363] The twenty-one-year-old slave did so with the knowledge and consent of his master, Edward Weir, who, despite having slaves, supported emancipation.

An historian described Edward Weir, who kept Wilson and about forty other slaves before the war, as "an influential merchant, lawyer, and politician, a slave-holder, an abolitionist, and a strong Union man" who owned a fine home and built brick cabins to house his slaves.[364]

Wilson lived in one of the cabins with his mother, Lucinda, and father, Jube. Young Wilson had a reputation as one of the best slave ministers in the area. He preached at worship meetings in schoolhouses and churches across his home county. Military service temporarily suspended his local ministry and forever ended his slave status.[365]

Wilson was assigned to a new regiment, the 108th U.S. Colored Infantry. After less than two weeks in uniform he received a promotion to corporal of the color guard.[366] He earned the respect of one company officer as "a thorough soldier."[367]

Wilson served in this capacity at various posts in Kentucky and Mississippi and in Rock Island, Illinois, where the regiment guarded Confederate prisoners.

In March 1866, he mustered out of the army with his comrades at Vicksburg, Mississippi, and returned via steamboat to Greenville. He resumed life as a preacher and married a local girl, Francis Martin.[368]

Chronic diarrhea, which he had developed during the war, continued to plague him intermittently. In early 1877, while on

a trip to get medicine in Louisville, he suffered another bout of the disease and fell ill with smallpox. Too sick to make the return trip home, he remained in Louisville and there succumbed to his afflictions at about age thirty-four. His wife survived him.[369]

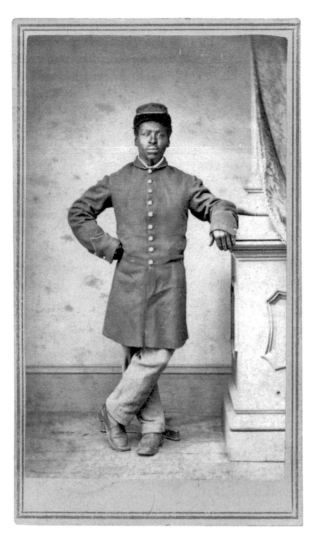

Pvt. George Brown, Company F, 108th U.S. Colored Infantry

Carte de visite by Alfred B. Gayford (b. ca. 1828) & Conrad S. Speidel (b. ca. 1827) of Rock Island, Illinois, about March 1865. Collection of the Beinecke Rare Book and Manuscript Library, Yale University.

A Giant in His Company

AT FIRST GLANCE, PEOPLE MIGHT HAVE WONDERED IF George Brown had the physical stamina to be a soldier. The diminutive infantryman stood less than five feet tall and barely filled his uniform. An officer in his company observed that he had, "feet & hands like a child's figure."[370]

Although small in stature, Brown was a giant in Company F of the 108th U.S. Colored Infantry. His fighting spirit outweighed any physical limitations he might have had. He "does his duty—shaming larger men," wrote the same company officer.[371]

Brown lived in Louisville, Kentucky, before the war. He was one of about eight slaves owned by Sam Richardson. In 1863, Richardson's daughter Maria married Harry Grant, a New York–born captain in the Union Twenty-seventh Kentucky Infantry. Richardson gave or sold Brown to his new son-in-law in May 1864.

Brown joined the army one month later, presumably with the consent of his new master.[372] He wound up in the 108th, a new regiment composed mostly of former slaves. During his twenty-one months in uniform, he earned a reputation as a competent soldier on various guard and garrison duties in his home state, at the prison camp at Rock Island, Illinois, and in Vicksburg, Mississippi, where he mustered out of the army with his comrades in March 1866.

He left Vicksburg, carrying his knapsack, haversack, and canteen, and returned to Louisville. The government awarded him a pension in 1890 because of gum disease and loss of teeth attributed to a case of scurvy he claimed to have contracted while in uniform. He received a modest regular payment until his death twelve years later at about age sixty-nine. He did not marry and had no known children.[373]

Sterling Soldier

IF ANY COMPANY OFFICER HAD HAD THE ABILITY TO PICK and choose the men in his command, Pvt. Lewis Chapman would likely have been on his short list of candidates. During Chapman's twenty-one months as an infantryman, he did not have a single blemish on his record. The first lieutenant of his company praised him as a "sterling soldier."[374]

Born a slave in south central Kentucky, Lewis Chapman tended his master's fields on a farm near Munfordville, strategically located along a railroad and a vital federal supply line that ran into middle Tennessee. He probably glimpsed his first Union soldiers in late 1861, when military authorities established the forty thousand–man Camp Wood north of town.[375] He might also have been in the vicinity during the Battle of Munfordville on September 14–17, 1862, when victorious Confederates briefly occupied the area.

By the summer of 1864, Chapman had left the farm and slavery and made his way about eighty miles north to Louisville, where he enlisted in the 108th U.S. Colored Infantry.[376] He joined Company F, where he gained a reputation for excellence. His first lieutenant remarked that he was "always up to time,"[377] a reference to his ability to execute complicated infantry movements and formations.

The same officer described Chapman as "very quiet."[378] A fellow private added, "He was a good honest straight forward man." These character traits served him well as he participated in various duties in Kentucky and Mississippi and on guard duty at the prisoner of war camp at Rock Island, Illinois.

Chapman mustered out of the army with his comrades in the spring of 1866 and returned to Munfordville. In the autumn of that year he wed a widow, Harriett Barracks. The minister who

presided over the ceremony noted, "No witnesses are on record, as the marriage was intended to be private as the parties wished it to be."[379]

In 1881, they moved to Louisville. According to a friend, the couple was "respected by all who knew them."[380] Chapman worked as a laborer and supported his wife. He lived until age fifty-six, dying of pneumonia in 1895.

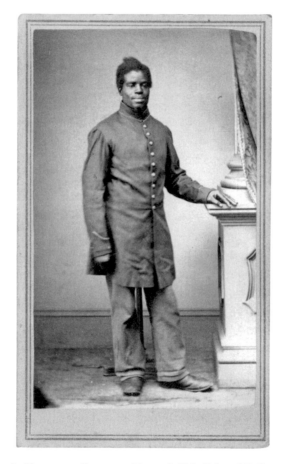

Pvt. Lewis Chapman, Company F, 108th U.S. Colored Infantry

Carte de visite by Alfred B. Gayford (b. ca. 1828) & Conrad S. Speidel (b. ca. 1827) of Rock Island, Illinois, about March 1865. Collection of the Beinecke Rare Book and Manuscript Library, Yale University.

Before and After

HUBBARD PRYOR MAY HAVE BEEN TOLD THAT PHOTO-
graphs taken to document his transformation from escaped
slave to Union soldier would be sent to Washington to illustrate
successful recruitment efforts of blacks in the South.[381] But he
probably never could have guessed that his likeness would wind
up on the pages of the North's most popular illustrated newspa-
per, *Harper's Weekly.*

Readers of the July 2, 1864, issue came face to face with a
woodcut engraving based upon a photograph of Pryor dressed
in the ragged clothes he wore when he entered Union-occupied
Chattanooga, Tennessee. A second engraving showed Pryor in
uniform, his upturned face gazing confidently ahead and hands
resting on the muzzle of a musket. This image bore no resem-
blance to the actual photograph of him in his military clothes. It
was a work of pure fiction invented by the staff of *Harper's* who
likely felt that Pryor, who stood stiffly at attention with a mus-
ket at his side, did not fit the idealized vision of a slave-turned-
soldier.

An article that accompanied the engravings praised the hero-
ism of fugitive slaves in rebellious states, where they risked their
lives to fight for freedom. The writer did not mention Pryor by
name.

Born in Georgia, Pryor had lived about sixty miles north and
west of Atlanta in Polk County.[382] His master, Haden Prior,[383]
owned 117 slaves about the start of the war.[384] When Pryor left
home and how he came to join the army is not exactly known.
He may have escaped in late 1863, fled to Montgomery, Ala-
bama, and then made his way to Chattanooga.[385] He enlisted on
March 7, 1864, and mustered into the Forty-fourth U.S. Colored

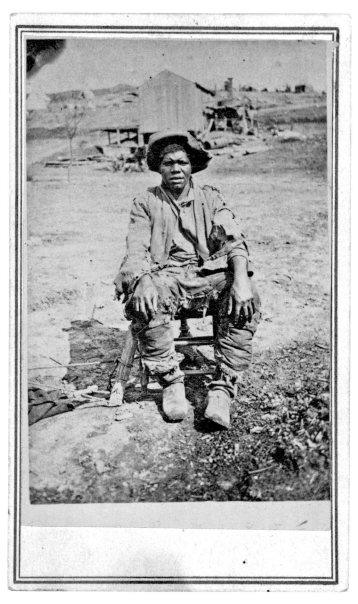

Hubbard D. Pryor before enlisting

Carte de visite by A. S. Morse (life dates unknown) of Nashville, Tennessee, March or April 1864. Collection of National Archives and Records Administration, Washington, D.C.

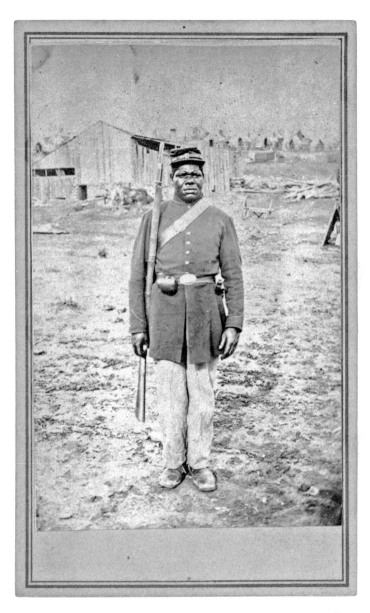

Pvt. Hubbard D. Pryor, Company A, Forty-fourth U.S. Colored Infantry

Carte de visite by A. S. Morse (life dates unknown) of Nashville, Tennessee, March or April 1864. Collection of National Archives and Records Administration, Washington, D.C.

Engraving based on the *carte de visite* of Pryor before enlistment, printed in the July 2, 1864, issue of *Harper's Weekly*. Collection of the author.

Infantry, a regiment composed of men unfit for the rigors of active campaigning but able to perform guard and other light duties.[386]

Pryor posed for the photographs about this time.[387] Three months later the engravings appeared in *Harper's Weekly*. Three months after that, he became a prisoner of war.

On October 13, 1864, he and most the Forty-fourth were garrisoning the north Georgia railroad town of Dalton when they were surrounded by Confederate troops from Gen. John B. Hood's Army of Tennessee, as they marched through northwest Georgia in the weeks before their disastrous incursion into

Engraving showing an idealized image of Pryor in uniform, printed in the July 2, 1864, issue of *Harper's Weekly*. Collection of the author.

middle Tennessee.[388] After a brief skirmish, the Forty-fourth's colonel, Lewis Johnson, surrendered.[389] Pryor and about 600 of his comrades fell into enemy hands. The officers were stripped of most of their clothing and paroled. They returned to federal lines within days.[390] Confederates robbed Pryor and the rest of the enlisted men of shoes and other accoutrements. Some of the captives were reclaimed by their masters and returned to slavery, and others were put to work as laborers in the Confederate military.[391]

Pryor remained in captivity for seven months, rebuilding railroads and other infrastructure in Alabama, Mississippi,

and southern Georgia. About May 1, 1865, with the war winding down, his captors abandoned him and others near Griffin, Georgia. Pryor later described how he "walked his way back to his old home in a sick, broken down, naked and starved condition, the country being everywhere full of returned Confederate soldiers, that he traveled after night and was fearful of being killed by them."[392]

Pryor returned safely to Polk County.[393] During his absence, Union cavalry had burned the county seat, Cedar Town.[394] Civil law collapsed and two gangs roamed the region. Members of one gang, Texas cavalrymen who had deserted the Confederate army, killed Pryor's former master during the closing days of the war.[395] Pryor visited the nearest U.S. military post for aid. "The federal officers there would give no relief or consolation," stated two companions who traveled with him.[396]

Pryor survived these tough times. By 1870, he had married a woman named Annie.[397]

Annie died childless in 1880.[398] Soon afterward, Pryor married former slave Ann Dever.[399] In early 1890, they moved to Texas and settled in Calvert, located midway between Dallas and Houston. Pryor died later that year at about age forty-eight, survived by his wife and four children, ages five months to six years.[400]

Action at Wallace's Ferry on Big Creek

At four o'clock on the afternoon of July 25, 1864, Sgt. James Baldwin and a column of about 350 Union infantry and artillerymen set out from Helena, Arkansas, on an expedition to flush out Confederates in the region. After a fatiguing twenty-mile march, the weary federals halted, about 3 a.m., near Wallace's Ferry along Big Creek. There they set up camp and snatched some sleep. At daylight, the men rose and prepared breakfast. As Baldwin and his messmates lounged about camp, 1,200 Confederate horse soldiers led by Col. Archibald S. Dobbins[401] descended upon them from three directions.[402]

The gray troopers opened fire with deadly accuracy. In a few frantic minutes, the expedition's commanding colonel, one of his aides, his surgeon, and the captain in charge of the artillery suffered mortal wounds or were instantly killed.[403] After the initial shock subsided, the surviving officers rallied the troops. "We formed our lines and held our position for about four hours under a severe and continuous fire from the enemy, their lines being in some places not more than fifty yards from our own," noted one officer.[404] Dozens more men were wounded during the action, including Baldwin.

A bullet struck him in the neck just below the left ear and tore through muscles before coming to rest below the shoulder blade. He remained on the battlefield with his comrades until Union cavalry led by Maj. Eagleton Carmichael[405] arrived and broke through the Confederate line.[406] The battered column returned to Helena. Medical personnel examined Baldwin and admitted him to a hospital. A surgeon extracted the projectile from his neck, dressed the wound, and left him to recuperate. He spent two months in the hospital.[407]

Baldwin had been living about two hundred miles south of Helena in Claiborne County, Mississippi, when he joined the army. Born into bondage to parents who hailed from Virginia, he labored with about 180 other slaves on Belmont Plantation, owned by a prosperous Natchez merchant.[408] Baldwin escaped at some point after the war started. In the summer of 1863, he joined Company G of the Third Arkansas Volunteer Infantry,

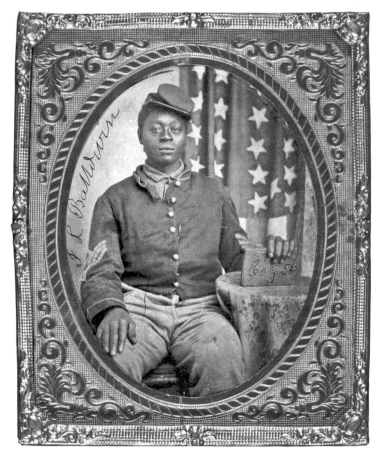

Pvt. James L. Baldwin, Company G, Fifty-sixth U.S. Colored Infantry

Tintype by unidentified photographer, about 1864–1866. Collection of the Chicago History Museum.

African Descent. The government later designated the regiment the Fifty-sixth U.S. Colored Infantry. Baldwin advanced to sergeant soon after his enlistment.[409]

One year later, he embarked with six companies of the Fifty-sixth on the expedition that ended with the Battle of Wallace's Ferry. Although a tactical draw, the battle was a moral victory for Baldwin and his comrades, for it proved their combat worthiness. Brig. Gen. Napoleon B. Buford,[410] who commanded the military district in which the action occurred, mourned those who had been killed at Wallace's Ferry but said, "We rejoice in the glory acquired on this well disputed field by our colored troops. Will they fight? Ask the enemy."[411]

When Baldwin had fully recovered from his wound and surgery, he rejoined the Fifty-sixth and subsequently participated in various operations in Mississippi and Arkansas until his three-year term of enlistment expired in September 1866. Company officers reduced Baldwin to the ranks, for reasons unknown, less than a month before he mustered out.[412]

Baldwin settled in the Helena area and worked as a general laborer, farmer, and dragman, a fisherman who uses a net. His first marriage ended when he divorced his wife in 1868.[413] Later that year he wed Mary Hines. They moved to St. Louis. After Mary died in 1903, Baldwin entered the National Home for Disabled Volunteer Soldiers in Danville, Illinois. He remained there until his death in 1922 at about age eighty-two from heart trouble. Two daughters survived him.[414]

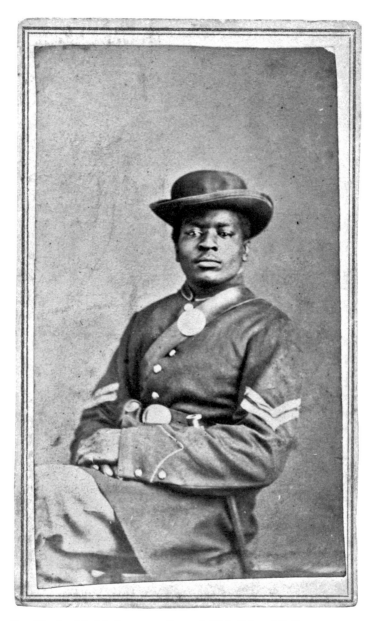

Pvt. Charles Mudd, Company C, 108th U.S. Colored Infantry

Carte de visite by unidentified photographer, about 1864–1865. Collection of the Gettysburg National Military Park Museum.

Attacked by Measles

CHARLIE MUDD SIPPED MILK AND NIBBLED CHICKEN AS he recovered from measles at a military hospital in Louisville, Kentucky, during the fourth summer of the war. He periodically received medicine ordered by the doctor assigned to his case.

The twenty-five-year-old private, a former slave, who had labored in his master's fields about sixty-five miles away in Washington County, joined the newly formed 108th U.S. Colored Infantry without his owner's consent in June 1864.[415] Charles Mudd was one of five brothers who served in black regiments.[416] Less than a month after Mudd enlisted, he fell ill while on duty in Louisville, as measles swept through the regiment.

Mudd's illness might have been avoided. About a year earlier, Maj. Gen. William T. Sherman proposed one way to reduce disease in rookie regiments. He suggested that inexperienced recruits be distributed among veteran regiments instead of being lumped together in new organizations. By doing so, Sherman explained, they "would learn from the sergeants and corporals and privates the art of taking care of themselves, which would actually save their lives and preserve their health against the host of diseases that invariably attack the regiments."[417] Authorities did not act on Sherman's suggestion.

The army's medical corps did make substantial improvements that contributed to the health and welfare of the troops. None of these changes prevented Mudd from getting sick. He recovered after two weeks in the hospital and rejoined his company. He spent the next twenty months at locations in Kentucky and Mississippi and guarding Confederate prisoners of war at Rock Island, Illinois. He served as a corporal for most of his en-

listment but was reduced to the ranks for an undisclosed reason before he mustered out of the army in March 1866.

He returned to Washington County and became a farmer in Springfield. He married Harriet McIntire in 1867. She died in 1872, possibly from complications of childbirth. She left Mudd widowed with a three-year-old son. Mudd married Rose Howard later that year, and they lived together until his death from influenza in 1915 at about age seventy-four.[418]

The Fifteenth Casualty

On July 27, 1864, a staff officer tallied the losses suffered by the Sixtieth U.S. Colored Infantry in the Battle of Wallace's Ferry, which had been fought a day earlier near Helena, Arkansas. Of the eighty officers and men from the rookie regiment who participated, fourteen became casualties, including four killed and ten wounded.[419]

One soldier whose name did not appear on the list, Isaiah Owens, could be counted as a fifteenth casualty. He came away from the battle with a sore back and complained to two comrades. They attributed it to exhaustion.[420] But over the next couple of days the pain worsened and medical personnel admitted him to the regimental hospital in Helena.

Meanwhile, about 450 miles north in Hannibal, Missouri, Owens's mother Melinda had no idea that her son was ill.

Born into slavery, Owens grew up in the vicinity of Hannibal with Melinda, his father Richard, and younger brother John. The family belonged to Nancy Newland, a widow who managed her late husband's property. In the late 1840s, she legally divided the Owens family. She gave Isaiah to one of her two sons and John to the other. She kept Isaiah's parents. Although separate on paper, the Owens family continued to live together.[421]

After Richard died unexpectedly in 1850, Melinda looked to young Isaiah as the man of the family. He was about twelve years old when his father passed away. From that time on he tended to his mother's needs. After the Emancipation Proclamation took effect on January 1, 1863, Mrs. Newland freed Melinda. Her sons continued to hold Isaiah and his brother in bondage.[422]

Isaiah's owner hired him out to local farmers to work for cash. Part of his earnings purchased tea, coffee, sugar, and clothing

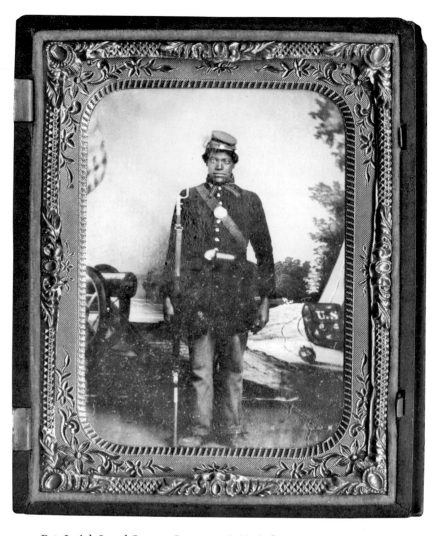

Pvt. Isaiah Israel Owens, Company C, Sixtieth U.S. Colored Infantry

Tintype by unidentified photographer, about 1863–1864. Collection of Tim Kernan.

for his master. Isaiah kept the remainder of his pay, a portion of which he gave to Melinda to buy essentials.

In the summer of 1863, Isaiah joined the army with his master's consent. He turned over to Melinda the small patch of potatoes and tobacco he had been working, made the short trip to the Mississippi River, crossed over to Quincy, Illinois, and enlisted in the First Iowa African Infantry. His brother John went with him and also signed up. The new regiment included six companies of Iowans—almost every able-bodied black man in the state—and four companies of Missourians.[423] The Owens boys became privates in Company C. After basic training the First reported to Union-occupied Helena for duty. All the while, Isaiah regularly sent his mother part of his army pay.

In March 1864 the regiment reorganized and was designated the Sixtieth U.S. Colored Infantry. Four months later, on July 25, eighty soldiers from the regiment, including Isaiah, joined a 350-man column of infantry and artillery on an expedition to root out Confederates. It ended the next day with the Battle of Wallace's Ferry, a tactical draw that ended in a Union retreat back to Helena—and the trip to the hospital for Isaiah.

A doctor diagnosed him with inflammation of the spinal column, or meningitis. He succumbed to the infection after two weeks of suffering. He was about twenty-six years old.[424] His army service had lasted less than a year.

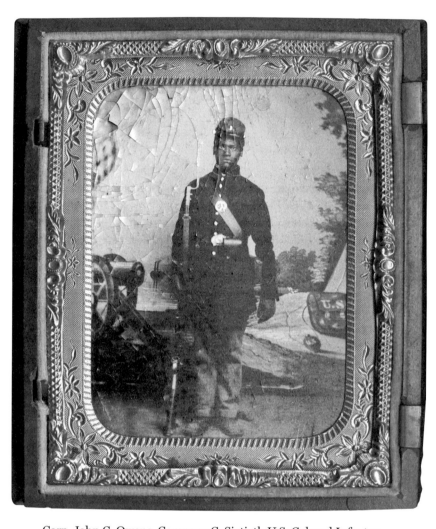

Corp. John C. Owens, Company C, Sixtieth U.S. Colored Infantry

Tintype by unidentified photographer, about 1863–1864. Collection of Tim Kernan.

On a Series of Scouts

ABOUT SUNSET ON AUGUST 29, 1864, ALONG THE BANKS of the Mississippi River in Union-occupied Helena, Arkansas, five hundred federal infantry, cavalry, and artillerymen crowded aboard the steamers *Dove* and *Hamilton Belle* with horses, cannon, equipment, and other supplies to begin a six-day scout for Confederates and disloyal citizens, to maintain security in the area.[425] The excitement of the expedition must have been tinged with sadness for one soldier, John Owens, who had recently watched his brother die of disease. Three weeks earlier, John's older and only sibling, Isaiah, had lost a battle with meningitis.

The previous summer, the slave-born boys had left their widowed mother, Melinda, and joined the army, with the consent of their masters. From their home near Hannibal, Missouri, they crossed the state border into Quincy, Illinois, and enlisted in the First Iowa African Infantry. The new regiment, 911 recruits from Iowa and Missouri, mustered at Keokuk, Iowa, for a three-year term.[426] After basic training at Benton Barracks in St. Louis, the First received orders to report for garrison duty at Helena. The city had fallen to Union forces earlier in the war.

In March 1864, in accordance with a War Department policy to no longer list colored organizations by their state names, the regiment was redesignated as the Sixtieth U.S. Colored Infantry. It fought under this name at the Battle of Wallace's Ferry on July 26, 1864. John survived the action without injury. His brother fell sick the day after the battle and soon died.

A couple of weeks later, John and the rest of Company C were participating in the series of scouts along the Mississippi River. The 500-man scout that began on August 29, 1864, ended five days later after a journey along the Mississippi and White rivers.

Highlights of the expedition included the burning of a gristmill and other buildings and the capture of a Confederate horse soldier.[427] John received his corporal's stripes two weeks after the assignment's completion.

On another scout, in January 1865, Company C embarked on the *Dove* for a three-day, sixty-five-man expedition. They returned with a captured deserter, five hundred bushels of corn, and three refugee families.[428]

The following month, on February 24, John and others in his company climbed aboard the steamer *Curlew* for a one-day, one hundred–man scout to break up a band of illegal traders. The raid ended in success.[429]

Three days later, when the *Curlew* was near the federal base at Friars Point, John fell off the steamer into the Mississippi River and drowned. He was about twenty-four years old.

The Owensboro Raid

THIS CHILLING HEADLINE IN THE SEPTEMBER 3, 1864,
issue of the *New York Times* announced an attack by Confederate
cavalry raiders on Union soldiers: "A Battalion of Negro Troops
Slaughtered in Cold Blood; Murders and Outrages in Kentucky."
The victims, as many as five hundred men who belonged to the
108th U.S. Colored Infantry, included twenty-four-year-old Sgt.
Alfred Jackson of Lexington, Kentucky.

Jackson had left his job as an army teamster two months
earlier and enlisted in the regiment.[430] Soon afterward, military
authorities ordered the 108th to garrison two Union-occupied
Kentucky towns. Half the regiment (one battalion) went to Mun-
fordville. The other half, including Jackson and his company,
traveled to Owensboro. It was here that the reported slaughter
occurred.

If the headline had been strictly true, the killings would have
been one of the largest such atrocities committed during the
war. However, the *Times* headline was misleading. An attack
did occur, but with far less loss than a battalion.

On August 27, 1864, about twenty cavalrymen from the Con-
federate Tenth Kentucky Partisan Rangers descended on Ow-
ensboro, along the Ohio River on the Indiana border. They were
led by Capt. Jake Bennett, a notorious figure who had escaped
from the Ohio State Penitentiary a year earlier with Gen. John
Hunt Morgan, and who, it was rumored, had the scars of twenty-
six bullets on his skin.[431] The partisan horsemen galloped into
the town with guns blazing. Residents ran for cover. At least one
man, a federal officer, suffered a wound.[432] The raiders rode to
the town wharf and charged a boat laden with government sup-
plies that was guarded by ten soldiers from the 108th. Accord-

ing to reports, the Confederate troopers shot seven of the guards and the other three hid on the vessel. The Confederates then set the boat on fire and fled. Citizens extinguished the flames and saved the remaining guards.[433] The rest of the battalion, including Jackson, had departed Owensboro a day earlier.[434]

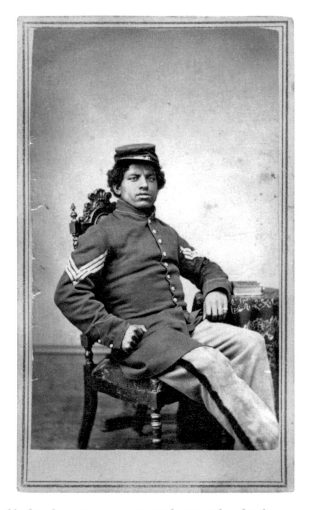

Sgt. Alfred Jackson, Company F, 108th U.S. Colored Infantry

Carte de visite by Alfred B. Gayford (b. ca. 1828) & Conrad S. Speidel (b. ca. 1827) of Rock Island, Illinois, about March 1865. Collection of the Gettysburg National Military Park Museum.

The raid on Owensboro turned out to be the only time any part of the 108th came under fire during its enlistment. The two battalions later reunited and served in a variety of garrison and guard duties in relative safety.

Jackson earned a reputation as one of the best sergeants in the regiment, according to one of his company officers.[435] He mustered out with his comrades in March 1866 and returned to Lexington. He died the following year of an unknown cause. His widow Annie, whom he had married in 1861, attributed his death to disability contracted during his army service, but the nature of the disability is not specified in the official record.[436]

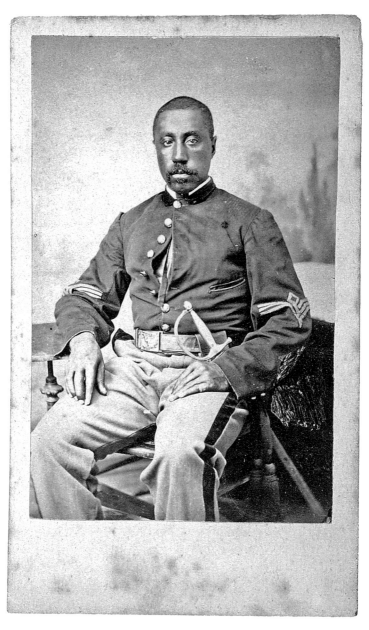

1st Sgt. Taylor B. Aldrich, Company B, Nineteenth U.S. Colored Infantry

Carte de visite by unidentified photographer, about December 1866. Courtesy of Cowan's Auctions, Cincinnati, Ohio.

On the Edge of the Crater

By the time 1st Sgt. Taylor Aldrich came upon the confusion, chaos, and carnage at the Battle of the Crater, charging Union soldiers in the initial attack wave had entered the 170-foot-long and 80-foot-wide hole that had been blown out of the Virginia countryside by a Union mine along the defenses of Petersburg. They could go no further. They struggled to escape while Confederates poured a murderous fire down upon them.

At this point, Aldrich and Company B of the Nineteenth U.S. Colored Infantry led the regiment into action. They ran across open ground as enemy lead ripped into their ranks from three sides. "The slaughter was fearful," recalled Aldrich's captain, Charlie Stinson.[437] "Bullets came in amongst us like hailstones." They made it up to the edge of the crater only to find it clogged with troops. Unable to go forward and not willing to withdraw, the Nineteenth lay down, hugged the ground, and waited for orders.[438]

Aldrich had joined the regiment when it formed nine months earlier. Born in the Maryland county of Talbot to a slave mother of African descent and an unnamed white father, he grew up in bondage along the Chesapeake Bay. The man to whom he belonged, Richard Trippe, died in 1849.[439] Ownership of the five-year-old boy, his mother, and other siblings passed to Trippe's daughter, Sarah.[440]

In December 1863, Aldrich and an older brother, Edward, left their mistress and enlisted as privates in the Nineteenth. It is not known if they ran way or were given leave to join the army. Edward served in Company A; he would die on active duty of cholera.[441] Aldrich joined Company B and advanced to first sergeant.

Six months into his enlistment, on July 30, 1864, Aldrich found himself in his first major engagement, at the Crater. He and the rest of the Nineteenth lay on the ground until the stalled Union assault collapsed. Capt. Stinson described what happened next: "Finally the front line got repulsed and they came back pel mel both black and white. We tried to stop them but it was like stopping so many sheep. Soon we got orders to fall back, and we did under a terrible fire.... The way was completely strewn with dead, dying and wounded."[442]

Aldrich survived the battle and went on to participate in other operations along the front lines at Petersburg. The Nineteenth remained in the vicinity after the fall of Petersburg and Richmond, and the surrender of Gen. Robert E. Lee's Army of Northern Virginia. In June 1865, the regiment left for duty in Texas; they mustered out in January 1867.

Aldrich returned to Maryland, lived in Baltimore for a few years, and then moved to Philadelphia. There he wed Sarah Homager. She had become estranged from her first husband, a war veteran who had moved to California.[443] Her marriage to Aldrich was short-lived, as she soon left him and returned to her former husband. Aldrich told the story of the failed relationship to his new wife, widow Becky Burton, on the day after they wed, in 1885. According to Becky, Aldrich "did not consider under the circumstances that he was ever lawfully married" to Sarah.[444]

Aldrich and Becky moved to Pittsburgh about 1891. She became an active and respected member of the African Methodist Episcopal Church. He worked as a hotel headwaiter and participated in events with his local Grand Army of the Republic post.[445]

The couple had no offspring, but they raised four children abandoned by a daughter from Becky's first marriage.[446]

Aldrich lived until age seventy-three, dying in 1918 after a brief illness.[447]

Fighting at the Crater

Pvt. Henry Gaither and his comrades in the Thirty-ninth U.S. Colored Infantry were among the last troops to enter the Battle of the Crater at Petersburg, Virginia. By the time they arrived, on July 30, 1864, the massive Union mine detonation that ripped asunder a section of the city's defensive earthworks had left a gaping hole, and covering the floor and sides of the crater were living, dead, wounded, and dying Union soldiers. The Confederates had recovered from the explosion and formed a devastating perimeter of fire along its rim, shooting down trapped Union soldiers as they attempted to climb out of the hole.[448]

The colonel of the regiment, Ozora Stearns,[449] recalled that they marched into a hail of fire. "A cannon-ball took off the head of one of the men near the front of his regiment," noted a biographer.[450] The shock rattled the troops. Col. Stearns climbed atop a chunk of clay about three feet high, drew his sword, and rallied the men. Unable to advance into the crater jammed with soldiers, they made their way along the right of the hole and held a portion of the line until overwhelmed by the enemy and forced to retreat. The Thirty-ninth suffered about 195 casualties.[451] Gaither survived the battle.

Born free in Montgomery County, Maryland, Henry Gaither moved with his family to Baltimore as a child. "He was a chestnut colored man 5 feet 7 or 8 inches high," according to his wife Rachel, whom he married in 1859. She added, "He had been raised as a domestic servant attending to the table."[452] At the time they met, Gaither lived and worked as a waiter at the Hand Tavern, a reputable inn and one of the earliest established in Baltimore.[453]

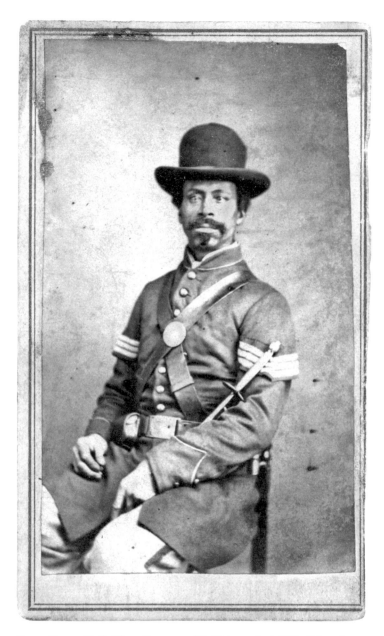

Corp. Henry C. Gaither, Company H, Thirty-ninth U.S. Colored
Infantry

Carte de visite by unidentified photographer, about 1865. Collection of the Gettysburg National Military Park Museum.

Gaither left behind his wife and home in the spring of 1864 to enlist in Company H of the Thirty-ninth, a new regiment organized in Baltimore. In April it left for Virginia via Annapolis and Washington, D.C. "We followed the star-spangled banner with the motto 'Freedom or Death!'" exclaimed one sergeant.[454] After a stint guarding wagon trains attached to the Army of the Potomac, the regiment moved into frontline positions at Petersburg six weeks before the Battle of the Crater.

In 1865, Gaither and the other Crater survivors went on to participate in the capture of Fort Fisher, North Carolina, on January 15 and the Carolinas Campaign that ended with the surrender of the armies commanded by Gen. Joseph E. Johnston on April 26. Gaither made corporal the following month. He mustered out of the army with the regiment in December. About this time he sat for his *carte de visite* photograph wearing sergeant's stripes. The chevrons appear to be temporarily attached. He never officially held this rank.[455]

Gaither returned to Baltimore. He and Rachel had four children, although three died young. A daughter lived to maturity. Gaither began to show signs of dementia in his early fifties. Rachel reported he was of a "serious state of mind." In 1884, she admitted him to an asylum, where doctors declared him insane. He died four years later at about age sixty.[456]

Rachel, a hard-working domestic servant, attributed his mental illness and death to exposure to the rigors of army life in camp and on the battlefield during the war. The government agreed and awarded her a widow's pension, which she received until her death in 1905.[457]

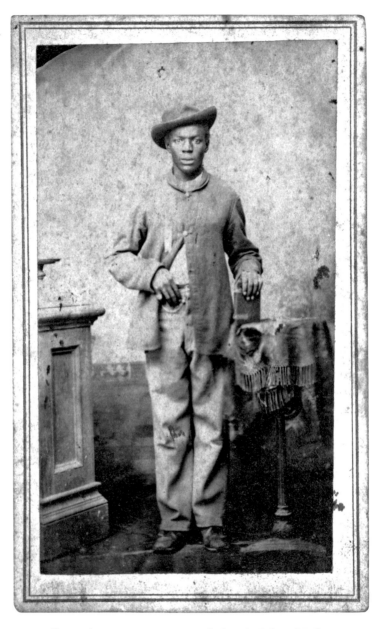

Pvt. William Thomas, Company H, Ninth U.S. Colored Infantry

Carte de visite by unidentified photographer, about 1864–1865. Collection of DeGloyer Library, Southern Methodist University.

Among the First to Fall at Deep Bottom

Eleven miles south and east of Richmond, Virginia, where the James River takes a horseshoe bend, is a stretch of ground called Deep Bottom, named by locals for the depth of water that flows through it. Nearby, Confederate frontline defenses were located on New Market Heights. On the night of August 13–14, 1864, thousands of Union troops crossed the James River at Deep Bottom and awaited orders to advance on the enemy troops holding the heights.

The federals went into action the following afternoon and soon suffered casualties. Among the first to fall was William Thomas, a private in the Ninth U.S. Colored Infantry. Thomas had joined the army less than a year earlier. In the fall of 1863, he left his home in Princess Anne, Maryland, a bustling market center on the state's Eastern Shore. He enlisted in the Ninth and took his place in Company H.[458]

He and his fellow volunteers earned a reputation as one of the best companies in the regiment. The men were "always neat and soldierly in their appearance," noted the Ninth's commander, who added that they performed "the various arduous duties to which they have been assigned, with a bravery, patriotism and zeal that could not be exceeded by any troops, thereby always winning the esteem of all their Officers and comrades."[459]

The men of Company H proved their mettle in combat during a weeklong series of actions known as the Second Battle of Deep Bottom, fought August 14–20, 1864. A musket ball struck Thomas in his right heel as Company H skirmished with rebel forces on the first day. His captain and five other privates also suffered wounds during the seven-day engagement.[460]

Two of the privates later died from their injuries. Thomas's

wound landed him in a military hospital and kept him out of action for weeks.[461] While he recuperated, the Union forces engaged at Deep Bottom were ultimately repulsed, having failed to break the Confederate lines. Thomas also missed battles along the Richmond and Petersburg front. In one of those engagements, the September 29, 1864, Battle of New Market Heights, the regiment and its brigade received high praise for their heroic efforts.

Thomas returned to Company H in mid-October and spent the rest of his military service on a series of detached duties, including stints as a guard at brigade headquarters, a quartermaster wagon driver, and an ordnance department orderly. He marched into Richmond with the Ninth after the capital fell on April 3, 1865, and moved with the regiment to Texas a few months later. He mustered out with his comrades after their three-year term of enlistment expired in November 1866.[462]

Thomas returned to Maryland and married in 1872. Five years later he died in Baltimore at about age thirty-eight. His wife and three children under age four, including four-month-old William Jr., survived him. A doctor attributed Thomas's demise to heart disease and malaria, and noted that these ailments were induced by rheumatism contracted in the hospital where he received treatment for his foot wound. His widow filed for and received a pension for her late husband's military service. She remarried four years after his death.[463]

"One of the Bravest Colored Soldiers"

BRAVE. AGGRESSIVE. FEARLESS. UNCOMPROMISING. THIS is how one writer described Milton Holland.[464] These qualities came into play when he and his regiment, the Fifth U.S. Colored Infantry, went into action in Virginia along the front lines of Richmond and Petersburg in the autumn of 1864.

On the night of September 28, the arrival of ammunition and other equipment at the camp of the Fifth was a clear indication that the regiment would soon be called to battle. While its 550 enlisted men received the supplies, a skeleton crew of officers barely covered its duties. On paper, three line officers were required to lead each of the ten companies, but the regiment could muster only ten, one for each company.[465]

The next day, the Fifth assaulted New Market Heights, part of the defenses of the Confederate capital, which included a fort, extensive earthworks, and two lines of slashed tree branches and brush, or abatis. The troops advanced into severe musket fire and suffered heavy casualties. Four of the ten company commanders were wounded.[466]

A loss of this magnitude might have crippled many regiments and caused an attack to falter and collapse. Not in the Fifth. At this critical time, the soldiers stepped up. Four men, three sergeants and Milton, who had been temporarily assigned as sergeant major, rallied the officerless companies and led them forward.

Maj. Gen. Benjamin Butler,[467] who commanded the Army of the James, to which the Fifth belonged, watched the assault: "The enemy concentrated their fire upon the head of the column. It looked in one moment as if it might melt away. The colors of the first battalion went down, but instantly they were up

again but with new color bearers. Wonderfully they managed to brush aside the abatis, and then at double quick the re-formed column charged the second line of abatis. Fortunately they were able to remove that in a few minutes, but it seemed a long time to the lookers on. Then, with a cheer and a yell that I can almost

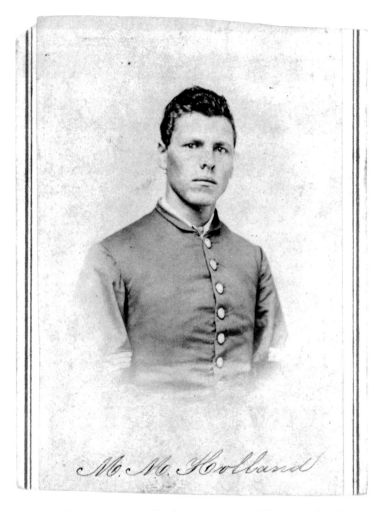

1st Sgt. Milton Murray Holland, Company C, Fifth U.S. Colored Infantry

Carte de visite by unidentified photographer, about 1864–1865. Collection of the Library of Congress.

hear now, they dashed upon the fort. But before they reached even the ditch, which was not a formidable thing, the enemy ran away and did not stop."[468]

Milton and the three sergeants received the Medal of Honor for their actions.[469]

New Market Heights marked the pinnacle of Milton's military career and a life journey that had begun twenty years earlier in East Texas. He is said to have been born to a slave woman and white man named Bird Holland. In the 1850s, Mr. Holland purchased the freedom of his alleged son, who was owned by Holland's half-brother, and sent the boy to Ohio to be educated and trained. Young Milton attended the Albany Manual Labor Academy, where he learned to make shoes, and became an apprentice to an Albany boot and shoemaker.

Eager to enlist in the Union army after the start of the war but ineligible because of his color, Milton signed on as a personal servant to peacetime state politician Nelson Van Vorhes,[470] a first lieutenant in the Third Ohio Infantry. Milton used his time in this position to observe and learn the art of soldiering.[471]

Van Vorhes went on to command the Ninety-second Ohio Infantry as colonel. Holland enlisted in the 127th Ohio Infantry in June 1863. The regiment joined federal service as the Fifth U.S. Colored Infantry. Holland's leadership at New Market Heights helped the regiment to victory. He emerged uninjured and went on to fight with the survivors in other actions during the siege of Petersburg and Richmond, the January 15, 1865, capture of Fort Fisher, North Carolina, and the campaign that ended in the surrender of Lt. Gen. Joseph Johnston's Confederate army on April 26, 1865.[472]

Meanwhile, Milton's alleged father Bird Holland had become an officer in the Confederate Twenty-second Texas Infantry. He died in action against Union troops in Louisiana at the Battle of Sabine Crossroads in April 1864.

Milton left the army after the Fifth mustered out of the service in September 1865. Military officials did not grant him the commission as an officer that he hoped for. One writer blamed

this denial for postwar emotional problems that Holland experienced: "Had he been white he would have received a commission and much of that pessimism and depression that clouded the latter years of his life might have been avoided."[473]

Despite these problems, Milton Holland led a productive life. He returned to Ohio and married Virginia Dickey. In 1869 they moved to Washington, D.C., where he studied law and worked in the U.S. Post Office and the Treasury Department. He dabbled in banking, real estate, and insurance. Active as a Republican, he spoke out on various issues on behalf of African Americans. His farm on the outskirts of the District of Columbia, in Silver Spring, Maryland, became a gathering place for black society.

On May 14, 1910, Milton collapsed with a heart attack at his office and was brought home, where he suffered a second episode and died the next morning at age sixty-five. His remains rest in Arlington National Cemetery.[474]

One newspaper remembered him as "one of the bravest colored soldiers during the Civil War."[475]

Assault on New Market Heights

A FOOT SOLDIER NAMED MAJOR MEEKINS AND HIS COM-
rades in Company K of the Thirty-sixth U.S. Colored Infantry
emerged from a stand of young pine into an open plain while
a hail of cannon and musket fire rained down upon them from
Confederate entrenchments along New Market Heights south-
east of Richmond, Virginia, on the morning of September 29,
1864. Meekins and his regiment, arranged in a double line of
battle with the rest of its brigade, charged 800 yards to the en-
emy's formidable works.

Brigade commander Col. Alonzo Draper[476] reported what
happened next: "Within twenty or thirty yards of the rebel line
we found a swamp which broke the charge, as the men had to
wade the run or stream and reform on the bank. At this juncture,
too, the men generally commenced firing, which made so much
confusion that it was impossible to make the orders understood.
Our men were falling by the scores."[477] Amidst the chaos and
carnage white officers and black noncommissioned officers ral-
lied the troops, who began to yell and with a shout went up and
over the enemy entrenchments and drove the Confederates out.
Col. Draper added, "Many sergeants of the Thirty-sixth distin-
guished themselves in urging on the men."[478] Meekins, who grew
up not far from Petersburg, was one of the sergeants in action
that day.

Meekins had been a slave in nearby New Kent County. He
had become separated from his parents during childhood and
only vaguely remembered them. "I think my father's name was
Bat Meekins[479] and my mother's Sippy or Susan Meekins. Father
was a slave to the same people I was and so was my mother.
Our master's name was Dick Crump[480] and I was born a slave to

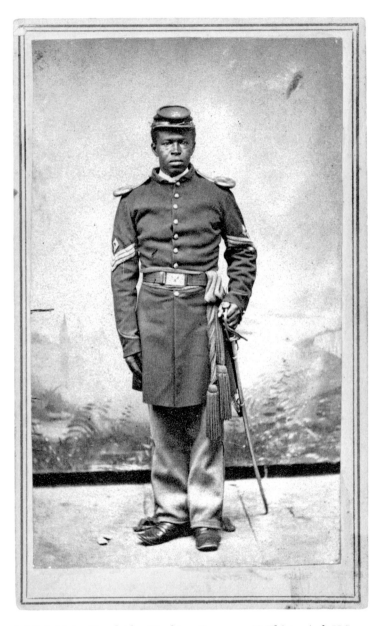

1st Sgt. Major Dandridge Meekins, Company K, Thirty-sixth U.S. Colored Infantry

Carte de visite by unidentified photographer, about 1865–1866. Collection of the Wisconsin Historical Society.

him. I got my name from my mother and father."[481] They named him Major Dandridge Meekins, a tribute to John Dandridge, a notable figure in the early history of the county and the father of Martha Washington.

"I had a slave wife named Patience," Meekins explained, "but she was sold away from me during the war or just as it broke out." He never saw her again.[482]

In October 1863, Meekins enlisted in the army at Portsmouth, Virginia, about seventy-five miles southeast of New Kent County. He joined the Second North Carolina Colored Infantry, a new Union regiment composed of volunteers from the border region of the two Confederate states. In 1864, authorities changed its designation to the Thirty-sixth U.S. Colored Infantry and assigned it to the Army of the James.

The assault on New Market Heights turned out to be the largest fight in which the Thirty-sixth participated. The federals succeeded in capturing a portion of the enemy entrenchments. Optimistic Union leadership had hoped the battle would end in the capture of Petersburg and Richmond, but the attackers were unable to crack the Confederate defenses. The cities held out for another six months. They finally fell to Union troops on April 3, 1865.

The Thirty-sixth received praise from division commander Brig. Gen. Charles Paine,[483] who noted that the regiment "behaved excellently."[484] Maj. Gen. Benjamin Butler, who commanded the Army of the James, ordered that the Thirty-sixth and eight other regiments "have the words New Market Heights inscribed upon their colors, for their gallantry in carrying the enemy's works at that point."[485]

After the war ended, the Thirty-sixth went to Texas for duty along the Rio Grande, part of a show of force against French troops occupying much of Mexico. In early 1866, France announced that it would withdraw its forces. Meekins and the rest of his regiment mustered out of the army before the end of that year.[486]

Meekins returned to Virginia and settled in Norfolk. He

owned and operated several businesses, including a saloon, a restaurant, an ice dealership, and a coal and wood delivery service. In 1867, a Methodist minister married Meekins and Sarah Pitts. They had one child, Mary Liza, who died in 1871. After Sarah's death in 1903, Meekins wed Maggie Cross, a woman thirty years his junior. She survived him after he succumbed to acute gastritis at age seventy-nine. He died on April 9, 1918, the fifty-third anniversary of the surrender of the Army of Northern Virginia at Appomattox Court House.[487]

Wounded at New Market Heights

AS THE FIRST RAYS OF SUNLIGHT STREAKED ACROSS THE Virginia sky above frontline positions at Richmond and Petersburg on September 29, 1864, Pvt. John Spence and his comrades in Company F of the Sixth U.S. Colored Infantry plunged into an almost impenetrable slashing of tree trunks and limbs fronting New Market Heights amidst a hail of artillery and small arms fire from well-entrenched Confederates. One captain recalled, "As we urged our way onward we were utterly unable to protect ourselves in any way. As we advanced I noticed our ranks getting thinner and thinner, and wondered what was becoming of the men."[488]

The captain continued, "We pressed on until we got through the slashing, into an open space before the enemy's rifle pits."[489] Confederate fire overwhelmed them. They were forced to withdraw. The fighting lasted about forty minutes. Of the 367 men from the Sixth who went into action, 210 became casualties—about six of every ten men.[490] Spence suffered three wounds caused by the bursting of an artillery shell.[491]

Soldiers placed Spence in an ambulance, which carried him to a hospital boat moored in the Appomattox River. The ship transported him and other casualties to a military hospital at Point of Rocks, located a few miles upriver from the sprawling Union base at City Point. There a surgeon removed one fragment embedded in the muscles of his right hip, treated a flesh wound in the biceps of his left arm, and repaired severed tendons between the ring and little fingers of his right hand.

Spence had grown up about two hundred miles north of the place where he suffered his wounds. Born free in Talbot County, Maryland, he moved to Delaware in his youth. According to one

account, a white farmer in Kent County, Delaware, raised him. About 1858 he met Elizabeth Davis. The couple married two years later and moved to Wilmington.[492]

In the summer of 1863, Spence left home and joined the Sixth, one of ten black regiments organized in Pennsylvania. After training at Philadelphia's Camp William Penn, the Sixth reported to Virginia for duty. It participated in numerous campaigns in the commonwealth and in North Carolina. An histo-

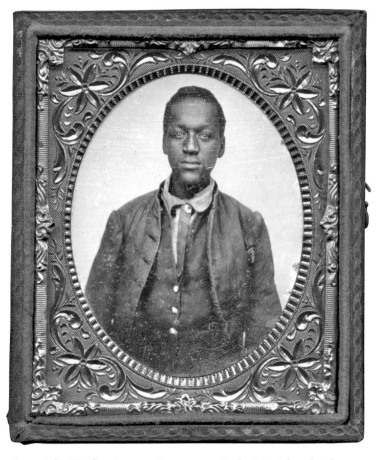

Corp. John Wesley Spence, Company F, Sixth U.S. Colored Infantry

Tintype by unidentified photographer, about 1863–1865. Collection of Gary L. and Theresa Raines.

rian noted, "In its two years of service the regiment had a more active part in a field of operations covering a large portion of two States than any other colored regiment mustered in Pennsylvania."[493]

The Sixth achieved its most notable record at New Market Heights, one target in the Army of the James's two-pronged attack designed to break the formidable defenses that protected the Confederate capital. More than twenty thousand Union troops participated. The charge by the Sixth and other regiments prevented Confederate troops from reinforcing the second target, nearby Fort Harrison, which fell to federal forces later on the 29th. The attacks caused the Confederates to readjust their weakened lines but did not gain the complete breakthrough that Union generals had hoped would result in the fall of Petersburg and Richmond.[494]

After two months in the hospital, Spence returned to the Sixth, in December 1864. He went on to participate in the capture of Fort Fisher and the Carolinas Campaign. He received his corporal's stripes in July 1865 and mustered out with his comrades two months later.[495]

Spence returned to Elizabeth in Delaware. In 1866 she gave birth to their only child, a girl. Both worked to support themselves and their daughter. Elizabeth took in washing, while Spence held several jobs, including laborer in a New Jersey brickyard, farmhand in Pennsylvania, and in Wilmington as an employee of the Lobdell Car Wheel Company, at one time the world's largest manufacturer of railroad car wheels.

Elizabeth remembered, "He would go off to work in different places, and then return home." In 1877 Spence went off to West Chester, Pennsylvania, but never returned. He had found work in a brickyard—and a new wife, Virginia-born Hannah Jamison, a woman ten years his senior.[496]

Spence never divorced Elizabeth. He lived with Hannah until he died in 1883 at about age fifty-five. A doctor declared his cause of death to be exhaustion due to liver disease and a bout with typhoid.[497]

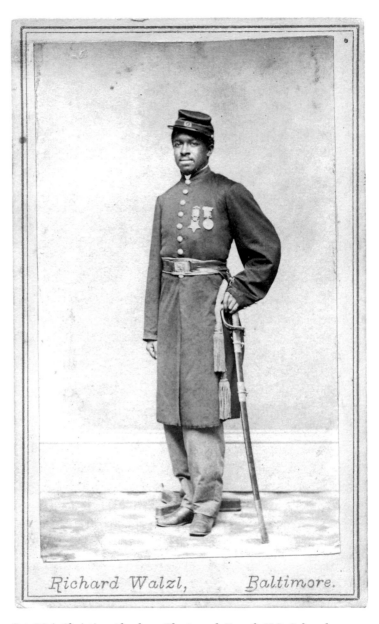

Richard Walzl, Baltimore.

Sgt. Maj. Christian Abraham Fleetwood, Fourth U.S. Colored
Infantry

Carte de visite by Richard Edmund Walzl (1843–1899) of Baltimore, Maryland,
after April 1865. Collection of Steve Turner.

"Boys, Save the Colors!"

SMALL IN STATURE, QUIET AND UNASSUMING, BOOK-keeper Christian Fleetwood ranked as one of the best and brightest talents in Baltimore's African American community. "As soon as the government decided to employ colored soldiers he threw down the pen and took up the sword to strike for the liberties of his less favored brethren," noted an admirer. "The influence he then wielded, though young, was such as to gain a greater impetus to the enlistment of colored men than that of any other one man in the city."[498]

The claim is perhaps more impressive in light of the fact that Baltimore's free black population ranked the largest of any metropolis in the country.

Born free in 1840, Fleetwood was marked for big things early in life. His father Charley worked in the household of wealthy businessman John C. Brune and his wife Anna.[499] She took a special interest in Christian's education and doted on him as though he were her son. John Brune's middle name was Christian, and whether that became Fleetwood's first name by coincidence or by design is not known.

Brune groomed Fleetwood for a job in his prosperous sugar refinery, as chief agent to Liberia—an African colony created by former American slaves that was rich in the resource upon which his business thrived. Brune sent him to Liberia and other nations on the continent to learn about the commodity. After Fleetwood returned, Brune put him in a clerical job, to train him as a bookkeeper, and then sent him to Ashmun Institute in Oxford, Pennsylvania, where he graduated as valedictorian in 1860. Fleetwood began an apprenticeship at a Baltimore firm and prepared to take his place in Brune's company.[500]

Then the war came and forever altered Fleetwood's career path. Brune sided with Maryland's secessionists and later fled to Canada. Fleetwood enrolled in the Fourth U.S. Colored Infantry in the summer of 1863 and within two weeks became the regiment's sergeant major—the highest rank permitted to a man of color at the time. He proved himself not only an able leader in camp and on the parade ground but a courageous and daring fighter in combat.[501]

On September 29, 1864, along the front lines of Petersburg and Richmond, the Fourth and other units prepared to attack a well-entrenched Confederate position on New Market Heights. "Our regiment lined up for the charge with eleven officers and 350 enlisted men," noted Fleetwood, who took his place on the right flank.

The Fourth advanced into a heavy fire, its twelve-man color guard led by two sergeants; one grasped the regimental standard and the other the Stars and Stripes. Early in the action a musket ball tore into one of the wooden staffs, snapped it in two, and passed through the body of the sergeant who carried it. As described by Fleetwood, the remaining color bearer, "a magnificent specimen of manhood, over six feet tall and splendidly proportioned, caught up the other flag and pressed forward with them both."[502]

The firing increased. "It was a deadly hailstorm of bullets, sweeping men down as hailstones sweep the leaves from the trees, and it was not long before [the color bearer] went down, shot through the leg. As he fell he held up the flags and shouted: 'Boys, save the colors!'" recounted Fleetwood. Before the banners could touch the ground, a corporal grabbed the regimental flag and Fleetwood the American banner.[503]

About this time, Fleetwood observed, "it was very evident that there was too much work cut out for our regiments. Strong earthworks, protected in front by two lines of abatis and one line of palisades, and in the rear by a lot of men who proved that they knew how to shoot and largely outnumbered us. We struggled through the two lines of abatis, a few getting through

the palisades, but it was sheer madness, and those of us who were able had to get out as best we could. Reaching the line of our reserves and no commissioned officer being in sight, I rallied the survivors around the flag."[504]

A total of 177 men became casualties, about half the regiment.[505] Fleetwood emerged without a scratch. "A bullet passed between my legs, cutting my bootleg, trousers and even my stocking, without breaking the skin."[506]

In April 1865, Fleetwood, the corporal, and the big sergeant received the Medal of Honor for saving the flags. Fleetwood posed for his *carte de visite* portrait with the star-shaped medal pinned to the chest of his uniform coat. He also donned his Butler Medal, awarded to him for courage by Maj. Gen. Benjamin Butler, the commander of the Army of the James, to which the Fourth belonged.[507]

Fleetwood left the army in 1866 without a hoped-for commission as an officer, disappointed that men of color were marked for subservient roles despite proven success as soldiers. Celebrated for his wartime achievements, he worried publicly that the memory of the role of African Americans in the Civil War would be lost to history.

In his 1895 paper, "The Negro as a Soldier," read to an audience in Atlanta, Georgia, he stated, "History repeats itself in the absolute effacement of remembrance of gallant deeds done for the country by its brave black defenders and in their relegation to outer darkness."[508] He urged the assemblage never to forget.

Fleetwood lived until age seventy-four. He died of heart failure on September 28, 1914, one day shy of the fiftieth anniversary of the Battle of New Market Heights. A daughter survived him. His wife, Sara, a wartime nurse and later a noted teacher and activist, predeceased him.

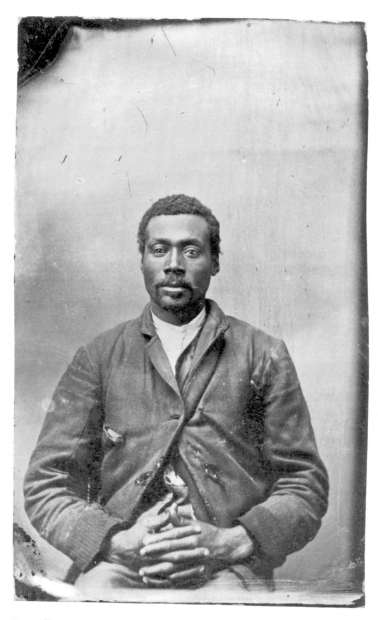

Pvt. Allen W. King, Company B, 122nd U.S. Colored Infantry

Tintype by unidentified photographer, before 1881. Collection of National Archives and Records Administration, Washington, D.C.

Sold into Substitution

POPULAR HUMORIST MARK TWAIN WROTE NUMEROUS stories about the war, including an account of his own brief experience as a Confederate soldier. The story of his cousin, Kentucky physician John Clemens,[509] is little known.

Dr. Clemens decided not to join the Union army after the government drafted him in 1863.[510] Recently widowed and left with a young son, he elected to pay for a substitute to take his place, a legal option exercised by many men across the North.[511] The brother of his late wife, attorney Ed Russell,[512] arranged the deal. Russell contracted with Kentucky farmer Pete Walkup[513] to buy one of his slaves, a young man named Allen, to stand in for John Clemens.[514]

Walkup had owned Allen for seven years. "He was about eleven years old when I bought him, and he was about 18 years old when I sold him. It was toward the close of the war, and the negroes were running away, and I took a small price for him, as he was threatening to leave."[515]

After the sale closed, Allen went to Louisville. On October 1, 1864, he enlisted in the army in place of Dr. Clemens and joined the 122nd U.S. Colored Infantry. Although he enlisted as Walkup, the name, perhaps misheard, was recorded as Walker. He would later change his last name to King, in honor of his father, Beverly King.[516]

The regiment left Louisville for Virginia in early 1865 and served various duties during the final months of the war. Allen did not accompany his comrades. Plagued by ailments, including acute rheumatism, he spent almost a full year in military hospitals in Louisville and just across the Kentucky border in New Albany, Indiana. He rejoined the regiment on November 5,

1865. By this time it had been redeployed to Texas. Six days after he arrived, his term of enlistment expired and he mustered out of service.[517]

Allen returned to Kentucky and settled in Columbia. He worked several jobs, including as a servant at a boarding house. The establishment owner remembered Allen King as a "rather small spare made man," and noted, "He was one of the quickest most active men I ever saw."[518]

In 1882, King met Joannah Morrison, an unwed mother of four. The couple fell in love and left Kentucky for Illinois in search of a better life.[519] There they married and started a family that grew to include three girls and a boy. In the mid-1890s, King's health fell into decline due to heart and kidney disease. He passed away in 1898 at about age fifty-five.

"Shall We Sustain the Government?"

THROUGH THE SUMMER OF 1864, AS UNION ARMIES appeared to be in a stalemate with the Confederates before Richmond and Atlanta, as a war-weary population across the North considered whether to continue the fight or settle for peace, and as the reelection of President Abraham Lincoln looked anything but a foregone conclusion, an African American sergeant in Kentucky publicly raised the question whether men of color should support the U.S. government in its time of peril. He answered with a resounding yes.

Sgt. Charles Singer of the 107th U.S. Colored Infantry, the eldest of eight children born to a Covington, Kentucky, barber and his wife,[520] explained his thoughts in a letter to the editor of *The Christian Recorder*,[521] a weekly newspaper widely read by rank and file in black regiments.

For Singer, personal liberty lay at the heart of the matter. "Freedom! What a glorious word to commence with! I place it above all others, except my God. I never was a slave; but my imagination furnishes to me a picture, which must approximate somewhat to the reality of that miserable condition. I sincerely and candidly think that every man in the North should, to the fullest extent of his abilities, aid and further the cause of freeing the slaves, now held in bondage by Southern tyrants."[522]

He cautioned readers: "We should not forget the fact, that the free colored man's elevation is at issue, as well as the slave's. Suppose the rebel army was as far North as the Union Army is South, what would be the result? I will tell you. Our homes would be burned to the ground, and our aged and defenceless parents barbarously treated. Rather than have such outrages perpetrated, I would remain in the army the rest of my life.

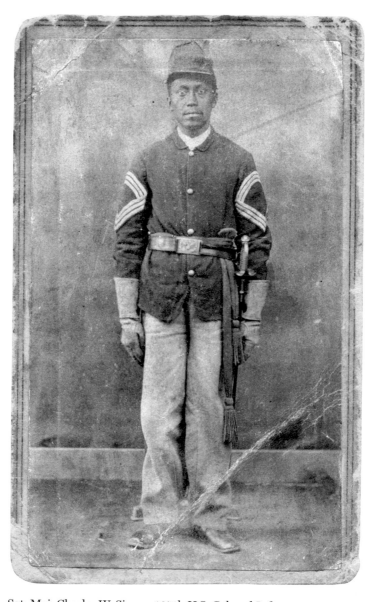

Sgt. Maj. Charles W. Singer, 107th U.S. Colored Infantry

Carte de visite by unidentified photographer, about 1866. Collection of the Gettysburg National Military Park Museum.

Should this Government be overthrown, the experiment of civil and religious liberty will be overthrown with it."[523]

He considered the situation from a global perspective. "Remember, soldiers, we are fighting a great battle, for the benefit, not only of the country, but for ourselves and the whole of mankind. The eyes of the world are upon us, and on the result depends our future happiness." He added: "I hope that we may never see the day that we cannot speak for the cause of freedom. Why should we not cling, with courage, to this Government— her interests, laws and institutions? There are many reasons for so doing. It is not merely that I am grateful for the protection and citizenship that I may hope for; but I recognize in the stability of this Government a source of strength to other nations. While this Government stands, there is hope for the most abject, disabled and helpless of mankind."[524]

Singer took a long view of civil rights. "Some say: 'Show me what the colored man has to fight for, and then I will go.' You cannot see it now; but wait until some future day, and it will unfold itself most gloriously to the whole country. We want the rights of freemen, and must have them; but we can never get them if the South gain its independence. If I were now a slave at the South, my motto would be: 'Give me liberty, or give me death!' I hope that motto will ring throughout the entire length and breadth of the rebel States, and fire the hearts of the men."[525]

By the time Singer's letter to the editor appeared in print, on October 8, 1864, the majority public opinion in the North had turned in favor of a continuation of the war, due in large part to military successes: Maj. Gen. William T. Sherman had captured Atlanta and Maj. Gen. Philip H. Sheridan's troops had turned the tide decisively against Confederate forces in the Shenandoah Valley.

One month later, Americans elected President Lincoln to a second term. About this time, the 107th left Kentucky for frontline positions in Virginia. Soon after the regiment arrived, medical authorities hospitalized Singer, treating him first for an undisclosed ailment and then for rupia, skin ulcers usually

caused by syphillis, which he had probably contracted before he enlisted.[526]

He remained in the hospital for one year. During his absence, the 107th participated in the mid-January 1865 capture of Fort Fisher, North Carolina, and the Carolinas Campaign, which ended in the surrender of the Confederate armies commanded by Gen. Joseph E. Johnston.

Singer rejoined the 107th in November 1865 and received a promotion to sergeant major. He served in this capacity at various posts in North Carolina and in the military Department of the South until November 1866, when he mustered out of the army with the rest of the regiment.[527]

Singer settled in Ohio and became a violin player and music teacher in Cincinnati. He never married. He belonged to the Catholic Church. In the late 1890s, rheumatism and failed hearing forced him to give up his life as a musician, and he became a waiter.[528]

Singer entered the Soldier's Home in Dayton in 1910 and died there of heart problems five years later at age seventy-five.[529]

"Co. B, I Shall Remember You"

On a late October day in 1864 along the front lines near Petersburg, Virginia, as battle raged in the vicinity of the Boydton Plank Road and Hatcher's Run, the colonel of the Nineteenth U.S. Colored Infantry ordered Company B to join a brigade already deployed in an advanced position.[530]

The men formed a line and marched into a wooded area led by their first lieutenant and an aide from the brigade staff. The officers marched some distance ahead of the company. They soon ran into trouble. The lieutenant explained, "The first thing I know the rebs were on my left flank and nearly in my rear." A Confederate volley surprised the troops and scattered the officers. The company quickly recovered, rallied, and drove off the enemy. Then they found the brigade and joined it on the skirmish line for a sleepless thirty-six hours.[531]

The ranks of Company B included a new corporal, Jacob Johns, who hailed from Talbot County on the Eastern Shore of Maryland. He had joined the army in December 1863.[532] Whether he was enslaved, recently freed, or long free at the time of enlistment is not known. After basic training and a stint on duty in Baltimore, he and his comrades reported to Virginia, in the spring of 1864, for service in the Army of the Potomac. Clerks listed Johns as present for duty in May, when the regiment guarded supply trains during the Battle of the Wilderness, and on July 30, when it suffered 115 casualties at the Battle of the Crater during the Siege of Petersburg.[533]

Johns's Company B participated in various actions on the front lines of Petersburg through the summer and fall of 1864, including the Battle of the Boydton Plank Road on October 27–28, where the company narrowly avoided being captured in the

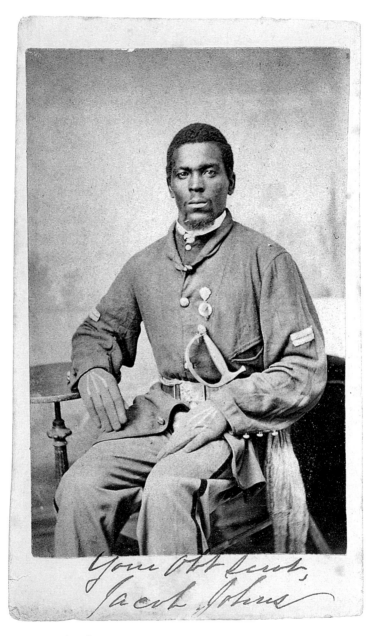

Corp. Jacob Johns, Company B, Nineteenth U.S. Colored Infantry

Carte de visite by unidentified photographer, about December 1866. Courtesy of Cowan's Auctions, Cincinnati, Ohio.

encounter with Confederates as it advanced to participate in the thirty-six-hour skirmish.

Upon its return, Company B received praise from Col. Henry Thomas,[534] who had ordered them into action. Charlie Stinson,[535] a lieutenant in charge of the company, recalled that Thomas approached him and, "extending his hand said I wish to thank you and your Co. for the manner in which you conducted yourself on the line. Then he turns to the Co. and says 'Co. B, I shall remember you. I sent you out on the skirmish line because I knew you would do better than any other Co. and I was not deceived in the least.'"[536]

The men of the Nineteenth remained in the Petersburg area and were among the first Union troops to occupy Richmond after the Confederate capital fell, on April 3, 1865. The regiment left for Texas two months later and served the remainder of its enlistment there.

Johns mustered out with his comrades on January 15, 1867. At the time, he was in a hospital to which he had been admitted with an unnamed disease. He died five days later at about age twenty-four. A sister, Eliza, survived him.[537]

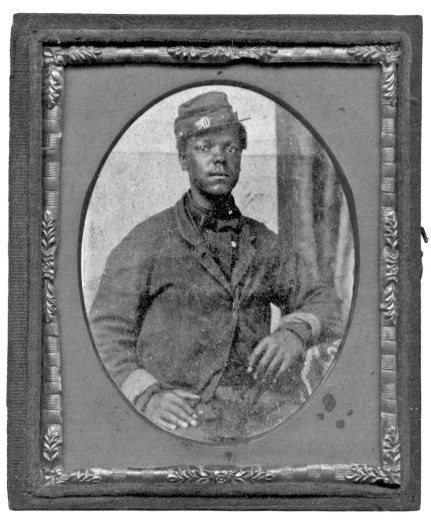

Pvt. George Alexander, Company I, Fourteenth U.S. Colored Infantry

Tintype by unidentified photographer, about 1863–1865. Collection of Cindy and Clint McCauley.

"Respect for the Fourteenth Colored"

On the morning of October 28, 1864, in northern Alabama near the banks of the Tennessee River at Decatur, Pvt. George Alexander and about four hundred comrades in the Fourteenth U.S. Colored Infantry prepared to assault entrenched Confederate infantry and artillerists. They stripped themselves of all personal items that might slow them down, and formed a line of battle armed with muskets and round, or rat-tail, files.[538]

The files were to be used to spike four cannon, following the standard method of ramming the long metal objects into the vent holes of the artillery pieces, thereby rendering them useless. The men "were cautioned that a battery was to be charged and taken, if only ten men survived to take it," explained the Fourteenth's commander, Col. Thomas Morgan,[539] who added, "They manifested no undue excitement or fear, but seemed anxious for the work."[540]

The regiment moved out at noon and charged 780 yards under fire. In minutes they drove away the gray troops and captured the artillery. "The enemy recovered from its fright," reported Col. Morgan, "and while I occupied his works reformed and moved for my rear, and rendered my position very hazardous."[541]

Morgan ordered a hasty retreat. Unable to take the captured cannon with them, his troops managed to spike two of the guns with the files. The other two artillery pieces were left behind intact. Morgan reported fifty-five casualties. Alexander survived the battle without injury.

George Alexander was born in the East Tennessee county of McMinn. Little is known of his early life other than that he

worked as a wagon driver before enlisting in the army at age twenty-two, in December 1863, at Gallatin, about thirty miles from Union-occupied Nashville.[542] He was assigned to the Fourteenth.

After a few months in Nashville, the regiment moved to Chattanooga, from which they participated in several expeditions. The first, a march to relieve a Dalton, Georgia, garrison under attack by Confederate raiders, culminated in a victorious charge by the Fourteenth and other forces on August 14–15, 1864. Col. Morgan wrote, "It was their first encounter, and they evinced soldierly qualities; the men were brave and the officers cool."[543]

Two months later, in Alabama, the regiment again proved its valor when it spiked the guns at Decatur. The action slowed the advance of Gen. John B. Hood's Army of Tennessee as it marched northward on a planned invasion of Alexander's home state. The Fourteenth "received an ovation from the white troops, who by the thousands sprang upon the parapets and cheered the regiment," recalled Morgan, who noted that the lieutenant colonel of the Sixty-eighth Indiana Infantry[544] requested that Morgan's regiment "might be brigaded with mine, giving as a reason that his soldiers had such respect for the Fourteenth Colored that they wanted to fight side by side with it."[545]

The Fourteenth met Hood's army a second time before the end of the year. On December 15, 1864, the regiment fought in the Battle of Nashville and contributed to the rout of Hood's Confederate army as a fighting force, at a cost of sixty-five casualties.

Alexander again emerged unscathed. He remained in the ranks and mustered out with his comrades in March 1866 at Nashville. He settled in Arkansas and became a farmer. In 1883, at about age forty-three, he married a woman twenty years his junior and started a family that grew to include ten children, eight of whom were alive at the turn of the century.[546] He lived until about 1911.[547]

Cruising with the Potomac Flotilla

On a fall day in 1864 along the Potomac River just south of Washington, D.C., George Commodore and his shipmates aboard the navy schooner *Adolph Hugel* happened upon the civilian sloop *James Landry*. Its crew appeared to be busy harvesting oysters at a place where the mollusks were not known to live. The *Hugel* investigated. The captain of the *Landry* admitted he was a smuggler. A search of the vessel turned up items not registered in the ship's manifest and passengers without proper papers.[548] The *Landry*'s days as an illegal trader were over.

Commodore had served in the navy only a few months before the incident. He had had no experience as a seaman prior to his enlistment, but he had worked on the water. Freeborn and raised in Baltimore, he earned a living as a dragman, a fisherman who uses a net. In the mid-1850s Commodore married Sarah Jones, whom he had known since childhood. She labored as a laundress and servant. "They were both hard-working people," remembered a friend.[549] Commodore apparently played hard, too: in 1859, he and another man were arrested and briefly held for gambling, when a constable observed them playing "sweat," a game of chance that involves a cup and three dice.[550]

Commodore joined the war effort in July 1864 at about age thirty-nine. He must have taken some ribbing, his surname being the same as a high naval rank. He served aboard three ships in his first three months, starting out on the *Allegheny*, a mammoth iron-hulled steamer used to train sailors. He then reported to the *Don*, a captured British blockade-runner converted for use by the U.S. Navy and assigned to patrol duty as part of the Potomac River Flotilla. In early October he transferred to the

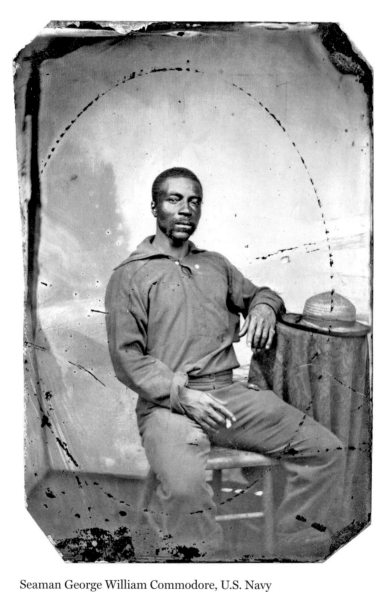

Seaman George William Commodore, U.S. Navy

Tintype by unidentified photographer, about 1865–1867. Collection of National Archives and Records Administration, Washington, D.C.

Hugel. Constructed in Philadelphia in 1860[551] and purchased by the navy in 1861, it participated in operations against New Orleans and Vicksburg before joining the Potomac flotilla. Commodore was part of an almost entirely African American crew— forty-six of forty-eight sailors were men of color.[552] The *James Landry*, captured on October 28, 1864, was the fifth and final prize taken by the *Hugel* while it was involved in the crackdown on smugglers operating in Maryland and Virginia.

In May 1865, Secretary of the Navy Gideon Welles ordered the Potomac Flotilla halved in size.[553] The *Hugel* was among the ships cut. Commodore was sent to the fleet's base at the Washington Navy Yard and then reassigned as a cook. He served in this capacity for the remainder of his service. During this time he sat for his tintype portrait, which he sent to Sarah, who often made the short trip from Baltimore to visit him.[554]

Commodore mustered out of the navy in July 1867 and rejoined Sarah in Baltimore. They had seven children, five born before his navy service and two afterwards.[555]

According to a friend, Commodore "was always a nice man." Among his kindnesses was the purchase of a small plot of land and house located along the Anacostia River in Washington, D.C., for his widowed mother and a sister.[556]

He died in 1885 of heart disease at about age sixty. The Independent Order of Odd Fellows, a fraternal organization to which he belonged, purchased a plot in Baltimore's Laurel Cemetery for his remains.[557]

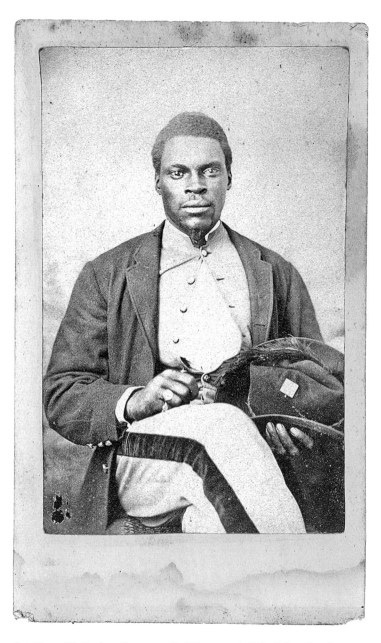

Sgt. Peter H. Butler, Company B, Nineteenth U.S. Colored Infantry

Carte de visite by unidentified photographer, about December 1866. Courtesy of Cowan's Auctions, Cincinnati, Ohio.

A Tacit Understanding Is Broken

On December 31, 1864, newly appointed corporal Peter Butler and his comrades in the Nineteenth U.S. Colored Infantry marched out of their winter quarters and through the Virginia countryside in rain and snow, slogging through slush and mud, to a new position outside Richmond near Bermuda Hundred. They arrived after sundown. Their wet and mud-spattered uniforms froze stiff as temperatures fell.[558]

"Our regiment was detailed for picket," explained one captain, "and relieved some white troops, who had a tacit understanding with the enemy not to fire on each other's relief when changing. This was in the night, and at daylight we stood facing the rebels, only a few rods apart. They were evidently angry at being confronted by negroes, and to some of the conversation of the officers replies were made that boded trouble."[559]

The Confederates soon attacked with a yell and muskets blazing. The Nineteenth recoiled from the initial shock, then rallied and drove the enemy back.[560]

Butler survived his first combat as a corporal and his first year as a soldier. A slave in southern Maryland prior to his enlistment, he was not freed by the Emancipation Proclamation, which applied only to those enslaved in seceded states. His owner, Peter Crain,[561] a former Maryland circuit court judge and state legislator who once kept thirty-nine slaves, gave his consent for Butler to join the Union army.[562] On Christmas Eve 1863, Butler enlisted as a private in Company B of the Nineteenth.[563] He and his comrades received basic training in Maryland and then reported to Virginia for duty with the Army of the Potomac's Ninth Corps.

The company's first assignment was to guard supply trains

during Lt. Gen. U. S. Grant's Overland Campaign. Beginning in the summer of 1864, they participated in operations associated with the Siege of Petersburg, including the Battle of the Crater on July 30. They remained on the Petersburg lines through year's end. The December 31 march that ended in the Confederate attack at Bermuda Hundred also marked the transfer of the regiment to the Army of the James's newly constituted all–African American Twenty-fifth Corps.

Butler wore the diamond-shaped corps emblem on a badge pinned to his plumed hat when he sat for his *carte de visite* portrait about 1866. By this time the Nineteenth had moved to Texas as part of a fifty-thousand-man U.S. force sent to threaten French troops who had invaded and occupied a significant portion of Mexico.

Butler mustered out with his comrades at Brownsville, Texas, on January 15, 1867, the last time his name appears on a government record.[564] He was then about twenty-five years old.

On Guard at Rock Island

D URING THE WINTER OF 1864–1865, FRIGID TEMPERA-
tures and snowstorms made life miserable for thousands of
Confederates huddled in the prisoner of war camp at Rock Is-
land, Illinois. To make matters worse, smallpox and other dis-
eases sickened the men, filling the camp hospital and cemetery.
Union soldiers on the other side of the stockade also suffered
in the harsh climate. "Many of our men froze their feet while on
guard and had to be taken to the Hospital," noted an officer.[565]
Others fell ill with colds, including Sgt. Abram Garvin of Ken-
tucky.[566]

Prior to his enlistment, Abram toiled in bondage as a farm-
hand and blacksmith in Hart County, one of about nineteen
slaves owned by Sinclair Garvin,[567] a Virginia native in his six-
ties who had settled in the village of Woodsonville early in the
century.

In June 1864, Abram traveled about seventy-five miles north
to Louisville and joined the Union army with his master's con-
sent. He took his place in the ranks of the 108th U.S. Colored
Infantry, a new regiment composed mostly of former slaves
from the north and west central regions of Kentucky. He soon
received his sergeant's stripes and assumed a leadership role in
Company F.[568]

In the fall of 1864, Garvin reported with the rest of the 108th
to Rock Island for duty as prison guards. On September 26, a
Mississippi Confederate captured ten months earlier after the
Battle of Lookout Mountain in Tennessee wrote in his diary,
"8,000 Southern men to day are guarded by their slaves who
have been armed by the Tyrant," a reference to Abraham Lin-
coln and his administration.[569]

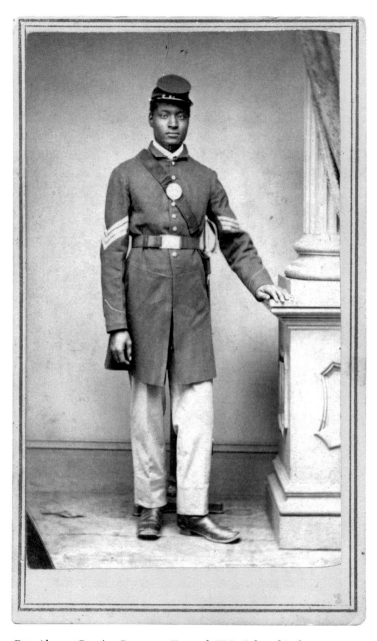

Pvt. Abram Garvin, Company F, 108th U.S. Colored Infantry

Carte de visite by unidentified photographer, about 1864–1865. Collection of the Gettysburg National Military Park Museum.

One captain in the 108th wrote of the "butternut colored cusses" in a letter to his family in Connecticut: "The Rebel prisoners here swear that they will not submit to be guarded by d—d niggers.... I don't know how they can help themselves, unless they can get away, and they will have a good time in trying to get away." He bragged about Garvin and his comrades, "These men are the best guards I ever saw. If an order is given them to guard anything, so be it to the man who attempts to interfere with them."[570]

Garvin did his duty despite the cold that settled in his lungs in January 1865. It left him with a dry, hacking cough that grew worse, even after he and the regiment were relieved from duty at Rock Island and deployed to Mississippi. A friend in another company estimated that Garvin was excused from his responsibilities about one-third of the time due to the cough. His compromised health may have caused his reduction to the ranks in the autumn of 1865.[571]

Garvin mustered out with the regiment in March 1866 and returned to Kentucky, where he died of "consumption" in 1879 at about age thirty-seven. He left behind a wife, Fanny, who was pregnant, and six children under age eleven. Family, friends, and his army buddies attributed his death to his army service.[572]

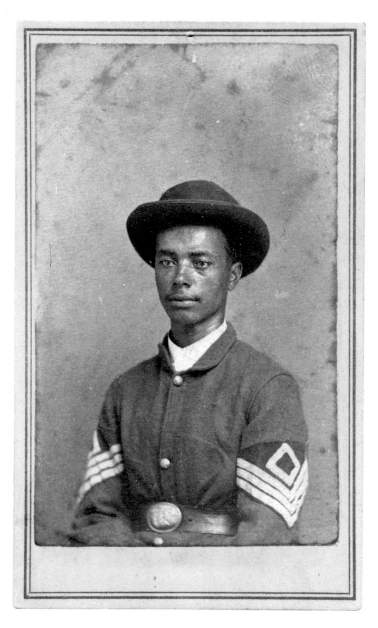

1st Sgt. Octavius McFarland, Company D, Sixty-second U.S. Colored Infantry

Carte de visite by unidentified photographer, about 1864–1866. Collection of the Gettysburg National Military Park Museum.

Studious Sergeant

OF THE NUMEROUS ORDERS ISSUED BY THE STAFF OF the Sixty-second U.S. Colored Infantry during its twenty-seven months in existence, General Order No. 4 is unique. Dated January 25, 1865, it announced a contest to recognize the best writers in the ranks. A committee of officers was appointed to judge the entries and pick thirty winners—one sergeant, corporal, and private from each of the regiment's ten companies. The top sergeant and corporal would each receive a gold pen, and the top private a "good book."[573] The deadline was set for the Fourth of July.

The troops had six months to prepare. Competition would be stiff. The standard one hundred–man company included one first sergeant, four sergeants, eight corporals and eighty-two privates. In Company K, ranking sergeant Octavius McFarland took the challenge seriously. Prior to enlistment, he and the majority of his comrades had lived in bondage and illiteracy.

Born a slave in Liberty, Missouri, a township south of St. Louis in Saint Francois County, McFarland joined the army in December 1863. He became a private in the First Missouri Colored Infantry and received his sergeant's stripes during his first month in uniform. In March 1864, army officials redesignated the regiment, which became the Sixty-second U.S. Colored Infantry. About this time McFarland advanced to first sergeant for "good conduct and faithful discharge of duty."[574]

His natural leadership qualities were strengthened by a series of general orders issued by the regimental staff to promote education. One bluntly stated, "No freed slave who cannot read well has a right to waste the time and opportunity here given him to fit himself for the position of a free citizen." Another mandated,

"All soldiers of this command who have by any means learned to read & write, will aid and assist to the extent of their ability their fellow soldiers to learn these invaluable arts."[575]

Officers intended the writing contest to encourage learning, and it succeeded. The winners were announced in July 1865. The judges selected McFarland as the best sergeant in Company K. The promised gold pen was not presented at that time because the shipment of writing implements ordered from New Orleans had been delayed.[576] It can be assumed that McFarland and the other recipients received their awards at a later date.

The Sixty-second spent its term of enlistment in Missouri, Louisiana, and Texas. At each post, the men's reading and writing skills improved.

In January 1866 a regimental reorganization consolidated the original ten companies into four. McFarland was transferred to Company D. Two months later the Sixty-second mustered out of service. Almost every soldier who had served in its ranks had learned the alphabet and could read and write. Moreover, the officers and men had donated money to fund the establishment of a school in Missouri to teach freed African Americans. Later that year, in Jefferson City, a two-room house became the first campus of Lincoln Institute.[577] The school flourished and is now known as Lincoln University.

McFarland settled in St. Louis. He found work on steamboats plying the Mississippi River and other jobs as a general laborer. He died of tuberculosis in 1894 at about age forty-eight. His body lay unclaimed in St. Louis City Hospital until local authorities buried his remains in Pottersfield Cemetery, a final resting place for those with no known next of kin.[578]

McFarland may not have had biological offspring, but in the little school that became a big university he partook in a shared legacy. As one of the school's founding officers, 1st Lt. Richard Foster,[579] proclaimed, "Lincoln Institute is the child of the 62nd regiment U.S. Colored Infantry."[580]

Simpsonville Slaughter

JETS OF WARM AIR STREAMED FROM THE NOSTRILS OF nine hundred cattle and mixed with frigid temperatures and snowflakes on a blustery January morning in 1864. The cows' hooves crunched against the frozen, snow-covered pike en route to Louisville, Kentucky, from where they would be sent south to feed Maj. Gen. George H. Thomas's hungry army. About eighty horse soldiers drove the cattle. Half were positioned in front of the herd, and half behind. The troopers belonged to Samuel Truehart's Company E of the Fifth U.S. Colored Cavalry. As the men and cattle moved outside the village of Simpsonville, the bucolic winter scene crumbled in chaos when a band of about fifteen Confederate guerrillas, "yelling like devils and shooting their pistols in the air, rode rapidly towards the panic stricken rear guard of the herd of cattle," explained an eyewitness, who added, "They began shooting down the men without compunction."[581]

The guerrillas fired with deadly accuracy, leaving a trail of dying and desperately wounded troopers in their wake. "The ground was stained with blood, and the dead bodies of negro soldiers were stretched along the road," noted one report.[582] The sudden shock spooked the cattle. The excited animals prevented the raiders from attacking the troopers riding at the head of the herd. The guerrillas disappeared into the countryside.[583]

The advance guard and alert villagers sped to the site of the massacre and counted casualties. About twenty-two cavalrymen had been killed and eight wounded.

Truehart, listed as present for duty, survived.[584] "He may well have been part of the regiment that was at the front of the herd," explained a family historian.[585]

Truehart had grown up in the same county, Shelby, where the attack occurred. Born into bondage, the son of a slave mother and free father, barrel maker Peter Truehart, he belonged to Lewis Young, a farmer who owned four slaves near the start of the war. According to a family historian, his father eventually bought his mother out of slavery.[586] But Samuel remained a slave.[587] At some point he married a boardinghouse cook, Mary Elliot. According to the family, she ran away from her master to marry Truehart.[588]

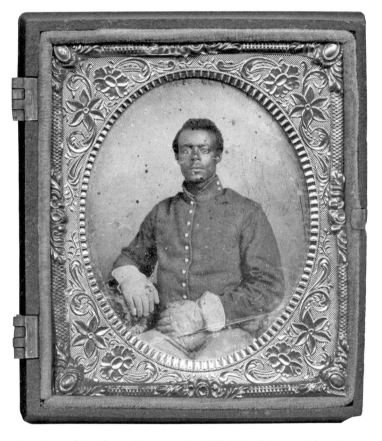

Pvt. Samuel Truehart, Company E, Fifth United States Colored Cavalry

Tintype by unidentified photographer, about 1864–1866. Collection of David E. Brown.

Saunders spent his entire enlistment at Camp Nelson. The first sergeant of his company noted, "Often times I had to excuse Corporal Jerry Saunders on the account of Diarrhoea," a complaint common to many soldiers.[599] His chronic condition

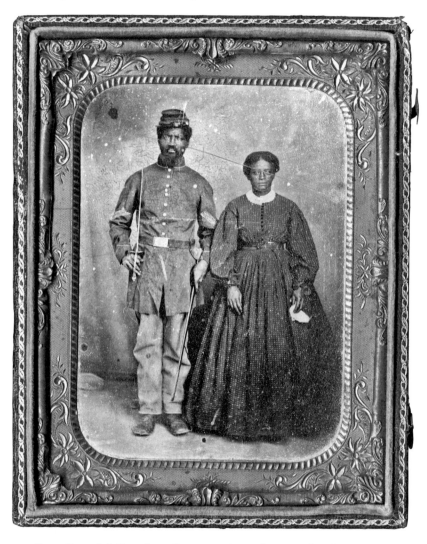

Corp. Jeremiah Saunders, Company K, 124th U.S. Colored Infantry, and his wife, Emily

Tintype by unidentified photographer, about 1865. Collection of Paul Rusinoff.

Taking Action after the Death of His Master

URIAS OFFUTT WAS DEAD. THE FIFTY-THREE-YEAR-OLD widower and father of three left behind a farm in tobacco-rich Scott County, Kentucky, and about seventeen slaves when he died on February 18, 1865.[597]

Among the slaves who worked the Offutt land was Jerry Saunders, an older man eager to leave the farm. He and the other slaves there were still in bondage, because the Emancipation Proclamation had granted freedom only to enslaved persons in the seceded Southern states. The Thirteenth Amendment to the U.S. Constitution, which would forever outlaw slavery and involuntary servitude, was still months away from being adopted by the full Congress.

After the demise of his master, Saunders made a beeline for the closest Union military establishment. He traveled to Camp Nelson, a federal army supply depot fifty miles south of the Offutt farm. The bustling hub also included facilities for refugees escaping slavery, and a major recruiting and training station for black regiments.

There he signed his enlistment papers with an "X" and joined the 124th U.S. Colored Infantry, a regiment composed of men between the ages of 35 and 45. These volunteers were considered too old for active duty but able to contribute to the army in various support roles off the front lines.[598] Saunders, his exact age unknown but probably within the age range of the other soldiers in the 124th, served as a private in Company K. He soon received a promotion to corporal. At some point afterwards, wearing the chevrons that befitted his rank, he posed for a portrait photograph with his wife, South Carolina–born Emily Spotts Saunders.

Kansas.[593] These men, women, and children became known as Exodusters.

The Trueharts migrated to the western part of the state. They took possession of a forty-acre plot near Nicodemus, an all-black town founded in 1877. However, Mary refused to live on the remote farm, so they moved about 275 miles east to Atchison.[594] Truehart worked as a teamster and earned a reputation as an industrious man.[595] Remembered as a pioneer settler, he lived until 1897.[596]

In early September 1864, Truehart joined the army at nearby Frankfort. He became a private in Company E of the Fifth Cavalry at Camp Nelson, a bustling military base overlooking the Kentucky River southeast of Frankfort. Ordered into action before organizers had completed its enrollment, the regiment joined a raid into southwestern Virginia on September 20. Its objective was the destruction of salt works near a town aptly named Saltville. The three-week expedition culminated in an assault on the well-entrenched Confederates who guarded the works.[589] The October 3, 1864, attack failed. Word of murders of black prisoners by their captors overshadowed the news of the outcome of the battle. The Fifth Cavalry, who had fought dismounted, suffered heavy casualties but received praise for its performance. The regiment's commander, Col. James Brisbin,[590] in peacetime an antislavery orator, declared, "I can only say that the men could not have behaved more bravely. I have seen white troops fight in twenty-seven battles and I never saw any fight better."[591]

Medical staff admitted Truehart to a Camp Nelson hospital with an undisclosed ailment at the end of the expedition. He may have returned to duty in time to participate in the second effort to destroy the salt works, on December 20–21. This time they succeeded.

A month thereafter, on January 25, 1865, the guerrillas attacked Company E as it drove cattle from Camp Nelson to Louisville. Newspapers North and South reported the killings, which came to be known as the "Simpsonville Slaughter." The *Louisville Journal* noted, "It was a horrible butchery."[592]

The Fifth spent the remainder of its enlistment on garrison duty in Kentucky and Arkansas. Truehart mustered out with his comrades at Helena, Arkansas, in March 1866.

He returned to Kentucky, rejoined Mary, and started a family that grew to include five children, one of whom died in infancy. By the late 1870s, as post-Reconstruction policies and paramilitary groups in Southern states threatened and oppressed freedmen, the Trueharts joined a mass exodus from the South to

did not prevent him from other duties, including detached service as a laborer for the quartermaster department and serving a stint as company cook.[600]

Corporal Saunders mustered out of the army with his comrades in October 1865, two months before the Thirteenth Amendment became law. He returned to Scott County, rejoined Emily, and went to work as a farmhand. He also bought fabric and iron scraps and sold them for a modest profit in nearby Lexington.

In the summer of 1882 he fell ill with pneumonia and soon succumbed to the infection. His wife and a daughter, Eliza, survived him.[601]

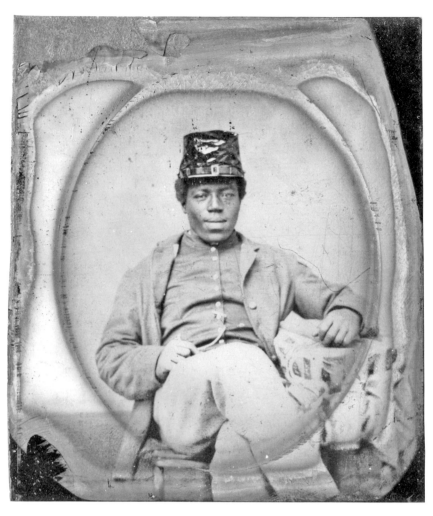

Pvt. James T. Cummings, Company G, Twenty-fourth U.S. Colored
Infantry

Tintype by unidentified photographer, 1865. Collection of C. Paul Loane.

Representative Recruit

DURING THE FINAL MONTHS OF THE WAR, PUBLIC-SPIRITED men and women of means across the North who had not been required to serve in the military or had finished their service showed their patriotism in a unique way: they paid a personal representative, or "representative recruit," to enlist.[602]

The War Department had hoped that this little-known program would boost sagging military enrollment and avoid the need for a formal draft, which they assumed would be as unpopular as the 1863 Conscription Act that had led to riots in cities across the Union states. The program received mixed reviews after it was announced in June 1864. One newspaper condemned the practice as fighting by proxy.[603]

The program did not meet its numerical expectations. Only 1,292 recruits were raised by it, despite the participation of prominent Americans, including President Abraham Lincoln, who paid to send one man, as did poet Henry Wadsworth Longfellow; New York philanthropist Peter Cooper sent two. Women furnished at least 131 of the total number of representative recruits.[604]

Among the lesser-known individuals who also participated was William Christman of Chester County, Pennsylvania.[605] He found and paid James Cummings to be his representative recruit.

For Christman, a veteran officer who had survived the Battle of Antietam and left the army when his term of enlistment expired in 1863, the arrangement provided an opportunity to further his support of the Union cause. It also helped his older brother Enos, a local recruiter, meet the ambitious troop quotas set by the federal government.

For twenty-six-year-old Cummings, born and raised in Chester County, the $650 he received equaled a small fortune. In March 1865, he left his home and job as a brickmaker and traveled a few miles to Camp William Penn on the outskirts of Philadelphia. There he became a private in a new regiment, the Twenty-fourth U.S. Colored Infantry.

While Cummings and his comrades were training to be soldiers, the bulk of the Confederate army surrendered and John Wilkes Booth assassinated President Lincoln. The Twenty-fourth arrived in Washington in May 1865, too late to fight but in time to participate in clean-up operations. The regiment spent the next few months guarding soon-to-be-released Confederate prisoners in Maryland and performing various other duties in Virginia.

Cummings mustered out when the Twenty-fourth disbanded in October 1865. He returned to Chester County and resumed his job in West Chester. He married a local girl, Anna Hazzard, before the end of the year. They lived together until his death in 1898 of abdominal cancer at age fifty-nine.[606]

"The Only Northern Person of Color"

IN THE SPRING OF 1865, SGT. LEWIS FULLER OF THE Ninety-second U.S. Colored Infantry tossed and turned in his quarters, wracked with throbbing pain in his head and a rumbling noise that roared in his ears. "So terrible were these pains that the field and Staff Officers were nightly disturbed by his groans and who repeatedly expressed pity and different ways showed feelings of sympathy," according to his account to the civil servant who processed his pension application many years after the war.[607]

The care and concern of the white officers touched Fuller. He attributed their compassion in part to his being a Northerner. Born free and raised in New Haven, Connecticut, he claimed to be "the only northern person of Color" in the regiment.[608]

Motivated by compassion to help slaves freed after Union troops invaded Louisiana and captured New Orleans in May 1862, Fuller had become a missionary and moved to the Pelican City to teach illiterate men, women, and children of color. He suspended his missionary work in September 1863 and enlisted as a sergeant in the Eighteenth Corps d'Afrique. The regiment reorganized in April 1864 as the Eighty-ninth U.S. Colored Infantry and disbanded three months later. During its brief history, Fuller served on detached duty in the regimental commissary and two stints on recruiting service.[609] After the breakup of the regiment, Fuller transferred to the Ninety-second.

About this time, he suffered "the most terrible pain of his life."[610] A doctor diagnosed his ailment as neuralgia, a nervous disorder that caused excruciating pain along the nerves in his head, and prescribed morphine. It failed to relieve his symp-

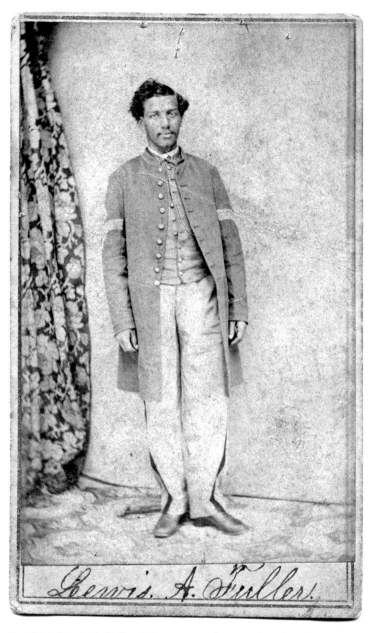

Lewis. A. Fuller.

Sgt. Maj. Lewis A. Fuller, Ninety-second U.S. Colored Infantry

Carte de visite by [William D.] McPherson (d. 1867) & Oliver (life dates unknown) of Baton Rouge, Louisiana, 1864–1865. Collection of the author.

toms. Fuller worked through the pain and received a promotion as the Ninety-second's sergeant major in May 1865. He served in this capacity until the regiment mustered out of the army in New Orleans at the end of the year.[611]

Despite a continuation of the chronic ear problems that plagued him during his military service, Fuller lived a life of peace and prosperity in Port Hudson, Louisiana, in the years just after the war. He taught school under the auspices of the American Missionary Association and the Freedmen's Bureau. He married a Louisiana girl and started a family that grew to include a son and two daughters. In 1867 he received an appointment as a justice of the peace under the reconstructed state government and was elected the following year on his own account.

His life began to fall apart in 1873, when members of the White League, a paramilitary group led by ex-Confederate officers, drove Fuller and other black officials from office. Fuller found a job as a public school teacher. The White Leaguers again began to harass him and his family. In 1876 several of his neighbors were shot or hanged. Fuller fled to Connecticut. He left his family behind; evidence suggests that he and his wife were having marital problems.[612]

His hearing failed about the time he left Louisiana, and he consulted several doctors, who declared him hopelessly deaf. After 1877 he used an ear trumpet to hear. He tried to find a job, but potential employers found his deafness objectionable.[613]

After a seventeen-month search, he finally found work as a general laborer with an African American coachman in Hartford. Fuller was so anxious for employment that he offered to work only for board. The coachman accepted. After the first year, the sympathetic coachman paid Fuller five dollars a month in addition to his board.[614]

Around 1881, Fuller left the coachman's employ for a job as a laborer at the Woman's Christian Association. He received twelve dollars a month—about a third of the pay a nonhandicapped worker received for the same work.[615]

Fuller never reunited with his wife, who remained in Louisiana. In 1886, the year after she died, he wed a New York–born widow. They lived together until his death in 1899 from kidney disease at age fifty-six.[616]

On to Richmond

On April 3, 1865, along the complex array of trench lines and earthworks carved into the Virginia landscape about eight miles from Richmond, Pvt. William Wright marched through Fort Harrison and halted. He loaded his musket and affixed the bayonet to its muzzle. The tearing sound of the paper cartridge and clink of metal against metal mixed with that of hundreds of his comrades in the 114th U.S. Colored Infantry as they performed the same actions.[617]

Orders came to move out. The men formed a column and marched unchallenged into territory recently abandoned by Confederates who had been ordered to evacuate Richmond. They filed through a narrow opening cut into a tangle of slashed tree branches, or abatis. They passed by crews of Union soldiers carefully digging up torpedoes placed as land mines, and crossed empty enemy entrenchments.

They hurried on to Richmond, moving in parallel with two other columns of infantrymen. Towards the end of the march, they came upon a hill and glimpsed the Confederate capital, which had been entered by Union troops a short time earlier. A section of the city was ablaze from fires set by retreating enemy troops. Wright watched as flames flickered and smoke billowed from workshops and warehouses, and as terrific explosions rocked the city.[618]

Wright likely never expected to participate in such a surreal event. Of African and German descent and described by one source as having a "copper complexion,"[619] he was raised in bondage on a farm in the vicinity of Frankfort, Kentucky, one of about thirty-five slaves owned by John Russell, a War of 1812 veteran, Mississippi River steamboat captain, and Unionist with

a reputation as a humane master.[620] Wright, a husband and father, named one of his seven children after him.[621]

In June 1864, Capt. Russell accompanied Wright to an army recruiting station in Lexington. Wright enlisted with the consent of his master and reported to nearby Camp Nelson for training. An officer noted the change from slaves to soldiers: "New uni-

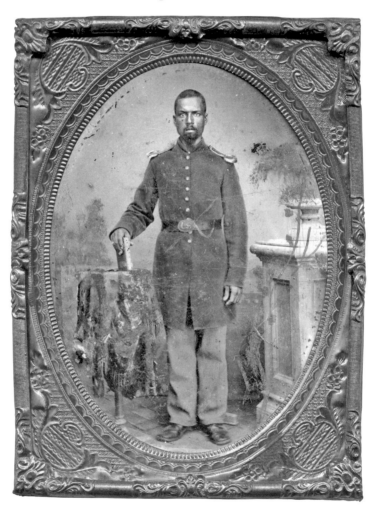

Pvt. William Wright, Company H, 114th U.S. Colored Infantry

Tintype by unidentified photographer, about 1864–1867. Collection of the author.

forms, guns in their hands, and the stamp of government upon them seemed to give them self respect and consciousness of manhood and power so that the rapidity of the transformation was marvelous."[622]

The regiment remained in Kentucky until January 1865, when it received orders to join the Army of the James in Virginia. Assigned to the all-black Twenty-fifth Corps, the 114th took its place along the siege lines north of the James River and southeast of Richmond. Wright and his comrades remained there until they entered Richmond on April 3. They set up camp on a rise of ground in full view of Libby Prison and the former Confederate Capitol.[623]

The 114th were serving on guard duty in the Richmond area when Gen. Robert E. Lee surrendered the Army of Northern Virginia at Appomattox Court House on April 9. Many expected to be mustered out of the army at that time. Instead, they departed for Texas with other regiments from the Twenty-fifth Corps to counter threats to U.S. sovereignty posed by French forces that had occupied much of Mexico.

The climate turned out to be a greater enemy than the French. On a three-day march to Brownsville, Texas, in March 1867, the troops struggled through a quagmire of ankle- to waist-deep mud caused by melting mountain snow that had flooded the lower Rio Grande. At night the soldiers sought refuge on damp knolls.[624] Wright suffered an attack of rheumatism in his left shoulder that plagued him on and off for the rest of his days.[625]

U.S. military and diplomatic pressure contributed to France's decision to withdraw its troops from Mexico, and the 114th mustered out of the army in May 1867.

Wright returned to Kentucky. He rejoined his family and his former master, Capt. Russell, who welcomed him to work on the farm as an employee. Wright accepted the offer. Russell died in 1869. About this time, Wright and his family, which had grown to ten children, suffered repeated harassment by lawless bands of angry white men who sought to establish authority over freed slaves through terrorism and violence.[626]

Many black families fled the state in search of better opportunities, and the Wrights did likewise. They left Kentucky in 1871 and moved about 700 miles north, to Plymouth County, Iowa, located along the Mississippi River. One account noted that Wright left because "he had fought too hard for his freedom and rights in the Civil War"[627] to have them taken from him.

Wright's wife, Charlotte, died the following year. In 1874, he married Mary Ellen White, a widow from Kentucky. Six children were born of their union. By 1880 they had relocated to Cerro Gordo County in north central Iowa. Wright died in neighboring Worth County in 1901 at age sixty-three.[628]

Protector of the Peace

ON MONDAY MORNING, APRIL 3, 1865, COLUMNS OF BLACK troops in the vanguard of the victorious Union army entered Richmond, Virginia, and mixed with throngs of people who were swarming the streets of the Confederate capital. "The excitement at this period was unabated," wrote an African American chaplain on the scene. "The tumbling of walls, the bursting of shells, could be heard in all directions, dead bodies being found, rebel prisoners being brought in, starving women and children begging for greenbacks and hard tack, constituted the general order of the day, the Fifth cavalry, colored, were still dashing through the streets, to protect and preserve the peace."[629] The chaplain referred to the Fifth Massachusetts Cavalry.

One of the troopers who participated in the momentous events was John Elliott of Company D. Born in North Carolina, he was living free in New Bern at the start of the war.[630] He likely encountered his first Northern soldiers in the late winter and early spring of 1862 during Maj. Gen. Ambrose Burnside's North Carolina expedition, which ended with the occupation of a significant portion of the state's coast.

Army recruiters from Massachusetts enrolled Elliott the following year. In December 1863 he enlisted as a private in the Fifth. He and his comrades received basic training at Camp Meigs on the outskirts of Boston. In May 1864, as Lt. Gen. Ulysses S. Grant with the Army of the Potomac began his Overland Campaign, the Fifth was assigned to the Army of the James and moved to the supply hub at City Point, Virginia, at the confluence of the James and Appomattox rivers near Petersburg. The army changed the function of the regiment, taking away its horses and assigning its troopers to guard duty.[631]

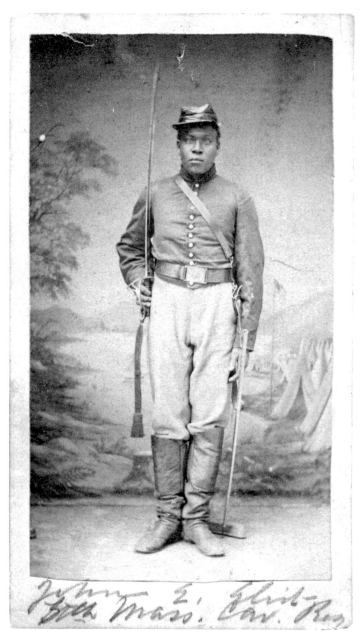

Corp. John E. Elliott, Company D, Fifth Massachusetts Cavalry

Carte de visite by unidentified photographer, about 1864–1865. Collection of Greg French.

The Fifth participated in its first and only major battle about a month later—a surprise attack on Petersburg. On June 15, a federal force of about fifteen thousand, including three thousand colored troops, achieved a significant break through the Confederate front lines near Baylor's Farm when the Fifth charged and captured a rebel battery. A failure to follow up on the initial success in a timely manner allowed the enemy to reinforce its defenses and prevent further damage. About twenty-three men from the Fifth became casualties. Elliott, listed as present for duty, emerged unscathed.[632]

The regiment soon left for Point Lookout, Maryland, where it guarded prisoners of war.

It returned to the Petersburg front in late March 1865, as escort for the headquarters of the Army of the James. This time the men had their horses. Within days of their arrival, they rode into the enemy capital unchallenged. There they helped to quell the chaos that had erupted in the conquered city and then to maintain law and order.

The regiment remained in Virginia until June, when it received orders to leave for Texas. About this time Elliott received a promotion to corporal; he served at this rank until he mustered out with his fellow troopers in October 1865.[633]

Elliott spent the rest of his days in the North. He first lived in Boston, where he married Roberta Lee in 1873. They became the parents of a son, Lewis. The family later moved to New York City, then settled in New Haven, Connecticut, where Elliott died in 1912 at age sixty-nine.[634]

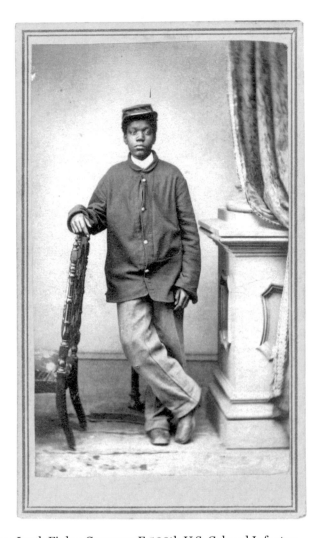

Corp. Jacob Finley, Company F, 108th U.S. Colored Infantry

Carte de visite by Alfred B. Gayford (b. ca. 1828) & Conrad S. Speidel (b. ca. 1827) of Rock Island, Illinois, about March 1865. Collection of the Beinecke Rare Book and Manuscript Library, Yale University.

Injured during a Mock Skirmish

On a spring day in 1865 soon after the fall of the Confederate capital, all ten companies of the 108th U.S. Colored Infantry performed a formal battalion drill on the grounds of the Rock Island prisoner of war camp, located on an island in the Mississippi River midway between Iowa and Illinois. The exercise proceeded without incident until the regiment deployed for a mock skirmish.[635]

"By some confusion of orders the companies on the right of the line ran over each other and a number of men were injured by being trampled over," explained Joe Taylor, a sergeant in Company F.[636] Several soldiers were hurt, including Pvt. Jake Finley.

Born and raised a slave in Kentucky, Finley enjoyed a reputation as a good man of moderate habits. Sgt. Taylor, who had known him before the war, remembered: "He'd take a drink, but I never saw him full but once in my life.... He was a great dancer & attended all the balls."[637]

Finley joined the army in the summer of 1864.[638] He was assigned to Company F of the 108th. After a few months on garrison duty in various locations in his home state, he and his comrades reported to Rock Island as guards at the prison camp.

According to Sgt. Taylor, during the 1865 mock skirmish, Finley "received an injury in his bowels. He was sent to hospital and remained there about two weeks. When he came out he was excused from duty, but would insist on doing duty" despite constant abdominal pain. Medical personnel diagnosed him with a double hernia and treated him with a truss.[639]

Sgt. Taylor took pity on his friend. "As soon as I could make a vacancy I made him a corporal on account of his condition."[640]

The promotion lightened somewhat the physical demand of Finley's duties. He held the rank until the regiment mustered out of the service in March 1866.[641]

Finley returned to Kentucky and worked as a laborer. About 1878 he married, moved to Indiana, and settled in the Indianapolis area. He found a job as a plasterer's assistant and worked additional odd jobs to make ends meet.[642]

In 1890, at about age forty-six, he suffered a stroke that left him paralyzed on the right side. His wife cared for him until 1895, when he gained admission to the U.S. National Home for Disabled Volunteer Soldiers in Marion, Indiana. He died nine years later at about age sixty.[643]

"He Refused to Sheathe His Sword"

About three o'clock on the afternoon of April 9, 1865, at Appomattox Court House, Virginia, generals Robert E. Lee and Ulysses S. Grant wrapped up the surrender negotiations that dealt the deathblow to Southern independence. At the same hour, 800 miles away in Alabama, another drama was playing out along the front lines of besieged Mobile, where Union troops were preparing to assault Fort Blakely, the last Confederate-held fortification in the city's once-formidable defenses.

Among those who readied for combat was the lone officer of African descent in the Seventy-third U.S. Colored Infantry, Louis Snaer. "His skin was as white as that of any officer in the regiment," observed Henry Merriam, the lieutenant colonel of the Seventy-third.[644] His family, a mix of African and European ancestry, had immigrated to Louisiana from Santo Domingo before Snaer's birth in New Orleans in 1842.[645]

After federal forces occupied New Orleans in May 1862, he joined the First Louisiana Native Guard, a regiment of free men of color who had organized back in 1861 to serve the Confederacy. After the city fell, the regiment joined the Union army and was designated the Seventy-third. Snaer, who did not belong to the regiment when it served the Confederate army, started as a first lieutenant in Company B.[646] Over the next three years, losses by disease and in battle and a systematic purge of black captains and lieutenants under military department commander Maj. Gen. Nathaniel Banks left him the sole officer of color in the regiment by April 1865.[647]

On April 9, two companies of black troops led the initial assault on Fort Blakely's double lines of rifle pits. "The capture

of the outer line was only the work of a few minutes," recalled Col. Merriam, "but so terrific was the fire concentrated upon us from front, and, at first, also from both flanks, by artillery and infantry, and plainly seeing the gathering of re-enforcements

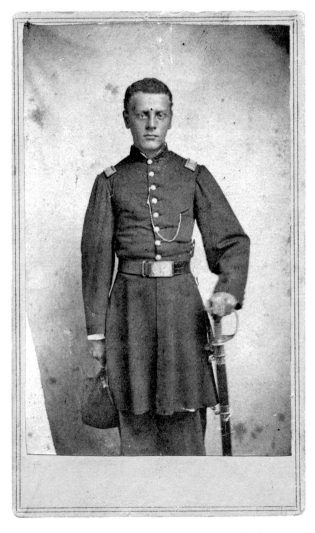

Capt. Louis Antoine Snaer, Company B, Seventy-third U.S. Colored Infantry

Carte de visite by unidentified photographer, about 1863–1865. Collection of Glen Cangelosi.

by the enemy in my front I sent forward as supports Captain Snaer, Company B, Lieutenant Lyon, Company I, and Company A, Captain Crydenwise, in rapid succession."[648]

Merriam followed his men. "Captain Snaer fell with a severe wound at my feet as I reached the line. He refused to sheathe his sword or to be carried off the field." They battled on and took the second line of rifle pits. Then, in Merriam's words, "by that soldierly instinct, which always responds quickly to opportunity," the men charged the main works. By this time thousands of federals had joined in the fight. The Seventy-third was the first to plant its banner on Blakely's parapet.[649] The fort fell, and its loss prompted the evacuation and surrender of Mobile on April 12.

Merriam received the Medal of Honor for his actions, and Snaer was given a brevet rank of major in recognition of his gallant conduct.[650]

Snaer's wound landed him in the regimental hospital, where medical personnel attended to his left foot. An artillery shell fragment or case shot struck near his little toe and destroyed part of the metatarsal bone. He spent the next few months in recovery and on detached duty with the Freedmen's Bureau. He mustered out in September 1865.[651]

Snaer returned to Louisiana and became active in politics during the Reconstruction era. Voters elected him to two terms as a state representative on the Republican ticket in the late 1870s. The following decade he received a federal appointment as an inspector in the New Orleans Customs office.[652]

He also served as commander of his local Grand Army of the Republic post and as a member of the board of trustees of Southern University, chartered in 1880 for the purpose of educating individuals of color.[653]

Snaer later moved to California, where he died in 1917 at age seventy-five. His wife of forty years, Maria, and three children survived him.

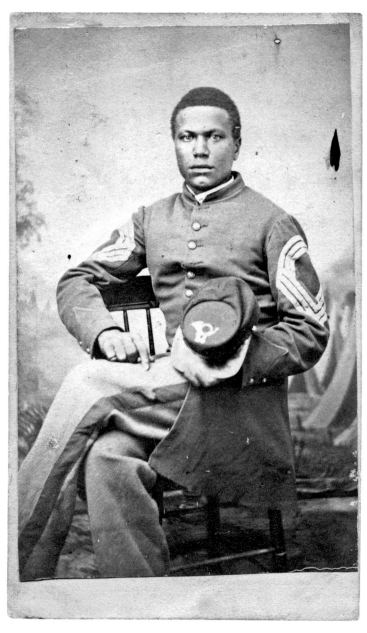

Sgt. Maj. John H. Wilson, Fifty-fourth Massachusetts Infantry

Carte de visite by unidentified photographer, about 1864–1865. West Virginia and Regional History Collection, West Virginia University Libraries.

Saved by a Lantern

AFTER NIGHTFALL ON APRIL 11, 1865, AT A SOUTH CAROlina railroad junction named Wateree,[654] a detachment of twenty troops from the Fifty-fourth Massachusetts Infantry surprised a group of about fifteen railroad workers. The trainmen fled, leaving behind thirteen cars, five locomotives, and other goods and materials.[655]

More troops from the Fifty-fourth arrived and prepared to move the captured trains. Sgt. Maj. John Wilson set out to couple two cars together—a hazardous task for a skilled trainman. Wilson, a boatman in peacetime, attempted it in the dark of night under lantern light. As he stepped between the cars, which were being inched slowly towards each other, another soldier unexpectedly squeezed in to the intercar space, startling Wilson. The lantern fell and broke, scattering shards of glass and extinguishing the flame. Trapped between the cars, the men were moments away from being crushed. Fortunately, the lantern also got caught in a position that stopped the movement of the cars. Wilson later claimed it had saved their lives.[656]

They were pinned, however, and their comrades had to pull them to safety. Wilson suffered a hernia and injuries to his stomach, chest, and back. The other soldier fractured his collarbone.[657] Both were placed on another train, which was carrying wounded, and sent to a hospital in Charleston for treatment.

This was Wilson's second brush with death during the war. The first had occurred at Fort Wagner on July 18, 1863. During the assault on the fort, he had fallen with a severe wound to his left shoulder.

Wilson hailed from Ohio and was a natural leader. Staff officers of the Fifty-fourth recognized his abilities early on. Shortly

after his enlistment, in April 1863, he received his sergeant's stripes and began to play a key role in Company G. One year later, he advanced to sergeant major of the regiment after Lewis Douglass, son of the prominent abolitionist, resigned the position due to health problems. Wilson served in this capacity for the rest of the war.

Wilson mustered out with his comrades at Mount Pleasant, South Carolina, on August 20, 1865. The day before his military service ended, he married a Palmetto State woman, Rosa Holland. They moved to Michigan and settled in the Grand Rapids area. Rosa died in 1879, reportedly of "consumption," leaving Wilson with two young daughters to care for. He raised them as a single father.[658]

Sometime after 1890, he moved to Indian Territory and started a barbershop with a partner. In 1898, at age forty-eight, he married Charlotte Bannister, an Ohio-born widow about twenty-six years his junior. They had one daughter, who died young.[659]

The couple later returned to their home state. Charlotte died there in 1915, leaving Wilson widowed again. In 1918 his own health failed, and he passed away the following year. He had lived until age seventy-eight.[660]

On Sorrow's Darkest Night

BESPATTERED WITH THE BLOOD OF HER DYING HUSBAND, grief-stricken Mary Todd Lincoln wept uncontrollably in a room in a nondescript brick row house across the street from Ford's Theater in Washington, D.C., during the night of April 14, 1865. At one point the First Lady called for her friend and confidante, dressmaker Elizabeth Keckley. At least three messengers made their way through throngs of anxious crowds and cordons of troops and spread out into the night to find her.[661]

Some blocks away, exhausted army surgeon Anderson Abbott lay asleep in bed. He had spent the day celebrating the fall of the Confederate capital and the surrender of Gen. Robert E. Lee's army. He continued to party into the evening at the home of a friend until a knock at the door brought word of the shooting of President Abraham Lincoln and the stabbing of Secretary of State William Seward.[662]

The news marked what Abbott later described as "sorrow's darkest night."[663]

Stunned, shocked, and apprehensive, Abbott and his friends walked the short distance to the Seward residence and stood vigil for a time. Abbott then escorted the ladies in the group home and walked to his own place for much-needed rest, arriving probably after midnight.

Meanwhile, the messengers had failed to locate Keckley. About 2 a.m., one of them showed up at Dr. Abbott's doorstep looking for her, for he and Keckley were well acquainted.[664]

Two years earlier, in 1863, Anderson Abbott had arrived in the federal capital from his home in Canada, where his parents had settled after leaving the United States in 1835. His father, a free man from Virginia who claimed to be of Scottish, Irish, and

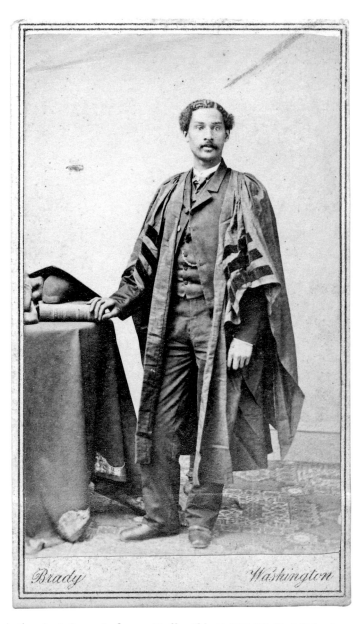

Acting Asst. Surg. Anderson Ruffin Abbott, U.S. Medical Volunteers

Carte de visite by Mathew B. Brady (b. ca. 1823, d. 1896) of New York City and
Washington, D.C., about 1863. Collection of Steve Turner.

224

African descent, had purchased the freedom of his slave sweetheart and married her. They had moved to Alabama and become successful in business. However, racial tensions and threats of violence compelled them to leave, going first to New York and then Toronto, the city of Anderson's birth.[665]

The Abbotts prospered in Toronto and provided their son with an excellent education. He graduated from the University of Toronto in 1861 with a degree in medicine. The following year, his mentor, Dr. Alexander Augusta,[666] went to Washington and successfully lobbied for a commission as a surgeon in the U.S. Army, becoming the first of a small group of black physicians to serve in this capacity during the war.[667]

Abbott followed Augusta to Washington. In the summer of 1863 he received a contract as an acting assistant surgeon in the army with the honorary rank of captain. He reported for duty to an 800-bed facility in the District of Columbia established for colored soldiers and former slaves. It came to be known as Freedmen's Hospital. Abbott worked as subordinate to Augusta for a time and later served as the hospital's chief executive.[668]

Abbott became acquainted with Elizabeth Keckley about this time. The skilled seamstress had befriended Augusta's wife, who had joined him in Washington.[669] It is likely that Abbott came to know the president through Keckley's influence. She later noted that Abbott had been one of Lincoln's "warmest friends."[670]

The messenger who visited Abbott on the night of Lincoln's assassination confirmed the president's grave condition. Abbott and the messenger set out to find Keckley but failed.[671] Abbott returned to his bed only to be awakened in the morning by the tolling of bells announcing the passing of his friend.[672]

Lincoln's death profoundly affected Abbott. He paid his respects at the White House. Abbott later described the moment in recollections written for publication: "As the writer looked upon the pale, cold face of the President as he lay in state in the guests' room, a great sorrow weighed heavily upon his heart, for he thought of the loss to the negro race in their nascent life of

freedom, and the great guiding hand that now lay paralyzed in death."[673]

In memory of his friendship with the president, Abbott was offered and accepted a shawl that Lincoln had liked to wear on damp, chilly days.[674]

Abbott resigned his army contract position in 1866, disappointed that he never attained a formal military commission, as had his friend, Augusta. He returned to Canada and became a prominent physician and surgeon. In 1871 he married and began a family that grew to include three daughters and two sons. Active in numerous professional societies and the Anglican Church, and as a writer and lecturer, he was described by one biographer as "a truly urbane and erudite man."[675]

Despite his not having been formally commissioned as an officer during the war, he was allowed to join the Grand Army of the Republic. In 1892 he received an appointment as aide-de-camp to the organization's staff of commanders, who led the New York posts.[676]

Abbott wrote and spoke with pride of all Canadians who fought for the Union. He offered these words about his own experience: "We who participated in that war can fully realize what war is.... In my position as a surgeon I had exceptional opportunity of witnessing the horrors of that conflict. The ghastly wounds, the mutilated bodies, the sickness, the suffering, the dying and the dead—that war cost billions of treasure and tons of blood. And after a great battle to witness miles of ambulances winding their way to the different Hospitals bearing the wounded, dying and sometimes dead. The surgeons with their sleeves rolled up and their arms covered with gore, working all night till day break, and working from sheer exhaustion."[677]

Abbott lived until age seventy-six, dying in 1913.

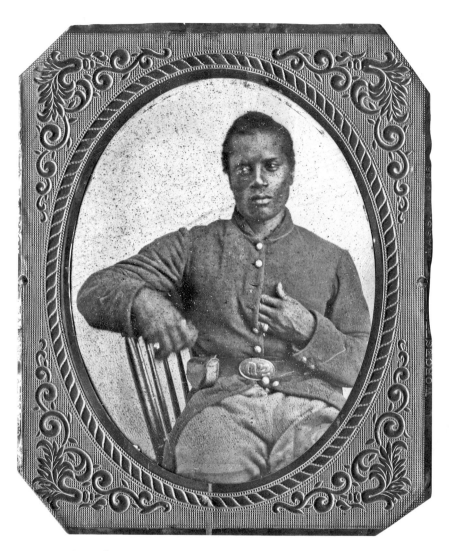

Pvt. Samuel J. Benton, Company A, Twenty-fifth U.S. Infantry

Tintype by unidentified photographer, about 1863–1865. West Virginia and Regional History Collection, West Virginia University Libraries.

had been a star student prior to his military service. According to a biographical sketch, he was "educated in the public schools of New Bedford and Boston, graduating at the head of a large class, all white except himself."[681]

He had joined the Fifty-fourth in February 1863 at age thirteen, and he served as a drummer in Company C for his entire enlistment. In August 1865, four months after Boykin's Mill, he mustered out of the army with his comrades[682] and moved, at age eighteen, to Maryland.

Monroe achieved more before thirty than many attain in a lifetime. By age nineteen he had taught school for the Freedmen's Bureau. By twenty-five he had received an appointment from President Ulysses S. Grant as inspector of customs at the port of Baltimore. By twenty-seven he had become the publisher of the *Standard Bearer*, a newspaper dedicated to African American interests.[683]

In 1878, at about twenty-nine, he took charge as pastor of a Methodist Episcopal church in Fairmont, Maryland. He subsequently ministered to faithful flocks in Maryland, Delaware, New York, New Jersey, and Pennsylvania, earning a reputation as a popular and eloquent preacher and a prolific fundraiser and church builder. He received a doctorate of divinity upon the petition of church elders.[684]

Active in the Grand Army of the Republic, he served as commander of the John Brown post in Maryland.[685] In 1888, "Boykin's Mill" appeared in *The Black Phalanx; A History of the Negro Soldiers of the United States*.

Monroe lived until age sixty-two. He died in 1912. Among those who survived him were his wife of twenty-three years, Madeline, and a son, Henry Jr.[686]

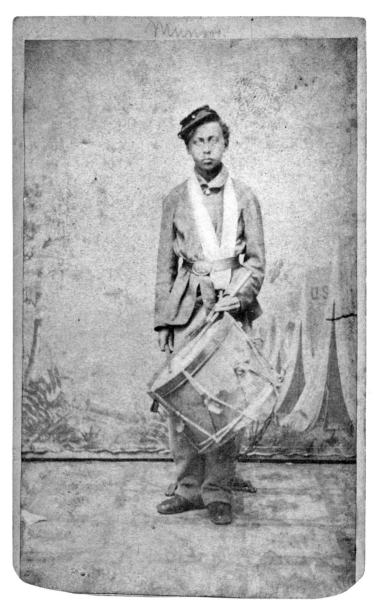

Pvt. Henry Augustus Monroe, Company C, Fifty-fourth Massachusetts Infantry

Carte de visite by unidentified photographer, about 1863–1865. West Virginia and Regional History Collection, West Virginia University Libraries.

The Last Fight of the Fifty-Fourth

DURING THE CONFEDERACY'S DYING DAYS, THE FIFTY-fourth Massachusetts Infantry participated in its last fight, near the South Carolina town of Camden along the heavily wooded banks of Swift Creek, at a saw- and gristmill owned by the Boykin family. On April 18, 1865, a band of regulars and home guardsmen pinned down the Fifty-fourth at the charred remains of a burned-out bridge at the mill site. The regiment countered with a flanking movement that resulted in a single file charge across a log dike. The charge broke the stalemate. The Fifty-fourth suffered fifteen casualties in the brief and bloody action.[678]

The final victory for the hard-fighting Fifty-fourth, the engagement left a lasting impression upon fifteen-year-old drummer Henry Monroe. He later wrote "Boykin's Mill," a poem that communicates the essential facts of the fight with vivid combat detail. It concludes with this passage:[679]

Facing the scathing fire
Without a halt or break;
Save when with moan or shriek,
In the blood-mingled creek
The wounded fall.

What could resist that charge?
Above the battle's roar,
There swells a deafening cheer
Telling to far and near,
The Mill is won!

Monroe hailed from New Bedford, Massachusetts. The son of a Virginia-born father and a mother from Rhode Island,[680] he

The Box

On April 30, 1865, the men of the Fifty-fourth Massachusetts Infantry busied themselves about its camp, along the South Carolina coast near the hamlet of Georgetown. They had recently returned from an exhausting three-week expedition into the interior of the state. During that time, Gen. Robert E. Lee surrendered, John Wilkes Booth assassinated President Abraham Lincoln, and Gen. Joseph E. Johnston surrendered the forces under his command to Maj. Gen. William T. Sherman.[687]

In Company A, Corp. William Wilson sat between two tents shaving, amidst the normal hustle and bustle of camp. Soon afterwards, Pvt. Sam Benton returned from a visit to a nearby encampment. He discovered that his box of personal items was missing and learned that Corp. Wilson had taken it to sit on as he shaved.[688]

Benton retrieved the box and opened it. Half of his butter was gone. One private recalled that Benton said to Wilson, "I have lost some butter and I don't wish you to bother with my things," and that Wilson replied, "I have not troubled any of your things, don't tell me that I have, for if you do, I will lick you like damnation," and then told Benton, "Shut up." Benton answered that he would not and that he would talk about his own things as much as he liked.[689]

At this point, Wilson lost his temper. "Now damn me if you don't shut up I will knock you down," he barked at Benton. Then he ran at Benton and head-butted him twice. Benton went down and Wilson kicked him repeatedly in the face and head.[690]

Benton mumbled a threat, reportedly "that it would be pretty dear butter before night."[691]

An hour or two later, the company fell into line for roll call and formed in two lines. Benton was among the last to arrive, and took up a position directly behind Corp. Wilson. The first sergeant commanded the men to "Support arms." They responded by standing straight up, left arms crossed over their muskets. The sergeant began to call roll.

Benton lowered his gun, aimed the muzzle at Wilson, and pulled the trigger. The bullet ripped into the back of his head behind the right ear and exited his forehead. Wilson fell to the ground without uttering a word.

"I heard the discharge of a musket," reported the sergeant, "and looking to the left of the Company I saw Corporal Wilson fall." The sergeant went down the line and asked who shot him. Benton admitted that he had. The sergeant had him arrested and taken away.[692]

Wilson died a few minutes after the shooting.

Benton faced a charge of murder before a court martial, during which eight members of Company A testified. All were questioned about the events leading up to and immediately after the shooting. One soldier, asked about Benton's character, admitted that some in the regiment thought him "not quite right" and that he had the occasional "wild spell."[693] The Fifty-fourth's major noted in his diary that Benton had a reputation as a dangerous man "said to have been moon struck at times."[694]

The trial spanned two days. After a brief deliberation, the court found Benton guilty and sentenced him to be hanged.[695]

The execution never happened. Authorities commuted his sentence to ten years in prison. Then, Massachusetts governor John Andrew ordered a review of the case. Benton received a pardon before the end of the year.[696]

Benton returned to his home state of New York and his pre-war occupation as a waiter. In 1867 he joined the regular army as a private in the Fortieth U.S. Infantry, later designated the Twenty-fifth.[697]

He mustered out of the army in Louisiana after his term of enlistment expired in January 1870. According to the federal

census taken that summer, he lived in New Orleans with a young woman named Virginia and worked as a steamboat porter. This is the last time his name appears on a government record. He was twenty-six.

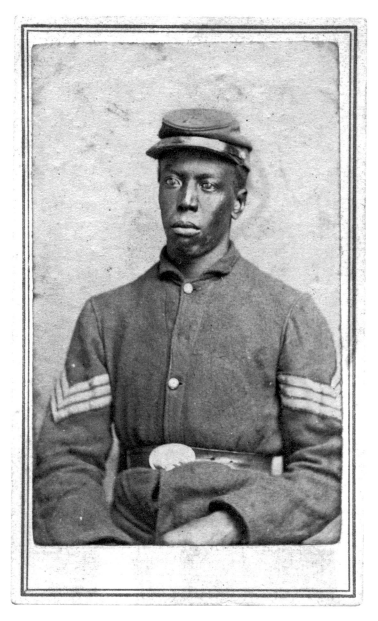

Sgt. George Mitchell, Company D, Sixty-second U.S. Colored
Infantry

Carte de visite by unidentified photographer, about 1864–1866. Collection of
the Gettysburg National Military Park Museum.

"That Winds Up the War"

LATE ON THE HOT AND MUGGY AFTERNOON OF MAY 13, 1865, determined Confederate horse soldiers harassed a Union column as it retreated from a two-day battle with them in the vicinity of Palmito Ranch, across a twelve-mile stretch of lowlands along the Rio Grande at the southern tip of Texas. The federals held the enemy troopers at a safe distance. When they got too close for comfort, the rear guard of the column brushed them back.[698]

About sunset the Confederates came on again. The federal commander ordered Sgt. George Mitchell and his comrades in Company K of the Sixty-second U.S. Colored Infantry to fan out in a skirmish line to protect the column. The men raised their muskets, took aim, and fired a volley into the enemy ranks. The troopers returned fire. Both sides blasted away at each other for a few minutes before the Confederates ceased their assault.[699]

Mitchell could not have known that his company had just fired the last shots of the Civil War.

George Mitchell was more accustomed to playing a fiddle than shooting a gun. In his off-work hours, he had performed at dances and balls in Missouri before the war. Born a slave about seventy-five miles south of St. Louis, in St. Francois County, he had been owned by four men in the course of his youth. His first master, Robert Mitchell, died. His second master, the son of the first, sold him at age twelve.[700] His third master, Jack Casey,[701] took him to Potosi, a town in neighboring Washington County, where he sold him to John Dean, who owned about sixteen slaves.[702] Dean put Mitchell to work as a teamster at his furnace, which smelted lead ore from area mines.[703]

Dean released Mitchell from bondage after President Abra-

ham Lincoln issued the Emancipation Proclamation on January 1, 1863. That summer, Mitchell traveled to nearby Pilot Knob and got a job helping to build federal Fort Davidson, a hexagonal earthwork surrounded by a dry moat.[704] He remained at Pilot Knob after its completion and joined the army as George Dean, using the surname of his last master. He took his place in the ranks of the First Missouri Colored Infantry, which became the Sixty-second U.S. Colored Infantry.

The regiment reported to Louisiana and served in the defenses of Port Hudson and Morganza. It received high praise for being well drilled and disciplined. Brig. Gen. Daniel Ullmann, a veteran organizer and leader of black soldiers, called the Sixty-second "the best under my command."[705]

Mitchell earned his sergeant's stripes in September 1864.[706] About this time the Sixty-second sailed to Brazos Island in southern Texas for garrison duty at the Brazos Santiago military base. The regiment served in this capacity until May 11, 1865, when its 250 men and about fifty dismounted troopers from the Union Second Texas Cavalry left on an expedition. The purpose of the movement was, and remains, unclear.[707] The following day, near Palmito Ranch, the column collided with 200 enemy horse soldiers. A short, indecisive fight ensued. Overnight, both sides received reinforcements and battled again the next day. This time the Confederates forced the Union retreat, pursuing them as they went and engaging in the war's final shots. After the final volley, Lt. Col. David Branson[708] of the Sixty-second turned to one of his company commanders and declared, "That winds up the war."[709]

One Union soldier had been killed, nine wounded, and 103 captured. Confederate losses went unreported. Mitchell made it back to Brazos Santiago with the other survivors.

By January 1866, the ranks of the Sixty-second had been depleted to 200. This prompted a consolidation of its ten companies into four. Mitchell and the rest of Company K were reassigned to Company D. The new company now had enough men but too many regular officers and noncommissioned officers. As

a result, regimental staff ordered Mitchell and a few other officers mustered out of the army.[710]

Mitchell returned to Missouri and his wife, Susan, whom he had married shortly before his enlistment. They started a family that included four children, including a mentally disabled boy. Mitchell labored in lead mines and other jobs. He also fiddled at dances. Susan worked as a washerwoman.

In 1881 the family moved to St. Louis. On a February day in 1892, Mitchell went to work at a local quarry. In the course of digging, a sand bank caved in upon him. Frantic workers extracted Mitchell, who had suffered serious injuries that proved mortal. He died about three hours later at home. His wife and two children survived him. He was about forty-four years old.[711]

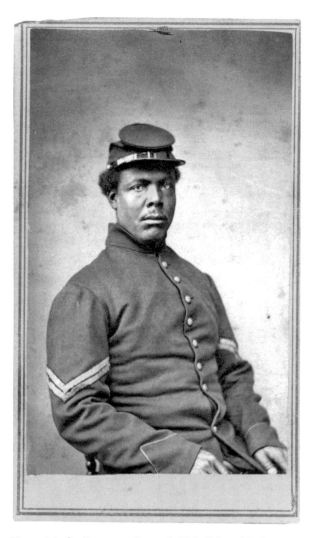

Corp. Henry Lively, Company F, 108th U.S. Colored Infantry

Carte de visite by Alfred B. Gayford (b. ca. 1828) & Conrad S. Speidel (b. ca. 1827) of Rock Island, Illinois, about March 1865. Collection of the Beinecke Rare Book and Manuscript Library, Yale University.

Hot Weather and Bad Water

ON MAY 30, 1865, AS LARGE NUMBERS OF UNION VOL-
unteers prepared to muster out of the army in the dawn of the
postwar period, Corp. Henry Lively and his comrades in the
108th U.S. Colored Infantry geared up for a new assignment.
They marched out of the barracks at Rock Island, Illinois, where
they had spent the previous nine months guarding Confeder-
ate prisoners, for duty in Mississippi as part of the garrison at
Vicksburg.

The regiment arrived in the once-formidable Confederate
stronghold ten days later. The conditions were awful. "The wea-
ther was very hot and the water was very bad," recalled one sol-
dier. Many became sick, including Lively, who fell ill with ma-
laria.[712] The chronic fever and chills symptomatic of the disease
took many men out of action, but not Henry. He remained in
the ranks despite his infirmity, although he reported for duty
only half the time.[713]

Born a slave about seventy-five miles south of Louisville, Ken-
tucky, in Hart County, Henry lived on the farm of his master,
Billy Mansfield, who also owned at least two of Henry's broth-
ers.[714] At some point, Mansfield sold young Henry to Ben Lively.
Henry took his new master's last name as his own.

During the late 1850s, then teen-aged Henry united in an
unofficial slave marriage with a woman named Mandy. After
her sudden and unexpected death a short time later, he began
a relationship with a Martha Smith. She was about four years
his senior and had two children fathered by a white man named
Harvey Adams.[715]

Martha noted of her marriage, "We didn't have any kind of
ceremony performed but we just took up with each other like

the slaves did. We did so with the permission of our masters and mistresses." They had their first child, a son, about 1860. He grew up in the same household with his two half-white siblings.[716]

In the summer of 1864, having been freed by his master, Henry bid farewell to his family and joined the army. He was assigned to Company F of the 108th. He earned his corporal's stripes and assisted company sergeants and officers in maintaining order and discipline at various posts in Kentucky, at Rock Island, and in Mississippi, where the regiment remained until it disbanded in March 1866.[717] Lively's lieutenant described him as the "best man in the company."[718]

Lively mustered out with his comrades and returned to Martha and the children in Kentucky. He died six years later of the malaria contracted at Vicksburg. He was about thirty-eight. Martha, pregnant with another son, survived him. She collected a government pension for Henry's war service until her death in 1908.[719]

After the Raid on Plaquemine

On an August day in 1864, Pvt. George Bryant and his company, part of the Eleventh U.S. Colored Heavy Artillery,[720] spread out across the Louisiana countryside and formed a routine picket line. Their orders were to guard the federal fort and garrison at Plaquemine, located along the west bank of the Mississippi River fifteen miles south of Baton Rouge. Any hopes they might have had for an uneventful day were shattered when about a hundred Confederates charged their line. "They dashed upon our pickets who made a bold stand for a short time, and then scattered for shelter," explained an officer.[721] The Confederates raided the Union-held town until reinforcements from the Eleventh forced them out after a fight through the streets.[722]

Bryant survived the attack. Several of his company became casualties, including three privates who fell into enemy hands.[723] Confederates carried the trio to the nearby town of Indian Village and shot them dead. The Eleventh's outraged commander, Col. J. Hale Sypher, deplored the cold-blooded killings as "cruel and inhuman murder."[724]

The emotional impact of the slayings on Bryant, a weaver born free in Buffalo, New York, went unrecorded. However, a pattern of delinquent behavior after the events of that day may offer a clue to his state of mind.

In August 1865, Bryant was among a group arrested for riotous behavior at an all-night party when he was on the sick list. His name also surfaced at this time in connection with a complaint made by a local ferryman, who charged that Bryant and others, while engaged in clearing their muskets each morning, disrupted his business. "By directing their pieces down the river they frequently strike near the boat," noted the officer who re-

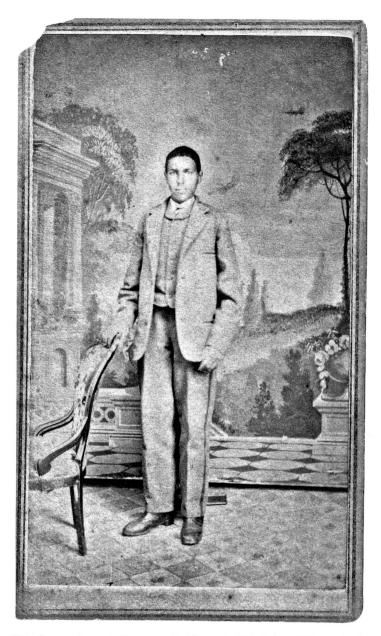

Pvt. George Bryant, Company G, Eleventh U.S. Colored Heavy Artillery

Carte de visite by D. W. Grout (life dates unknown) of Pulaski, New York, about 1862–1864. Collection of Donald M. Wisnoski.

ported the complaint, "causing much consternation among the passengers. Frequently the shots strike on the other side, causing danger to persons passing."[725] Bryant escaped that charge with no serious punishment.[726]

The following month he fell into trouble again. On September 5, members of the provost guard arrested him as he attempted to board a steamer moored at the Plaquemine levee, dressed in civilian garb. He had been missing for two days. The provost returned him to his company, where the first lieutenant filed a charge of desertion against Bryant and recommended a court martial.[727]

Military authorities closed Bryant's case two days after his arrest. No trial is on record. No explanation for the abrupt closure of the case is reported.[728]

The impending muster out of the regiment may have been a factor in the decision. A few weeks later, on October 2, 1865, the Eleventh ended its army service at New Orleans. That date is the last time Bryant's name appears on any government record. He was about twenty-five years old at the time.

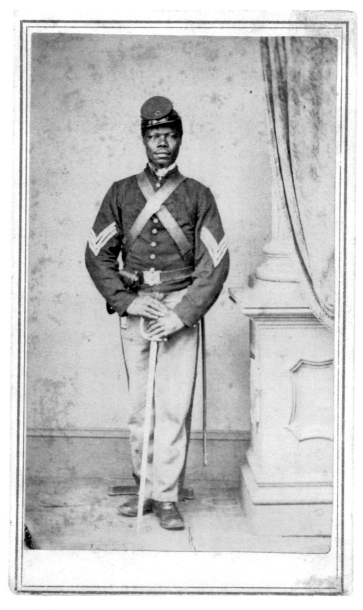

Sgt. Charles English, Company C, 108th U.S. Colored Infantry

Carte de visite by unidentified photographer, about 1864–1865. Collection of Cindy and Clint McCauley.

Left Behind in Vicksburg

On August 11, 1865, the commander of the U.S. Army Department of Mississippi issued Special Order No. 22, which transferred the 108th U.S. Colored Infantry from Vicksburg to the vicinity of Jackson.[729] Poor health forced at least one man, Sgt. Charley English of Company C, to remain behind. He suffered from chronic dysentery.

English had no known medical issues before he joined the army. A slave born in Hardin County, Kentucky, he grew up on a farm near the village of Elizabethtown, about twenty miles from the birthplace of President Abraham Lincoln. Charley was one of about six slaves owned by Robert English, a prosperous merchant, one-time sheriff, and former state legislator.[730]

About 1855, Charley married Sarah Ann, a slave who also lived on the farm. She became pregnant the following year. Late in her pregnancy, their master sold Sarah Ann to a neighbor; but after their son was born—named Charles after his father— the two owners allowed Charley, Sarah, and their baby to live together.[731]

In the summer of 1864, Charley left his family and enlisted in the 108th Infantry, without the consent of his master. Two days later he became a sergeant and added chevrons to his uniform coat sleeves to designate his rank. In this capacity he implemented the orders of his company officers at various posts in his home state until January 1865, when the regiment was sent to Rock Island, Illinois, where they guarded Confederate prisoners of war. In May 1865, Charley departed with his comrades for duty in Mississippi.

He fell ill with dysentery about this time. On August 24, 1865,

medical personnel admitted him to a military hospital in Vicksburg. He succumbed to the disease three days later at about age thirty-three. His wife survived him by five years. She died in 1870, leaving twelve-year-old Charles an orphan.[732]

"Good and Faithful Soldier"

The beginning of the end of the military service of Dave Long can be traced to a single march in eastern Mississippi. "We went double quick," he remembered of the journey one day in late August 1865. He fell ill with fever and diarrhea after his return and was admitted to the post hospital at Meridian.[733]

Long had arrived in the state two months earlier with his regiment, the 108th U.S. Colored Infantry, for duty in Vicksburg. His stay there was unpleasant. Night after night of sleeping on cold ground as spring turned to summer left him with chronic joint pain. He also dislocated his left ankle while carrying water.[734]

The thirty-year-old slave-turned-soldier had no history of health problems before he entered Mississippi. He was born George Davis Long in Shelby County, Kentucky, but most folks called him "Dave" or "David." He and his mother and father were part of a group of about thirteen individuals owned by Robert Long, a farmer who hailed from Pennsylvania. After Robert's death in 1847, ownership of twelve-year-old Dave and the other slaves passed to Long's son William, who sided with the Union during the war.[735]

In 1864, with his master's consent, Dave traveled to nearby Louisville and joined the army. He summarized his service, which included a stint at the Rock Island, Illinois, prisoner of war camp, in one sentence: "I enlisted as a private and excepting a short time at Rock Island when I cooked I carried a gun, but was never in battles."[736] Shortly before the regiment left Rock Island for Mississippi, one of his company officers described Dave as a "good and faithful soldier."[737]

Within months, he landed in the hospital at Meridian. The fever and diarrhea persisted. In November 1865 he was transferred to a general hospital at Columbus, Mississippi. His condition remained unchanged. The doctor assigned to his case de-

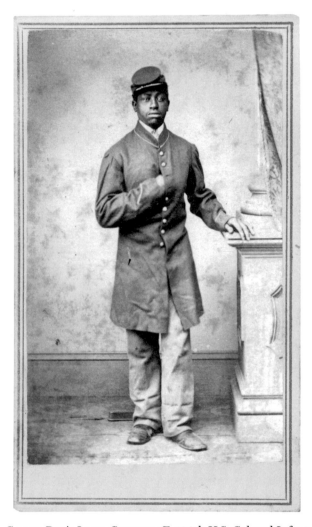

Pvt. George Davis Long, Company F, 108th U.S. Colored Infantry

Carte de visite by Alfred B. Gayford (b. ca. 1828) & Conrad S. Speidel (b. ca. 1827) of Rock Island, Illinois, about March 1865. Collection of the Beinecke Rare Book and Manuscript Library, Yale University.

clared Dave unfit for further service and ordered him discharged a week before Christmas 1865.[738]

He returned to Shelby County and there regained his health and lived a long life. He outlived his wife Emily, whom he married in 1872. She died in 1913. He succumbed to kidney disease two years later at age eighty. Four children, two sons and two daughters, survived him.[739]

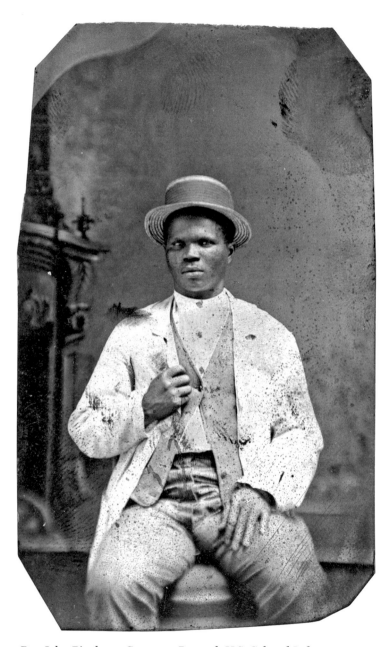

Pvt. John Pinckney, Company B, 104th U.S. Colored Infantry

Tintype by unidentified photographer, about 1866. Collection of National Archives and Records Administration, Washington, D.C.

"Something Got the Matter with My Head"

ONE DAY IN THE SUMMER OF 1865, IN SOUTH CAROLINA near the border with Georgia about fifty miles north of Savannah, Pvt. John Pinckney and his company reported to the crossroads village of Robertville to relieve a detachment of soldiers. Pinckney fell ill at some point after he and his comrades arrived. "Something got the matter with my head," he explained, "and they sent me to Hilton Head with some others to be examined."[740]

Medical personnel admitted him to a military hospital on Hilton Head Island to recuperate. They did not record the nature of his ailment or his symptoms. Pinckney later told a friend he had suffered sunstroke.[741]

Pinckney grew up about 200 miles north of the hospital, near the coastal community of Georgetown. Born into bondage on Rose Hill Plantation, a prosperous rice-growing estate, he numbered among forty slaves owned by William Alston, the son and namesake of a wealthy Revolutionary War officer known as "King Billy," and the brother of Joseph Alston, a former governor of the Palmetto State.[742]

Pinckney recalled, "I lived here at home until in 1865, I think, when a man came here and got us to go with him and join the army." He and other recruits were transported to Beaufort and on to Charleston, where Pinckney enrolled in Company B of the 104th U.S. Colored Infantry. He enlisted on April 13, 1865—four days after Robert E. Lee surrendered the Army of Northern Virginia and the day before the assassination of President Abraham Lincoln. The 104th spent its time on garrison and guard duty at various places in the state, including Robertville, where Pinckney fell ill.

Six weeks after his admission to the hospital, Pinckney appeared before an examination board. In the board's judgment, Pinckney suffered from "imbecility" which had existed before he enlisted. He received an honorable discharge and left the army after seven months in uniform.[743]

One friend, when much later asked by officials about Pinckney's diagnosis, answered, "I don't know that anything was ever the matter with his mind, but he was never very bright."[744]

Pinckney returned to Georgetown and went to work as a farmer and "stock minder," tending farm animals. In 1866 he married Louisa Blaine, who lived on a nearby plantation. They became the parents of a girl and a boy.

At some point after 1880 the family moved to Forlorn Hope Plantation, a property owned by one of the daughters of Pinckney's former master.[745] Pinckney's wife died there in 1903. About a year later he married Rose Beckett, who had already survived two husbands. She also outlived Pinckney, who died at age seventy-four in 1916.[746]

Voyage Aboard the Mistress of the Seas

THE LOSS OF THE USS *MONITOR* IN A GALE OFF CAPE Hatteras, North Carolina, in 1862 left the impression that experimental ironclads of this type, distinguished by a round revolving turret and armored deck rising barely above the waterline, were not seaworthy and were suited only for coastal defense. Foreign navies that were engaged in their own iron fighting ship programs took comfort that the metal monsters were confined to the U.S. homeland.

American engineers, aware of the *Monitor's* shortcomings, tweaked the design. New improved vessels steamed out of Northern shipyards for combat and blockade duty. One of these, the twin-turret *Monadnock*, named for a New Hampshire mountain,[747] played a key role in the closing months of the war. On January 13–15, 1865, the iron giant belched shells from the fiery mouths of its four Dahlgren guns, pointed at Fort Fisher, North Carolina, and disabled many of the fort's cannon. The fall of the fort and subsequent capture of Wilmington deprived the Confederacy of its last major port.

Meanwhile, around 150 nautical miles north, at Hampton Roads, Virginia, a rookie sailor on board the triple-turret behemoth *Roanoke* could not have known he would be soon be transferred to the *Monadnock*.

Seaman Alfred Bailey, a free man from Virginia who moved to Baltimore before the war, left his job as a waiter in the summer of 1864 and enlisted.[748] After training on the *Vermont*, he joined the *Roanoke*. When the *Roanoke* was decommissioned in June 1865, Bailey was transferred to the single-turret monitor *Dictator* for service along the Atlantic coast. He remained aboard only a few months. The navy placed this ship out of com-

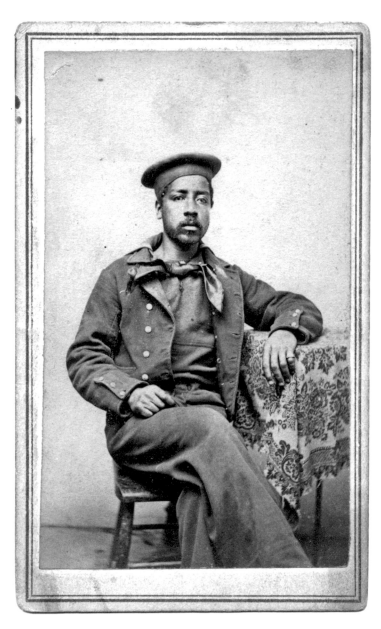

Seaman Alfred Bailey, U.S. Navy

Carte de visite by Lafayette V. Newell (1833–1914) of Portsmouth, New Hampshire, about 1864–1867. Collection of Thomas Harris.

mission in September, coincident with the organization of a new crew for the *Monadnock*.

Bailey joined the 130-man crew in Philadelphia, where the *Monadnock* had undergone repairs in preparation for its next assignment. Ordered to join the North Pacific Squadron, the monitor would travel from Philadelphia around Cape Horn to fleet headquarters in San Francisco. Successful completion of the fifteen thousand–mile voyage would prove American monitors seaworthy and capable of carrying war to foreign coasts.

On October 25, 1865, the *Monadnock* and three other ships began their odyssey with little fanfare. They ran into trouble almost immediately. One night off Cape Hatteras, where the original *Monitor* had sunk, a violent storm battered and scattered the convoy. The crews of the other ships lost contact with the *Monadnock* and feared the worst. At daylight the next morning, they found her intact.[749]

By late November, the *Monadnock* was cruising the coast of South America. In French Guiana, locals delivered four hundred tons of coal by catamaran to refuel the ship. On January 3, 1866, the *Monadnock* arrived at Rio de Janeiro, where Brazilian emperor Pedro II inspected the monitor and reportedly fired one of her guns.[750]

The convoy left soon after, rounded Cape Horn through the Straits of Magellan, and came upon a naval war between Spain and its former colonies Chile and Peru. The U.S. vessels and a contingent of British boats watched as the Spanish fleet bombarded the Chilean port city of Valparaiso on March 31, 1866. The crew of the *Monadnock* paid special attention to Spain's metal-skinned *Numancia*, which went on to become the first ironclad to circumnavigate the globe.

By this time, the *Monadnock*'s half-completed journey had caught the attention of the American press, and newspapers across the country buzzed with excitement that one of the United States' own monitors could sail the open seas. The *New Orleans Times* proclaimed, "The voyage of the *Monadnock* has settled a great naval question, and is one of the most remark-

able on record, since the Argonauts first ventured out timidly on the unknown sea."[751] From Philadelphia, the *Illustrated New Age* boasted, "With a fleet of such vessels as the *Monadnock*, a nation would be mistress of the seas, and defy all successful competition."[752] An editorial in the *Boston Daily Advertiser* viewed the journey in broader context: "The Monroe Doctrine has been a fruitful theme for bluster and vaporing, but there is a rational enjoyment to be had in seeing it at last laid down quietly but with the firmness of conscious strength, and as a rule for action and not a theme for diplomatic or literary diversion."

The *Monadnock* anchored off San Francisco on June 21, 1866, its eight-month journey a success. Large crowds toured the "great naval wonder" and celebrated its mastery of ocean travel.[753]

Fame was short lived. About this time, another U.S. monitor, the *Miantonomah*, completed a high-profile trans-Atlantic voyage, carrying Assistant Secretary of the Navy Gustavus Fox[754] to Ireland on a diplomatic mission. Naval authorities decommissioned the *Monadnock* soon after she arrived in San Francisco. In 1874, she was dismantled and rebuilt in a different design. Her life was brief but historic.

Alfred Bailey was transferred to the sidewheel steamer *Saginaw* and served in the North Pacific until his term of enlistment expired in August 1867. He returned to Baltimore and married a local woman who unfortunately died the next year. About two years later he went to work for a Baltimore businessman and earned a reputation as a faithful coachman and a "very capable and efficient driver."[755]

He remarried in 1878. Sometime thereafter he happened to attend a revival meeting. The preacher inspired Bailey to join a local African Methodist Episcopal church, where he became known as "a zealous worker in the religious and charitable enterprises among his people." In February 1885, while involved in a charity-related project at the home of a friend, he collapsed and died from a stroke. He was forty-eight years old.[756]

From Slave to Buffalo Soldier

IN LATE 1867, THE *SAN ANTONIO HERALD* REPORTED THE observations of a group of adventurous citizens who had just returned from a sightseeing trip through the Rio Grande frontier in southwest Texas. According to the newspaper, the region was "looking charmingly verdant, cattle fat—buffalo ditto and only to be enumerated by hundreds. No Indians were seen by them—only one moccasin track observed during the entire trip. The colored soldiers of the 9th Cavalry at Fort Davis are dying fast..., afflicted with a loathsome disease."[757]

The illness that swept through Fort Davis was dysentery, and it claimed six lives in the summer and fall.[758] The list of fatalities included Pvt. Solomon Starks.

Born a slave in Nelson County, Kentucky, Starks fled his master after the Civil War began and settled in Moline, Illinois. On October 1, 1864, army recruiters signed Starks and twelve other Moline men to a three-year term of enlistment in the 108th U.S. Colored Infantry.[759] Starks joined Company F and reported for guard duty at the prison camp at nearby Rock Island. In May 1865, the regiment transferred to the Department of Mississippi, then mustered out of the army at Vicksburg in March 1866.

Starks returned to Kentucky, where army recruiters enlisted him again, this time for the Ninth U.S. Cavalry, one of two new regular army regiments of African American cavalrymen who became known as Buffalo Soldiers. He was one of ninety-four recruits who traveled to Louisville, boarded the steamer *Alice*, journeyed down the Ohio and Mississippi rivers to New Orleans, and mustered into the Ninth at nearby Carrollton in March 1867.[760]

The army ordered the regiment to Texas to establish law and order on the Rio Grande frontier. The twelve companies of the Ninth were divided and dispatched to three separate locations. Six companies, under the command of distinguished Civil War

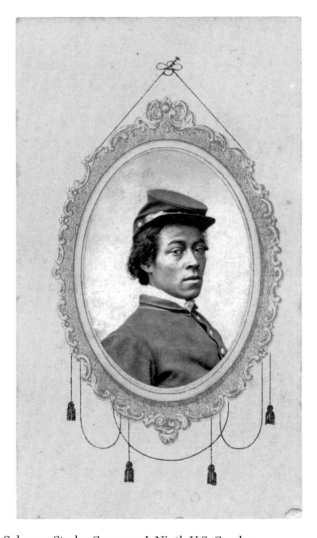

Pvt. Solomon Starks, Company I, Ninth U.S. Cavalry

Carte de visite by unidentified photographer, about March 1865. Collection of the Beinecke Rare Book and Manuscript Library, Yale University.

veteran Lt. Col. Wesley Merritt,[761] including Starks's Company I, arrived at Fort Davis for duty in June.[762]

Two months later, Starks fell ill with dysentery and succumbed to the disease at the post hospital on August 7, 1867. He was about twenty-four years old. A detail of troopers buried him on the fort grounds.

About a quarter-century later, the army ordered Fort Davis abandoned. During the winter of 1891–1892, a detachment of men removed the remains of eighty-seven soldiers, including Starks, for interment in the national cemetery at San Antonio.[763]

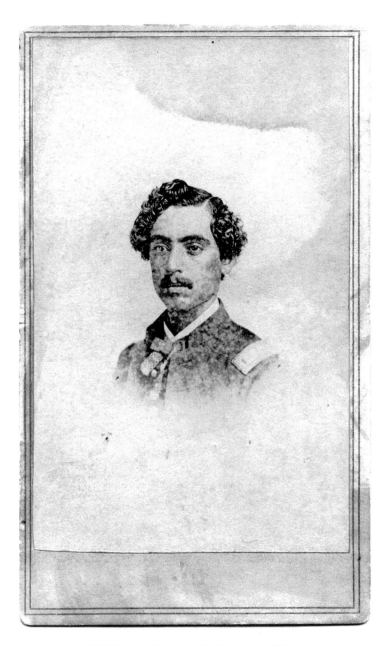

1st Lt. Morris W. Morris, Company F, First Corps d'Afrique

Carte de visite by unidentified photographer, about 1862–1863. Collection of Glen Cangelosi.

The Veteran Officer at the Heart
of an Acting Dynasty

ON THE EVENING OF NOVEMBER 17, 1873, AT SAN FRAN-
cisco's California Theatre, an almost packed house watched
Lewis Morrison on stage, resplendent in the uniform of a Union
officer in the star role as the noble patriot "Captain Airey" in the
premier of *Field and Fireside*. A reviewer described the play as
"a portrayal of some of the incidents of the rebellion...full of
the exciting scenes of war and the quiet, happy scenes of peace;
scenes of love and hatred, of sorrow and shame, of friendship
and treachery."[764]

The crowd might never have guessed that the handsome,
twenty-eight-year-old leading man had been a real officer dur-
ing the Civil War.

Born Morris W. Morris in Jamaica, he reportedly descended
from English, Spanish, and African ancestry. According to fam-
ily sources, Morris's mother, a Jewish woman with the surname
Carvalho, migrated with him to Louisiana shortly before the
war began. They settled in New Orleans. His father stayed in
Jamaica.[765]

Morris joined the army after Union forces occupied New
Orleans in May 1862. He enlisted in the First Louisiana Native
Guard, an African American infantry regiment later reorganized
as the First Corps d'Afrique.[766] Led by a white colonel, lieuten-
ant colonel, and major, the regiment's captains and lieutenants
were all men of color, including Morris, who became a second
lieutenant in Company F.

In early 1863, the head of U.S. forces in the U.S. Army De-
partment of the Gulf, Maj. Gen. Nathaniel Banks,[767] initiated a
purge of black officers under his command. Morris at first man-
aged to hold on to his commission and receive a promotion to

first lieutenant. He served in this capacity during the Siege of Port Hudson and was present for duty during the ill-fated assault against the formidable Confederate defenses on May 27, 1863. The regiment sustained heavy casualties in the attack.

Meanwhile, Banks's dogged quest to remove black officers finally caught up with Morris, who resigned his commission three months after the surrender of Port Hudson with the explanation that the recent death of his father required him to go to Jamaica to settle affairs and secure financial support for his aging mother.[768]

Morris launched an acting career before the end of the war. He adopted the stage name Lewis Morrison, possibly in an attempt to escape his Jewish and African heritage, according to one member of the family.[769] An audience favorite in New Orleans theaters, he starred in popular dramas and comedies. In the summer of 1865, he wed Rosabella Wood, a glamorous dancer known professionally as Rose Wood, the daughter of William Wood, an English-born pantomimist.[770] The *New Orleans Times* announced the marriage and quipped, "We wish Mr. Morrison all the joy possible with the splendid piece of *rosewood* lately added to his household furniture."[771]

Far more than decoration, Rose was a talented actress who performed in the same troupe as Morrison. The couple left New Orleans about 1870. After a stint in Philadelphia, they arrived in San Francisco in 1873. Morrison landed a gig as the headliner at the California Theatre. His debut, as "Lord Rochester" in *Jane Eyre*, received a mixed review. "The character in his hands was not a strong one," declared a critic, who added, "The gentleman had stiffness without dignity, and was nervous to a marked degree. Once, indeed, he gave a sample of his latent dramatic power, during the love scene in the closing act, but in the main the character was too tame. Mr. Morrison has a good presence and will, we hope, improve on acquaintance."[772]

Morrison did improve. Three months later he received a positive review for his role as "Captain Airey" in *Field and Fireside*.[773] He and Rose left San Francisco in 1874 and spent the

next two years on tour in the Midwest and East. They established themselves in New York City about 1876. Rose became a star on stage and on the screen in the silent film era.[774] After minor roles alongside Edwin Booth and other celebrities, Morrison went on to star as a leading man and stage manager in Brooklyn. He became best known as Mephistopheles in *Faust*, a role he played regularly for two decades beginning in 1885.[775]

In 1886 Rose accused Morrison of adultery and filed for divorce. The court found in her favor and required Morrison to pay alimony to her and their two daughters and son.[776] He married Maryland-born actress Florence Roberts[777] four years later. She was twenty-seven years his junior.

In August 1906, Morrison underwent stomach surgery at a New York hospital and died of complications five days later at age sixty-one.[778] His wife, ex-wife, and children survived him. One week before he passed away, his daughter Mabel[779] gave birth to his granddaughter, Barbara Bennett.[780] Barbara and her sisters, Joan and Constance, all went on to movie careers. Barbara, who never gained the celebrity status of her sisters, became the mother of singer, songwriter, and radio and television host Morton Downey Jr.

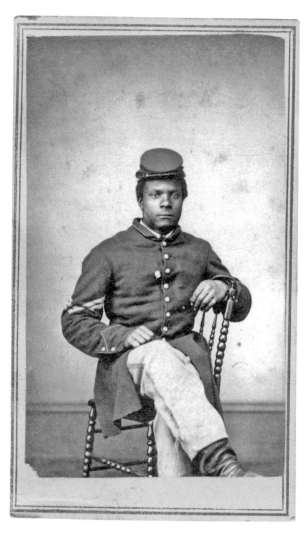

Sgt. Kendrick Allen, C Troop, Ninth U.S. Cavalry

Carte de visite by Alfred B. Gayford (b. ca. 1828) & Conrad S. Speidel (b. ca. 1827) of Rock Island, Illinois, about March 1865. Collection of the Beinecke Rare Book and Manuscript Library, Yale University.

A Trooper of Superior Character

ON DECEMBER 4, 1890, SGT. KENDRICK ALLEN AND HIS fellow Buffalo Soldiers rode into the South Dakota settlement of Oelrichs, a small community of homesteaders. The horsemen belonged to C Troop of the Ninth U.S. Cavalry, an outstanding company in one of the army's elite regiments. It was part of a larger force posted in the southeast corner of the state, where tragic events would unfold at Wounded Knee Creek before the end of the month.[781]

Recognized as a soldier of superior character, Allen's qualities came to light twenty-five years earlier during the Civil War. In the summer of 1864, at age nineteen, he joined the army in Louisville, Kentucky. He enlisted as a private in Company F of the 108th U.S. Colored Infantry and quickly rose in rank to sergeant. Soon after he received the promotion, the first lieutenant of his company noted of Allen, "now Serg't and an excellent one, and commands obedience."[782]

Allen was born a slave in Anderson County, Kentucky, about seventy-five miles east of Louisville; details of his early life are sketchy. Evidence suggests that he moved to neighboring Mercer County before the war and fled his master to join the military.[783]

Allen spent about two years in the 108th at various posts in Kentucky and Mississippi. He also guarded Confederate prisoners at Rock Island, Illinois, where he sat for his *carte de visite* photograph.

Allen mustered out of the army in March 1866, reunited with his family in Mercer County, and went into business as a stonemason with a relative.[784]

He was not cut out for stonework, however, and in 1871 he

joined the regular army and spent the next ten years with the Twenty-fourth Infantry in west Texas. He and his regiment built roads, hunted horse thieves, and guarded various strategic points. The soldiers also removed Native Americans from the region—Allen left no account of whether or not these actions reminded him of the persecution he suffered as a slave. According to one officer, the Twenty-fourth performed "arduous service which brought no fame, but required of its officers and men constant vigilance, discretion and care in the performance of the service."[785] During this time he advanced from corporal to sergeant.[786]

In 1881 he transferred to the Ninth Cavalry. He joined L Troop, a company known for its esprit de corps and excellent conduct. It had the distinction of being the first African American company posted at Fort Leavenworth, Kansas. Allen and his comrades were recognized as the best company at the fort during their 1886–1890 stay. The troop "performed its duties flawlessly without a hint of disciplinary problems," declared an historian, proving again that race was not a factor in a company's ability to excel.[787]

In 1890, the troop's designation was changed from L to C after a regimental reorganization, and they redeployed to South Dakota. On December 29 of that year, Seventh Cavalry troopers infamously slaughtered Sioux men, women, and children at Wounded Knee Creek. Allen and Troop C, located about forty miles away, did not participate.

Allen retired from the army in November 1897.[788] Less than a year later, during the Spanish-American War, the Ninth fought at the Battle of San Juan (Kettle) Hill alongside colonel and future president Theodore Roosevelt and his Rough Riders.

Allen lived out the rest of his days in Kentucky. He died in 1911 in his mid-sixties.

Honored Veteran

More than a half-century after the end of the Civil War, citizens of the town of North Adams in western Massachusetts organized a reception to welcome home local soldiers and sailors of color returned from service in World War I. On the evening of August 7, 1919, veterans and other dignitaries lined up for a formal march into the Grand Army of the Republic Hall. Conspicuous in his blue uniform and brass buttons stood an honored guest, seventy-five-year-old Charles Arnum.[789] As he looked out over the crowd, his thoughts may have gone back to his own army days.

Back in November 1863, then twenty-year-old Arnum left his job as a teamster in Littleton, a town northwest of Boston, and joined the Fifty-fourth Massachusetts Infantry.[790] At the time he enlisted, the regiment had already gained the attention and respect of the nation for fighting, in the words of Frederick Douglass, "like heroes to plant the star spangled banner on the blazing parapets of Fort Wagner."[791]

Pvt. Arnum joined other recruits for basic training in the Boston area. In May 1864 he received orders to join the regiment, and reported to Company E the following month in its camp on Folly Island, South Carolina, a base from which Union forces operated against nearby Charleston and the surrounding area. He went on to participate in numerous expeditions and engagements in the Palmetto State and Georgia.[792]

He mustered out with his comrades in August 1865, returned to Massachusetts, and settled in North Adams, his birthplace. He became a truckman, or trucker, hauling wagonloads of various goods and materials. About 1872 he married and started a family; he and his wife had two children, a girl and a boy. His

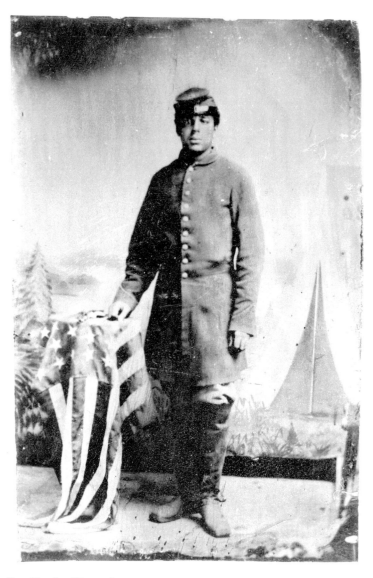

Pvt. Charles Henry Arnum, Company E, Fifty-fourth Massachusetts
Infantry

Ambrotype by unidentified photographer, about 1863. Collection of the Massachusetts Historical Society.

son, Harry, followed him into the trucking business. The two later established their own company.

Arnum retired about 1919, the same year he attended the reception to honor veterans from the Great War. By this time he had become active with the Grand Army of the Republic. He served various offices in his local post, including commander and chaplain, and also participated as a representative on the state level.

Arnum was one of the last remaining Civil War veterans in North Adams upon his death in 1934 at age ninety. He received full military honors at his burial, including the playing of taps and the firing of a volley to salute his service.[793]

Notes

Abbreviations Used in Notes and References

NARS: National Archives and Record Service, U.S. National Archives and Records Administration, Washington, D.C.

OR: U.S. Government, *The War of the Rebellion: A Compilation of the Official Records of the Union and Confederate Armies.* 128 vols. Washington, D.C., 1880-1901.

USAMHI: U.S. Army Military History Institute, Carlisle Barracks, Pennsylvania.

Biographical information for some enlisted men and officers is from NARS and Boatner's *Civil War Dictionary*, New York: David McKay Co., 1962.

1st Lt. Theodore Francis Wright's collection of *cartes de visite* of men in Company F of the 108th U.S. Colored Infantry is held in the Randolph Linsly Simpson African-American Collection, which is part of the James Weldon Johnson Collection at the Beinecke Rare Book and Manuscript Library, Yale University.

The federal government enumerated slaves in the seventh census (1850) and the eighth census (1860). These slave schedules usually included the name of the owner, the number of slaves owned, and the age, gender, and race of each slave. The name of each slave was not included. This information has been included when applicable. The records are part of the National Archives and Record Service in Washington, D.C.

1. The Northern officer is identified as Col. C. C. Willetts of Leavenworth, Kansas. The commander of the regiment was Lt. Col. David Branson of the Sixty-second U.S. Colored Infantry. The Southern officer was Maj. Thomas B. Webber of the Second Kentucky Cavalry. *Anglo-African (New York)*, January 31, 1863; General Order No. 36, November 9, 1864. Regimental Books and Papers, Sixty-second U.S. Colored Infantry, NARS; Affidavit of Lee Webber, June 30, 1909, transcribed from the Shelby County, Tennessee, courthouse records; Lee Webber Tennessee Confederate Pension Applications: Soldiers and Widows, Tennessee State Library and Archives.

2. The writer is identified as "Hannibal," from the Western Theological

Seminary and a veteran of the Fifth U.S. Colored Infantry. *The Christian Recorder (Philadelphia)*, November 4, 1865.

3. *Anglo-African (New York)*, January 31, 1863.

4. Ibid.

5. Newton, *Out of the Briars*, pp. 36–37.

6. Delany, *Blake; or, The Huts of America*, p. 290.

7. Ibid., p. xx.

8. Ibid., p. xxi.

9. Rollin, *Life and Public Services of Martin R. Delany*, pp. 15–16.

10. Charlestown is now in West Virginia, not a state in 1812.

11. *The Plain Dealer (Cleveland, Ohio)*, November 9, 1971.

12. Delany conceived of the idea of returning to his ancestral homeland in the winter of 1831–1832. Delany, *Official Report of the Niger Valley Exploring Party*, p. 8.

13. Delany, *Blake; or, The Huts of America*, p. xiv.

14. Rollin, *Life and Public Services of Martin R. Delany*, p. 141.

15. Ibid., pp. 141–146.

16. Toussaint L'Ouverture Delany was named for the man who led Haitian slaves in a rebellion against French colonizers. Toussaint L'Ouverture Delany military service record, NARS.

17. Delany's plan to have a black officered army did not come to pass during the Civil War. Rollin, *Life and Public Services of Martin R. Delany*, pp. 166–175.

18. Ibid., p. 22.

19. *The Plain Dealer (Cleveland, Ohio)*, November 9, 1971; Catharine A. Delany pension record, NARS.

20. *Cleveland (Ohio) Gazette*, February 21, 1885.

21. Ibid.

22. Rollin, *Life and Public Services of Martin R. Delany*, p. 19.

23. Asher, *Incidents in the Life of the Rev. J. Asher*, pp. 15–20.

24. *Public Ledger (Philadelphia)*, December 3, 1859.

25. Asher, *Incidents in the Life of the Rev. J. Asher*, p. 26.

26. Ibid., pp. 43–48.

27. Wilson, *Campfires of Freedom*, pp. 111–112.

28. Jeremiah Asher military service record, NARS.

29. *The Christian Recorder (Philadelphia)*, January 16, 1864.

30. Abigail Asher pension record, NARS; *The Christian Recorder (Philadelphia)*, August 12, 1865.

31. *North American and United States Gazette (Philadelphia)*, August 10, 1865; *The Christian Recorder (Philadelphia)*, August 26, 1865.

32. *The Christian Recorder (Philadelphia)*, August 19, 1865.

33. The regulars left Harrisburg under the command of Pennsylvania native Maj. John Clifford Pemberton (1814–1881). Pemberton, who had made up his mind to resign his commission and join the Confederate army,

turned over command to an orderly sergeant. He escorted the Pennsylvanians part of the way through Baltimore before turning off to report to the garrison at Fort McHenry. Pemberton subsequently went on to Washington and resigned there. He soon became a lieutenant colonel in the Confederate army and advanced to lieutenant general and department command. He is perhaps best known for surrendering the garrison of Vicksburg to Maj. Gen. Ulysses S. Grant on July 4, 1863.

34. *The Sun (Baltimore, Md.)*, April 19, 1861.

35. Military authorities designated James Wren (1825–1901) and the Washington Artillery as Company B of the Twenty-fifth Pennsylvania Infantry. After its three-month term of enlistment ended, Wren returned to the army as captain of Company B of the Forty-eighth Pennsylvania Infantry. He resigned as a major in 1863.

36. Capt. Wren shared his recollections in the *Weekly Press (Philadelphia)*, July 21, 1886.

37. *Weekly Miners' Journal (Pottsville, Pa.)*, August 4, 1876.

38. Wren in the *Weekly Press (Philadelphia)*, July 21, 1886.

39. Ibid. Excerpts from a letter written by Maj. Benjamin Poore of the Eighth Massachusetts Infantry appeared in the *Lowell (Massachusetts) Daily Citizen and News,* April 20, 1870.

40. Poore in the *Lowell (Massachusetts) Daily Citizen and News,* April 20, 1870.

41. Hoptak, "A Forgotten Hero of the Civil War," pp. 6–13.

42. Capt. Edmund McDonald of the National Light Infantry, one of the five companies that marched through Baltimore, shared his recollections in the *Weekly Press (Philadelphia)*, March 24, 1886. He and his comrades became Company D of the Twenty-fifth Pennsylvania Infantry.

43. *Weekly Miners' Journal (Pottsville, Pa.)*, August 4, 1876.

44. Ibid., August 11, 1876; Hobbs, "Nicholas Biddle," pp. 29–32.

45. Guthrie, *Camp-Fires of the Afro-American*, p. 265.

46. *Weekly Miners' Journal (Pottsville, Pa.)*, August 11, 1876.

47. The writer of the poem, Baptist minister James M. Guthrie, also authored the book *Camp-Fires of the Afro-American; or, The Colored Man as a Patriot* (1899).

48. Hoptak, "A Forgotten Hero of the Civil War," pp. 6–13.

49. Newton's mother, Mary (about 1814–1904), is listed in the 1900 U.S. Census as the mother of fifteen children, three of whom were alive at that time. She left North Carolina in the 1850s for New York City. There she connected with prominent abolitionists who helped her raise money to buy her husband's freedom. She was ultimately successful. Her husband, Thaddeus, belonged to Cathrine E. Custis of New Bern, who owned thirteen slaves in 1860. Newton joined his mother in New York in 1857. 1860 U.S. Census; 1860 Slave Schedules; Newton, *Out of the Briars*, pp. 19, 26, 37, 89.

50. Newton, *Out of the Briars*, p. 33.

51. Ibid., p. 31.

52. Mandeville, *History of the 13th Regiment, N.G., S.N.V.*, p. 23.

53. The Thirteenth arrived in New York City on July 17, 1863, and disbanded one week later. *New York Herald-Tribune*, July 20, 1863; *New York Times*, July 24, 1863.

54. Alexander H. Newton military service record, NARS.

55. Newton, *Out of the Briars*, p. 38.

56. Ibid., pp. 37–38.

57. Ibid., p. 41.

58. The private was James F. Fowler. Lula L. Newton pension record, NARS.

59. Ibid., p. 65.

60. A staunch advocate of African Americans as soldiers, Robert Hamilton (1819–1870) founded the *Weekly Anglo-African* in July 1861, three months after his brother Thomas (1823–1865) sold a newspaper by the same name, which he had established in 1859. Robert Hamilton published his newspaper until December 1865.

61. Newton, *Out of the Briars*, p. viii.

62. New Haven machinist Daniel Stanley Lathrop (1846–1924) began his service in the Twenty-ninth Connecticut Infantry as a sergeant in Company A. He received an appointment as quartermaster sergeant in January 1864. He mustered out with the regiment at Brownsville, Texas, on October 24, 1865.

63. Ambrose Everett Burnside (1824–1881) went on to become a brigadier when he took command of a successful expedition to North Carolina. He received a promotion to major general for his achievement. The general is perhaps best known for his three-month stint as commander of the Army of the Potomac (1862–1863) and the prominent mutton-chop whiskers with which his name is associated. He graduated from West Point in 1847.

64. Woodbury, *A Narrative of the Campaign of the First Rhode Island Regiment*, pp. 109–110.

65. Reports of Col. Ambrose E. Burnside, First Rhode Island Infantry, and commander of the Second Brigade, Second Division, Army of Northeastern Virginia. *OR*, I, II: 395–399.

66. Woodbury, *A Narrative of the Campaign of the First Rhode Island Regiment*, p. 170; Poore, *The Life and Public Services of Ambrose E. Burnside*, p. 70.

67. William Lloyd Bowers to Ambrose Burnside, February 4, 1862. Ambrose Burnside Papers, NARS.

68. The officers who signed the petition had all been captured by Burnside's forces after Brig. Gen. Henry Wise surrendered his garrison on Roanoke Island on February 8, 1862: Col. Henry M. Shaw of the Eighth North Carolina Infantry; Col. John V. Jordan, Thirty-first North Carolina Infantry; Lt. Col. Wharton J. Green, Second North Carolina Infantry Battalion;

and Lt. Col. Frank P. Anderson of the Fifty-ninth Virginia Infantry. Brig. Gen. Ambrose E. Burnside, U.S. Army, to Maj. Gen. Benjamin Huger, Commanding Department, Norfolk, December 31, 1861. *OR*, II, II: 184–185.

69. Poore, *The Life and Public Services of Ambrose E. Burnside*, p. 137.

70. Daniel R. Larned to Mrs. Ambrose E. Burnside, March 11, 1862. Daniel Read Larned Papers, Library of Congress.

71. Poore, *The Life and Public Services of Ambrose E. Burnside*, p. 388.

72. Bristol's Babbitt Post 15 is named for townsman Jacob Babbitt (1809–1862), who served as major of the Seventh Rhode Island Infantry. He suffered mortal wounds at the Battle of Fredericksburg on December 13, 1862. Bartlett, *Memoirs of Rhode Island Officers*, pp. 265–266.

73. Grand Army of the Republic, Headquarters Department of Rhode Island, *Proceedings at the Twentieth Annual Encampment*, pp. 55–56.

74. Ibid.

75. *The New York Herald*, May 18, 1862.

76. *Cleveland (Ohio) Gazette*, July 2, 1898; Guthrie, *Camp-Fires of the Afro-American*, p. 314.

77. Guthrie, *Camp-Fires of the Afro-American*, p. 314.

78. The three Confederate officers were Capt. Charles J. Relyea, Pilot Samuel H. Smith, and Engineer Zerich Pitcher.

79. *The Liberator (Boston)*, August 8, 1862.

80. *Cleveland (Ohio) Gazette*, July 2, 1898; Miller, *Gullah Statesman*, p. 3; *The State (Columbia, S.C.)*, December 28, 1902.

81. *The Topeka (Kansas) Plaindealer*, October 23, 1903.

82. According to an individual identified as "E.P.B.," the steam gunboat *Madgie*, commanded by Acting Master Frank B. Meriam, observed the *Planter*. The information source may have been Edward P. Blague, who served on the *Madgie* as an acting master's mate. *Springfield (Massachusetts) Republican*, July 12, 1893.

83. J. Frederick Nickels is often referred to in accounts as captain of the *Onward*. He ranked as acting volunteer lieutenant.

84. Miller, *Gullah Statesman*, p. 2; Guthrie, *Camp-Fires of the Afro-American*, p. 313; Reef, *African Americans in the Military*, p. 210.

85. Guthrie, *Camp-Fires of the Afro-American*, p. 313.

86. *Boston Daily Advertiser*, August 1, 1876.

87. Guthrie, *Camp-Fires of the Afro-American*, p. 313.

88. Samuel Francis Du Pont (1803–1865) of Delaware began his naval career in 1815 and made flag officer in 1861. His victory at Port Royal, South Carolina, in October 1861 earned him the Thanks of Congress and a promotion to rear admiral. Defeated in a bid to take Charleston in April 1863 (the same attack in which Smalls piloted the *Keokuk*), he asked to be relieved. His request was granted in July 1863. He died of poor health two years later.

89. Report of Flag Officer Samuel F. Du Pont, commanding the South

Atlantic Blockading Squadron, *Official Records of the Union and Confederate Navies in the War of the Rebellion*, I, XII: 820–821.

90. The article was reprinted in the *Macon (Georgia) Telegraph*, November 1, 1862.

91. *New York Tribune*, September 10, 1862.

92. Miller, *Gullah Statesman*, pp. 14–17.

93. Robert Smalls pension record, NARS.

94. Ibid.

95. *Augusta (Georgia) Chronicle*, March 29, 1876.

96. State of South Carolina, *Journal of the Constitutional Convention*, p. 476.

97. Born in Lexington, Massachusetts, Loring William Muzzey (1831–1909) enlisted as a quartermaster sergeant in the Twelfth Massachusetts Infantry during the summer of 1861. He advanced to first lieutenant and regimental quartermaster in May 1862, about a month after he met Henry Scott. In March 1864 Muzzey left the Twelfth to accept a commission as captain in the U.S. Commissary Department, and served in this capacity until October 1865. He left the army with a brevet rank of major for his war service. After returning to Massachusetts, he served in the state militia until 1876. He also played an active role in veterans' organizations. Cutter, *Historic Homes and Places and Genealogical and Personal Memoirs*, vol. 2, pp. 672–673.

98. *Woburn (Massachusetts) News*, undated, about 1903.

99. Two of Loring Muzzey's brothers also saw military service for the Union. George Eveleth Muzzey (1838–1896) enlisted as a quartermaster sergeant in the Twelfth Massachusetts Infantry with Loring in the summer of 1861. He advanced to second lieutenant in 1862 and made first lieutenant the following year. In May 1864, two months after Loring left the Twelfth, George took over as the regiment's quartermaster. Charles Otis Muzzey (1824–1864) joined the navy and served on the *Housatonic*. He died in the attack on the ship by the Confederate submarine *H.L. Hunley* in February 1864.

100. Hooper, "A Tale of the War."

101. Loring's mother, born Elizabeth Wood in Newburyport, Massachusetts, in 1798, married Benjamin Muzzey in 1822. They had seven children, five boys and two girls. Loring was her fourth child. Her daughter Helen Elizabeth Muzzey Hooper (1828–1906) authored "A Tale of the War." Elizabeth Muzzey died in 1870.

102. The corporal, George Kimball (1841–after 1910), served in Company A. He suffered battle wounds at Fredericksburg and Gettysburg. *Boston Guardian*, July 12, 1910.

103. Loring W. Muzzey military service record, NARS; Loring, *Proceedings at the Dedication of the Town and Memorial Hall, Lexington, April 19,*

1871, p. 59; General Order No. 13, Army of the Potomac, April 10, 1865. *OR,* I, XLVI, 3: 688.

104. Scott, *Biography of William Henry Scott*, p. 1.

105. Garrison Centenary Committee, *The Celebration of the One Hundredth Anniversary of the Birth of William Lloyd Garrison*, p. 50.

106. William Monroe Trotter (1872–1934) graduated from Harvard University in 1895. His father, James Monroe Trotter (1842–1892), who is profiled in this volume, had also been a political activist. William was publisher of the *Boston Guardian*, described as "an organ to voice intelligently the needs and aspirations of the colored American." The paper ran editorials that attacked Booker T. Washington and other leading African Americans of the era for what William Trotter viewed as conservative policies regarding discrimination.

107. *Boston Guardian*, July 12, 1910.

108. *Woburn (Massachusetts) News*, undated, about 1903.

109. *Boston Guardian*, July 12, 1910.

110. He predicted that the clash would occur in 1940. Ibid.

111. *Alexandria (Virginia) Gazette*, September 22, 1874; 1910 U.S. Census.

112. *Boston Guardian*, July 12, 1910.

113. Ibid.

114. *Anglo-African (New York)*, January 31, 1863.

115. Ibid.

116. *Washington (D.C.) Bee*, April 9, 1904.

117. *Anglo-African (New York)*, January 31, 1863.

118. *Washington (D.C.) Bee*, April 9, 1904.

119. *Anglo-African (New York)*, January 31, 1863.

120. Ibid.

121. Ibid.

122. Massachusetts-born Daniel Read Anthony (1824–1904) was a younger brother of the noted woman's suffragist Susan Brownell Anthony. A pioneer in Kansas during territorial times and early statehood, he became an influential figure in Leavenworth as a publisher and editor, politician, and wartime lieutenant colonel of the Seventh Kansas Cavalry. He also played a key role in the founding of the Kansas Historical Society.

123. *Washington (D.C.) Bee*, April 9, 1904.

124. James Henry "Jim" Lane (1814–1866) served as a U.S. congressman in his home state of Indiana before he moved to the Kansas Territory in 1855. Elected to the U.S. Senate in 1861, he also served as a brigadier general and as U.S. Army recruiting commissioner for Kansas (1862–1863). In this latter role he is credited with authorizing the formation of the First Kansas Colored Infantry. A charismatic and controversial leader, he dominated state political and military affairs. He committed suicide after be-

ing accused of financial irregularities and falling into disfavor with Radical Republicans.

125. *Washington (D.C.) Bee*, April 9, 1904.

126. Ibid.

127. Report of Maj. Richard G. Ward, First Kansas Colored Cavalry, *OR*, I, LIII: 455–458.

128. *Anglo-African (New York)*, January 31, 1863.

129. The officer was Maj. Theodore J. Reed.

130. U.S. House of Representatives, *The Reports of Committees of the House of Representatives for the First Session of the Fifty-First Congress*, vol. 3, pp. 191–194; Berlin, Reidy, and Rowland, *Freedom: A Documentary History of Emancipation*, Series II, pp. 69–70.

131. Andrew J. Armstrong of Emporia, Kansas, served as captain of Company D from March 1863 to October 1865, when the regiment mustered out of service. He had previously served as a first sergeant in Company C of the Ninth Kansas Cavalry.

132. In December 1864, the regiment was designated the Seventy-ninth U.S. Colored Infantry.

133. *Washington (D.C.) Bee*, April 9, 1904.

134. The superior officer, Col. Charles W. Blair, commanded the post at Fort Scott, Kansas. William D. Matthews military service record, NARS.

135. William D. Matthews pension record, NARS.

136. *(Little Rock) Arkansas Weekly Mansion*, April 19, 1884.

137. Martha Cunnigen pension record, NARS.

138. Ibid.

139. Joseph A. Regan (1818–1898) served Claiborne County as a state representative 1850–1852, 1854, and 1863. He enlisted as a captain in Company F of the Second Battalion Mississippi Infantry in 1861 and reported with his comrades for duty in Virginia. The battalion became the Forty-eighth Mississippi Infantry in late 1862. He resigned due to illness soon after the Forty-eighth came into existence. Lowry and McCardle, *A History of Mississippi*, p. 460; 1860 Slave Schedules; Joseph Regan military service record, NARS; Curtis, "Regan-Lum Family Bible / Joseph Regan Obituary," pp. 27–29.

140. Martha Cunnigen pension record, NARS.

141. The soldier who enlisted Emanuel Cunnigen recorded his name "Cunniga," a phonetic spelling. This name followed him throughout his service. Martha Cunnigen pension record, NARS.

142. Emanuel Cunniga military service record, NARS.

143. Cunnigen's great-grandson, Dr. Donald Cunnigen, provided key details about his family in his essay "Race, Class, Civil Rights, and Jim Crow America: Silences and Smiles," published in Myers, *Minority Voices*, pp. 78–82.

144. Ibid.

145. Ibid.

146. Ibid.

147. Martha Cunnigen pension record, NARS.

148. Myers, *Minority Voices*, pp. 78–82.

149. Sarah Armstrong pension record, NARS.

150. Alabama-born Peter Cornelius Byrne (1810–1878) owned ten slaves, including Jackson, according to the 1850 Slave Schedules. Sarah Munnerlyn took the maiden name of her owner, Sarah Boles Munnerlyn Thompson (1821–1893) of South Carolina.

151. Sarah Armstrong pension record, NARS.

152. Albert Jackson military service record, NARS.

153. In October 1862, Col. Daniel Ullmann (1810–1892) of the Seventy-eighth New York Infantry met with President Abraham Lincoln to discuss raising black troops. In early 1863, Ullmann received his brigadier's star and reported to Louisiana to organize regiments for the Corps d'Afrique. Instructions to Maj. Gen. Nathaniel P. Banks and Brig. Gen. Daniel Ullmann by Secretary of War Edwin M. Stanton, *OR*, III, III: 101–102; General Order No. 47, Headquarters Department of the Gulf, Nineteenth Army Corps, *OR*, I, XVI, 1: 539.

154. Sarah Armstrong pension record, NARS.

155. Albert Jackson military service record, NARS.

156. Sarah Armstrong pension record, NARS.

157. Little is known about Crispus Attucks, reportedly of African and Native American descent. He was one of five civilians shot and killed by British soldiers during an incident, on March 5, 1770, that came to be known as the Boston Massacre. An icon of the antislavery movement, he was memorialized as a black hero of the American Revolution. *The New York Herald,* May 29, 1863; *The Liberator (Boston),* June 5, 1863.

158. Emilio, *History of the Fifty-Fourth Regiment,* pp. xi–xii.

159. Register of Enlistments in the U.S. Army, 1798–1914, NARS.

160. Ardele Moore pension file, NARS.

161. Louisiana Collins (about 1830–1917), known as "Lou" or "Lulu," was first married to Christopher Roberts, who died before the Civil War. *The Yazoo (Mississippi) Semi-Weekly Sentinel,* May 9, 1917; John E. Ellzey, Reference and Local History Librarian, B. S. Ricks Memorial Library, to the author, July 22, 2009.

162. 1860 U.S. Slave Schedules.

163. Cyrus N. Brown (about 1837–1893) was born in Chenango County, New York. He moved to Yazoo County before the start of the war. In 1861 he enlisted as first sergeant in the "Benton Rifles," an infantry company that became Company B of the Eighteenth Mississippi Infantry. He later commanded the company as captain. 1860 U.S. Census; Cyrus N. Brown military service record, NARS.

164. Brown served as acting assistant surgeon. Report of Surg. F. W. Patterson of medical officers and wounded of McLaws' division left at Gettysburg, *OR*, I, XXVII, 2: 364.

165. Another refugee was George T. Collins. His last name suggests that he belonged to Lou Brown prior to her first marriage. Tibby Johnson pension record, NARS.

166. Silas Brown military service record, NARS.

167. Labor contract between C. N. Brown and foremen, January 5, 1866. Records of the Field Offices for the State of Mississippi, Bureau of Refugees, Freedmen, and Abandoned Lands, 1865–1872, NARS.

168. Tibby Johnson pension record, NARS.

169. Ibid.

170. Emilio, *History of the Fifty-Fourth Regiment*, p. 54.

171. Abraham F. Brown military service record, NARS.

172. George Crockett Strong (1833–1863), a member of the West Point Class of 1857, served as a staff officer to generals Irvin McDowell, George B. McClellan, and Benjamin F. Butler before taking command of the forces that would participate in the two assaults on Fort Wagner. During the second attack, on July 18, 1863, he suffered a mortal wound while leading a charge. That same day he was promoted from brigadier to major general. He died twelve days later. Luis F. Emilio describes Strong as "a brilliant young officer" (*History of the Fifty-Fourth Regiment*, p. 46).

173. Ibid., p. 54; Report of Brig. Gen. George C. Strong, U.S. Army. *OR*, I, XXVIII, 1: 354–355.

174. Abraham F. Brown military service record, NARS.

175. *Worcester (Massachusetts) Telegram*, September 29, 1907.

176. According to the regimental history and military service records, three young musicians enlisted in the Fifty-fourth Massachusetts before Alex Johnson did on March 2, 1863: Samuel Sufphay (February 18), John Wright (February 25), and Henry A. Monroe (February 26). A fourth, Charles Draper, is not listed as a musician but worked as a drummer in Philadelphia before he enlisted on February 23.

177. Ward, "From the Slave Quarters to the Courtroom" (Web article).

178. *Worcester (Massachusetts) Telegram*, September 29, 1907.

179. Ibid.

180. Ibid.

181. Mary Ann Johnson pension record, NARS.

182. *Worcester (Massachusetts) Telegram*, September 29, 1907; Massey, "Alexander H. Johnson: 54th Massachusetts Volunteer Infantry" (Web article).

183. *Worcester (Massachusetts) Telegram*, September 29, 1907.

184. Carney later noted: "It will be remembered that John W. Wall was chosen regimental color-bearer while at Readville, and pledged his honor

as a soldier that he would maintain the flag." John Wall of Company G began his enlistment as a private in the camp of the Fifty-fourth at Readville, Massachusetts. He advanced to sergeant in May 1863. According to his military service record, he was present at the battle at Fort Wagner. He is not listed as a casualty. In November 1863 he was reduced to the ranks for "unsoldierly and cowardly conduct." In June 1865 he returned to the rank of sergeant. *Cleveland Gazette,* June 19, 1886; John Wall military service file, NARS.

185. *Cleveland (Ohio) Gazette,* June 19, 1886.

186. Emilio, *History of the Fifty-Fourth Regiment,* pp. 80–82.

187. *The Topeka (Kansas) Plaindealer,* June 24, 1904.

188. Ibid.

189. Carney described this injury in his pension file but failed to place it in context to his overall experience at Fort Wagner. This injury is variously mentioned in several early public accounts as a wound to his breast or a second shot (distinguished from the first shot, in his hip, and the shell fragment that struck his head). Later accounts mention only his hip and head wounds. Susanna Carney pension file, NARS.

190. *The Topeka (Kansas) Plaindealer,* June 24, 1904.

191. Ibid.

192. Carney's notes refer to the officer as "Lt. Johnson." This is probably 2nd Lt. Alexander Johnston of Company F. Johnston's war service started with the Second Massachusetts Cavalry. He resigned from the Fifty-fourth Massachusetts Infantry in November 1863. In his regimental history, Capt. Luis Emilio states that the national flag carried by Carney was brought to him. Emilio does not state who brought him the flag. It may have been Lt. Johnston, as Carney was likely in no condition to move, because of his wounds. *Cleveland (Ohio) Gazette,* June 19, 1886; Emilio, *History of the Fifty-Fourth Regiment,* p. 84.

193. William H. Carney military service record, NARS.

194. National Association of Letter Carriers, "NALC Pioneer William Carney," pp. 6–12.

195. This account of Carney's story is based upon a series of statements made by and interviews with Carney at various times after the events of July 18, 1863. The basic story line is consistent in every instance. However, variations occurred over the years. In this version, the author brings together a number of accounts by Carney.

196. *The Topeka (Kansas) Plaindealer,* June 24, 1904.

197. *The Christian Recorder (Philadelphia),* November 14, 1895.

198. A writer identified as "Old Banjo," recorded these lyrics in *The Postal Record:*

The old flag never touched the ground, boys;
The old flag never touched the ground.

It's been in many a fix
Since 1776,
But the old flag never touched the ground.

Johnson, *A School History of the Negro Race in America*, pp. 115–117; National Association of Letter Carriers, "Branch Items of Interest: Jacksonville, Florida," p. 217; Blatt, Brown, and Yacovone, *Hope and Glory*, pp. 111–112.

199. *The Colored American (Washington, D.C.)*, June 2, 1900.

200. Ibid.

201. Ibid. Several versions of the Douglass rallying cry exist. Others include "Come, boys, come let's fight for God and Governor Andrew" and "Come on boys, and fight for God and Gov. Andrew!" The author selected the version quoted by Sgt. William H. Carney of the Fifty-fourth, who received the Medal of Honor for his actions at Fort Wagner.

202. An expanded view of the formation of the first African American regiments appears in the introduction to this volume. *Douglass' Monthly (Rochester, N.Y.)*, March 1863.

203. Two of Lewis Douglass's brothers participated in the war effort. Frederick Douglass Jr. (1842–1892) helped recruit volunteers in Mississippi. Charles Remond Douglass (1844–1920) served as a private in Company F of the Fifty-fourth Massachusetts Infantry and fought at Fort Wagner. He later transferred to the Fifth Massachusetts Cavalry to become a sergeant in Company I. Douglass, *Life and Times of Frederick Douglass*, p. 355; Charles R. Douglass military service record, NARS.

204. Washington, *Frederick Douglass*, p. 160; *Washington (D.C.) Bee*, September 26, 1908.

205. Douglass joined a group that planned to colonize Chiriqui on the Isthmus of Panama. The federally funded project ultimately failed.

206. *Lowell (Massachusetts) Daily Citizen and News*, August 14, 1863; *The Colored American (Washington, D.C.)*, June 2, 1900.

207. "Minnie" is a slang term for the minie bullet, a conical-shaped, grooved lead bullet. Minnies were standard ammunition for the Minié rifle, invented by Capt. Claude-Etienne Minié of France.

208. Lewis Douglass to his parents, July 20, 1863. *Douglass' Monthly (Rochester, N.Y.)*, August 1863; Lewis Douglass to Helen Amelia Loguen, Woodson, *The Mind of the Negro*, p. 544.

209. Douglass, *Life and Times of Frederick Douglass*, p. 347.

210. Lewis H. Douglass military service record, NARS; Helen Amelia Douglass pension record, NARS; Greene, *Swamp Angels*, pp. 87–88.

211. *The Liberator (Boston)*, August 25, 1865.

212. *The Christian Recorder (Philadelphia)*, December 21, 1867; Spude, "Mining History: A New Dialogue," p. 3.

213. *The New York Times*, August 8, 1869.

214. *Washington (D.C.) Bee*, September 26, 1908.

215. *Weekly Louisianian (New Orleans)*, July 6, 1872.

216. Helen Amelia Douglass pension record, NARS.

217. Townsend's nickname was revealed in a newspaper article touting his political accomplishments. *The Christian Recorder (Philadelphia)*, January 8, 1891.

218. Emilio, *History of the Fifty-Fourth Regiment*, p. 82.

219. Cornelia A. Townsend pension record, NARS.

220. Pennsylvania-born Albanus S. Fisher enlisted as a private in Company I and made sergeant on July 20, 1863, two days after the failed assault on Fort Wagner. He survived the war and mustered out with the regiment in August 1865.

221. Morgan, *Morgan's History of the New Jersey Conference*, pp. 239–241.

222. Where the Townsends lived in Virginia became part of the state of West Virginia in 1863.

223. Morgan, *Morgan's History of the New Jersey Conference*, pp. 239–241.

224. Ibid.

225. *The Christian Recorder (Philadelphia)*, November 12, 1891.

226. Morgan, *Morgan's History of the New Jersey Conference*, pp. 239–241.

227. *The Christian Recorder (Philadelphia)*, November 12, 1891.

228. In 1881, voters elected the first African American member of the Indiana state House of Representatives. James Sidney Hinton (1834–1892) served a single term. A native of Raleigh, North Carolina, he played an active role as an army recruiter during the Civil War.

229. *Palladium-Item (Richmond, Ind.)*, Jan. 18, 2010.

230. Twenty-third U.S. president Benjamin Harrison (1833–1901) of Ohio began his war service as a line officer in the Seventieth Indiana Infantry and advanced to the colonelcy of the regiment. He eventually received his brigadier's star and commanded on the brigade level in the Army of the Cumberland.

231. The white man whom Harrison named as secretary of the treasury was William Windom (1827–1891). After Windom died in office, Harrison named former Ohio governor Charles W. Foster (1824–1904) to replace him. Many years would have to pass before appointment of the first African American cabinet member, Robert Clifton Weaver (1907–1997), who served as the first secretary of housing and urban development under President Lyndon B. Johnson from 1966 to 1968. The editorial originally appeared in *The Boston Courant* on February 6, 1891. *Omaha (Nebraska) World Herald*, February 7, 1891.

232. *The Christian Recorder (Philadelphia)*, November 12, 1891.

233. Companies B, H, and K "rendered very valuable services in keeping open communications and watching the movements of the enemy," noted Maj. Gen. Rosecrans in his official report of the Chickamauga campaign. The defeat at Chickamauga resulted in the dismissal of William Starke Rosecrans (1819–1898) as commander of the Army of the Cumberland. A West Point graduate known as "Old Rosey" to his men, he later became head of the Military Department of Missouri. After the war he served as U.S. minister to Mexico (1868–1889) and as a member of Congress from California. *OR*, I, XXX, 1: 47–64.

234. Jane Hines pension record, NARS.

235. William Rix Hines (1811–1884) owned John and Adeline. John's pension file mentions two of his master's sons, John D. Hines (b. 1850) and Fayette E. "Faye" Hines (b. 1851), as his "young masters." Jane Hines pension record, NARS; 1860 Slave Schedules.

236. Ophelia Minerva Hines Chandler (b. 1846) was the oldest of four children born to William Rix Hines and Mary Twoomy Hines.

237. The relative was Hines's brother-in-law George O'Connor. Jane Hines pension record, NARS.

238. Ibid.

239. The officer was Abram Beitler Garner (1838–1909) of Howellville, Pennsylvania. He started his military service as a first sergeant in the Fifteenth Pennsylvania Cavalry and became captain of Company K two weeks after Jack Hines enlisted. Garner ended the war as the regiment's major.

240. William Jackson Palmer (1836–1909) started his war service in 1861 as captain in the Fifteenth Pennsylvania Cavalry. He became colonel in 1862. Captured at Antietam, he spent several months as a prisoner of war. He later commanded on the brigade level and received the Medal of Honor for his actions at Red Hill, Alabama, in January 1865. He ended the war as a brevet brigadier general of volunteers.

241. Authorized by the Adjutant General's Office on March 24, 1863, General Order No. 73 formalized a number of congressional acts, including Act No. 57, designed "to promote the efficiency of the corps of engineers and of the ordnance department, and for other purposes." Several sections address the feeding of soldiers. Section 10 states: "That the President of the United States be, and he is hereby, authorized to cause to be enlisted, for each cook, two under cooks of African descent, who shall receive for their full compensation ten dollars per month, and one ration per day; three dollars of said monthly pay may be in clothing." General Order No. 323, issued by the War Department on September 28, 1863, provided additional detail about the enlistment of under cooks. Adjutant General's Office, *General Orders Affecting the Volunteer Force*, pp. 44–46, 176.

242. Jane Hines pension record, NARS.

243. Ibid; 1880 U.S. Census.

244. Jane Hines pension record, NARS.

245. Ibid. The citizen was attorney L. C. Hemmings. He helped Jane Hines file for her pension.

246. Andrew Martin Chandler (1844–1920) served his entire enlistment in the Forty-fourth Mississippi Infantry. The wound he received at Chickamauga crippled him for life.

247. Andrew M. Chandler military service record, NARS.

248. The descendant was Andrew's son Benjamin Sterling Chandler, not to be confused with Andrew's brother, Benjamin S. Chandler (1846–1909). The uncle was Malachi "Kyle" Chandler (1810–1878). *West Point (Mississippi) Daily Times Leader*, January 4, 1950.

249. Louisa Chandler, formerly Louisa Garner (1810–1867), managed the family farm after the death of her husband, Guilduroy "Roy" Chandler (1814–1854). Rowland, *Mississippi, Contemporary Biography*, vol. 3, pp. 135–137; Andrew M. Chandler military service record, NARS; 1850 U.S. Census and 1860 U.S. Census; 1860 Slave Schedules; Bobbie Chandler to the author, May 8, 2010.

250. According to the 1910 Census, Silas and Lucy had been married for fifty years in 1910.

251. 1910 U.S. Census; Bostic, *Gone But Not Forgotten*, p. 9.

252. Andrew M. Chandler to his mother, August 31, 1862. Andrew M. Chandler Papers, Collection of Andrew Chandler Battaile.

253. Andrew M. Chandler military service record, NARS.

254. Report of Col. Jacob H. Sharp, Forty-fourth Mississippi Infantry. *OR*, I, XXX, 2: 327–328.

255. *West Point (Mississippi) Daily Times Leader*, January 4, 1950.

256. Ibid. Cal Weaver is probably 1st Sgt. James C. Weaver, who served with Andrew in Company F.

257. Cunningham, "Benjamin S. Chandler," p. 178; Benjamin S. Chandler military service record, NARS; Silas Chandler pension record, Mississippi Department of Archives and History.

258. 1910 U.S. Census.

259. Bostic, *Gone But Not Forgotten*, pp. 15, 17.

260. Mt. Hermon Baptist Church stood from 1896 to 1964, when it was replaced by a new building. Sampson, *Silas Chandler*, p. 4.

261. Ibid., p. 1.

262. Rollins, *Black Southerners in Gray*, Epilogue.

263. Bobbie Chandler to the author, May 8, 2010.

264. Steward is also known as Henry Stewart. Emilio, *History of the Fifty-Fourth Regiment*, p. 131.

265. Bonner, *Memoirs of Lenawee County Michigan*, vol. 1, pp. 469–471.

266. Henry Steward military service file, NARS.

267. Emilio, *History of the Fifty-Fourth Regiment*, p. 131.

268. The author arrived at these numbers based upon the roster of soldiers at the end of the regimental history. Company E had sixteen Michigan men in its ranks, the highest number in any company. One man from the town of Adrian transferred to the Fifty-fourth's sister regiment, the Fifty-fifth Massachusetts Infantry.

269. Henry Steward military service file, NARS.

270. Emilio, *History of the Fifty-Fourth Regiment*, p. 131.

271. *The New York Herald*, March 6, 1864.

272. Dr. Charles King (1789–1867) served as president of Columbia College from 1849 to 1864. (The college became Columbia University in 1896.) The son of politician and 1816 U.S. presidential candidate Rufus King, Charles King served in the War of 1812 and edited the *New York American* before he embarked on an academic career.

273. *The New York Herald*, March 6, 1864.

274. Rev. George Washington LeVere (about 1821–1886) served as the Twentieth's original chaplain. Born in Brooklyn, New York, he later became the first pastor of Shiloh Presbyterian Church in Knoxville, Tennessee. A series of his wartime letters was published in the *New York Weekly Anglo-African* in 1864 and 1865.

275. *Anglo-African (New York)*, March 12, 1864; Matthews, *African American Freedom Journey in New York*, p. 198.

276. Euphemia Benson pension record, NARS; 1850 U.S. Census and 1860 U.S. Census.

277. Euphemia Benson pension record, NARS.

278. Ibid.

279. Emilio, *History of the Fifty-Fourth Regiment*, p. 141; John Goosberry military service record, NARS.

280. Register of Applications of Freedmen for Land, Records of the Assistant Commissioner for the State of Louisiana Bureau of Refugees, Freedman and Abandoned Lands, 1865–1869, NARS; Knight, "The Rost Home Colony, St. Charles Parish, Louisiana," pp. 214–220.

281. French-born Pierre Adolphe Rost (1797–1868) served in the military of his home country before he emigrated to the United States in 1816. He served two stints as a judge on the Louisiana Supreme Court prior to the Civil War.

282. According to the 1870 Census, John Goosberry lived in Lockport, New York.

283. Simon, *The Papers of Ulysses S. Grant*, Vol. 26, p. 519.

284. Estimates of Goosberry's age at death vary extremely, from thirty-eight to sixty-one.

285. This pay was established by an act of Congress in 1862.

286. Fox, *Record of the Service of the Fifty-Fifth Regiment*, pp. 17–18.

287. The enlisted man, Pvt. James T. Rix, served in Company I. He left the Fifty-fifth in June 1864 with a disability discharge. *The Christian Recorder (Philadelphia)*, March 3, 1887.

288. Trotter, *Music and Some Highly Musical People*, p. 254.

289. Biographers and genealogists list Richard S. Trotter as the father of James. The author has found only one reference to Richard, that he was born in Vicksburg, Mississippi, in 1816 and died in the same place.

290. Trotter attended Gilmore High School, founded by wealthy British clergyman and philanthropist Hiram S. Gilmore in 1844. Miller and Smith, *Dictionary of Afro-American Slavery*, p. 264.

291. Fox, *The Guardian of Boston*, pp. 3–4.

292. Trudeau, *Voices of the 55th*, p. 181.

293. The order for equal pay came with a stipulation: to receive the thirteen dollars, each soldier was required to take an oath that he had been free on or before April 19, 1861. The ruling affected few in the Fifty-fifth, according to its historian. The historian of the Fifty-fourth Massachusetts Infantry noted that those who were slaves on that day "took the oath as freeman, by God's higher law, if not by their country's." Emilio, *History of the Fifty-Fourth Regiment*, p. 221; Fox, *Record of the Service of the Fifty-Fifth Regiment*, p. 35.

294. Fox, *Record of the Service of the Fifty-Fifth Regiment*, p. 36.

295. This quote is taken from comments read at an annual reunion of officers from the Fifty-fourth and Fifty-fifth regiments, held in Boston on November 8, 1882. *The Christian Recorder (Philadelphia)*, December 14, 1882.

296. *The Christian Recorder (Philadelphia)*, December 31, 1864; Trudeau, *Voices of the 55th*, p. 166.

297. James M. Trotter military service record, NARS.

298. Trotter, *Music and Some Highly Musical People*, p. 4.

299. Fox, *The Guardian of Boston*, p. 11.

300. Yellin, *Harriet Jacobs, a Life*, p. 251.

301. William Monroe Trotter (1872–1934) graduated from Harvard University in 1895. Like his father, he became a political activist. As publisher of the *Boston Guardian*, "an organ to voice intelligently the needs and aspirations of the colored American," Trotter ran editorials that attacked Booker T. Washington, the leading African American of the era, for what he viewed as conservative policies regarding discrimination. Trotter was a charter member of the Niagara Movement, which gave rise to the National Association for the Advancement of Colored People (NAACP).

302. Attorney Frederick Lyman Hitchcock (1837–1924) started service as a first lieutenant in the 132nd Pennsylvania Infantry. He participated in several major battles, including Fredericksburg, where he suffered two wounds and mustered out as major when the regiment's term of enlistment

expired in June 1863. Some months later he returned to the army as lieutenant colonel of the Twenty-fifth U.S. Colored Infantry and advanced to become its colonel and commander. His book *War From the Inside*, published in 1904, is a history of his first regiment. He is also the author of *History of Scranton and Its People*, published in 1914.

303. Bates, *History of Pennsylvania Volunteers,* vol. 5, pp. 1026–1027.

304. 1880 U.S. Census.

305. Owens Dawson military service record, NARS.

306. Scott, *Camp William Penn,* pp. 11, 42.

307. Bates, *History of Pennsylvania Volunteers,* vol. 5, pp. 1026–1027.

308. Margaret Dawson pension record, NARS; 1880 U.S. Census.

309. Margaret Dawson pension record, NARS.

310. Dawson belonged to O. P. Morton Post #4. Church and Ingram, *What You Most Want to Know,* p. 47.

311. Ruth E. Hogue pension record, NARS.

312. John Sample pension record, NARS.

313. The farmer was Newton Cockerell (1841–1900). John Sample military service record, NARS.

314. John Sample pension record, NARS.

315. Ibid.

316. A reference to Hopson's escape can be found on the back of the *carte de visite* of Hopson belonging to Theodore Francis Wright, who served as first lieutenant of Company F. A note penned by Wright states of Hopson, "Hunted through the swamps a week by his master before he reached a boat—performed his duty well—not very smart."

317. 1860 Slave Schedules; 1860 U.S. Census; Perrin, *Counties of Christian and Trigg, Kentucky,* pp. 213–214.

318. Jesse Hopson military service record, NARS.

319. Ibid.

320. Perrin, *Counties of Christian and Trigg, Kentucky,* pp. 213–214.

321. Jesse Hopson pension record, NARS.

322. Charles Wesley Fribley (1835–1864) of Lycoming County, Pennsylvania, started his wartime military service as a private in the Eleventh Pennsylvania Infantry. After the regiment's three-month term of enlistment ended, he became a sergeant in the Eighty-fourth Pennsylvania Infantry. He advanced to captain and left the regiment to become colonel of the Eighth. Attempts to remove his body during the fight at Olustee failed, and it is presumed to have been buried on the battlefield. Fribley and the Eighth were memorialized in the song *Hymn of the Freedman,* written in 1864. Thompson, "Civilian of the Month: Kate Fribley."

323. Fox, *Regimental Losses in the American Civil War,* p. 54; Report of Capt. Romanzo C. Bailey, Eighth U.S. Colored Infantry. *OR,* I, XXXV, 1: 311–314; John Peck disability pension record, NARS.

324. The lieutenant, Oliver Willcox Norton (1839–1920) of Springfield,

Pennsylvania, began as a private in the Erie Regiment. After its three-month term of enlistment expired, the regiment reformed as the Eighty-third Pennsylvania Infantry. He left in 1863 to become a first lieutenant in the Eighth and later served as its quartermaster. He wrote several books about his military experience, including a collection of wartime letters. Norton, *Army Letters*, pp. 201–203.

325. Alexander Peter Heichhold (1825–1882) served as surgeon of the 105th Pennsylvania Infantry before joining the Eighth in the same capacity. According to a biographer, "The doctor was an ultra Republican, and an early advocate for the enlistment of colored troops." Scott, *History of Jefferson County Pennsylvania*, pp. 378–379; *The Christian Recorder (Philadelphia)*, March 12, 1864.

326. *The Christian Recorder (Philadelphia)*, March 12, 1864; Report of Capt. Romanzo C. Bailey, Eighth U.S. Colored Infantry. *OR*, I, XXXV, 1: 311–314.

327. There is no evidence that Peck came into close contact with enemy troops, although Confederate cavalry were present during the battle. John Peck disability pension record, NARS.

328. 1880 U.S. Census; John Peck military service record, NARS; John Peck disability pension record, NARS.

329. Norton, *Army Letters*, pp. 201–203.

330. Estimates on the amount of time the Eighth fought vary from one-and-a-half to two-and-a-half hours. *The Christian Recorder (Philadelphia)*, March 12, 1864.

331. John Peck disability pension record, NARS.

332. John Peck military service record, NARS.

333. 1880 U.S. Census.

334. John Peck disability pension record, NARS.

335. According to Drummer Alexander H. "Alex" Johnson of the Fifty-fourth Massachusetts Infantry, the caisson belonged to the Third Rhode Island Battery. Johnson referred to a section of Light Company C of the Third Rhode Island Artillery, commanded by 1st Lt. Henry H. Metcalf, Third Rhode Island Infantry. Metcalf does not mention a runaway caisson in his report. However, Capt. Loomis L. Langdon of Battery M, First U.S. Artillery, describes such a caisson in his official account of Olustee. Emily A. Netson pension record, NARS; Report of 1st Lt. Henry H. Metcalf, Third Rhode Island Infantry. *OR*, I, XXXV, 1: 320; Report of Capt. Loomis L. Langdon, Battery M, First U.S. Artillery. *OR*, I, XXXV, 1: 315–319.

336. Minor spelling and punctuation adjustments have been made for clarity. Emily A. Netson pension record, NARS.

337. Ibid.

338. According to its Web site, Yale College became Yale University in 1887.

339. Emily A. Netson pension record, NARS.

340. Ibid.

341. Report of Brig. Gen. Daniel Ullmann. *OR*, I, XXXIV, 1: 933–934.

342. Thomas Stafford military service record, NARS.

343. 1850 and 1860 U.S. Censuses and Slave Schedules.

344. Lebanon, Missouri, "History of Lebanon" (Web article).

345. Daniel Ullmann (1810–1892) raised five African American regiments for the Union army in Louisiana in 1863. These units became the Corps d'Afrique and were later designated as USCT infantry regiments.

346. Report of Brig. Gen. Daniel Ullmann. *OR*, I, XXXIV, 1: 933–934.

347. The officer was 2nd Lt. John A. Moulton. Born in Maine, he started as a sergeant in Company F of the Seventh Minnesota Infantry. John A. Moulton military service record, NARS; Urwin, *Black Flag Over Dixie: Racial Atrocities and Reprisals in the Civil War*, p. 53.

348. Gentry Emerson military service record, NARS.

349. Thomas Stafford pension record, NARS.

350. Mollison, *The Leading Afro-Americans of Vicksburg, Miss.*, pp. 78–79.

351. John Ancrum Winslow (1811–1873) served as the second captain of the *Kearsarge*. Its original captain, Charles Whipple Pickering (1815–1888), was relieved of duty in 1863 for a less than vigorous pursuit of Confederate cruisers that were wreaking havoc on Union merchant ships. Winslow received the Thanks of Congress and a promotion to commodore for his defeat of the *Alabama*. After the war he advanced to rear admiral and head of the Pacific Squadron.

352. Report of Capt. John A. Winslow, commanding the *Kearsarge*. Naval War Records Office, *Official Records of the Union and Confederate Navies in the War of the Rebellion*, I, III: 59.

353. Edge, *The Alabama and the Kearsarge*, p. 27.

354. 1850 U.S. Census.

355. Henry Lemon (1809–1885) is variously described as an upholsterer, decorator, Egyptologist, and scholar. Legal entanglements, financial troubles, and the death of his wife are reasons given for his suicide at age seventy-six. 1860 U.S. Census; Sweetser, *King's Handbook of Newton Massachusetts*, pp. 48, 50; *Boston Morning Journal*, April 27, 1885.

356. Historic Newton, The Jackson Homestead and Museum, "Seeking Freedom in 19th Century America: Charles Redding of the Kearsarge" (Web article).

357. Sweetser, *King's Handbook of Newton Massachusetts*, pp. 48, 50.

358. *The New York Herald*, July 6, 1864.

359. The eyewitness, William Lewis Dayton Jr. (1839–1897), was the son of the U.S. Minister to France. He wrote an account of the action on June 21, 1864, two days after the fight. *Philadelphia Inquirer*, July 7, 1864.

360. The ship was renamed the *Guard* in 1866.

361. Charles F. Redding naval service record, NARS.

362. Isabella E. Redding pension record, NARS.

363. The friend, Hudson Sturt, became a private in Company B of the 108th U.S. Colored Infantry. He survived the war. Hudson Sturt military service record, NARS.

364. Edward Rumsey Weir Sr. (1816–1891) lived in Greenville his entire life. In 1861, he raised and partially equipped a company of soldiers for the Eleventh Kentucky Infantry. The volunteers he recruited elected his son, Edward Rumsey Weir Jr. (1839–1906), as captain and company commander. The younger Weir resigned in January 1863. He rejoined the army later that year as lieutenant colonel of the Thirty-fifth Kentucky Infantry. 1860 Slave Schedules; Rothert, *A History of Muhlenberg County*, pp. 60, 252; Edward R. Weir military service record, NARS.

365. Rothert, *A History of Muhlenberg County*, p. 340.

366. Wilson Weir military service record, NARS.

367. Theodore Francis Wright, who served as first lieutenant of Company F, wrote these words on the back of his *carte de visite* of Weir. The complete note reads: "Is Color Corp: marches between the color bearers—is a thorough soldier—does not go on guard."

368. Lucinda Weir pension file, NARS.

369. Ibid.

370. Theodore Francis Wright, who served as first lieutenant of Company F, wrote the quoted words on the back of his *carte de visite* of Brown.

371. Ibid.

372. A distant relative of Ulysses S. Grant, Henry Bannister Grant (1837–1912) married Maria Louise Richardson (1840–1933) in 1863. Her father, and George Brown's previous owner, was Samuel Kirby Richardson, a wealthy Louisville builder. George Brown military service record, NARS; 1860 Slave Schedules; 1880 U.S. Census; Johnson, *A History of Kentucky and Kentuckians*, vol. 3, pp. 1638–1639.

373. George Brown military service record, NARS; George Brown pension record, NARS.

374. Theodore Francis Wright, who served as first lieutenant of Company F, wrote these words on the back of a *carte de visite* of Chapman. The complete note reads: "A very quiet man—sterling soldier—always up to time."

375. McBride, *The Union Occupation of Munfordville, Kentucky, 1861–1865*, p. 3.

376. Lewis Chapman military service record, NARS.

377. Also on the back of Chapman's *carte de visite*.

378. Ibid.

379. Harriett Chapman pension record, NARS.

380. Ibid.

381. Report of Col. Reuben D. Mussey, 100th U.S. Colored Infantry and Commissioner for Organization of U.S. Colored Troops, submitted to Maj. Charles W. Foster, Assistant Adjutant General, Chief of the Colored Bureau, Adjutant General's Office, Washington, D.C., October 10, 1864. Letters Received, Colored Troops Division, Records of the Adjutant General's Office, NARS.

382. Davis, "A Soldier's Story: The Records of Hubbard Pryor, Forty-Fourth United States Colored Troops," pp. 266–272.

383. Ibid. Haden Matthew Prior (1812–1865) was the son of North Carolina–born Asa T. Prior (1783–1854). Upon Asa's death in 1854, Haden inherited his father's Georgia property, including the slaves.

384. Note the difference in the spelling of Prior and Pryor. The author believes Pryor to be an alternative spelling introduced by the army at his enlistment.

385. *Harper's Weekly,* July 2, 1864.

386. The Forty-fourth was one of two regiments described as "invalid" or "laboring" regiments authorized in Tennessee about February 1864. The other regiment mustered into federal service as the 101st U.S. Colored Infantry. Report of Col. Reuben D. Mussey, 100th U.S. Colored Infantry and Commissioner for Organization of U.S. Colored Troops, submitted to Maj. Charles W. Foster, Assistant Adjutant General, Chief of the Colored Bureau, Adjutant General's Office, Washington, D.C., October 10, 1864. Letters Received, Colored Troops Division, Records of the Adjutant General's Office, NARS.

387. National Archives records credit the *cartes de visite* of Pryor to Nashville-based photographer A. S. Morse. *Harper's Weekly* attributes the "before" photograph of Pryor to T. B. Bishop.

388. Kentucky-born and West Point–trained John Bell Hood (1831–1879) received the temporary rank of full general and command of the Army of Tennessee in July 1864. He succeeded Gen. Joseph E. Johnston. Hood led the army during the rest of the Atlanta Campaign. After it ended in early September 1864, Hood embarked on an invasion of Tennessee. The capture of 600 men of the Forty-fourth and about 150 other Union troops at Dalton occurred early in the campaign, which ended in disaster at the Battles of Franklin (November 30, 1864) and Nashville (December 15–16, 1864). After the defeats, Hood requested to be and was relieved of his command. He reverted to the rank of lieutenant general.

389. German-born Lewis Johnson (1841–1900) started as a private in the Tenth Indiana Infantry, worked his way to captain, and left the regiment to become the colonel and commander of the Forty-fourth. He initially refused a written request for "unconditional and immediate surrender" submitted by Gen. John B. Hood. After slight skirmishing and a second, oral, summons to surrender was received, Johnson, realizing that he and

his troops were surrounded and outnumbered by the Confederate troops, soon surrendered. Report of Col. Lewis Johnson, Forty-fourth U.S. Colored Infantry. *OR*, I, XXXIX, 1: 717–723.

390. About three hundred men, including a group on forage duty at the time of the surrender and a number of escapees, comprised a new Forty-fourth that remained in service until April 1866.

391. Report of Col. Lewis Johnson, Forty-fourth U.S. Colored Infantry. *OR*, I, XXXIX, 1: 717–723.

392. Hubbard Pryor record cards, Records and Pension Division, NARS.

393. According to the 1870 Census, the Pryor household included Jane, Hubbard, Ann, and three teen-aged children.

394. Cedar Town, the seat of Polk County, was burned by troops under the command of Brig. Gen. Hugh Judson "Kill Cavalry" Kilpatrick in 1864. The community was reestablished after the war as Cedartown. *Macon (Georgia) Daily Telegraph and Confederate*, December 7, 1864.

395. On April 6, 1865, a group of deserters from the Eighth and Eleventh Texas Cavalries commanded by Jack Colquitt of the latter regiment shot and killed Haden Prior, who served as the captain of the home guard. One of Prior's sons, John T. Prior, hunted down and killed his father's murderers. Davis, "A Soldier's Story: The Records of Hubbard Pryor, Forty-Fourth United States Colored Troops," pp. 266–272; *The Cedartown (Georgia) Standard*, December 8, 2005; *The Rome (Georgia) News Tribune*, January 4, 1931.

396. Pryor's companions were Garnett Peek and Joseph Birge. They served as privates in the Forty-fourth.

397. Pryor's wife is named as "Annie" in the 1870 Census and "Ann" in his pension papers.

398. Annie Pryor is listed as forty years old in the 1880 Census, enumerated on June 8 of that year. The date of Pryor's marriage to Ann Dever is listed as September 15, 1880, in her pension record.

399. The 1860 Slave Schedules include a listing for James F. Dever of Polk County, Georgia. He owned thirty-one slaves.

400. Ann Pryor pension record, NARS.

401. Tennessee-born Archibald S. Dobbins moved to Arkansas in 1850. After the start of the Civil War, he raised the First (Dobbins') Arkansas Cavalry. A courageous but unskilled officer, his actions as a commander were called into question on more than one occasion. He died, a few years after the war ended, in Brazil, where he had moved to build a plantation.

402. Robertson, "'Will They Fight? Ask the Enemy,'" pp. 320–332.

403. A bullet ripped into the side of Col. William S. Brooks of the Fifty-sixth as he rallied his men. He fell from his horse mortally wounded. Surg. John C. Stoddard made his way through a hailstorm of bullets to aid his

colonel, knelt down to examine the injury, and was struck in the chest by a bullet and killed. 1st Lt. and Adjutant Theodore W. Pratt of the Sixtieth U.S. Colored Infantry, who volunteered to serve Brooks as an aide during the expedition, also suffered a mortal wound. Capt. James F. Lembke of Battery E, Second U.S. Colored Light Artillery, died instantly after a bullet struck him in the forehead.

404. Report of Lt. Col. Moses Reed, Fifty-sixth U.S. Colored Infantry. *OR*, I, XLI, 1: 19–20.

405. Eagleton Carmichael (1827–1881) participated in the Mexican War as a teamster. Born in Tennessee, he settled in Illinois in 1860. After the start of the Civil War he raised Company B of the Fifteenth Illinois Cavalry and distinguished himself in numerous military operations. When the Fifteenth was combined with the Tenth Illinois Cavalry in early 1865, Carmichael became colonel of the consolidated regiment, which was afterwards known by the latter name.

406. The Union cavalry force included 150 horse soldiers from the Fifteenth Illinois Cavalry, commanded by Maj. Eagleton Carmichael. The column left Helena at the same time as the column of infantrymen from the Fifty-sixth.

407. Surg. Daniel Laforce of the Fifty-sixth performed the operation. James L. Baldwin pension record, NARS.

408. The 1860 Slave Schedules list Joseph Addison Montgomery (1807–1888) as the owner of 180 slaves.

409. James L. Baldwin military service record, NARS.

410. Napoleon Bonaparte Buford (1807–1883) graduated in the West Point class of 1827 and left the military in 1835 to work in the private sector. He returned to the army in 1861 as a brigadier. His half brother, Maj. Gen. John Buford (1826–1863) is best known for his role during the opening phase of the Battle of Gettysburg.

411. General Order No. 47, Headquarters District of Eastern Arkansas, by order of Brig. Gen. Napoleon B. Buford. *OR*, I, XLI, 1: 18–19.

412. No explanation for this reduction in rank appears in his files. James L. Baldwin military service record, NARS.

413. His first wife, Francis Baldwin, died about 1878 or 1879. James L. Baldwin pension record, NARS.

414. Ibid.

415. Mudd's military service record lists his owner as A. Mudd. This may be Austin Mudd (1801–1874) of Springfield, Kentucky; according to federal slave schedules, he owned eight slaves in 1850 and two in 1860. According to great-great-grandnephew Adrian Wells, John Donatus Mudd (1805–after 1884) of Springfield owned Charles Mudd. This may be Donattus Mudd, who owned thirteen slaves according to the 1850 Slave Schedules but is not mentioned in the 1860 Slave Schedules. Adrian Wells (great-great-grandson of George Henry Mudd, brother of Charles) to the author, July 6, 2009.

416. Jack Mudd served in the 107th U.S. Colored Infantry. George Henry Mudd served in the 109th U.S. Colored Infantry. Allen and Harrison Mudd served in the 123rd U.S. Infantry. All of the brothers ranked as privates.

417. Maj. Gen. William T. Sherman to Maj. Gen. Ulysses S. Grant, June 2, 1863. *OR*, III, III: 387.

418. Rose Mudd pension record, NARS.

419. Report of Lt. Col. Moses Reed, Fifty-sixth U.S. Colored Infantry. *OR*, I, XLI, 1: 19–20.

420. Owens's comrades, Corp. Henry Combs and Pvt. Zachariah Johnson, knew him before they enlisted in the army. Both survived the war. Melinda Owens pension record, NARS.

421. Nancy Garrard Newland (1782–1864) of Virginia married Kentucky-born John Newland (1778–1817) in 1812. Newland owned five slaves. Her son Jacob owned Isaiah Owens and six others. Her son William owned eighteen men and women, including Owens's brother John. 1860 Slave Schedules; Isaiah Owens military service record, NARS; John Owens military service record, NARS; Melinda Owens pension record, NARS.

422. Melinda Owens pension record, NARS.

423. Logan, *Roster and Record of Iowa Soldiers*, vol. 5, p. 1585.

424. Isaiah Owens military service record, NARS.

425. Report of Col. John G. Hudson, Sixtieth U.S. Colored Infantry. *OR*, I, XLI, 1: 302–303.

426. Logan, *Roster and Record of Iowa Soldiers*, vol. 5, p. 1585.

427. The trooper, Pvt. Stephen C. McCommas, served in Company B of the Nineteenth Texas Cavalry. Report of Col. John G. Hudson, Sixtieth U.S. Colored Infantry. *OR*, I, XLI, 1: 302–303.

428. According to the official report, the deserter was Willis Harbert, but no soldier by that name appears in the military service records. The soldier may be Willis Hobbert, who served in Company D of the Fifty-fourth U.S. Colored Infantry. Reports of Capt. Eli Ramsey, Sixtieth U.S. Colored Troops. *OR*, I, XLVIII, 1: 34–35.

429. Report of Capt. John N. Wasson, Eighty-seventh Illinois Infantry. *OR*, I, XLVIII, 1: 126.

430. Alfred Jackson military service record, NARS.

431. Jacob Coffman "Jake" Bennett (1840–1904) started his Confederate army service with Company H of the Eighth Kentucky Infantry. He later joined the Tenth Kentucky Partisan Rangers. Watson, *Confederate Guerrilla Sue Mundy*, pp. 37–38, 119, 206.

432. Period newspaper reports name the officer as Capt. Walters of the Third Kentucky Cavalry. No one by that name and rank is on the rolls of the regiment. However, two first lieutenants named Waters are on the rolls, John L. Waters of Company B and William Waters of Company K.

433. *Louisville (Kentucky) Journal*, August 30, 1864; Collins, *History of Kentucky*, vol. 1, p. 139.

434. *Louisville (Kentucky) Journal,* August 30, 1864.

435. The reference can be found on the back of the *carte de visite* of Jackson owned by Theodore Francis Wright, who served as first lieutenant of Company F. A brief note penned by Wright states, "Freeman in the army as teamster, is considered one of the best Sergeants in the regiment."

436. Annie (Jackson) Thompson pension record, NARS.

437. Charles Frederick Stinson (1840–1893) of Mont Vernon, New Hampshire, started his war service as a private in Company B of the Thirteenth New Hampshire Infantry. He left the regiment to become an officer in Company B of the Nineteenth U.S. Colored Infantry. He joined the regiment as a first lieutenant and mustered out in 1867 as a captain and brevet major. After the war he settled in Boston, married, and became a partner in a box manufacturing company.

438. 1st Lt. Charles F. Stinson to his "dear ones at home," August 1, 1864. Stinson Letters, Musick and Leigh Collections, USAMHI.

439. Mackenzie, *Colonial Families of the United States of America,* vol. 6, p. 446.

440. Taylor Aldrich military service record, NARS.

441. Edward Aldrich military service record, NARS.

442. 1st Lt. Charles F. Stinson to his "dear ones at home," August 1, 1864. Stinson Letters, Musick and Leigh Collections, USAMHI.

443. Henry "Harry" Homager served as a sergeant in Company D of the Thirty-second U.S. Colored Infantry.

444. Rebecca Jane "Becky" Myers first married David C. Burton, a veteran who served as a corporal in Company D of the Fifty-fifth Massachusetts Infantry. He died in 1876, leaving Becky a widow with six children. Rebecca J. Aldrich pension record, NARS.

445. Ibid.

446. Ibid.

447. Ibid.

448. Report of Col. Joshua K. Sigfried, Forty-eighth Pennsylvania Infantry, commanding First Brigade, Fourth Division. *OR,* I, XL, 1: 596–597.

449. New York–born Ozora Pierson Stearns (1831–1896) graduated from the University of Michigan and became an attorney before the Civil War. He joined the army in 1862 as a first lieutenant in the Ninth Minnesota Infantry. He left in 1864 to become colonel of the Thirty-ninth U.S. Colored Infantry. He settled in Duluth after the war and became a judge. He served briefly as a Republican U.S. senator in 1871, completing the unexpired term of Daniel S. Norton after his death.

450. Butterfield, "Bench and Bar of Duluth."

451. Estimates range from 150 to 250 casualties.

452. Rachel M. E. Gaither pension record, NARS.

453. Lathrop, *Early Inns and Taverns,* p. 209.

454. The sergeant was Norman B. Sterrett. He survived the war. *The Christian Recorder (Philadelphia)*, June 3, 1865.

455. Henry C. Gaither military service record, NARS.

456. Rachel M. E. Gaither pension record, NARS.

457. Ibid.

458. William Thomas military service record, NARS.

459. The Ninth's commander was Lt. Col. George M. Dennett (born about 1820) of Maine. He started his war service as a private in the Thirty-eighth New York Infantry and advanced to captain before mustering out with the regiment after its enlistment expired in June 1863. He rejoined the army as captain of Company A of the Seventh U.S. Colored Infantry in October 1863 but soon left to become the major of the Ninth U.S. Colored Infantry. He advanced to lieutenant colonel. Dennett wrote a brief history of the Ninth before the regiment mustered out. It was published in book form in 1866. Dennett, *The History of the Ninth U.S.C. Troops*, quotes on p. 117.

460. William Thomas military service record, NARS.

461. Ibid.

462. Ibid.

463. Maria Thomas pension record, NARS.

464. *Washington (D.C.) Bee*, May 21, 1910.

465. One of the ten officers was the regimental adjutant, who volunteered to lead one officer-less company. The writer of this account, Ulysses Leslie Marvin (1839–1901), served as captain of Company I. He was one of the four officers wounded during the battle after gunshot struck him in the right arm. He started as a corporal in the 115th Ohio Infantry. Marvin, "General Shurtleff," pp. 305–325.

466. Ibid.

467. Maj. Gen. Benjamin Franklin Butler (1818–1893) was profoundly moved by the actions of the colored troops under his command at New Market Heights. He later wrote, upon riding over the battlefield and seeing all the fallen soldiers, "I swore to myself an oath, which I hope and believe I have kept sacredly, that they and their race should be cared for and protected by me to the extent of my power so long as I lived." Ibid., p. 322.

468. Ibid., pp. 305–325.

469. The three first sergeants were James H. Bronson (1838–1884) of Company D, Powhatan Beaty (1837–1916) of Company G, and Robert A. Pinn (1843–1911) of Company I.

470. Pennsylvania-born Nelson Holmes Van Vorhes (1822–1882) moved to Athens County, Ohio, at about age ten. He followed in his father's footsteps as a newspaperman and politician. Van Vorhes served as a state legislator on the Whig and Republican tickets before enlisting in the Third Ohio Infantry in 1861. After the expiration of his three-month term, he reenlisted

as regimental quartermaster of the Eighteenth Ohio Infantry. He left that regiment in 1862 to become colonel of the Ninety-second Ohio Infantry. He resigned from the army in March 1863 due to poor health. He recovered and later served as a U.S. Congressman.

471. Washington, *Eagles on Their Buttons*, p. 15.

472. Milton M. Holland military service record, NARS.

473. *Washington (D.C.) Bee*, May 21, 1910.

474. Ibid.

475. Ibid.

476. Alonzo Granville Draper (1835–1865) of Vermont served as the original colonel of the Thirty-sixth U.S. Colored Infantry. He commanded the brigade to which his regiment belonged during the attack at New Market Heights. A journalist and city official in Lynn, Massachusetts, he started war service as a captain in the First Massachusetts Artillery. After the war but before mustering out, he was in Texas with his regiment when he suffered an accidental gunshot wound and died.

477. Report of Col. Alonzo G. Draper, Thirty-sixth U.S. Colored Infantry, commanding Second Brigade. *OR*, I, XLII, 1: 819–820.

478. Col. Draper noted in the official report cited above that he did not have the names of the sergeants. Brig. Gen. Charles J. Paine, who commanded the division that included Draper's brigade, explained in a separate report that during the assault, the command of four companies devolved upon first sergeants after their commissioned officers were wounded. Meekins's Company K was among those listed. Paine mentions the names of the four first sergeants. The first sergeant of Company K at the time was Samuel Gilchrist. Brig. Gen. Charles J. Paine to Maj. Gen. Benjamin F. Butler. *OR*, I, XLII, 3: 100–101.

479. The 1830 U.S. Census for New Kent County, Virginia, lists a free white person named Batts Meekins.

480. Dick Crump may be Richard Crump (about 1788–1860) of New Kent County, Virginia. He owned thirty-five slaves, according to the 1850 U.S. Slave Schedules. The 1850 U.S. Census lists ten children born to him. Some or all of them may have inherited slaves after their father's death.

481. Maggie L. Meekins pension record, NARS.

482. Ibid.

483. Harvard-educated lawyer Charles Jackson Paine (1833–1916) became a brigadier and division commander two months before the fighting at New Market Heights. He served as an officer in two Massachusetts infantry regiments, the Twenty-second and the Thirtieth, and the Second Louisiana Infantry before becoming a general. He earned a brevet as major general of volunteers for his war service.

484. Brig. Gen. Charles J. Paine to Maj. Gen. Benjamin F. Butler. *OR*, I, XLII, 3: 100–101.

485. Address by Maj. Gen. Benjamin F. Butler to the soldiers of the Army of the James. *OR*, I, XLII, 3: 161–175.

486. Major D. Meekins military service record, NARS.

487. Maggie L. Meekins pension record, NARS.

488. The captain was John McMurray (1838–1920). He commanded Company D, which suffered twenty-eight casualties among thirty-two soldiers engaged in the assault on New Market Heights—a loss of 87.5 percent, reportedly the highest loss ever sustained by a company in the Union armies during a single charge. McMurray started as a first lieutenant in the 135th Pennsylvania Infantry. After its nine-month term of enlistment expired, he returned to the army for a one-month stint in the Fifty-seventh Pennsylvania Militia before joining the Sixth. He mustered out as the regiment's major. After the war, he became editor of the Brookville, Pennsylvania, *Jeffersonian Democrat* newspaper. McMurray, *Recollections of a Colored Troop*, pp. 53–55.

489. Ibid.

490. Paradis, *Strike the Blow for Freedom*, p. 76.

491. Elizabeth Spence pension record, NARS.

492. Ibid.

493. Taylor, *Philadelphia in the Civil War*, p. 190.

494. The engagements at New Market Heights and Fort Harrison are part of a series of events that occurred September 29–30, 1864, also known as Chaffin's Farm, Fort Johnson, Fort Gilmer, and Laurel Hill.

495. John W. Spence military service record, NARS.

496. Elizabeth Spence pension record, NARS.

497. Ibid.

498. *Washington (D.C.) Bee*, October 3, 1914; *The Christian Recorder (Philadelphia)*, July 13, 1867.

499. John Christian Brune (1814–1864) and Anna Letitia Brune (1817–1856) married in 1837. John, an avowed secessionist who served in the Maryland legislature, died of "disease of the heart resulting in brain fever" on a ship that had come from Canada, where he spent the summer months, and was bound for Havana, Cuba, where he lived during the wintertime. Mayer, *Baltimore Past and Present*, pp. 208–210; U.S. Consul General in Canada Joshua R. Giddings to Assistant Secretary of State Frederick W. Seward, October 22, 1861. *OR*, II, I: 603.

500. Founded in 1854 as an institution of higher education for African Americans, Ashmun Institute was renamed Lincoln University in 1866, to honor President Abraham Lincoln. Longacre, *A Regiment of Slaves*, pp. 1–4.

501. Christian A. Fleetwood military service record, NARS.

502. Maryland-born Sgt. Alfred B. Hilton of Company H may have appeared taller than six feet to Fleetwood, who stood about five feet four-

and-one-half inches. According to Hilton's military service record, he was five feet ten-and-one-half-inches tall. Surgeons amputated Hilton's right leg at the knee, and he died of complications on October 21, 1864. He was awarded the Medal of Honor posthumously. Alfred B. Hilton military service record, NARS; Beyer, *Deeds of Valor*, pp. 434–435.

503. Virginia-born Charles Veale (1838–1872) of Company D also received the Butler Medal (see n. 507). In November 1864 he advanced to sergeant. Charles Veale military service record, NARS; Beyer, *Deeds of Valor*, pp. 434–435.

504. Beyer, *Deeds of Valor*, pp. 434–435.

505. A list in Fleetwood's diary totals 177 casualties. The official record is 178. Fleetwood's total is used here to be consistent with his statement of the number of men from the Fourth who went into the battle. Diary of Christian A. Fleetwood for 1864, Christian A. Fleetwood Papers, Library of Congress, Washington, D.C.; Return of Casualties in the Union Forces. *OR*, I, XLII, 1: 136.

506. Beyer, *Deeds of Valor*, pp. 434–435.

507. Commissioned by Butler in late 1864, the Butler Medal is not recognized as an official decoration by the army. It was one of several organization-specific medals struck during the war.

508. Fleetwood, *The Negro as a Soldier*, p. 18.

509. Dr. John Marshall Clemens (1835–1892) was the son of Hannibal Clemens (1803–1836), who was brother of John Marshall Clemens (1798–1847), the father of Samuel Langhorne Clemens—Mark Twain. Dr. Clemens married Elizabeth "Betty" Russell (about 1839–1863). 1850 and 1860 U.S. Censuses; Joannah King pension record, NARS.

510. According to a note on one document in Allen Walker's military service record, he enlisted as a substitute for William Temple. His pension file includes no mention of Temple, however, yet does contain numerous references to Dr. Clemens as the draftee and the individual for whom Allen became a substitute.

511. Section 13 of the Enrollment Act approved March 3, 1863, stated, "any person drafted and notified to appear as aforesaid may, on or before the day fixed for his appearance, furnish an acceptable substitute to take his place in the draft, or he may pay to such person as the Secretary of War may authorize to receive it, such sum, not exceeding three hundred dollars, as the Secretary may determine, for the procuration of such substitute." Adjutant General's Office, *General Orders Affecting the Volunteer Force*, p. 38.

512. Born and raised in Adair County, Kentucky, William Edward "Ed" Russell (1830–1900) served as an officer in the Mexican War and afterwards became a lawyer. Elected to the state assembly, he served as a legislator 1857–1858. He moved to Lebanon, Kentucky, in 1867. He served as a circuit court judge 1886–1892. Johnson, *A History of Kentucky and Kentuckians*, vol. 3, pp. 1270–1271.

513. William Peter "Pete" Walkup (1818–1905) married Elizabeth Alloway Strange in 1842. Her father, Archelaus Alloway Strange (1780–1852) owned eight slaves, according to the 1850 Slave Schedules. Walkup owned one slave, a nineteen-year-old male, according to the 1860 Slave Schedules.

514. Joannah King pension record, NARS.

515. Ibid.

516. Allen is listed as "Allen Walker" in his military service record. The change to King is not reflected there.

517. Allen Walker military service record, NARS.

518. Joannah King pension record, NARS.

519. Ibid.

520. 1860 U.S. Census.

521. First published in 1852 by the African Methodist Episcopal Church in Philadelphia, *The Christian Recorder* provided secular and religious news to black Americans, and also the church's positions on political issues of the day.

522. *The Christian Recorder (Philadelphia)*, October 8, 1864.

523. Ibid.

524. Ibid.

525. Ibid.

526. Singer's original hospitalization was in November 1865. Doctors treated him for rupia from February to October 1865, and from October into November 1865 for intermittent fever. The lag time between acquiring syphillis and the manifestation of rupia (3–15 years according to one source) indicates that Singer probably contracted the disease before the war. Peter J. D'Onofrio, Ph.D., president of a group of amateur historians called Society of Civil War Surgeons, to the author, January 4, 2010; Charles W. Singer military service record, NARS.

527. Charles W. Singer military service record, NARS.

528. Charles W. Singer pension record, NARS.

529. Ibid.

530. 1st Lt. Charles F. Stinson to his mother Sarah, October 30, 1864. Stinson Letters, Musick and Leigh Collections, USAMHI.

531. Ibid. The aide is not identified by name in this account.

532. Jacob Johns military service record, NARS.

533. Fox, *Regimental Losses in the American Civil War*, p. 55.

534. Henry Goddard Thomas (1837–1897) of Portland, Maine, attended Bowdoin College and graduated from Amherst College in 1858. After the war started, he raised and became captain of Company G of the Fifth Maine Infantry. He left the regiment after a few months to accept a captaincy in the regular army and serve as a recruiting and mustering officer. In early 1863 he became colonel of the Seventy-ninth U.S. Colored Infantry, reportedly the first regular army officer to command a colored regiment. Typhoid

fever forced his resignation. He returned to active duty with the Eleventh U.S. Infantry, in his final wartime assignment, as colonel of the Nineteenth U.S. Colored Infantry. He went on to command at the brigade and division levels and ended the war as a brigadier. He remained in the regular army until 1891.

535. Charles Frederick Stinson (1840–1893) of Mont Vernon, New Hampshire, started his war service as a private in Company B of the Thirteenth New Hampshire Infantry. He left the regiment to become an officer in Company B of the Nineteenth U.S. Colored Infantry. He joined the regiment as a first lieutenant and mustered out in 1867 as a captain and brevet major. After the war he settled in Boston, married, and became a partner in a box manufacturing company.

536. 1st Lt. Charles F. Stinson to his mother Sarah, October 30, 1864. Stinson Letters, Musick and Leigh Collections, USAMHI.

537. Eliza Johns pension record, NARS.

538. Report of Col. Thomas J. Morgan, Fourteenth U.S. Colored Infantry. *OR*, I, XXXIX, 1: 714–716.

539. Thomas Jefferson Morgan (1839–1902) was active in the wartime recruitment and postwar education of African Americans. He began his military service as a first lieutenant in the Seventieth Indiana Infantry. He left the regiment to accept a commission as lieutenant colonel of the Fourteenth U.S. Colored Infantry, a regiment he helped organize. He advanced to colonel and commander of the Fourteenth in January 1864. He also commanded an all–African American brigade that included his regiment. He resigned from the army in August 1865 and went on to become a Baptist minister and author of several books.

540. Report of Col. Thomas J. Morgan, Fourteenth U.S. Colored Infantry. *OR*, I, XXXIX, 1: 714–716.

541. Ibid.

542. George Alexander military service record, NARS.

543. Report of Col. Thomas J. Morgan, Fourteenth U.S. Colored Infantry. *OR*, I, XXXVIII, 2: 506.

544. According to Col. Morgan, Lt. Col. Harvey J. Espy (1832–1868) was ordered to report to him. A regular army officer before the war, Espy became politically active in Kansas during its struggle to gain statehood. A supporter of Kansas's being a non-slavery state, he participated in the 1858 Leavenworth Constitutional Convention. He signed the proposed constitution, which includes in its Bill of Rights the statement, "All men are by nature equally free and independent." Rhode Island Soldiers and Sailors Historical Society, *Personal Narratives of Events in the War of the Rebellion*, 3rd ser., no. 13, p. 36.

545. Morgan's statement that thousands of men cheered the Fourteenth should be considered in context: estimates of the total number of Union

troops who participated in the Battle of Decatur range from 2,000 to 5,000. Morgan, *The Negro in America and the Ideal American Republic*, p. 65.

546. 1900 U.S. Census.

547. Maria Alexander pension record, NARS.

548. Report of Commander Foxhall A. Parker, U.S. Navy, commanding Potomac Flotilla, regarding capture of schooner *Coquette* and sloop *James Landry*. Naval War Records Office, *Official Records of the Union and Confederate Navies in the War of the Rebellion*, I, V: 490–492.

549. Sarah Commodore pension record, NARS.

550. *The Sun (Baltimore, Md.)*, May 29, 1860.

551. The schooner may have been named for Philadelphia merchant Adolph Hugel.

552. Schneller, *Breaking the Color Barrier*, p. 7.

553. Order of Secretary of the Navy Gideon Welles to Commander Foxhall A. Parker, U.S. Navy, commanding Potomac Flotilla, for the reduction of the force under his command. Naval War Records Office, *Official Records of the Union and Confederate Navies in the War of the Rebellion*, I, V: 567.

554. Sarah Commodore pension record, NARS.

555. Ibid.

556. Ibid.

557. Ibid.

558. Rhode Island Soldiers and Sailors Historical Society, *Personal Narratives of Events in the War of the Rebellion*, 5th ser., no. 1, pp. 39–40.

559. The captain, James Helme Rickard (1838–1914), commanded Company G at the time of the attack. He later commanded Butler's Company B. Rickard started his war service as a corporal in the Eighteenth Connecticut Infantry. He resigned to become an officer in the Nineteenth. Ibid.

560. Ibid.

561. Peter W. Crain (1805–1892) served as a circuit court judge in Charles County 1847–1861 and in the Maryland House of Delegates 1841–1842.

562. 1850 Slave Schedules.

563. Peter H. Butler military service record, NARS.

564. Ibid.

565. The officer, Capt. Leroy D. House (about 1829–1875), a clockmaker from Bristol, Connecticut, commanded Company I of the 108th U.S. Colored Infantry. He served in the Sixteenth Connecticut Infantry and the Third Veteran Reserve Corps before he joined the regiment. Capt. Leroy D. House to his friends, December 28, 1864. Leroy D. House Letters, Connecticut Historical Society.

566. Fanny Garvin pension record, NARS.

567. Sinclair Garvin (1791–1866) of Rockingham County, Virginia, owned nineteen slaves, according to the 1860 Slave Schedules. He married

Harriet Woodson (1803–1863) in 1821. Woodsonville is named for her father, Thomas Woodson (1772–1857).

568. Abram Garvin military service record, NARS.

569. The soldier was Lafayette Rogan (1830–1906), who served as a second lieutenant in Company B of the Thirty-fourth Mississippi Infantry. Hauberg, "A Confederate Prisoner at Rock Island: The Diary of Lafayette Rogan," p. 46.

570. Capt. Leroy D. House to "Friend B," September 26, 1864. Leroy D. House Letters, Connecticut Historical Society.

571. Fanny Garvin pension record, NARS.

572. Ibid.

573. General Order No. 4, January 25, 1865. Regimental Books and Papers, Sixty-second U.S. Colored Infantry, NARS.

574. Octavius McFarland military service record, NARS; Special Order No. 25, March 12, 1864. Regimental Books and Papers, Sixty-second U.S. Colored Infantry, NARS.

575. General Order No. 31, July 3, 1864. Regimental Books and Papers, Sixty-second U.S. Colored Infantry, NARS.

576. General Order No. 13, July 31, 1865. Ibid.

577. Foster, *Historical Sketch of Lincoln Institute*, pp. 5–12.

578. 1880 and 1890 U.S. Censuses; St. Louis City Death Records, 1850–1902.

579. Richard Baxter Foster (1826–1901) served as the first principal of Lincoln Institute. Born in New Hampshire, he graduated from Dartmouth College and became a schoolteacher in Illinois and Indiana. He served as a noncommissioned officer in the First Nebraska Infantry prior to joining the Sixty-second U.S. Colored Infantry.

580. Foster, *Historical Sketch of Lincoln Institute*, p. 5.

581. *The Shelby (Kentucky) Record*, February 21, 1913.

582. *Louisville (Kentucky) Journal*, January 26, 1865.

583. Ibid.

584. Samuel Truehart military service record, NARS.

585. *Lexington (Kentucky) Herald-Leader*, January 21, 2009.

586. Brown, "Samuel Truehart" (Web article).

587. Samuel Truehart military service record; 1860 Slave Schedules; 1860 U.S. Census.

588. Brown, "Samuel Truehart" (Web article).

589. Known as Burbridge's Raid into southwestern Virginia, it is named for Brig. Gen. Stephen Gano Burbridge (1831–1894) of Kentucky. He is perhaps best known for his role in repulsing Confederate general John Hunt Morgan's failed raid into Ohio during the summer of 1863. Burbridge received a brevet rank of major general for his actions.

590. James Sanks Brisbin (1838–1892) of Pennsylvania started his war

service as a private in the First U.S. Dragoons and soon received a commission as a second lieutenant. He suffered two wounds at the First Battle of Bull Run. He served as a company officer in two other cavalry regiments before becoming colonel of the Fifth U.S. Colored Cavalry in 1864. He later served as chief of staff to Gen. Burbridge and received his brigadier's star in May 1865. After the Fifth mustered out of service, Brisbin joined the regular army; he died on active duty.

591. Report of Col. James S. Brisbin, Fifth U.S. Colored Cavalry. *OR*, I, XXXIX, 1: 556–557.

592. *Louisville (Kentucky) Journal*, January 26, 1865.

593. Brown, "Samuel Truehart" (Web article).

594. Ibid.

595. *The Globe (Atchison, Kansas)*, May 27, 1881.

596. *The Atchison (Kansas) Daily Globe*, March 24, 1947.

597. 1850 U.S. Census; 1860 Slave Schedules.

598. In documents, Saunders is variously listed as Garry Saunders, Harry Sanders, and Jeremiah Sanders. Garry Saunders military service record, NARS; Emily Spotts Saunders pension record, NARS.

599. James Jackson served as first sergeant of Company K. Emily Spotts Saunders pension record, NARS.

600. Garry Saunders military service record, NARS.

601. Emily Spotts Saunders pension record, NARS.

602. Circular No. 25, issued by the Provost Marshal General's Office of the War Department on June 26, 1864, detailed the program. *OR*, III, V: 913–932.

603. *The Daily Age (Philadelphia)*, June 29, 1864.

604. The representative recruit paid for by President Lincoln was Stroudsburg, Pennsylvania, native John Summerfield Staples (1845–1888), who served as a private in the 176th Pennsylvania Infantry. He left the regiment with a disability discharge after six months. Henry Wadsworth Longfellow sent Alexander Thackston. Peter Cooper sent Martin Schlotter and Daniel Reardon. List of Representative Recruits. *OR*, III, V: 913–932.

605. William Davis Christman (1830–1911) served as a first lieutenant in Company F of the 124th Pennsylvania. After the regiment's nine-month term of enlistment ended in May 1863, he became a deputy to his brother Enos Lewis Christman (1828–1912), captain and provost marshal assigned to coordinate federal military activities in Pennsylvania's Seventh Congressional District. Enos served as major of the Thirty-third Pennsylvania Infantry prior to his appointment as a provost marshal. A third brother also served: Jefferson A. Christman (1836–1916), a private in Company H of the Seventy-second Pennsylvania Infantry.

606. Anna Cummings pension record, NARS.

607. Grace A. Fuller pension record, NARS.

608. Ibid.

609. Lewis A. Fuller military service record, NARS.

610. Grace A. Fuller pension record, NARS.

611. Ibid.; Lewis A. Fuller military service record, NARS.

612. Grace A. Fuller pension record, NARS.

613. Ibid.

614. The coachman who hired Lewis Fuller, William Conover, is listed in the 1880 U.S. Census as a husband and father of six. Ibid.

615. Ibid.

616. Ibid.

617. Warren Goodale to his children, April 6, 1865. Warren Goodale Papers, Massachusetts Historical Society.

618. Ibid.

619. William Wright military service record, NARS.

620. 1860 Slave Schedules; Levin, *The Lawyers and Lawmakers of Kentucky*, p. 226.

621. Culver, *Manly's Memories, 1877-1977*, unpaginated.

622. The officer, Ludlum Crossman Drake (1839–1924), started as a corporal in Company C of the Eighteenth Michigan Infantry. He later served as captain of Company I of the 114th U.S. Colored Infantry. Ludlum C. Drake, "War Reminiscences." Papers of the Military Order of the Loyal Legion of the United States, Michigan Commandery, Bentley Historical Library, University of Michigan.

623. Warren Goodale to his children, April 6, 1865. Warren Goodale Papers, Massachusetts Historical Society.

624. Ludlum C. Drake, "War Reminiscences." Papers of the Military Order of the Loyal Legion of the United States, Michigan Commandery, Bentley Historical Library, University of Michigan.

625. Wright experienced his first bout of rheumatism at Deep Bottom, Virginia, in 1865. Mary Ellen Wright pension record, NARS.

626. Culver, *Manly's Memories, 1877-1977*, unpaginated.

627. Ibid.

628. 1870 and 1880 U.S. Censuses; Mary Ellen Wright pension record, NARS; Stoddard, *William Wright, Veteran of the Civil War*, unpaginated.

629. Chaplain Garland H. White (about 1829–about 1894) escaped from his owner, former U.S. senator and Confederate secretary of state Robert Toombs of Georgia, before the Civil War began and fled to Canada. By 1863 he had returned to the United States and settled in Ohio. He helped recruit men of color in Indiana for an infantry regiment mustered into federal service as the Twenty-eighth U.S. Colored Infantry. This quote is part of a letter written by White on April 12, 1865. *The Christian Recorder (Philadelphia)*, April 22, 1865; Miller, "Garland H. White, Black Army Chaplain."

630. John E. Elliott military service record, NARS.

631. Warner, *Crossed Sabers*, pp. 234–237.

632. John E. Elliott military service record, NARS.

633. Ibid.

634. Roberta Elliott pension record, NARS.

635. Jacob Stanford pension file, NARS.

636. Ibid.

637. Ibid.

638. According to Sgt. Taylor, Finley's master was Dr. Standiford of Louisville, Kentucky. A search of the 1860 Census and Slave Schedules failed to find a physician named Standiford (or variants on this surname) who owned slaves.

639. Jacob Stanford pension file, NARS.

640. Ibid.

641. Jacob Stanford military service record, NARS.

642. Jacob Stanford pension file, NARS.

643. Ibid.

644. The commander, Henry Clay Merriam (1837–1912), served as a captain in the Twentieth Maine Infantry prior to his association with the Seventy-third. After the war, he became a major in the regular army and went on to serve as a general during the Spanish-American War. He retired in 1901. State of Maine, Military Order of the Loyal Legion of the United States, *War Papers*, vol. 1, p. 247.

645. 1870 U.S. Census.

646. Louis A. Snaer military service record, NARS.

647. Hollandsworth, *The Louisiana Native Guards*, pp. 70–82.

648. Lucius V. Lyon served as a corporal in the Sixth Michigan Infantry and left the regiment to become a second lieutenant in the Seventy-third. He later advanced to first lieutenant. Henry Mortimer Crydenwise started his military service as a sergeant in the Ninetieth New York Infantry. He left the regiment as a second lieutenant to become a captain in the Seventy-third. State of Maine, Military Order of the Loyal Legion of the United States, *War Papers*, vol. 1, p. 245.

649. Ibid., pp. 246–247.

650. Snaer received his brevet in 1868. Louis A. Snaer military service record, NARS.

651. Ibid.

652. David R. Poynter Legislative Research Library, *Membership in the Louisiana House of Representatives 1877–2008*, p. 71; U.S. Department of the Interior, *Official Register of the United States*, vol. 1, p. 172.

653. *La Tribune de la N.-Orleans (New Orleans)*, December 4, 1867; *The Daily City Item (New Orleans)*, May 16, 1880.

654. Wateree Junction linked the South Carolina Railroad and the Wilmington and Manchester Railroad.

655. Emilio, *History of the Fifty-Fourth Regiment*, p. 297.

656. John H. Wilson pension record, NARS.

657. Pvt. George W. Jarvis of Company A, a barber born in Greenfield, Massachusetts, served his entire enlistment in the Fifty-fourth. He survived the war. George W. Jarvis military service record, NARS.

658. John H. Wilson pension record, NARS.

659. Ibid.

660. Ibid.

661. Keckley, *Behind the Scenes*, p. 189.

662. Abbott, "Some Recollections of Lincoln's Assassination," pp. 397–402.

663. Ibid.

664. Ibid.

665. Slaney, *Family Secrets*, pp. 13–18.

666. Born free in Norfolk, Virginia, Alexander Thomas Augusta (1825–1890) studied in the United States and Canada and earned a medical degree from Trinity Medical College in Toronto in 1856. Commissioned a surgeon in April 1863 with the rank of major, he joined the Seventh U.S. Colored Infantry as surgeon six months later. He practiced medicine in Washington, D.C., after the war.

667. Anderson Ruffin Abbott Papers, Toronto Public Library; Alexander T. Augusta military service record, NARS.

668. Anderson Ruffin Abbott Papers, Toronto Public Library; Cobb, "A Short History of Freedmen's Hospital," pp. 271–287.

669. Abbott first met Lincoln after he crashed a White House reception during the winter of 1863–1864. Anderson Ruffin Abbott Papers, Toronto Public Library; Slaney, *Family Secrets*, p. 54.

670. Keckley, *Behind the Scenes*, p. 309.

671. Abbott's account of his experience does not explicitly state that he met Keckley, and she states in her memoir that the messengers failed to find her.

672. Abbott, "Some Recollections of Lincoln's Assassination," pp. 397–402.

673. Ibid.

674. Keckley, *Behind the Scenes*, p. 309.

675. Robinson, "Anderson Ruffin Abbott, M.D., 1837–1913," pp. 713–716.

676. Dictionary of Canadian Biography Online, "Abbott, Anderson Ruffin" (Web article); Slaney, *Family Secrets*, p. 73.

677. Anderson Ruffin Abbott Papers, Toronto Public Library.

678. Other federal regiments that participated in the fight include the Thirty-second and 102nd U.S. Colored Infantries and the 107th Ohio Infantry. Report of Brig. Gen. Edward E. Potter, commanding expedition. *OR*, I, XLVII, 1: 1027–1032; Report of Col. Edward N. Hallowell, Fifty-fourth Massachusetts Infantry, commanding Second Brigade, Provisional Divi-

sion. *OR*, I, XLVII, 1: 1036–1037; Emilio, *History of the Fifty-Fourth Regiment*, pp. 301–305.

679. Wilson, *The Black Phalanx*, pp. 278–279.

680. 1880 U.S. Census.

681. *Cleveland (Ohio) Gazette*, December 5, 1891.

682. Henry A. Monroe military service record, NARS.

683. *Cleveland (Ohio) Gazette*, December 5, 1891.

684. Ibid.

685. Ibid.

686. 1910 U.S. Census.

687. Gen. Joseph E. Johnston formally surrendered his army on April 26, 1865, the day after the Fifty-fourth returned with other federal units from the April 5–25 expedition known as Potter's Raid, a three-hundred-mile march led by and named for Brig. Gen. Edward Elmer Potter (1823–1889). The raid included a fight at Boykin's Mills on April 18, the last action in which the Fifty-fourth participated during the war.

688. Testimony of Pvt. Charles VanAlstyne. Samuel J. Benton court martial record case, NARS.

689. Ibid., Testimony of Pvt. Peter H. Pruyn.

690. Ibid.

691. Ibid.

692. Ibid., Testimony of 1st Sgt. Burrill Smith Jr.

693. Ibid., Testimony of Pvt. Peter H. Pruyn.

694. Maj. John Whittier Messer Appleton (1832–1913) wrote on a piece of paper attached to the back of the tintype of Benton: "Nicknamed 'Slickey' at the time, Capt. Homans' servant. He was said to have been moon struck at times thereby dangerous. Said to have made several assaults on Capt. Homans and at other times was fond and kind. He shot and killed Corpl Wilson, Co. A." Capt. William H. Homans commanded Company A. John Cuthbert to the author, July 26, 2010; John W. M. Appleton Papers, West Virginia and Regional History Collection, West Virginia University Libraries.

695. Ibid.

696. Emilio, *History of the Fifty-Fourth Regiment*, p. 309.

697. Register of Enlistments in the U.S. Army, 1798–1914, NARS.

698. Marvel, "Last Hurrah at Palmetto Ranch," pp. 66–73.

699. Ibid.

700. The second owner, J. B. Mitchell, does not appear in the 1850 or 1860 U.S. Slave Schedules. Susan Mitchell pension record, NARS.

701. John H. "Jack" Casey owned three slaves according to the 1850 U.S. Slave Schedules. In 1861, he organized and became captain of a company of horse soldiers that became part of the Second Missouri State Guard Cavalry. He later became captain of Company C of the Confederate Third Missouri Cavalry.

702. 1860 U.S. Slave Schedules.

703. Susan Mitchell pension record, NARS.

704. Ibid.

705. Daniel Ullmann (1810–1892) raised five African American regiments for the Union army in Louisiana in 1863. These units became the Corps d'Afrique and were later designated as U.S. colored infantry regiments. Brig. Gen. Daniel Ullmann to Brig. Gen. Michael K. Lawler, July 30, 1864. *OR*, I, XLI, 2: 473.

706. George Dean military service record, NARS.

707. Hunt, *The Last Battle of the Civil War: Palmetto Ranch*, p. 57.

708. Mississippi-born David Branson (1840–1916) started military service in 1861 as a sergeant in the Twenty-eighth Illinois Infantry. He left the regiment as a sergeant major to become the lieutenant colonel of the Sixty-second U.S. Colored Infantry. After the war he played a leading role in the founding of the Lincoln Institute in Jefferson City, Missouri. It became known as Lincoln University of Missouri in the early twentieth century. Branson later worked as a mining engineer in Philadelphia.

709. Trudeau, *Out of the Storm: The End of the Civil War, April-June 1865*, p. 310.

710. The remainder of the Sixty-second mustered out of the army on March 31, 1866.

711. Susan Mitchell pension record, NARS.

712. Martha A. Lively pension record, NARS.

713. Ibid.

714. Several men named William Mansfield lived in Hart and the surrounding counties. Henry's two brothers, Richard and Thomas, kept the Mansfield name. This suggests that Henry was sold away from them.

715. A search of federal census records to determine the identity and background of Harvey Adams had been inconclusive. Martha A. Lively pension record, NARS.

716. Ibid.

717. Henry Lively military service record, NARS.

718. Theodore Francis Wright, who served as first lieutenant of Company F, wrote these words on the back of the *carte de visite* of Lively.

719. Martha A. Lively pension record, NARS.

720. Originally organized as the Fourteenth Rhode Island Heavy Artillery (African Descent), its name was changed to the Eighth U.S. Colored Heavy Artillery in April 1864. Shortly after the action at Plaquemine, its name was changed to the Eleventh U.S. Colored Heavy Artillery.

721. Addeman, *Reminiscences of Two Years with the Colored Troops*, p. 8; Chenery, *The Fourteenth Regiment Rhode Island Heavy Artillery*, pp. 61–62.

722. Chenery, *The Fourteenth Regiment Rhode Island Heavy Artillery*, pp. 61–62.

723. The murdered privates were Samuel O. Jefferson of Troy, New York, Anthony King of Norfolk, Virginia, and Samuel Mason of Hartford, Connecticut.

724. Col. Jacob Hale Sypher (1837–1905) served as the Eleventh's original colonel. He had previously served in Ohio's Cleveland Light Artillery and the First Ohio Light Artillery. Col. J. Hale Sypher, commanding post at Plaquemine, Louisiana, to Capt. W. B. Ratliff, commanding Confederate forces west of Atchafalaya. *OR*, I, XLI, 2: 933.

725. The officer who received and reported the complaint was Capt. Joshua Melancthon Addeman (1840–1930) of the Eleventh. He started in the war as a private in the Tenth Rhode Island Infantry. George Bryant military service record, NARS.

726. The officer who received the report of the behavior and would have meted out any punishment was Richard Godfrey Shaw (1832–1898), who served as major of the Eleventh. He started his war service as a captain in the Third Rhode Island Heavy Artillery. He joined the regular army after the war and retired from active duty in 1896. Ibid.

727. The first lieutenant, Sigourney B. Goffe (about 1842–1905), had previously served in the Ninth and Twelfth Rhode Island Infantry regiments. As a member of the latter, he suffered a chest wound in the Battle of Fredericksburg in 1862.

728. George Bryant military service record, NARS.

729. Special Order No. 22, Headquarters Department of Mississippi. *OR*, I, XLVIII, 2: 1,177.

730. Haycraft, *A History of Elizabethtown, Kentucky, and Its Surroundings*, p. 117.

731. 1860 Slave Schedules; Charles English pension record, NARS.

732. Charles English military service record, NARS; Charles English pension record, NARS.

733. David (George D.) Long pension record, NARS.

734. Ibid.

735. According to the 1840 U.S. Census, the household of Robert Long (1773–1847) included eighteen persons, five of whom were free white people. Twenty years later, his son William (1813–1894) owned fifteen slaves, according to the 1860 Slave Schedules. In 1866, William Long filed an application for compensation for Dave from the federal government. He received a $300 payment in 1867. David (George D.) Long military service record, NARS.

736. David (George D.) Long pension record, NARS.

737. Theodore Francis Wright, who served as first lieutenant of Company F, wrote these words on the back of the *carte de visite* of Long.

738. David (George D.) Long pension record, NARS.

739. Ibid.

740. John Pinckney pension record, NARS.

741. Ibid.

742. William Algernon Alston (1782–1860) owned fifty slaves in 1850 and forty slaves in 1860. After his death, the ownership of John Pinckney may have passed to one of his children. Alston's father, William Alston (1756–1839), served as an officer under Gen. Francis Marion, the "Swamp Fox," during the Revolution and later became a colonel in the state militia. He also changed the spelling of his surname from Allston to Alston to distinguish his branch of his family. From 1812 to 1814, his brother Joseph Alston (1779–1816) was governor of South Carolina. 1850 and 1860 Slave Schedules; Côté, *Mary's World*, pp. 26–46.

743. John Pinckney (Allston) military service record, NARS.

744. The friend, Edward Carr, provided this information in 1907 to a special examiner assigned to Pinckney's pension case. John Pinckney pension record, NARS.

745. Linder, Hurley, Thacker, and Baldwin, *Historical Atlas of the Rice Plantations of Georgetown County and the Santee River*, p. 66.

746. John Pinckney pension record, NARS.

747. Also known as Grand Monadnock, the picturesque mountain was the subject of the 1845 poem *Monadnoc* by poet, essayist, and philosopher Ralph Waldo Emerson (1803–1882).

748. Alfred Bailey naval service record, NARS.

749. *Philadelphia Inquirer*, February 24, 1866.

750. *Pacific Commercial Advertiser (Honolulu)*, August 4, 1866.

751. *New Orleans Times*, May 26, 1866.

752. *Illustrated New Age (Philadelphia)*, January 8, 1866.

753. *Pacific Commercial Advertiser (Honolulu)*, August 4, 1866.

754. Massachusetts-born Gustavus Vasa Fox (1821–1883) gathered naval intelligence during his 1866 trip, and he informally negotiated with Russia about the purchase of Alaska made by Secretary of State William Seward the following year. Fox, appointed to his post by Abraham Lincoln in 1861, resigned after the trip and returned to private business.

755. *The Sun (Baltimore, Md.)* Feb. 19, 1885.

756. Ibid.; Esther Louise Bailey pension record, NARS.

757. Reported in the *Times-Picayune (New Orleans)*, December 7, 1867.

758. Quartermaster's list of "Interments at Fort Davis 1867–1879."

759. Illinois Military and Naval Department, *Report of the Adjutant General of the State of Illinois*, vol. 8, p. 810.

760. *Cincinnati Daily Enquirer*, January 5, 1867; *Memphis Daily Avalanche*, January 1, 1867.

761. Wesley Merritt (1834–1910) graduated with the West Point class of 1860. At the start of the Civil War, he served as an aide to two generals, and he became a brigadier in 1863. He fought in numerous battles and cam-

paigns with the Army of the Potomac and the Army of the Shenandoah. He ended the war as a major general of volunteers. Joining the regular army at the rank of lieutenant colonel, he continued his military career through the Spanish-American War, retiring in 1900 as a major general.

762. Companies C, D, F, G, H, and I reported to Fort Davis. Regimental headquarters and companies A, B, E, and K, commanded by Gen. Edward Hatch, reported to Fort Stockton. Companies L and M reported to Brownsville. Rodenbough and Haskin, *The Army of the United States: Historical Sketches of Staff and Line with Portraits of Generals-in-Chief*, p. 283.

763. Eight soldiers from nearby Camp Del Rio were also part of this move. *Times-Picayune (New Orleans)*, December 18, 1891.

764. *San Francisco Bulletin*, November 18, 1873.

765. Philip A. Downey to the author, January 19, 2010; Morris W. Morris military service record, NARS.

766. Some members of the First Louisiana Native Guard had previously served in a militia unit with the same name, formed for Confederate service in 1861 and disbanded in early 1862. Morris was not one of these men. The regiment became the First Corps d'Afrique in June 1863. In April 1864 it became the Seventy-third U.S. Colored Infantry. In September 1865 it was consolidated with the Ninety-sixth U.S. Colored Infantry.

767. Nathaniel Prentiss Banks (1816–1894) of Massachusetts succeeded Maj. Gen. Benjamin Butler as commander of the Department of the Gulf in late 1862. A former member of the U.S. Congress and governor of Massachusetts, he led forces in the unsuccessful Red River Campaign and in failed attacks at Port Hudson. He resigned in 1864 and returned to politics.

768. Hollandsworth, *The Louisiana Native Guards*, pp. 70–83; Morris W. Morris military service record, NARS.

769. Jewish-American History Foundation, "A Black, Jewish Officer in the Civil War" (Web article).

770. Phelps, *Addenda to Players of a Century*, p. 22.

771. *New Orleans Times*, September 9, 1865.

772. *San Francisco Bulletin*, August 12, 1873.

773. Ibid., November 18, 1873.

774. Rose Wood (1850–1932) played "Pearl" in the film *Sylvia on a Spree* (1918).

775. Kellow, *The Bennetts*, p. 2.

776. *The New York Times*, May 9, 1886.

777. Florence Roberts (1861–1940) had a successful career as a stage and screen actress. Her credits include Madame Zola in *The Life of Emile Zola* (1937). The critically acclaimed film received three Academy Awards, including Best Picture.

778. Kellow, *The Bennetts*, p. 2.

779. Mabel Adrienne Morrison (1883–1940) was a stage actress. She married actor Richard Bennett (1870–1944) in 1903. Their three daughters all became actresses: Constance, Barbara, and Joan.

780. Barbara Jane Bennett (1906–1958) married popular singer Morton Downey (1901–1985) in 1929. They had five sons. Their second son was Morton Downey Jr. (1933–2001).

781. U.S. War Department, *Annual Report of the Secretary of War for the Year 1891*, vol. 1, p. 170; Kenner, *Buffalo Soldiers and Officers of the Ninth Cavalry*, pp. 188–189; Yuhasz, *In Defense of a Career*, p. 145.

782. Theodore Francis Wright, first lieutenant of Company F, penned this observation about Allen on the back of a *carte de visite* of the sergeant.

783. Kendrick Allen military service record, NARS; 1870 U.S. Census.

784. The relative may have been his father or an uncle. 1870 U.S. Census.

785. Rodenbough and Haskin, *The Army of the United States: Historical Sketches of Staff and Line with Portraits of Generals-in-Chief*, p. 696.

786. Register of Enlistments in the U.S. Army, 1798–1914, NARS.

787. Kenner, *Buffalo Soldiers and Officers of the Ninth Cavalry*, pp. 188–189.

788. Register of Enlistments in the U.S. Army, 1798–1914, NARS.

789. *The North Adams (Massachusetts) Transcript*, August 8, 1919.

790. Charles H. Arnum military service record, NARS.

791. *Douglass' Monthly (Rochester, N.Y.)*, August 1863.

792. Charles H. Arnum military service record, NARS.

793. *The North Adams (Massachusetts) Transcript*, April 2, 1934.

References

Books and Unpublished Manuscripts

Addeman, Joshua M. *Reminiscences of Two Years with the Colored Troops.* Providence, R.I.: N. B. Williams & Co., 1880.

Adjutant General's Office. *General Orders Affecting the Volunteer Force.* Washington, D.C.: Government Printing Office, 1864.

Asher, Jeremiah W. *Incidents in the Life of the Rev. J. Asher.* London, England: Charles Gilpin, 1850.

Bartlett, John R. *Memoirs of Rhode Island Officers Who Were Engaged in the Service of Their Country During the Great Rebellion of the South.* Providence, R.I.: Sidney S. Rider & Brother, 1867.

Bates, Samuel P. *History of Pennsylvania Volunteers, 1861–1865*, vol. 5. Harrisburg, Pa.: B. Singerly, 1871.

Berlin, Ira, Joseph P. Reidy, and Leslie S. Rowland. *Freedom: A Documentary History of Emancipation 1861–1867*, Series II: *The Black Military Experience.* Cambridge: Cambridge University Press, 1982.

Berlin, Ira, Barbara J. Fields, Steven F. Miller, Joseph P. Reidy, and Leslie S. Rowland. *Slaves No More: Three Essays on Emancipation and the Civil War.* Cambridge: Cambridge University Press, 1992.

Beyer, William F. *Deeds of Valor: How America's Civil War Heroes Won the Congressional Medal of Honor.* Stamford, Conn.: Longmeadow Press, 1994.

Blatt, Martin H., Thomas J. Brown, and Donald Yacovone. *Hope and Glory: Essays on the Legacy of the 54th Massachusetts Regiment.* Amherst: University of Massachusetts Press, 2001.

Boatner, Mark M., III. *The Civil War Dictionary.* New York: David McKay Co., 1962.

Bonner, Richard I. *Memoirs of Lenawee County Michigan*, vol. 1. Madison, Wisc.: Western Historical Association, 1909.

Bostic, Judith M. *Gone But Not Forgotten.* N.p., 1988.

Campbell, Stanley W. *The Slave Catchers: Enforcement of the Fugitive Slave Law, 1850–1860.* Chapel Hill: University of North Carolina Press, 1970.

Chenery, William H. *The Fourteenth Regiment Rhode Island Heavy Artillery (Colored,) in the War to Preserve the Union, 1861–1865.* Providence, R.I.: Snow & Farnham, 1898.

Church, John P., and C. H. Ingram. *What You Most Want to Know: A Complete Guide and Directory, Prepared for the Members of the Grand Army of the Republic and Their Friends, Visiting the Washington National Encampment.* Washington, D.C.: John C. Parker, n.d.

Collins, Lewis, and Richard H. Collins. *History of Kentucky,* vol. 1. Covington, Ky.: Collins & Co., 1878.

Côté, Richard N. *Mary's World: Love, War, and Family Ties in Nineteenth-Century Charleston.* Mt. Pleasant, S.C.: Corinthian Books, 2001.

Culver, Marjorie. *Manly's Memories, 1877–1977.* Manly, Iowa: n.p., 1977.

Cutter, Richard W. *Historic Homes and Places and Genealogical and Personal Memoirs Relating to the Families of Middlesex County, Massachusetts,* vol. 2. New York: Lewis Historical Publishing Co., 1908.

Darrah, William C. *Cartes de Visite in Nineteenth-Century Photography.* Gettysburg, Pa.: Privately printed, 1981.

David R. Poynter Legislative Research Library. *Membership in the Louisiana House of Representatives, 1877–2008.* Baton Rouge, La.: David R. Poynter Legislative Research Library, 2005.

Delany, Martin R. *Blake; or, The Huts of America, A Novel.* Boston: Beacon Press, 2000. (Originally published as a newspaper serial in the 1850s.)

Delany, Martin R. *Official Report of the Niger Valley Exploring Party.* New York: Thomas Hamilton, 1861.

Dennett, George M. *The History of the Ninth U.S.C. Troops, From Its Organization Till Muster Out.* Philadelphia: King & Baird, 1866.

Dickinson, Anna. *What Answer?* 1869; reprint, New York: Prometheus Books, 2003.

Douglass, Frederick. *Life and Times of Frederick Douglass.* Hartford, Conn.: Park Publishing Co., 1881.

Edge, Frederick M. *The Alabama and the Kearsarge.* Philadelphia: King & Baird, 1868.

Emilio, Luis F. *History of the Fifty-Fourth Regiment of Massachusetts Volunteer Infantry, 1863–1865.* Boston: Boston Book Co., 1894.

Fahs, Alice. *The Imagined Civil War: Popular Literature of the North and South, 1861–1865.* Chapel Hill: University of North Carolina Press, 2001.

Fehrenbacher, Don E. *The Dred Scott Case: Its Significance in American Law and Politics.* New York: Oxford University Press, 1978.

Fleetwood, Christian A. *The Negro as a Soldier.* Washington, D.C.: Howard University Print., 1895.

Foster, Richard B. *Historical Sketch of Lincoln Institute, Jefferson City, Missouri.* N.p., 1871.

Fox, Charles B. *Record of the Service of the Fifty-Fifth Regiment of Massachusetts Infantry.* Freeport, N.Y.: Books for Libraries Press, 1971.

Fox, Stephen R. *The Guardian of Boston: William Monroe Trotter.* New York: Atheneum Books, 1970.

Fox, William F. *Regimental Losses in the American Civil War, 1861–1865.* Albany, N.Y., 1889.

Gallagher, Gary W. *The Union War.* Cambridge, Mass.: Harvard University Press, 2011.

Gallagher, Gary, and Joan Waugh, eds. *Wars within a War: Controversy and Conflict over the American Civil War.* Chapel Hill: University of North Carolina Press, 2009.

Garrison Centenary Committee. *The Celebration of the One Hundredth Anniversary of the Birth of William Lloyd Garrison.* Boston: Garrison Centenary Committee, 1906.

Grand Army of the Republic. Headquarters Department of Rhode Island, *Proceedings at the Twentieth Annual Encampment of the Department of Rhode Island, Grand Army of the Republic, January 28, 1887.* Providence, R.I.: George F. Chapman & Co., 1887.

Greene, Robert E. *Swamp Angels: A Biographical Study of the 54th Massachusetts Regiment.* N.p.: BoMark/Greene Publishing Group, 1990.

Groves, Joseph A. *The Alstons and Allstons of North and South Carolina Compiled from English, Colonial and Family Records with Personal Reminiscences.* Atlanta, Ga.: Franklin Printing and Publishing Co., 1901.

Guthrie, James M. *Camp-Fires of the Afro-American; or, The Colored Man as a Patriot.* 1899; New York: Johnson Reprint Corp., 1970.

Haycraft, Samuel. *A History of Elizabethtown, Kentucky, and its Surroundings.* Elizabethtown, Ky.: Woman's Club of Elizabethtown, Kentucky, 1921.

Hollandsworth, James G., Jr. *The Louisiana Native Guards: The Black Military Experience During the Civil War.* Baton Rouge: Louisiana State University Press, 1995.

Hunt, Jeffrey W. *The Last Battle of the Civil War: Palmetto Ranch.* Austin: University of Texas Press, 2002.

Illinois Military and Naval Department. *Report of the Adjutant General*

of the State of Illinois, vol. 8. Springfield, Ill.: Phillips Bros., State Printers, 1900–1902.

Johnson, E. Polk. *A History of Kentucky and Kentuckians*, vol. 3. Chicago, Ill.: Lewis Publishing Co., 1912.

Johnson, Edward A. *A School History of the Negro Race in America from 1619 to 1890*. New York: Isaac Goldmann Co., 1911.

Keckley, Elizabeth. *Behind the Scenes*. New York: G. W. Carleton & Co., Publishers, 1868.

Kellow, Brian. *The Bennetts: An Acting Family*. Lexington: University Press of Kentucky, 2004.

Kenner, Charles L. *Buffalo Soldiers and Officers of the Ninth Cavalry, 1867–1898: Black and White Together*. Norman: University of Oklahoma Press, 1999.

Lathrop, Elise. *Early American Inns and Taverns*. New York: R. M. McBride & Co., 1926.

Levin, H. *The Lawyers and Lawmakers of Kentucky*. Chicago, Ill.: Lewis Publishing Co., 1897.

Linder, Suzanne C., Marta L. Thacker, and Agnes L. Baldwin. *Historical Atlas of the Rice Plantations of Georgetown County and the Santee River*. Columbia: South Carolina Department of Archives and History, 2001.

Litwack, Leon. *North of Slavery: The Negro in the Free States, 1790–1860*. Chicago: University of Chicago Press, 1961.

Logan, Guy E. *Roster and Record of Iowa Soldiers in the War of the Rebellion*, vol. 5. Des Moines, Iowa: Emory H. English, State Printer, 1911.

Longacre, Edward G. *A Regiment of Slaves: The 4th United States Colored Infantry, 1863–1866*. Mechanicsburg, Pa.: Stackpole Books, 2003.

Loring, George B. *Proceedings at the Dedication of the Town and Memorial Hall, Lexington, April 19, 1871*. Boston: Press of T. R. Marvin & Son, 1871.

Lowry, Robert, and William H. McCardle. *A History of Mississippi*. Jackson, Miss.: R. H. Henry & Co., 1891.

Mackenzie, George N. *Colonial Families of the United States of America*, vol. 6. Baltimore, Md.: Seaforth Press, 1917.

Mandeville, James de. *History of the 13th Regiment, N.G., S.N.V.* New York: Press of George W. Rodgers, 1894.

Matthews, Harry B. *African American Freedom Journey in New York and Related Sites, 1823–1870: Freedom Knows No Color*. Cherry Hill, N.J.: Africana Homestead Legacy Publishers, 2008.

Mayer, Brantz. *Baltimore: Past and Present, With Biographical Sketches*

of Its Representative Men. Baltimore, Md.: Richardson & Bennett, 1871.

McBride, W. Stephen. *The Union Occupation of Munfordville, Kentucky, 1861–1865: A Narrative Summary.* N.p., 1999.

McMurray, John. *Recollections of a Colored Troop.* Brookville, Pa.: McMurray Co., 1994.

McPherson, James. *For Cause and Comrades: Why Men Fought in the Civil War.* New York: Oxford University Press, 1997.

McPherson, James. *The Negro's Civil War.* New York: Pantheon Books, 1965.

Miller, Edward A., Jr. *Gullah Statesman: Robert Smalls from Slavery to Congress, 1839–1915.* Columbia: University of South Carolina Press, 2008.

Miller, Randall M., and John D. Smith. *Dictionary of Afro-American Slavery.* Westport, Conn.: Praeger Publishers, 1997.

Mitchell, Reid. *The Vacant Chair: The Northern Soldier Leaves Home.* New York: Oxford University Press, 1993.

Mollison, Willis E. *The Leading Afro-Americans of Vicksburg, Miss., Their Enterprises, Churches, Schools, Lodges and Societies.* Vicksburg, Miss.: Biographia Publishing Co., 1908.

Morgan, Joseph H. *Morgan's History of the New Jersey Conference of the A.M.E. Church.* Camden, N.J.: S. Chew, Printer, 1887.

Morgan, Thomas J. *The Negro in America and the Ideal American Republic.* Philadelphia: American Baptist Publication Society, 1898.

Myers, John P. *Minority Voices: Linking Personal Ethnic History and the Sociological Imagination.* Boston: Allyn & Bacon, 2005.

Newton, Alexander H. *Out of the Briars: An Autobiography and Sketch of the Twenty-Ninth Regiment, Connecticut Volunteers.* Philadelphia: A.M.E. Book Concern, 1910.

Norton, Oliver W. *Army Letters, 1861–1865.* Chicago: O. L. Deming, 1903.

Paradis, James M. *Strike the Blow for Freedom: The 6th United States Colored Infantry in the Civil War.* Shippensburg, Pa.: White Mane Books, 1998.

Perrin, William H. *Counties of Christian and Trigg, Kentucky, Historical and Biographical.* Chicago: F. A. Battery Publishing, 1884.

Phelps, H. P. *Addenda to Players of a Century: A Record of the Albany Stage.* Albany, N.Y.: N.p., 1889.

Poore, Benjamin P. *The Life and Public Services of Ambrose E. Burnside.* Providence, R.I.: J. A. & R. A. Reid, Publishers, 1882.

Reef, Catherine. *African Americans in the Military.* Ann Arbor, Mich.: Sheridan Books, 2010.

Rhode Island Soldiers and Sailors Historical Society. *Personal Narratives of Events in the War of the Rebellion: Being Papers Read Before the Rhode Island Soldiers and Sailors Historical Society*, 100 vols. Providence: Rhode Island Soldiers and Sailors Historical Society, 1878–1915.

Rodenbough, Theophilus F., and William L. Haskin. *The Army of the United States: Historical Sketches of Staff and Line with Portraits of Generals-in-Chief.* New York: Maynard, Merrill, & Co., 1896.

Rollin, Frank A. *Life and Public Services of Martin R. Delany.* New York: Arno Press and New York Times, 1969.

Rollins, Richard. *Black Southerners in Gray: Essays on Afro-Americans in Confederate Armies.* Redondo Beach, Calif.: Rank and File Publications, 1994.

Rothert, Otto A. *A History of Muhlenberg County.* Louisville, Ky.: John P. Morton & Co., 1913.

Rowland, Dunbar. *Mississippi: Comprising Sketches of Counties, Towns, Events, Institutions, and Persons*, vol. 3, *Contemporary Biography.* Atlanta, Ga.: Southern Historical Publishing Association, 1907.

Sampson, Myra C. *Silas Chandler.* N.p., 2010.

Sandweiss, Martha, ed. *Photography in Nineteenth-Century America.* Fort Worth, Tex.: Amon Carter Museum, 1991.

Schneller, Robert J. *Breaking the Color Barrier: The U.S. Naval Academy's First Black Midshipmen and the Struggle for Racial Equality.* New York: New York University Press, 2005.

Scott, Donald, Sr. *Camp William Penn.* Charleston, S.C.: Arcadia Publishing, 2008.

Scott, Kate M. *History of Jefferson County Pennsylvania.* Syracuse, N.Y.: D. Mason & Co., Publishers, 1888.

Scott, William H., Jr. *Biography of William Henry Scott.* N.p., n.d.

Simon, John Y. *The Papers of Ulysses S. Grant*, Vol. 26, *1875.* Carbondale: Southern Illinois University Press, 2003.

Slaney, Catherine. *Family Secrets: Crossing the Color Line.* Toronto, Ontario: Natural Heritage Books, 2003.

Smith, John David, ed. *Black Soldiers in Blue: African American Troops in the Civil War Era.* Chapel Hill: University of North Carolina Press, 2002.

State of Maine, Military Order of the Loyal Legion of the United States. *War Papers*, vol. 1. Portland, Maine: Thurston Print, 1898.

State of South Carolina. *Journal of the Constitutional Convention of the State of South Carolina.* Columbia: Charles A. Calvo Jr., State Printer, 1895.

Stauffer, John. *The Black Hearts of Men: Radical Abolitionists and the Transformation of Race.* Cambridge, Mass.: Harvard University Press, 2004.

St. Louis Genealogical Society. *Index to Death Records in the City of St. Louis, 1850–1902.* St. Louis, Mo.: St. Louis Genealogical Society, 1999.

Stoddard, Sharlene. *William Wright, Veteran of the Civil War.* N.p., n.d.

Sweetser, M. F. *King's Handbook of Newton Massachusetts.* Boston: Moses King Corp., 1889.

Taylor, Frank H. *Philadelphia in the Civil War, 1861–1865.* Philadelphia: City of Philadelphia, 1913.

Trachtenberg, Alan. *Reading American Photographs: Images as History, Mathew Brady to Walker Evans.* New York: Hill & Wang, 1989.

Trotter, James M. *Music and Some Highly Musical People.* Boston: Lee and Shepard, Publishers, 1880.

Trudeau, Noah A. *Out of the Storm: The End of the Civil War, April–June 1865.* Baton Rouge: Louisiana State University Press, 1995.

Trudeau, Noah A. *Voices of the 55th: Letters from the 55th Massachusetts Volunteers, 1861–1865.* Dayton, Ohio: Morningside, 1996.

Ural, Susannah J., ed. *Civil War Citizens: Race, Ethnicity, and Identity in America's Bloodiest Conflict.* New York: New York University Press, 2010.

Urwin, Gregory J. W. *Black Flag over Dixie: Racial Atrocities and Reprisals in the Civil War.* Carbondale: Southern Illinois University Press, 2004.

U.S. Department of the Interior. *Official Register of the United States,* vol. 1. Washington, D.C.: Government Printing Office, 1883.

U.S. House of Representatives. *The Reports of Committees of the House of Representatives for the First Session of the Fifty-First Congress,* vol. 3. Washington, D.C.: U.S. Government Printing Office, 1892.

U.S. Naval War Records Office. *Official Records of the Union and Confederate Navies in the War of the Rebellion,* 30 vols. Washington, D.C.: U.S. Government Printing Office, 1894–1922.

U.S. War Department. *Annual Report of the Secretary of War for the Year 1891,* vol. 1. Washington, D.C.: Government Printing Office, 1892.

Warner, John D., Jr. *Crossed Sabres: A History of the Fifth Massachusetts Volunteer Cavalry, an African American Regiment in the Civil War.* N.p., 1997.

Washington, Booker T. *Frederick Douglass.* Philadelphia: George W. Jacobs & Co., 1907.

Washington, Versalle F. *Eagles on Their Buttons: A Black Infantry Regiment in the Civil War.* Columbia: University of Missouri Press, 1999.

Watson, Thomas S. *Confederate Guerrilla Sue Mundy: A Biography of Kentucky Soldier Jerome Clarke.* Jefferson, N.C.: McFarland & Co., 2008.

Wilson, Joseph T. *The Black Phalanx.* Hartford, Conn.: American Publishing Co., 1890.

Wilson, Keith P. *Campfires of Freedom: The Camp Life of Black Soldiers during the Civil War.* Kent, Ohio: Kent State University Press, 2002.

Woodbury, Augustus. *A Narrative of the Campaign of the First Rhode Island Regiment, in the Spring and Summer of 1861.* Providence, R.I.: Sidney S. Rider, 1862.

Woodson, Carter G. *The Mind of the Negro as Reflected in Letters Written During the Crisis, 1800–1860.* Washington, D.C.: Association for the Study of Negro Life and History, 1926.

Yellin, Jean F. *Harriet Jacobs, a Life: The Remarkable Adventures of the Women Who Wrote* Incidents in the Life of a Slave Girl. New York: Basic Civitas Books, 2004.

Yuhasz, Mary H. *In Defense of a Career.* Parker, Colo.: Outskirts Press, 2005.

Articles

Abbott, Anderson R. "Some Recollections of Lincoln's Assassination." *Anglo-American Magazine,* vol. 5, no. 5 (May 1901).

Butterfield, Consul Willshire. "Bench and Bar of Duluth." *Magazine of Western History* (March 1889).

Cobb, W. Montague. "A Short History of Freedmen's Hospital." *Journal of the National Medical Association,* vol. 54, no. 3 (1962).

Cunningham, Sumner A. "Benjamin S. Chandler." *Confederate Veteran Magazine* (1910).

Curtis, Carita Moore. "Regan-Lum Family Bible / Joseph Regan Obituary." *Mississippi River Routes,* vol. 6, no. 1 (1998).

Davis, Robert Scott, Jr. "A Soldier's Story: The Records of Hubbard Pryor, Forty-Fourth United States Colored Troops." *Prologue: The Quarterly of the National Archives,* vol. 31, no. 4 (1999).

Foner, Philip S. "The Battles to End Discrimination Against Negroes in Philadelphia Streetcars." *Pennsylvania History* 40, Part One (July 1973), Part Two (October 1973).

Hauberg, John H. "A Confederate Prisoner at Rock Island: The Diary

of Lafayette Rogan." *Journal of the Illinois State Historical Society*, vol. 34, no. 1 (March 1941).

Holmes, Oliver Wendell. "Doings of the Sunbeam." *Atlantic Monthly*, vol. 12 (July 1863).

Hobbs, Herrwood E. "Nicholas Biddle." *Historical Society of Schuykill County*, vol. 7, no. 3 (1961).

Hooper, Helen E. "A Tale of the War." *Clarendon Light* (April 1896).

Hoptak, John David. "A Forgotten Hero of the Civil War." *Pennsylvania Heritage*, vol. 36, no. 2 (Spring 2010).

Knight, Michael F. "The Rost Home Colony, St. Charles Parish, Louisiana." *Prologue: The Quarterly of the National Archives*, vol. 33, no. 3 (2001).

Marvel, William. "Last Hurrah at Palmetto Ranch." *Civil War Times* (January 2006).

Marvin, Ulysses L. "General Shurtleff." *Oberlin Alumni Magazine*, vol. 7, no. 9 (1911).

Miller, Edward A., Jr. "Garland H. White, Black Army Chaplain." *Civil War History* (September 1997).

National Association of Letter Carriers. "Branch Items of Interest: Jacksonville, Florida." *The Postal Record*, vol. 30, no. 8 (August 1917).

National Association of Letter Carriers. "NALC Pioneer William Carney: From Runaway Slave to Civil War Hero." *The Postal Record*, vol. 114, no. 2 (February 2001).

Robertson, Brian K. " 'Will They Fight? Ask the Enemy': United States Colored Troops at Big Creek, Arkansas, July 26, 1864." *Arkansas Historical Quarterly* (Autumn 2007).

Robinson, Henry S. "Anderson Ruffin Abbott, M.D., 1837–1913." *Journal of the National Medical Association*, vol. 72, no. 7 (1980).

Spude, Robert L. "Mining History: A New Dialogue." *CRM*, vol. 21, no. 7 (1998).

Thompson, Jenny. "Civilian of the Month: Kate Fribley." *HARDTACK: Indianapolis Civil War Round Table Newsletter* (November 2006).

Manuscript Collections

African American Confederate Pension Applications, Mississippi Department of Archives and History, Archives and Library Division, Jackson.

Ambrose Burnside Papers, U.S. National Archives and Records Administration, Washington, D.C.

Anderson Ruffin Abbott Papers, Toronto Public Library, Toronto, Ontario.

Andrew M. Chandler Papers, collection of the family.

Christian A. Fleetwood Papers, Library of Congress, Washington, D.C.

Compiled Military Service Records, U.S. National Archives and Records Administration, Washington, D.C.

Confederate Pension Applications, Mississippi Department of Archives and History, Archives and Library Division, Jackson.

Court-Martial Case Files, U.S. National Archives and Records Administration, Washington, D.C.

Daniel Read Larned Papers, Library of Congress, Washington, D.C.

John W. M. Appleton Papers, West Virginia and Regional History Collection, West Virginia University Libraries, Morgantown.

Leroy D. House Letters, Connecticut Historical Society, Hartford.

Letters Received, Colored Troops Division, Records of the Adjutant General's Office, U.S. National Archives and Records Administration, Washington, D.C.

Papers of the Military Order of the Loyal Legion of the United States, Michigan Commandery, Bentley Historical Library, University of Michigan, Ann Arbor.

Records of the Adjutant General's Office, 1780s–1917, U.S. National Archives and Records Administration, Washington, D.C.

Records of the Field Offices for the State of Mississippi, Bureau of Refugees, Freedmen, and Abandoned Lands, 1865–1872, U.S. National Archives and Records Administration, Washington, D.C.

Regimental Books and Papers, Sixty-Second U.S. Colored Infantry, U.S. National Archives and Records Administration, Washington, D.C.

Register of Applications of Freedmen for Land, Records of the Assistant Commissioner for the State of Louisiana Bureau of Refugees, Freedman and Abandoned Lands, 1865–1869, U.S. National Archives and Records Administration, Washington, D.C.

Register of Enlistments in the U.S. Army, 1798–1914, U.S. National Archives and Records Administration, Washington, D.C.

Stinson Letters, Musick and Leigh Collections, U.S. Army Military History Institute (USAMHI), Carlisle Barracks, Pa.

Tennessee Confederate Pension Applications: Soldiers and Widows, Tennessee State Library and Archives, Nashville.

Warren Goodale Papers, Massachusetts Historical Society, Boston.

Newspapers

Alexandria (Virginia) Gazette
The Anglo-African (New York)
(Little Rock) Arkansas Weekly Mansion
The Atchison (Kansas) Daily Globe

Augusta (Georgia) Chronicle
The Boston Courant
Boston Daily Advertiser
Boston Guardian
Boston Morning Journal
The Cedartown (Georgia) Standard
The Christian Recorder (Philadelphia)
Cincinnati Daily Enquirer
Cleveland (Ohio) Gazette
The Colored American (Washington, D.C.)
The Daily Age (Philadelphia)
The Daily City Item (New Orleans)
Douglass' Monthly (Rochester, N.Y.)
The Globe (Atchison, Kans.)
Harper's Weekly
Illustrated New Age (Philadelphia)
Lexington (Kentucky) Herald-Leader
The Liberator (Boston)
Louisville (Kentucky) Journal
Lowell (Massachusetts) Daily Citizen and News
Macon (Georgia) Daily Telegraph and Confederate
Macon (Georgia) Telegraph
Memphis Daily Avalanche
New Orleans Times
The New York Herald
New York Herald-Tribune
The New York Times
The North Adams (Massachusetts) Transcript
North American and United States Gazette (Philadelphia)
Omaha (Nebraska) World Herald
Pacific Commercial Advertiser (Honolulu)
Palladium-Item (Richmond, Ind.)
Philadelphia Inquirer
The Plain Dealer (Cleveland, Ohio)
Public Ledger (Philadelphia)
The Rome (Georgia) News Tribune
San Francisco Bulletin
The Shelby (Kentucky) Record
Springfield (Massachusetts) Republican
The State (Columbia, S.C.)
The Sun (Baltimore, Md.)
Times-Picayune (New Orleans)

The Topeka (Kansas) Plaindealer
La Tribune de la N.-Orleans (New Orleans)
Washington (D.C.) Bee
Weekly Louisianian (New Orleans)
Weekly Miners' Journal (Pottsville, Pa.)
Weekly Press (Philadelphia)
West Point (Mississippi) Daily Times Leader
Woburn (Massachusetts) News
Worcester (Massachusetts) Telegram
The Yazoo (Mississippi) Semi-Weekly Sentinel

World Wide Web Sites

AfriGeneas: African Ancestored Genealogy. "AfriGeneas Military Research Forum." 2010. www.afrigeneas.com/forum-military/index.cgi?page=1;md=index.

Accessible Archives: Primary Source Material from 18th & 19th Century Publications. "African American Newspapers." 2011. www.accessible.com/accessible/.

Ancestry.com. "RootsWeb.com." 1998–2011. www.rootsweb.com.

Brown, David E. "Samuel Truehart: Fifth Regiment Cavalry United States Colored Troops." 2010. home.comcast.net/~5thuscc/truehar.htm.

The Church of Jesus Christ of Latter-Day Saints. "FamilySearch." 1999–2011. www.familysearch.org.

Cornell University Library. "The Making of America Collection." 2011. cdl.library.cornell.edu/moa/browse.monographs/waro.html.

Dictionary of Canadian Biography Online. "Abbott, Anderson Ruffin." 2011. www.biographi.ca/009004–119.01-e.php?BioId=41288.

George Eastman House. "George Eastman House Catalog." 2011. www.eastmanhouse.org.

Historic Newton, The Jackson Homestead and Museum. "Seeking Freedom in 19th Century America: Charles Redding of the Kearsarge." 2010. www.ci.newton.ma.us/jackson/seeking-freedom/03.html.

Historical Data Systems. "American Civil War Research Database." 2011. www.civilwardata.com/.

Jewish-American History Foundation. "A Black, Jewish Officer in the Civil War." 2010. www.jewish-history.com/civilwar/morris.html.

Lebanon, Missouri. "History of Lebanon." 2010. www.lebanonmissouri.org/index.aspx?nid=108

Martin, James M. "The Civil War Message Board Portal." 2011. historysites.com.

Massey, Richard. "Alexander H. Johnson: 54th Massachusetts Volunteer Infantry." N.d. battleofolustee.org/pics/alexander_johnson .html.

MyFamily.com Inc. "Ancestry.com." 1998–2011. www.ancestry.com.

MyFamily.com Inc. "Genforum." 2011. genforum.genealogy.com.

NewsBank, Inc. "News in History." 2011. newsinhistory.com.

Ward, Robert V., Jr. "From the Slave Quarters to the Courtroom: The Story of the First African American Attorney in the United States." 2007–2011. www.blackpast.org/?q=perspectives/william-henry-squire-johnson-slave-quarters-courtroom.

Acknowledgments

On the frontlines of this project has stood Anne, my wife, my love, my best friend. Day after day she listened to me recite newly discovered facts and other details as I researched and reconstructed the lives of the men profiled on these pages. She supported me as I made field trips, visited libraries and archives, and tackled countless other tasks involved with the production of this book. Her enthusiasm and dedication for my efforts to chronicle the lives of these men kept me going. I am truly fortunate to have her at my side.

Over the past three years, a running Coddington family gag has wondered aloud what fantastic contribution would get one's name into "Ronnie's next book." My mother, Carol, has always been and continues to be an infinite source of love and has taken a sincere interest in all of my projects. For this I will be forever grateful. My brothers, Gary and Michael, and their families have also been extremely supportive.

Of the many individuals who have given so generously of their time and knowledge, a few who have gone above and beyond the call of duty merit special mention.

Dennis Edelin of the National Archives in Washington, D.C., directed me to pension files that contained original photographs of veterans, retrieved military service files temporarily off limits to researchers, and pulled other files as needed. Always friendly and ready with a kind word, he represents the very best of the Archives staff.

I met Tim Kernan at his table at the Civil War show in Gettysburg, Pennsylvania, during the summer of 2009. He gave me permission on the spot to include his extraordinary tintypes of the Owens brothers. He then allowed me to bring my laptop and portable scanner to the site and make the necessary scans at the table. In the weeks and months that followed, Tim provided contacts and introductions to a number of other collectors focused on images of African American soldiers. He and his wife, Peggie, also invited me to their home. I am indebted to them for their generosity.

Paul Rusinoff of Baltimore, Maryland, shared his wonderful wartime artifacts and permitted me to include his tintype of Corp. Jeremiah Saunders, the first photograph secured for this volume.

Ronn Palm, owner of Ronn Palm's Museum of Civil War Images in Gettysburg, contributed the second image for this volume, that of Sgt. Silas Johnson. Ronn and I passed a pleasant afternoon viewing the 3,500 images displayed in his museum.

Ron Rittenhouse of Westover, West Virginia, generously shared his *carte de visite* of Sgt. John Peck. He led me to John Cuthbert, curator of the West Virginia and Regional History Collection at the West Virginia University Libraries in Morgantown. John played a key role in arranging permissions to include five photographs of soldiers from the Fifty-fourth Massachusetts Infantry.

I am grateful to Gary and Theresa Raines and Paul and Judith Loane, who welcomed me into their homes with kindness and hospitality. I left having made new friends, and with new images for this volume.

Forever lodged in my memory is the April 2010 day I met Chandler Battaile for lunch in Washington, D.C. We chatted for several hours about his great-grandfather, Confederate Sgt. Andrew Martin Chandler, and the sergeant's personal servant Silas. At the end of our meeting, he produced an original tintype of the two men and trusted it to my safekeeping for a few days. His desire to accurately and fairly tell the story of his forefather deeply impressed itself on me. His passion was equaled by that of Silas's great-grandson, Bobbie Chandler, whom I met and interviewed at his home in the nation's capital.

I worked with a number of institutions to secure scans and permissions for photographs and other materials. The easiest and friendliest to work with include the Beinecke Rare Book and Manuscript Library at Yale University, the Chicago Historical Society, the Kansas State Historical Society, and the Wisconsin Historical Society.

At the Arlington, Virginia, Public Library, Lynn Kristianson fielded numerous and often unusual requests for materials through the interlibrary loan program. I am thankful for her assistance.

Robert J. Brugger and Anne M. Whitmore of the Johns Hopkins University Press have been involved in all three of my books. I am deeply grateful for their professionalism and countless kindnesses over the years.

I appreciate those who reviewed the manuscript prior to submission. They include Garry Adelman, director of history and education at the Civil War Trust, Lisa Crawley, resource center manager of the Reginald F. Lewis Museum of Maryland African American History and Culture in Baltimore, and Edward G. Longacre, author of *A Regiment of Slaves: The 4th United States Colored Infantry, 1863–1866* and other books. Very special thanks are due to Edwin C. Bearss of the National

Park Service. His enthusiasm and support for all three of my books has inspired and motivated me to continue telling these stories.

My thanks go to other friends who pitched in at various points. Peter Horkitz and David D'Ostilio joined me on the pizza and research trip to New Haven. The spontaneous Suzy Rainsford arranged an impromptu book signing in Gettysburg. Richert Salondaka suddenly reappeared from the San Jose days and brought Chandler Battaile's appearance on PBS's *Antiques Roadshow* to my attention.

The debt of gratitude owed to Chuck Myers, steadfast friend and veteran battlefield traveler, for his numerous contributions can never be repaid.

The pugs again played their part. Lucy left at the start, Bella hiked many a battlefield and other Civil War trail, and Missy napped through most of this project.

Index

Gettysburg, Battle of, xxxii, 18, 32, 51, 114
Glory (movie), xv
Goosberry, John, 87, *88*, 89
Grand Army of the Republic, 5, 24, 61, *96*, 146, 219, 226, 229, 267, 269
Grant, Henry B., 120
Grant, Ulysses S., xx, 66, 89, 186, 211, 217, 229
Greeley, Horace, 47

Hampton, Wade, 5
Harrisburg, Pennsylvania, 13
Harrison, Benjamin, 70
Hayes, Rutherford B., 93
Henderson, Tom, *ii*, iv
Hines, John, *72*, 73–75
Hitchcock, Frederick L., *95*, 96
Hogue, Elijah, 97
Holland, Milton M., 153, *154*, 155–156
Holloway, Robert, 21, *22*, 23–24
Holmes, Oliver Wendell, xvii
Honey Hill, Battle of, 48, 92
Hood, John B., 126–127, 180
Hopson, Jesse, xxii, *100*, 101–102

Illinois troops: Third Cavalry, 41
Indiana troops: Sixty-eighth Infantry, 180
Indians, 55, 78, 109, 111, 222, 257
Iowa troops: First African Infantry (Sixtieth Infantry USCT), 135, 137, 139
Island Mound, Battle of, 38

Jackson, Albert E., *44*, 45–46
Jackson, Alfred, 141, *142*, 143
James Island (South Carolina), skirmish on, 53, 55
James Landry (sloop), 181
Jim Crow laws, 33
Johns, Jacob, 175, *176*, 177
Johnson, Alexander H., 55, *56*, 57, 107
Johnson, Andrew, 66
Johnson, Lewis, 127
Johnson, Silas L., *50*, 51–52
Johnson, William H., 55
Johnston, Joseph E., 149, 155, 174, 231

Kansas troops: First Colored Infantry, 35, 38
Keckley, Elizabeth, 223, 225
Kentucky troops (C.S.A.): Tenth Partisan Rangers, 141
Kentucky troops (U.S.): Twenty-seventh Infantry, 120
King, Allen, xxxix, *168*, 169–170
King, Charles, 85

Lamborn, Charles B., iv
Lane, James H., 37, 38
Lathrop, Daniel Stanley, *16*, 20
Lee, Robert E., 209, 217, 223, 231, 251
Lemon, Henry, 113
LeVere, George W., 85
Liberia, 165
Lincoln, Abraham, x, xii, xiii, xv, xxxi, xxxiii, xli, 4, 11, 13, 19, 28, 171, 187, 201, 202, 223, 225–226, 231, 245
Lincoln, Mary Todd, 223
Lively, Henry, *238*, 239–240
Long, George Davis "Dave," xxiii, 247, *248*, 249
Longfellow, Henry Wadsworth, 201
Lookout Mountain, Battle of, 187
Louisiana troops: First Native Guard (Seventy-third Infantry USCT), 217
Lyon, Lucius V., 219

Massachusetts Troops: Fifth Cavalry, 211, 213; Sixth Infantry, 13; Twelfth Infantry, 31; Fifty-fourth Infantry, xv, xxv, xxxv, xxxvi, 4, 47, 53, 55, 57, 59, 60, 61, 62, 63, 65, 69, 81, 82, 87, 92, 103, 107, 109, 221, 227, 229, 231, 267; Fifty-fifth Infantry, xv, 91, 92, 93
Matthews, William D., 35, *36*, 37–39
McFarland, Octavius, *190*, 191–192
Medal of Honor, 61, 155, 167, 219
Meekins, Major D., 157, *158*, 159–160
Merriam, Henry C., 217, 218
Merritt, Wesley, 259
Mexico, French occupation of, 159, 186, 209
Mississippi River, 41, 111, 139, 140, 192, 210, 215, 241
Mississippi troops (C.S.A.): Ninth Cavalry, 78, 79; Eighteenth